THE MONASTERY OF SAINT CATHERINE AT MOUNT SINAI

THE ICONS

VOLUME ONE:
FROM THE SIXTH TO THE
TENTH CENTURY

THE UNIVERSITY OF ALEXANDRIA
THE UNIVERSITY OF MICHIGAN
PRINCETON UNIVERSITY

THE MONASTERY OF SAINT CATHERINE
AT
MOUNT SINAI

George H. Forsyth
Field Director
The University of Michigan

Kurt Weitzmann
Editor
Princeton University

Publication of this book has been aided by
the Publication Committee of the Department of Art
and Archaeology of Princeton University

THE MONASTERY OF SAINT CATHERINE

AT

MOUNT SINAI

THE ICONS

VOLUME ONE:
FROM THE SIXTH TO THE
TENTH CENTURY

KURT WEITZMANN

WITH PHOTOGRAPHS BY
JOHN GALEY

PRINCETON UNIVERSITY PRESS
PRINCETON, NEW JERSEY

Copyright © 1976 by Princeton University Press
Published by Princeton University Press,
Princeton, New Jersey
In the United Kingdom: Princeton University Press,
Guildford, Surrey

Library of Congress Cataloging in Publication Data

Weitzmann, Kurt, 1904—
 The Monastery of Saint Catherine at Mount Sinai,
the icons.
 Includes index.
 CONTENTS: 1. Weitzmann, K. From the sixth
to the tenth century.
 1. Icons, Byzantine—Sinai—Catalogs. 2. Icons—
Sinai—Catalogs. 3. Sinai. Saint Catherine
monastery I. Galey, John. II. Title.
N8189.E32S558 755'.2 75–3482
ISBN 0-691-03543-1

Color separations by Schwitter AG, Basel
Plates printed by Basler Druck- und Verlagsanstalt, Basel
Text printed in the United States of America
by Princeton University Press, Princeton, New Jersey

Contents

List of Figures

List of Plates

Preface

THE idea of publishing the collection of icons of St. Catherine's Monastery in a comprehensive corpus was not the result of a long familiarity on my part with problems of icon painting. My more than cursory interest in this subject was awakened only when I was brought face to face with that collection. I immediately realized that this is the most outstanding assemblage of holy images to have survived to the present day, and that it deserves extensive study and full publication.

After a short exploratory visit to the monastery with Professor Forsyth and Mr. Anderegg of the University of Michigan in the summer of 1956, it was decided to undertake in the years to come an organized expedition. Four campaigns were subsequently made, with the purpose of studying, photographing and publishing the artistic treasures of the monastery—architecture, mosaics, frescoes, icons, illustrated manuscripts and objets d'art alike. At the time of our first visit almost nothing had been published or was even known about the icon collection. What still remains a mystery is that Kondakov, one of the greatest authorities on Byzantine art in general and on icon painting in particular, had hardly anything to say about the icons in his book about Sinai, written after a visit in 1877 and published in 1879. One can only surmise that the majority of the icons, including the most important ones, was at that time inaccessible.

Only after a new, fireproof wing in concrete was built between the years 1930 and 1942 to house the invaluable library, was a special room reserved in this wing, next to the new library, for the display of the finest icons and labelled "Picture Gallery." Until recently there were about one hundred icons exhibited there, most of them resting on ledges in three tiers on the walls, in such a way that the largest panels—including the very best and early icons—were placed in the top row, the middle-sized in the middle, and the smallest in the bottom row. Moreover, some of the smaller icons were exhibited in glass cases. This exhibit includes almost all the important icons discussed in this first volume. My first glimpse of the display was an experience comparable, I imagine, to that of Konstantin Tischendorf when he first saw the Codex Sinaiticus. Since then, the number of icons displayed in the gallery has increased, turning the room into a veritable icon museum.

My second great surprise came two days before we were to end our first visit, when a monk informed me that the Old Library had been converted into a storeroom for icons; here I saw, lined up on the old bookshelves, ten rows high, an array of more than six hundred icons and icon fragments in various stages of preservation, from the very best to the worst. In addition, there were at that time even more, about seven hundred, in the church proper, where the side chapels were also used to store icons. For all these riches I was unprepared, save that one person, Professor Aziz Atiya, who is not an art historian, had strongly insisted that, in going to Sinai, I should pay close attention to the monastery's icon collection, the value of which he had clearly sensed. He knew St. Catherine's very well, having participated in the Library of Congress Expedition in 1950, during which the manuscripts of the library were microfilmed.

Upon my return to Cairo from the first visit in 1956, I proposed to His Beatitude the late Archbishop Porphyrios III that a thorough study of the icons be made and published in several volumes. He and Gregorios, the secretary of the monastery at that time, who since became the new archbishop and died recently, confronted me with the plate volume of Sotiriou's publication of the icons of Sinai. To the Sotirious must be given credit for having first recognized the inestimable value of this icon collection and for having made the first comprehensive publication. However, after quickly leafing through this volume, I immediately realized that it contained only a selection of the icons, and that some of those included deserved fuller treatment. The mere statistics that about

150 icons were published by the Sotirious, while my personal checklist contained 2048 icons, leads of course to an unfair comparison. There are hundreds of icons, especially of the more recent periods, which are uninteresting from the artistic point of view and were rejected by the Sotirious for publication, as they will be by us. On the other hand, there are also hundreds of icons of the same artistic level as those published by the Sotirious that were not included in their volume and do deserve publication, not only to increase the number of items, but to reveal entirely new insights and trends in the history of icon painting. The Archbishop and his secretary responded to my argument with full understanding and gave their gracious permission and fullest support for a more thorough study, detailed photography, and a comprehensive publication. I feel it is my first duty to express my most sincere thanks not only to the two enlightened heads of the Sinaitic Church, the late Archbishop Porphyrios III and the late Archbishop Gregorios, but also to the monks in charge of the icon collection and the library, the late Pater Christophoros and the late Pater Eugenios during the first campaigns, and Pater Dionysios and Pater Damianos during the later campaigns. All of them gave liberally of their time, enabling us to work long hours. Moreover, I wish to extend my thanks to the late Pater Nikephoros, the *xenodochos*, to Pater Jeremias, the custodian of the church, and to all the other monks who took a personal interest in my work on the icons, for their unfailing help and their tolerance in permitting me to handle the venerable icons.

The University of Michigan, Princeton University, and the University of Alexandria having joined forces, four campaigns were undertaken in the years 1958, 1960, 1963, and 1965. The foremost task, in so far as the study of the icons was concerned—to be sure only one of the projects of the expeditions—was to make a satisfactory photographic record of every individual panel *in toto*, and of a certain number of them in many details. For his devotion in coping with such a gigantic task my sincere thanks go first of all to Mr. Fred Anderegg, supervisor of Photographic Services of the University of Michigan. Along with the additional burdens of keeping the expedition supplied with its many needs, he set up a laboratory in which he ingeniously developed black and white and color films under the most trying circumstances and primitive conditions. He also engaged most competent helpers. In 1958 our assistant photographer was Mrs. Grace Durfee from the Memorial Hospital in New York, not only an efficient photographer but indispensable to our expedition for her medical knowledge. In 1960, when the volume of photographic work on the icons increased, Mr. Walther Grunder from Basel was engaged as an additional photographer. In 1963 and 1965 the photography of the icons was in the hands of John Galey from Basel, who in addition to being an expert photographer, learned so much about icons that he could work without my supervision. To all these photographers I am deeply indebted for their loyal services.

While there are many icons on Sinai in a condition of perfection rarely to be seen in the great galleries of the world—largely owing to the dry climate—there are just as many in a deplorable state of preservation, ranging all the way from slightly damaged to the almost complete obliteration of the painted surface. Earlier centuries had solved the problem simply by overpainting the damaged icons wholly or partially, often with little regard for the preservation of the older layers of paint, a common practice in all orthodox countries. Still other icons were the victims of total neglect. Moreover, there are hundreds of panels whose surfaces were covered with blisters that had already begun to flake in varying degrees. I felt strongly that our expedition had not only to serve scholarship with a comprehensive publication —its chief aim—but that it also had to serve the monastery by doing what it could to preserve this unique collection. I therefore proposed in 1958 that a competent restorer be attached to our next campaign. To this the Archbishop agreed just as willingly as he had consented to the preservation and the cleaning of the great mosaic in the apse of the basilica, which in the course of our expedition was successfully accomplished. Thus Mr. Carroll Wales from Boston, who had been well trained at the restoration laboratory of the Fogg Museum of Harvard University, joined our expedition in 1960. His job was not so much to restore thoroughly a few individual icons, but rather to prevent the greatest possible number of the most endangered icons from further deterioration. Thus, Mr. Wales took on the unglamorous task of confining himself almost exclusively to reattaching blistered areas, and little time was left for removing the darkening varnish from those panels where discoloration had much spoiled the original impression of the once rich and harmonious colors.

Pater Gregorios had followed this work of restoration with great interest and wished that this operation, so successfully initiated by Mr. Wales, be continued as the responsibility of the monastery. He thus turned to the Greek Archaeological Service, which recommended to him Mr. Margaritoff, of the Byzantine Museum at Athens, as the chief restorer, who with several assistants has continued the task to the present day under the supervision of Mr. Chatzidakis, the able director of the Byzantine Museum.

Over the years many of the most important icons have been restored and cleaned and can therefore be published in their new splendor. At the same time, the publication cannot be delayed until the last icon is cleaned, since this would postpone even the first volume indefinitely. Thus I have had to assume the risk of publishing certain icons in their present unrestored state, making on occasion statements that I may have to modify after cleaning and restoration. But there will be an opportunity to publish corrections in subsequent volumes.

Each time we returned to the monastery, some changes had been made in the arrangement and the location of the icons. The monks had become increasingly concerned over the security of their priceless collection. While they wanted to make it accessible to the ever-increasing number of visitors, they also wished to do everything in their power to provide for its safekeeping. Most of all they considered that the great assemblage of icons in the open side chapels of the basilica were not sufficiently guarded and transferred several hundred of them, especially those of smaller format, into the already overcrowded Old Library. Thus by 1960 the number of icons on the shelves had swollen from about six hundred to more than a thousand. Quite a number of icons had also been transferred from the Upper Panagia Chapel to the Old Library, with which it is connected by a common anteroom. The inventory of the numerous chapels within the monastery, whose walls are lined with icons of every period and great variance in quality, was left untouched since these chapels are not open to the public. However, the monks were greatly concerned about the various chapels that are scattered over the ridge of Ras es-Safsâf, the high mountain ridge above the monastery, and are not easily accessible, being seldom visited even by the monks themselves. The late Pater Nikephoros suggested that we visit each of these chapels, and I was authorized by the monastery to choose among the icons stored there, and to transfer all that I considered of sufficient artistic value to the safety of the Old Library.

The monastery also acquired, for the preservation and display of the icons, additional glass cases for the gallery room. I was asked to select a number of the most valuable icons from the collection in the Old Library to fill them. If I am correctly informed, additional icons have been transferred to the Gallery since my last visit in 1965. At the same time, the monastery had become much concerned about the overcrowding of icons in the Old Library and the fire hazard of the wooden shelves on which they were placed. An architect was engaged to build steel ledges in the Library proper and additional ones on the empty walls of the ante-

room; this increased the wall space available for the display of icons by about one third. Furthermore, about a dozen freestanding glass cases were acquired for the exhibition of icons of small and sometimes minute format. This whole installation, which makes the Old Library and its treasures more accessible, was made possible by a contribution from Princeton University in gratitude for the monastery's liberal support of our icon studies. It would not be surprising if the monks should continue to make changes and improvements in the display, leading to still further shifts. The locations of the icons given in this volume are those of 1965, the year of our last campaign, and they cannot be considered as permanent, but I shall note the changes made during the years of our expedition.

I must ask the indulgence of the reader for this unusually extended preface. It has been prompted by the extraordinary circumstances under which the expedition had to operate, and which I believe should be recorded as part of the monastery's most recent history. For the expressions of gratitude to those institutions and individuals who supported and assisted the expedition, above all to the high dignitaries and the monks of the monastery, and to the various representatives of the Egyptian Government in Cairo and of the University of Alexandria, I refer the reader to the preface in G. H. Forsyth and K. Weitzmann, *The Monastery of Saint Catherine at Mount Sinai. The Church and Fortress of Justinian* (Ann Arbor, Michigan, 1973). I need not, thus, repeat them here and shall confine myself to mention of those institutions and individuals who supported in particular my work on the icons.

I am indebted to Professor Forsyth for having initiated the expedition and for having taken over the major burden of its organization, and to the University of Michigan for having supported him in this task. For sustained moral support I am indebted to Princeton University and particularly to my good friend, the former chairman of the Department of Art and Archaeology, Professor Rensselaer W. Lee, who succeeded in raising, single-handedly, most of the funds that enabled me to pursue the lengthy and painstaking study of the icons. Through his mediation, Mr. Arthur Amory Houghton, Jr., of New York became the most benevolent benefactor of our enterprise. Another friend of Mr. Lee, Mr. William Hendrickson of Houston, Texas, also made a generous contribution, and a third donor was the late Mr. Frank P. Leslie from Minneapolis, an old friend of Princeton. All three gentlemen honored us with their visit to the monastery and took a personal interest in our work, especially the photography and the restoration and cleaning of the icons. A major contribution to three of

the four campaigns was made by the Bollingen Foundation. During the campaigns of 1963 and 1965 the American Research Center in Egypt, whose former president, the late Egyptologist, Dr. Stevenson Smith, had taken a lively interest in the work of our expedition, contributed substantially toward our expenses while on Egyptian soil. During all four campaigns my personal expenses within the framework of the expedition were shared by the Spears Fund of the Department of Art and Archaeology of Princeton University and by the Institute for Advanced Study.

In 1966 I had the great privilege of seeing the four icons in Kiev which had been brought there from Sinai by Porphyrius Uspensky, and I wish to express my sincere thanks to the authorities of the Kiev Museum who supported my study of them and to Professor Victor Lazarev, Moscow, and Mr. Hrihoriy Logvin, Kiev, for securing good photographs of them.

Ten years have passed since our last campaign, and it has taken longer than originally expected to produce this first volume of the icons. However, it must be realized that final publication could not be initiated until the entire material has been assembled and, in a preliminary fashion, divided into groups by approximate date and possible location. Since so much of the material, particularly from the early periods, is unique, the preparatory work was necessarily more extensive than that of a normal catalogue

raisonné in which most of the objects have previously been introduced into art historical literature. In more than twenty articles on individual icons and groups of icons, the author has prepared the ground on which to build the descriptions and evaluations of the corpus, knowing only too well that even so shortcomings inevitably result from working in virgin territory. It is hoped that the subsequent volumes, of which those covering the Byzantine period proper will be prepared by the author and those of the post-Byzantine period by Professor Manolis Chatzidakis, the director of the Byzantine and the former director of the Benachi Museum at Athens, will follow at shorter intervals.*

The publication of the present volume was made possible by a most generous contribution by an anonymous donor to the Princeton Department of Art and Archaeology for which I am most grateful.

For extensive editorial help I must thank my assistant, Ms. Lynda Hunsucker, on whose devotion I could always count. I also should like to express my high appreciation to the Princeton University Press, to its director Herbert Bailey for having shown a lively interest in the Sinai publication as a whole, to Ms. Mary Laing, and especially to Ms. Margot Cutter for having given a final polish to the text. Finally, I wish to acknowledge the special attention which Mr. Jan Schwitter and Mr. Georg Kloos in Basel have paid to the perfection of the color reproductions.

* The letter B before each catalogue number indicates "Byzantine," to distinguish from the "Post-Byzantine" icons to be published by Manolis Chatzidakis, which will be marked P.B.

Abbreviations

Ainalov, "Син. Ик.": Д. В. Айналов, "Синайские иконы восковой живописи," *Византийский Временник*, ix, 1902, pp. 343–377.

Banck, *Byz. Art:* A. Banck, *Byzantine Art in the Collections of the U.S.S.R.*, Leningrad and Moscow 1966.

D.O.P.: Dumbarton Oaks Papers.

Felicetti-Liebenfels, *Byz. Ik.:* W. Felicetti-Liebenfels, *Geschichte der byzantinischen Ikonenmalerei*, Olten and Lausanne 1956.

Goldschmidt and Weitzmann, *Byz. Elf.:* A. Goldschmidt and K. Weitzmann, *Die byzantinischen Elfenbeinskulpturen des X-XIII Jahrhunderts*, i, *Kästen;* ii. *Reliefs*, Berlin 1930 and 1934.

Kiev Museum Catalogue: Киевский Государственный музей западного и восточного искусства. *Каталог западноевропейской живописи и скульптуры*, Moscow 1961.

Kitzinger, "Icons": E. Kitzinger, "On Some Icons of the Seventh Century," *Late Classical and Mediaeval Studies in Honor of A. M. Friend, Jr.*, Princeton 1955, pp. 132ff.

Kondakov, *Иконы:* Н. П. Конаков, *Синайской и Афонской колекций*, St. Petersburg 1902.

Kondakov, *Памят.:* Н. П. Кондаков, *Памятники Христианского Искусства на Афонъ*, St. Petersburg 1902.

Lazarev, *История:* В. Н. Лазарев, *История Византийской живописи*, 2 vols., Moscow 1947–1948.

Lazarev, *Storia:* V. Lazarev, *Storia della pittura bizantina*, Turin 1967.

Migne, *P.G.:* J.-P. Migne, *Patrologia Graeca*.

Millet, *Rech. Ev.:* G. Millet, *Recherches sur l'iconographie de l'évangile aux XIVe, XVe et XVIe siècles*, Paris 1916.

Omont, *Miniatures:* H. Omont, *Miniatures des plus anciens manuscrits grecs de la Bibliothèque Nationale*, 2nd ed., Paris 1929.

Petrov, *Альбом:* Н. Петров, *Альбом достопримечательностей церковно-археологическаго музея при Киевской Духовной Академии*, вып i. *Коллекция Синайскихь и Афонскихь иконь преосвященнаго Порфирия Успенскаго*, Kiev 1912.

Sotiriou, *Icones:* G. and M. Sotiriou, *Icones du Mont Sinai*, i, *Album*, Athens 1956; ii, *Text*, Athens 1958.

Uspensky, *Втор. Пут.:* Порфирий Успенский, *Второе путежествие на Синай*, Kiev 1850.

Volbach, *Elfenb.:* W. Volbach, *Elfenbeinarbeiten der Spätantike und des Frühen Mittelalters. Römisch-Germanisches Zentralmuseum zu Mainz*, 2nd ed., Mainz 1952.

Weitzmann, *Byz. Buchmalerei:* K. Weitzmann, *Die byzantinische Buchmalerei des 9. und 10. Jahrhunderts*, Berlin 1935.

Weitzmann, "Jephthah Panel": K. Weitzmann, "The Jephthah Panel in the Bema of the Church of St. Catherine's Monastery on Mount Sinai," *Dumbarton Oaks Papers* xviii, 1964, pp. 341ff.

Weitzmann, *Frühe Ikonen:* K. Weitzmann, M. Chatzidakis, K. Miatev, S. Radojčić, *Frühe Ikonen*, Vienna and Munich 1965.

Weitzmann, *Studies:* K. Weitzmann, *Studies in Classical and Byzantine Manuscript Illumination*, ed. by H. L. Kessler, Chicago 1971.

Weitzmann, "Loca Sancta": K. Weitzmann, "Loca Sancta and the Representational Arts of Palestine, "*Dumbarton Oaks Papers* xxviii, 1974, pp. 31 ff.

Wulff and Alpatoff, *Denkmäker:* O. Wulff and M. Alpatoff, *Denkmäler der Ikonenmalerei in kunstgeschichtlicher Folge*, Hellerau bei Dresden 1925.

THE MONASTERY OF SAINT CATHERINE AT MOUNT SINAI

THE ICONS

VOLUME ONE:
FROM THE SIXTH TO THE
TENTH CENTURY

Introduction

A. Publication Plan

THE present publication is essentially a catalogue raisonné adjusted to the peculiar nature of the material gathered together in this and the subsequent volumes. Historians of art have used the catalogue form for two different types of publication. The first describes the holdings of a museum or a private collection, thus forming a basis for further studies. O. M. Dalton's *Catalogue of the Ivories of the British Museum* is an exemplary publication of this type, in which the ivories from antiquity to the baroque, covering many civilizations, are described and analyzed in considerable detail. The second type of catalogue is the corpus, which assembles the whole material of a certain period and culture as completely as possible. The highest standard for this type of publication has been set by Adolph Goldschmidt in his corpus of the mediaeval ivories from the Carolingian to the Romanesque period. This first volume of the Sinai icons fits neither type precisely, but in a sense combines both. For the early period, i.e. the sixth to the tenth centuries, the material is quite unique and this is to a large extent also true for the material of the eleventh and twelfth centuries, since from this span of time there exist very few icons outside of Sinai and most of these actually came from Sinai.

For works of the early periods—the sixth through the tenth centuries, the subject of the present volume, and the eleventh and twelfth centuries, to be treated in the subsequent volume—our publication aims at completeness even where works of poorer quality and condition are concerned, because almost every piece is in some sense unique, can be of considerable archaeological value, and may provide clues to the solution of problems arising in connection with new icons coming to light. We intend to maintain the principle of completeness also for the icons from the thirteenth century. Although for this century the material outside of Sinai is considerable and a good deal of it has already been published, the Sinai material of this period presents many new aspects—the impact of the crusades among them—that will broaden our general knowledge of icon painting.

It is only with the fourteenth and fifteenth centuries that the Sinai material loses its character of uniqueness, and icons of poor quality and of a type that can be found elsewhere are increasingly mixed with works of the highest artistic standard. Here it has seemed advisable to be selective and to concentrate on those icons that either from the artistic or the iconographic point of view contribute to our growing knowledge of icon painting. This is even more true for works of the post-Byzantine period, such vast treasures of which are to be seen in many places on Greek soil that it became a question whether this period should be included at all. The Sotirious had excluded it from their publication of the Sinai icons. Yet our decision to include a Sinaitic school that operated on a large scale, apparently shortly after the fall of Constantinople in 1453, in addition to a considerable number especially of Cretan icons from the late fifteenth to the eighteenth centuries is based on the realization, first, that there are very outstanding masterpieces of Cretan icon painting on Sinai which greatly enrich our already extensive knowledge of this period; and, second, that among them are a considerable number of signed and dated works which further enhance our knowledge of the *oeuvre* of individual artists. Last but not least, the assured collaboration of Professor Manolis Chatzidakis, the great expert of late and post-Byzantine icon painting, has helped to make this plan a reality. It will actually be possible to publish the volumes of post-Byzantine icons simultaneously with those of the Byzantine works.

The description of each icon will report first its physical condition. This aspect could not, however, be treated in each case with the desired thoroughness for two reasons. Whether an early icon is executed in encaustic technique or

3

in tempera is in many cases obvious, but in others it is not. Mr. Margaritoff, the Greek restorer, who had with him special equipment for testing from the scientific point of view, was extremely helpful in answering technical questions submitted to him, but time did not permit a systematic investigation. The other shortcoming I am aware of was our ignorance of the kinds of wood on which the icons were painted. None of the restorers had any experience in this field and there was no expert available to our expedition. The usual guess, "cedar from Lebanon," would need confirmation, though there is, of course, a certain probability that cedar was used, at least for the icons made in the nearby Syro-Palaestinian region. Here a supplementary study by an expert would be desirable and could even result in some regrouping of the icon material.

Whenever an icon has been restored, the name of the restorer when known will be recorded. Some restorations were made quite early. In the second half of the eighteenth century, Ioannes Kornaros, himself a painter who in 1780 painted the iconostasis of the Jacobos chapel, not only restored many icons by overpainting whole or parts of figures, but, reflecting a change in taste, he also loved to overpaint gold ground with an azure color, repainting on it the older inscriptions in a typical late script and not always very correctly. In modern times Pater Pachomios, who must be credited with having saved many icons from total destruction, restored many of them, not very skillfully, with modern oil paints. Usually he confined himself to filling in lacunae rather than overpainting the old surface (cf. the Peter icon [no. b.5]). These fillings can be removed and have been, e.g., from the Peter icon and others. Pater Pachomios, a saintly monk, died in 1960, when we were in the monastery and able to attend the funeral. He was the last icon painter of Sinai, and with him died a tradition more than a millenium old.

In describing subject matter, the inclusion of considerable detail has been, on occasion, unavoidable. For the Sinai icons the bibliography is as yet very limited, consisting primarily of the publication of the Sotirious, sporadic publications of individual or groups of icons by the author, and a few references by other scholars. Moreover, quite a number of icons are published here for the first time. Since frequently, especially for the material dealt with in this first volume, the iconography is unique or has unique features, we have supplemented the bibliography by a separate set of footnotes. There are cases, like the icon with the Ancient of Days (no. b.16), when mere iconographical description is not enough and problems of dogmatic interpretation must be considered; in other cases liturgical aspects must be discussed.

To do justice to the artistic quality of the icons, a certain amount of color description has seemed to us necessary. One may object that where the icons are reproduced in color this description may not have been necessary at all, but such an objection would have validity only if every icon could have been reproduced in color. We have been guided by the consideration that comparatively few scholars will be able to see the originals, much less study them intensively.

The difficulties in defining the style of the early icons are due to a large extent to the lack of comparative material. One need only refer to the three great masterpieces (nos. b.1, 3 and 5)—instead of fitting into any preconceived concept of sixth-century icon style, they will in the future define such a style. A fuller discussion of stylistic details than would normally be called for was, therefore, required. Not before the eleventh century will we find an icon style that recalls parallels in either miniature or fresco painting.

B. Organization of Material

There were two alternatives for the organization of the material: it could be arranged, within broad time limits, according to subject matter, i.e. iconography, or according to style. In Byzantine art more than in the art of any other culture, and especially in Byzantine icon painting, the subject matter—narrative, liturgical, or dogmatic—has a remarkable precision, and therefore can provide accurate criteria for grouping. Arrangement by style, however, harbors many uncertainties and promises less accurate results. Moreover, the difficulties generally inherent in organizing by style are magnified for the material in the present volume because there is not a single icon with a fixed date. Although a few either depict or bear the name of a donor (nos. b.14, 16, 39), not one of the donors is historically identifiable. Yet, in spite of these difficulties, we have preferred an arrangement by style, in order to trace, however incompletely, the development with respect to chronology and place of origin.

The extent of the time limits set for each individual icon varies considerably and depends largely on the density of the material within a certain period. Where the material is sparse—and this applies to every century between the sixth and the ninth—the limits have had to be set rather widely. At the present state of our knowledge, we will have to be content with determining the century, and only in the rarest cases has it seemed justifiable to suggest its first or second half. Sometimes it has seemed even preferable to give a two-century span. The period covered by the present

volume is usually divided on a historical basis into the preiconoclastic, the iconoclastic, and the posticonoclastic periods. But since we have reason to believe that in the Eastern provinces, no longer controlled by the Byzantine emperor, icon painting continued after the outbreak of the controversy over images, iconoclasm itself does not provide a clear line of demarcation. Furthermore, it does not seem to have led to any unusual changes in the continuing style.

There can be no doubt that quite a number of the Sinai icons reach back into the preiconoclastic period, but it is not easy to determine how far the earliest Sinai icons are removed from the time when icon painting originated. The literary sources make clear that the first icons were produced sporadically in the fourth century, that their number increased in the fifth and that only in the sixth was the cult of the images firmly established.[1] Although no definite proof can be given, we believe that the two great early masterpieces (nos. B.1 and 3) and most likely also the third (no. B.5), belong to the sixth century. The small icon of the Ascension (no. B.10), of somewhat poorer quality and different style, seems also to belong to the sixth century, and there does not seem to be a single icon for which a case could be made for a fifth-century date. However, the very thought that some Sinai icons take us back into the period when icon painting had just become a widespread and generally accepted branch of Christian painting, opens new perspectives to scholarship.

The Arab conquest in the seventh century neither interrupted the flow of icons to Sinai nor prevented their production at Sinai itself. But it did apparently stop the influx from Constantinople and, if we are not mistaken, the majority of icons here attributed to the seventh and eighth centuries (nos. B.16–36) came from regions that were at that time already under Moslem domination.

To make the claim that some icons of Sinai belong to the period of iconoclasm (726–843) contradicts the generally accepted belief that no icons were produced during the period when imperial decrees had ordered all existing images to be destroyed and no new ones to be produced. What, then, is the basis for our contention that, in spite of these decrees, icons *were* produced during this period? The point of departure is the Crucifixion icon (no. B.36), which stylistically has a rather close affinity to the Crucifixion fresco in S. Maria Antiqua in Rome painted at the time of Pope Zacharias I (741–752). Moreover, the icon is not an isolated piece, but stands in the center of a small group (nos. B.37–41) which is a direct continuation of the larger

group previously mentioned (nos. B.16–36). There can be little doubt that the icons of this group spread over a considerable span of time which could neither be exclusively pre- or posticonoclastic, but which must include the iconoclastic period proper.

While the icons here ascribed to the iconoclastic period continue the preiconoclastic style, one does get the impression that the tradition based on the heritage of classical forms has weakened. The vestiges of Hellenistic naturalism, still comparatively strong in the masterpieces of the sixth century, begin to fade and artists start to use more summary, more decorative, more linear, and thus more abstract forms. Yet the term abstract is to be used with caution as abstraction is never at any time in Byzantine art carried so far as to obliterate the classical tradition entirely.

The centers we assume to have produced icons during the period of iconoclasm seem to have continued to do so for quite some time after the controversy had come to an end in the middle of the ninth century, and a new style asserts itself, at first only weakly in an icon we should like to attribute to the second half of the ninth century (no. B.51) and then with great force in the tenth century. The icons of this period show the style we associate with the Macedonian Renaissance, as exemplified in its initial stages by the miniatures of the Gregory manuscript in Paris, cod. gr. 510, dated 880 to 886, and in its full development by tenth-century manuscripts like the Leningrad fragment of a lectionary, cod. 21 (p. 92 and fig. 32).[2] For the first time in the history of icon painting there begins to be firmer ground for dating, owing to the fact that these icons can be related to miniature paintings, for which a chronology can be established within relatively precise time limits. Compared with the icons of the seventh and eighth, and even the earlier ninth century, like the Crucifixion no. B.50, the tenth-century icons reflect a stronger use of the classical repertory of forms for human proportions, drapery motifs, flickering highlights, and delicate color shading. Only in one respect do they show restraint in reviving the classical mode, and this is in the rendering of the physical reality of the human body. Its dematerialization was a device for fusing Christian spirituality with the classical tradition, and from this point of view the Macedonian Renaissance was not a mere revival of the style of the Justinianic and earlier periods, but has a character of its own. But while this Renaissance style has been well known in miniature painting, ivory carving, and other branches especially of the so-called minor arts, Sinai has brought to light the first icons of the tenth century to

[1] E. Kitzinger, "The Cult of Images in the Age before Iconoclasm," *D.O.P.* VIII, 1954, pp. 83ff.

[2] Weitzmann, *Byz. Buchmalerei*, pp. 2–34.

reflect the same tendencies. Admittedly they are very few and they do not illustrate the full range of the Renaissance, but they have the advantage that they can be compared with products of the same medium from the preceding centuries, and this is not now true for miniature painting and may never have been possible for ivory carving.[3]

Three phases of development are recognizable in icon painting of the tenth century, and they parallel developments in miniature painting. In the icons of the first half of that century (nos. B.52–57), greater attention than before is paid to the understanding of human proportions and the classical system of highlights, while the figures themselves remain comparatively flat. The corporeality increases somewhat in the second phase, around the middle of the tenth century (nos. B.58–59), and in the third phase, the second half of the tenth century, the colors are more saturated and begin to become brilliant under the influence of cloisonné enamels (nos. B.60–61).

Places of origin are even more difficult to determine. Here we must admit that only reasonable hypotheses can be offered. Among the earliest icons, the three masterpieces (nos. B.1, 3 and 5) are so closely linked by technique and style that they must not only be considered contemporary, but the products of the same locality, although it is an open question whether they were produced in the same atelier.[4] The very high level of quality and the purity of the classical heritage reflected in them suggests Constantinople as the place of origin. It was there in the sixth century that the classical tradition was preserved with greater purity than in any of the other great metropolitan centers of the Eastern Mediterranean, such as Alexandria or Antioch, which in the late classical period were open to the influences of their hinterlands.[5] It must also be kept in mind that Sinai was founded by the emperor Justinian, and that, therefore, gifts worthy of its imperial patronage are to be expected among the icons as, similarly, the great apse mosaic with the Metamorphosis is, in our opinion, a creation of a Constantinopolitan workshop. Only a few icons (nos. B.2, 4, 6, and 9) can be grouped around the three masterpieces and an origin in the capital suggested for them. The icons with the Virgin and Child (no. B.2) and SS. Sergius and Bacchus (no. B.9), both of which are now in Kiev, have the best chance of being Constantinopolitan.

At the same time there exists at Sinai quite a number of icons that form a coherent group and give various indica-

tions that their likely place of origin was Palaestine or, perhaps more precisely, Jerusalem. The key work here is the Ascension icon (no. B.10), which is contemporary with the three masterpieces and yet has a style of its own. It is closely related to the painted lid of the box of the Sancta Sanctorum in Rome (p. 32, fig. 14) containing relics of the holy places of Jerusalem; its iconography is linked with the Monza ampullae (fig. 13), likewise products of Jerusalem. Moreover it exhibits a stylistic affinity with the icon of John the Baptist (no. B.11) now in Kiev, which shows a vital and expressive style. If its attribution to Jerusalem is correct, this would indicate that in the sixth century Palaestine, and more precisely Jerusalem, had a high standard of artistic production. But this standard apparently could not be maintained after the impact of the Arab conquest, and in the later products we should like to attribute to the same center the quality gradually diminishes, although some of the later icons still maintain a competent and respectable standard. The icons that continue the style of the Ascension and the Baptist icons form the only comparatively large, coherent group (nos. B.19–45), the most striking among them being the icon with the Three Hebrews in the Fiery Furnace (no. B.31) and the triptych wings with figures of saints (no. B.33).

Moreover, to this phase of the Palaestinian group belong the two encaustic panels painted on the marble pilasters in front of the apse of the basilica, below the Metamorphosis mosaic, representing the Sacrifice of Isaac and the Sacrifice of Jephthah's Daughter (nos. B.29–30). Here the problem arises of whether these panels are isolated works by an artist who came from the outside, presumably Jerusalem, or whether there might have been a workshop at Sinai that was responsible not only for these panels, but also for a number of icons in the same style. But since Sinai at no time had a style of its own, it does not greatly matter whether the icons were executed at Palaestine or in the monastery. As is well known, Sinai has always had close ecclesiastical ties to Jerusalem—still today its new archbishops are usually invested by the Patriarch of Jerusalem. Moreover, Sinai was visited by pilgrims as a holy place, along with the *loca sancta* of the Holy Land, even before the monastery was founded, as is documented by the pilgrimage of Etheria, the noblewoman from Spain at the end of the fourth century. Actually Sinai, once part of Arabia Petraea, had in the Constantinian era become politically part of

[3] Goldschmidt and Weitzmann, *Byz. Elf.* II, pp. 10ff.

[4] Cf. the remarks on this point by M. Chatzidakis, "An Encaustic Icon of Christ at Sinai," *Art Bull.* XLIX, 1967, pp. 197ff.

[5] K. Weitzmann, "Das klassische Erbe in der Kunst Konstantinopels," *Alte und Neue Kunst* III, 1954, pp. 41ff. (repr. "The Classical Heritage in the Art of Contantinople," Weitzmann, *Studies*; pp. 96ff.).

Palaestine and was named Palaestina Tertia. Thus there were important cultural and artistic connections between Sinai and Jerusalem.

We must note, however, that our emphasis on Palaestine is not in accord with the results published by the Sotiriou, who ascribed many of the icons of the group under discussion to Egypt. Geographically Sinai is as close to Egypt as it is to Palaestine, and it has been politically more or less a part of Egypt since the Arab conquest. Yet when one compares the early icons of Sinai with those we know to be from Egypt, especially the Coptic ones, we must admit that we are unable to find affinities close enough to justify the attribution of the Sinai material to an Egyptian workshop. From the sixth century on, as exemplified in the frescoes of Bawit or Saqqara and icons like that with Christ and St. Menas in the Louvre,[6] the Egyptian works show a human figure style of more thickset proportions, and a tendency toward square, flattening outlines and staring eyes. By comparison, the Sinai icons manifest a relatively stronger preservation of hellenistic forms, with their undulating outlines, livelier poses, and more vivid expression of the eyes. These are the same elements that we find more strongly preserved in Syro-Palaestinian than in Egyptian art. There may, however, be a few exceptions: the icons with St. Theodore (no. B.13), and with Christ enthroned (no. B.16) whose styles indicate some connections with the early phase of Christian art in Egypt when the Greek tradition still held sway especially in and around Alexandria, and that of St. Mercurius (no. B.49), which suggests a later phase.

Supposedly conclusive evidence for the attribution of a number of Sinai icons to Egypt was seen by the Sotiriou in the fact that some of them (nos. B.8, 19, 27, 28, 32, 36, 40, 41) inscribe the Virgin, in most cases in monogrammatic form, H AΓIA MAPIA instead of MHTHP ΘEOV. Since this inscription is known so well from the frescoes of Bawit and other Egyptian works of art, scholarship in general has believed it to be characteristic for, and confined to, Egypt.[7] Yet H AΓIA MAPIA is written above the Virgin of the apse mosaic in Kiti on Cyprus, to mention one important work of art outside of Egypt, and the frequent use of this inscription on the icons of Sinai which, in our opinion, are not Egyptian in style, only confirms that it was used widely in orthodox countries other than Egypt before it was, at a later time, replaced by MHTHP ΘEOV (nos. B.50, 53, 54).

Moreover, it should not be overlooked that some of the

latest works of our Palaestinian group, like the icon with St. Irene (no. B.39), display an ever greater simplification and loss of understanding of the classical forms, features one finds similarly in Coptic art. This is not to say that the Sinai icons like that of St. Irene should, therefore, be considered Egyptian products, but it seems rather that the Islamization of Syria, Palaestine, and Egypt provided the conditions for a greater interpenetration of the arts of these regions.

If the thesis is accepted that the place of origin of our major coherent group, covering the sixth through the eighth and reaching into the ninth and perhaps even the tenth century, was Palaestine and most likely Jerusalem, then the problem raised earlier concerning the production of icons during the period of iconoclasm appears in a new light. During this critical period Palaestine and Sinai were under Moslem domination, and so the imperial iconoclastic decrees could not be enforced within their boundaries. A vivid testimony to this is the fact that the Justinianic mosaic of the Metamorphosis in the apse of the basilica, unlike so many other mosaics within the empire, was never covered with whitewash. Moreover, in the monasteries of Palaestine the movement resisting iconoclasm was especially strong. It must be remembered that in the Sabas monastery, close to Jerusalem, John of Damascus wrote his challenging treatise in defense of the holy images, and from this we may infer that he also did everything in his power to guarantee the continuation of the cult of the images, not only the preservation of the old, but the production of the new.

There is no reason to assume that Palaestine and Sinai were the only centers of production of icons in the Eastern provinces in those turbulent times. The Crucifixion icon no. B.50 from about the early ninth century, seemingly related to Carolingian works, though itself surely an East Christian product, is a reminder that there must have existed other centers which, at the present state of our knowledge, cannot yet be identified.

With the increased activity not only in the production of icons but of Byzantine art in general after the end of iconoclasm, the local differences that had existed in pre-iconoclastic and iconoclastic art gradually diminished. Constantinople became the absolute cultural and artistic arbiter, and the new style formed in the capital during the rule of the Macedonian dynasty radiated into the farthest provinces of the empire and even beyond its frontiers. Thus

[6] K. Wessel, *Koptische Kunst*, Recklinghausen 1963, pls. VII–X; XIV.

[7] K. Weitzmann, "Eine vorikonoklastische Ikone des Sinai mit der Darstellung des Chairete," *Tortulae. Studien zu Altchristlichen und*

Byzantinischen Monumenten, Röm. Quartalschrift, Suppl. 30, 1966, pp. 318, 324; Idem, "The Ivories of the So-Called Grado Chair," *D.O.P.* XXVI, 1972, pp. 78ff.

to determine whether a work of art of this period was actually produced *in* the capital or under its influence in the provinces becomes difficult. It surely would be misleading to consider the level of quality the only sure criterion for attribution to Constantinopolitan ateliers, since on the one hand the capital itself also produced works of lesser quality, and on the other, it sent excellent artists trained in the capital out into the provinces. Characteristic tenth-century icons like the three with standing saints (nos. B.52–54), the one with the Washing of the Feet (no. B.56), and the two wings with the Abgarus legend (no. B.58) surely reflect the style of Constantinople. Yet there are indications, stylistic as well as iconographic, that they were not made in the capital, in spite of the fact that they show no definite elements of provincialism. Only in the case of the last three icons of St. Philip, the fragmentary Crucifixion and the majestic Nicholas icon (nos. B.59–61) do we feel justified in proposing almost with certainty an origin in the capital proper.

That the present volume ends with the tenth century is merely a matter of convenience, since there is no decisive break in style around the turn of the millenium. One might have made, with some justification, a break at the middle of the eleventh century, i.e. at the end of the Macedonian dynasty,[8] but, then, the extant material, especially in icon painting, is too sparse for the proposal of precise dates within the eleventh century.

C. Technique

A detailed study of the techniques of early icon painting is the province of technical experts, and we may anticipate some writing on this subject by those who have worked on, and are still working on, the restoration of the Sinai icons. We shall therefore confine ourselves to a few general remarks. Very important in the early phase of icon painting is the technique of heated wax colors that we call encaustic, and it has already been noted that without special equipment it cannot always be determined clearly whether wax colors have been used or not. We have tried to be cautious and to note the use of the encaustic technique only in cases about which we were certain; it is possible a case, here and there, may have escaped our detection.

The best known monuments in encaustic technique are, of course, the mummy portraits found in the Egyptian oasis of the Fayyum.[9] This has induced many scholars to believe that the technique is exclusively Egyptian. However, the encaustic technique was also used in other parts of the ancient world, not only on wood, but also on linen and even on marble, as has been proved by paintings from the Hellenistic period found recently on the island of Delos. Thus there exists a precedent from classical antiquity for our two encaustic panels with the Sacrifices of Isaac and Jephthah's Daughter on the marble pilasters of the basilica (nos. B.29–30). Obviously then, the mere use of the encaustic technique in an icon cannot be induced as proof of its Egyptian origin, and the encaustic Sinai material, which, as we have tried to demonstrate, has a style not rooted in Egyptian tradition, further supports this fact. The unquestionably Egyptian encaustic paintings in Berlin and Moscow published by Wulff and Alpatoff are quite different in style.[10]

For the history of icon painting the important question is not that of determining the point in time when the encaustic technique was first used for holy images, since there is every reason to believe that icon painting began in this technique, but rather of establishing how long it was in use. In other words, one must try to determine the date of the latest icons executed in the encaustic technique, and this question must be answered by the stylistic critic rather than the technical expert. That it was used in the sixth century by the best icon painters is affirmed by the three great masterpieces and the icons grouped around them (nos. B.1–9). Within the so-called Palaestinian group, it will be noted that here, too, the early panels like the Ascension from the sixth century (no. B.10) and the Three Hebrews from the seventh (no. B.31) are encaustic, whereas the Crucifixion, from about the middle of the eighth century (no. B.36) is painted in tempera. There is no other icon known to us from that period or later in which the encaustic technique was employed. It cannot be emphasized strongly enough that our basis for generalization is very narrow, and consequently it must seem hazardous to suggest that the encaustic technique was altogether discontinued between the seventh and the eighth centuries; nevertheless, it is indicated that at about that time the technique began to go out of fashion.

[8] K. Weitzmann, "Byzantine Miniature and Icon Painting in the Eleventh Century," *Proceedings of the XIIIth International Congress of Byzantine Studies, Oxford, 1966*, London 1967, pp. 207ff. (repr. Weitzmann, *Studies*, pp. 271ff.

[9] Of the rich bibliography on this subject I quote only: P. Buberl, *Die griechisch-römischen Mumienbildnisse der Sammlung Th. Graf*, Vienna 1922; H. Zaloscer, *Porträts aus dem Wüstensand*, Vienna and Munich 1961; K. Parlasca, *Mumienporträts und verwandte Denkmäler*, Wiesbaden 1966.

[10] Wulff and Alpatoff, *Denkmäler*, p. 24 and fig. 9; p. 32 and fig. 13. (This plaque, whose location is here given as Collection Goleniščew, Petrograd, is now in the Pushkin Museum in Moscow.)

This does not mean, however, that it was "replaced" at that time by the tempera technique, because the latter had existed in icon painting from the very beginning alongside the encaustic. It simply means that from about the eighth century on, tempera became the preferred and, finally, the *only* technique practiced. When in the early fifteenth century the Van Eycks invented oil as a new medium for painting, the innovation quickly spread from the Netherlands to all parts of Europe, but did not have much impact on icon painting. Here, tempera still survived for centuries.

D. Shape and Function

The shape of an icon is not a mere formal problem, like the format of a canvas in modern panel painting, but it is closely tied to its function, and therefore deserves special consideration.

A peculiarity of two of the early icons is the frame into which a sliding lid could be inserted (nos. B.10, 15), not unlike that still preserved on a seventh-century reliquary box in the Sancta Sanctorum treasury in Rome (p. 32 and fig. 14). Such a protective cover makes sense only if the icon was intended not to be permanently on display but to be carried about. This means that such an icon was probably not kept in a church but was more likely to have been privately owned and taken along by the owner wherever he might travel. The earliest literary sources, in fact, almost always refer to icons as objects in private possession. In this early period the display of icons in churches was still frowned upon by some bishops. These early lid-covered icons deserve the term "portable" in its most literal sense.

It will be noted that the average size of the icons published in this volume is comparatively small, with the exception of the three great sixth-century masterpieces (nos. B.1, 3 and 5) and icons nos. B.7 and B.16. Apparently those belonging to a church and not privately owned had no fixed places in it, but were stored in some side room, from which they were taken out only to be displayed on the proskynetarion on the day a certain saint or feast was commemorated. Another possibility was that they were stored in the nave of the church, hanging in long rows on the walls of the aisles as now done in the Sinai basilica. There they follow each other in the order of the calendar year so that they are easily at hand when needed for veneration on the proskynetarion. This method, however, appears to be rather recent, for in many cases the holes at the center of the top of the panels can be seen to be com-

paratively new, often drilled crudely through the painted surface. These icons also can justifiably be called "portable" although they were meant to be carried about only within the church, and therefore needed no protective lid.

Not so easily answered is the question of where in the church the icons of larger format, such as the three early masterpieces (nos. B.1, 3 and 5) were installed. This much, however, is sure: they were not in the intercolumnar spaces of the iconostasis. Recently Lazarev has demonstrated that the first real evidence for intercolumnar icons is no earlier than the thirteenth century.[11] It could be argued that as early as the twelfth century icons were used for such purposes, but in the period with which we are concerned, and still later through most of the Middle Byzantine period, the intercolumnar space was not filled with wooden panels but with curtains. Where, then, were large icons placed in the church? Probably they occupied almost any suitable free space on a wall, a pier, or a column. The various votive mosaics with St. Demetrius in the great basilica of the patron saint of Thessalonike are located on the walls and the piers —in places that in other churches may have been occupied by icons painted on wood.

One of the surprises of the early Sinai material is the fact that so many icons are either the central panels or the wings of triptychs, although in only one case were we able to reconstruct a whole triptych from plaques kept in different places in the monastery (nos. B.42–44). The precarious method of attaching the wings to the central panel by means of ledges, nailed at the top and bottom of the central plaque, into which the wings were attached by dowels—an organization still preserved in a few tenth-century ivory triptychs[12]—is the obvious reason that no early painted triptych has come down to us intact. The wings of a triptych, either individually or in pairs, can easily be identified because of the dowels in the corners and the rounding of the inner edge, and central plaques are recognizable by the evenly spaced holes in the broad borders at the top and the bottom for affixing the ledges.

Most of the early triptychs (nos. B.13, 18, 22–26, 33–35, 37, 40–45, 47, 55, 58) are of rather small format and were surely intended for private worship. The wings, when closed, like the lids of portable icons, serve to reveal the central plaque only when it is actually being worshipped. But while the removal of the lid of the portable icon has the effect of the lifting of a curtain, the opening of the wings of a triptych may be compared to the opening of the royal doors of the iconostasis, through which one gains a view into the

[11] V. Lazarev, "Trois Fragments d'epistyles peintes et le templon byzantin," Τιμητικὸς Γ. Σωτηρίου, Δελτ. Χριστ. Ἀρχ. Ἑταιρείας, Per. IV, Vol. IV, 1964–1965, Athens 1966, pp. 117ff.

[12] Goldschmidt and Weitzmann, *Byz. Elf.* II, pl. XIII, 33; XXVIII, 72a–b; LIV, 155a; LXIV, 195.

sanctuary. There seems indeed to be an iconographical as well as a formal connection between the wings of a triptych and the royal doors. The wings nos. B.19–20 have in their upper register a representation of the Annunciation, a standard theme on royal doors. Moreover, it can be observed first in ivory triptychs of the tenth century[13] and later on painted icons from the eleventh century on,[14] that the shape of the wings changes from a rectangle to one with a semicircular or three-lobed top. This is precisely the shape that became typical of the valves of many royal doors, of which the earliest ones, preserved on Sinai, are no earlier than the thirteenth century.[15]

The Early Byzantine period also had larger triptychs which cannot be classified as portable altars. The wing with the standing Elijah (no. B.17) measures more than sixty centimeters in height and the central panel must have been even slightly higher. One must assume that this triptych had a fixed place, most probably in the church, although it could not have been the high altar, as was the case in the later Middle Ages in the Latin West. In the orthodox church nothing but the eucharistic implements and the Gospel lectionary were ever allowed to be placed on the high altar. Presumably large triptychs were set against the walls of the nave or a chapel, perhaps on a kind of pedestal.

The backs of the sixth-century icons show bare wood (e.g. fig. 1). The earliest icon with an ornamental decoration on its back, a simple diaper pattern painted on the gesso ground, is the rough plaque with the Virgin and Child (no. B.48) which we have tentatively attributed to the eighth century. Only in the Middle Byzantine period does one find richer, ornamental patterns like the fretsaw ornament on the back of the Crucifixion no. B.60. The most common motif, however, seems to have been a cross, simple or ornate (no. B.52).

But long before crosses began to appear on the backs of icons proper, they had been the standard decoration from the beginning for the backs of triptych wings. Each wing either had its own cross so that there were a pair when the triptych was closed (nos. B.22, 23 and 35) or had only half a cross which became complete only when the wings were closed (no. B.37). An unusually elaborate *crux gemmata*, set against a mandorla of which only one half is preserved, is found on the back of the wing with Elijah (no. B.17). There is a certain crescendo effect in the painting of a simple cross

on the back of the wings, letting the full splendour of a rich scenic composition unfold before one's eyes at the moment the wings are opened. This dramatic effect is lost when the outsides of the wings are also decorated with human figures or scenes. For this development the wing with St. Damian on the outside and two feast scenes on the inside (no. B.55) is the earliest known example. It belongs to the tenth century and this may well be the approximate date of the innovation.

Two-sided icons cannot be proved to have existed within the time limits of the present volume. The single example is a pair of wings with two saints from the eighth century or later, which were nailed together (no. B.38) to provide a surface for a new icon on the other side (fig. 25). Bilateral icons became popular only later, either as processional icons or as the decoration of an iconostasis where they were inserted in the intervals between the piers supporting the epistyle. But this custom, as stated before, does not appear before the twelfth or maybe even the thirteenth century.

Yet the iconostasis was not without iconic decoration, even at a time when the intercolumnar space was filled with curtains. Figurative decoration was from the very beginning concentrated on the epistyle of the iconostasis, as is known from the description by Paulus Silentarius of the silver iconostasis of Hagia Sophia in Constantinople, in which he mentions discs with the busts of saints.[16] This system of decoration, but in other materials, continued into the Middle Byzantine period as is proved by a recent excavation in Sebaste in Phrygia, where a marble iconostasis from the tenth century was found whose epistyle is decorated with medallion busts of saints in the rare technique of glass intarsia.[17] At the same time there have come to light at Sinai several epistyles with the painted cycle of the twelve great feasts, usually interrupted in the center by a Deesis, none of which however is earlier than the twelfth century.[18] This indicates a change in the decoration of the epistyle from the medallion busts to scenic decoration, and poses the question of whether the time of the change can be determined more precisely.

If we are not mistaken, the earliest fragment of a scenic epistyle is the panel with the Washing of the Feet (no. B.56) which we dated in the first half of the tenth century. The choice of the subject, not included in the cycle of the twelve

[13] Ibid., pl. xv, 38; xvi, 39; xxviii, 72; xxix, 73.

[14] K. Weitzmann, "Fragments of an Early St. Nicholas Triptych on Mount Sinai," Τιμητικὸς Γ. Σωτηρίου, pp. 1ff and figs. 1–5.

[15] Ibid., p. 17 and fig. 13.

[16] St. Xydis, "The Chancel Barrier, Solea and Ambo of Hagia Sophia," Art. Bull. xxix, 1947, pp. 2ff.

[17] N. Firatli, "Découverte d'une église byzantine à Sébaste de Phrygie," Cah. arch. xix, 1969, pp. 151ff.

[18] Sotiriou, Icones i, figs. 87–102, 112–116.

feasts, would not militate against its having belonged to an iconostasis beam. During the period when the liturgical cycle was formed, exceptions were not uncommon, and the first choices for any substitute or additional scenes would be the Washing of the Feet and the Last Supper. As a matter of fact, there is at Sinai a thirteenth-century beam that has, in addition to the twelve feast scenes, a representation of the Last Supper.[19] Thus the presently available evidence favors the tenth century as the period when this decisive change in the decoration of iconostasis beams occurred, a change that must be understood as part of an increasingly liturgical trend within the representational arts of Byzantium. Moreover, the evidence provided by the panel with the Washing of the Feet is supported by a tenth-century ivory diptych of the Romanos group in Leningrad with a Presentation in the Temple, which we believe to be part of a dodecaorton decorating an iconostasis beam.[20]

E. Sinai Icons Outside of Sinai

Our publication of the Sinai icons will have to include also those no longer in the monastery proper but known to have been there until the middle of the last century. It is known that in returning from trips to the Near East in 1845 and 1850, the Russian archimandrite Porphyrius Uspensky had brought icons to Kiev from Sinai as well as from the monasteries of Mount Athos, and that he had cut out many leaves from manuscripts and even taken to Russia whole codices from Sinai, Jerusalem, and Athos, manuscript material which today is deposited in Leningrad in the Public Library.

In 1902 Ainalov was the first to publish the four early encaustic icons from Sinai, which are now kept in the Museum of Eastern and Western Art in Kiev.[21] Our knowledge of the earliest phase of icon painting depended exclusively on them for more than half a century, until the Sotirious in 1956 introduced into the literature the rich holdings in St. Catherine's proper.

Uspensky had also taken from Sinai many icons of later periods. These were published by Kondakov in lithographic technique,[22] which rendered indistinct and at times even falsified the original style of the icons, so that dating on the basis of these reproductions must in many cases be ambiguous. Another selection, including some of those already published by Kondakov and a few new icons, was published by Petrov a few years later,[23] but this publication also omits some of the icons known to have come from Sinai. Unfortunately, all Sinai icons from the Middle and Late Byzantine periods—and all the Russian scholars I have consulted in Moscow and Kiev agree on this point— were destroyed in World War II during the last days of the German occupation of Kiev, although just how is unclear. Uspensky was in his day one of the best connoisseurs of Byzantine art, and the Kiev collection assembled by him included very important icons from Sinai, among them some fragments of larger panels, parts of which are still in the monastery's collection. Whatever the details of the disaster, it follows that only the four early encaustic icons can be reproduced in the present volume from good photographs; for the later volumes, I shall have to depend on the reproductions in Kondakov's and Petrov's works.

Moreover, St. Catherine's Monastery still maintains *metochia* in various parts of the orthodox world, some large and some small, some with and some without collections of icons. An attempt will be made to include in our volumes as much as possible of the icon material preserved in these monastic estates, although most of it, as far as our knowledge goes, belongs to the post-Byzantine period. A major collection is on the island of Zakynthos where the icons from two *metochia* have recently been studied by Mr. Chatzidakis and cleaned under his supervision. I visited the three *metochia* on Crete, where the most important collection is in Hagios Matthaios at Candia, while some noteworthy icons are also in the *metochia* at Canea and Spileotissa. What I saw in the two still extant *metochia* on Cyprus, one at Kyrenia and the other at Paphos, was rather disappointing. Numerous, but not particularly noteworthy, are the icons in the *metochion* at Tor on the Red Sea coast. What the *metochia* in places like Asmara, Tripoli in Syria, or Janina may contain I am unable to say, but they, too, should be investigated. A *metochion* in Istanbul, if my information is correct, was destroyed in 1956. Whereas the material in St. Catherine's and its outlying chapels has been completely recorded by our expedition, the photographic record still needs to be completed by the material from the *metochia*.

[19] Unpublished. Mentioned in: K. Weitzmann, "An Ivory Diptych of the Romanos Group in the Hermitage," *Vizantiysky Vremennik* XXXII, 1971, p. 151.

[20] Ibid., p. 142, and fig. 1.

[21] Ainalov, "Син. Ик."

[22] Kondakov, *Иконы.*

[23] Petrov, *Альбом.*

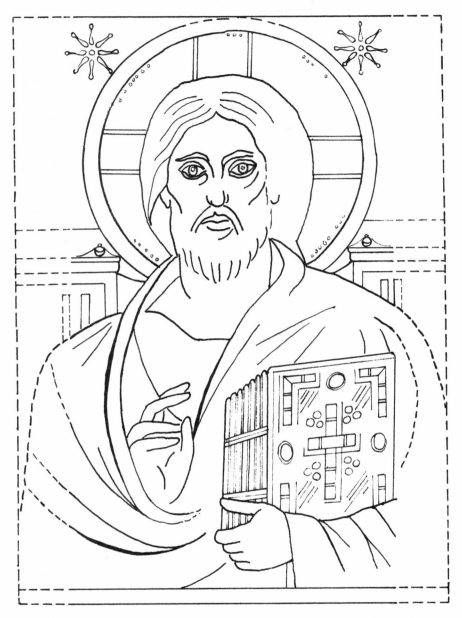

A. Reconstruction drawing for B.1

Catalogue

B.1. ICON. PLATES I–II AND XXXIX–XLI
BUST OF CHRIST PANTOCRATOR
FIRST HALF OF SIXTH CENTURY
GALLERY

H. 84 cm; W. 45.5 cm; thickness 1.2 cm. The icon was originally slightly higher and somewhat wider, for it has been cut at the top and at both sides. There can be little doubt that Christ's arms, though held close to his body, were fully visible originally and that the elbows touched the frame at the sides. Since it is to be assumed that the head of Christ was laid out on the axis of the panel in such a way that the lateral limits of the nimbus were equidistant from the frame, it follows that a wider strip has been lost from the left side than from the right. In a reconstruction drawing (fig. A, opposite)[1] this shortcoming has been corrected.[2] A narrow border strip at the bottom has been left unpainted for a frame. Since it is too narrow for a frame to be nailed on to it and since, moreover, no nail holes are to be seen, we assume that the icon was framed in a fashion similar to that described more fully in connection with Virgin icon no. B.3. For an icon of this size the wood is rather thin (1.2 cm) and this is typical of all the early masterpieces (nos. B.1–3 and 5). In this particular case the thinness may have prevented the usual crack down the center, though some warping has resulted in a curvature of 2.8 cm. The reverse has a chipped surface, as do icons nos. B.3 and 5. A later hand has drawn a very crude head on the reverse (fig. 1).[3]

The Sotirious published this icon as belonging to the thirteenth century on the basis of the surface paint as it appeared in their time (fig. 2). Yet they had already considered the possibility that this was an Early Christian icon which had been overpainted. Before the cleaning of the icon in 1962 by Tassos Margaritoff, the mantle of Christ was painted blue and was rendered in thick, soft folds lacking any distinguishing stylistic features. The gold nimbus had a brown varnish, the background was greyish green, and the inscription in the spandrels read $\overline{\text{IC}}$ $\overline{\text{XC}}$ in large red letters. The color of the background and the style of the letters indicated that the icon had been overpainted in recent times, in the eighteenth or perhaps even the nineteenth century. The thirteenth-century dating by the Sotirious can only be understood as an attempted compromise between the old and the new features of the icon. There is major damage in only one spot: a large area of Christ's hair on his left side, including the left ear and extending to the shoulder. This area was filled in with modern paint, apparently by the same painter who overpainted the whole surface except for the face, the hands, and most of the book.[4] Otherwise only smaller repairs in the neck, over Christ's left eyebrow, and in various other spots are noticeable. As a whole the old encaustic surface is in a remarkably good state of preservation, except that the upper layers of pigment, especially on the hands, are somewhat flaked. The extent of this kind of damage, however, is difficult to assess in the case of a technique that superimposes several layers of paint, especially for the face and the hands. The whole lower part of the icon is somewhat rubbed.

The cleaning of the icon revealed that Christ's tunic as well as his mantle were painted in a saturated purple, the

[1] Acknowledgment is made to George Bauger, former graduate student of the Princeton University Art Department, for the execution of this drawing.

[2] In the reconstruction drawing published by Manolis Chatzidakis ("An Encaustic Icon," fig. 9), in compensating for this shortcoming, the other extreme has been followed and too much space has been added at the left, thus unbalancing the composition in reverse.

[3] In a reproduction published by Chatzidakis (loc. cit. fig. 13) the technique of chipping can be seen more clearly than in our photograph. In ours, however, the head itself is clearer.

[4] The repainted area is clearly visible in the photograph published by Chatzidakis ("An Encaustic Icon," fig. 11).

folds distinguished only by very subtle shades within this color, giving the surface a homogeneous and rather flat appearance and thereby diminishing the three-dimensionality of the body. A very broad, light brown clavus shows the incised lines that served as a guide for the gold striation, of which traces are clearly visible. The blessing hand, held deep in the sling of the mantle, displays an almost geometrically designed palm consisting of two ovals and soft, almost boneless fingers. The other hand holds a thick Gospel book of which the cover is light ochre with gold lines drawn around jewels and with striations filling the ground. This suggests a pressed leather binding rather than a metal cover, and the two clasps also appear to be leather. Precious stones painted in dark blue form the central cross, the four corner strips in the form of *gammadiae* and the rounded shapes appearing singly between them, while clusters of pearls fill the spandrels. This scheme of decoration reflects that of actual contemporary bindings, as is demonstrated by a comparison with the covers of the Gospels in Monza, given to that cathedral by Queen Theodolinda in the early seventh century, though here the ground is metal and not leather.[5] Christ's face has a warm ivory tone on which the highlights are set quite sharply around the eyes, and a pattern of striation is used in a few places. There are brown shadows on the cheeks and along the ridge of the nose, but below the eyebrows, below the lips, and around the neck can be seen a grey olive tone which also appears in the lower part of the eyeballs where it is contrasted with a sharp white in the upper half. Most pronounced is the intense carmine violet of the lips and the eyelids. Black pupils are set within a brown iris outlined in black. This sensitively modelled face is framed by a great mass of brown hair permeated by a strong violet which harmonizes with Christ's purple garment and adds to the tonal unity of the icon. The large gold nimbus has a dark blue border identical to that in the Virgin icon no. B.3. This original outline was revealed under the later red and green one, remains of which were left by the restorer above Christ's left shoulder. Close to the inner edge of the nimbus there is a line of alternating four-petalled and eight-petalled punched rosettes. This and the nimbi of the Kiev Virgin (no. B.2) and the Sinai Virgin (no. B.3) appear to be the earliest known examples of the punching technique. The cross of the nimbus is marked by

red double lines and red dotted rosettes, but this coloration is of a later date. Originally the cross was indicated by lines of more polished gold, as is the case in the nimbus of the Christ Child of the Virgin icon no. B.3.

The bust of Christ is set against an olive brown niche decorated with slit windows and a white cornice topped by golden knobs at either side—a classical element commonly used for securing draperies. Beyond the niche one looks into a sky where intense blue gives way to a lighter blue above, suggesting a change of atmosphere. The spandrels contain huge brown stars with golden highlights.

On the left side of the wall there appears in red the inscription $\overline{\text{IC}}$ $\overline{\text{XC}}$ O ΦΙΛ[ΑΝΘΡω]Π[OC] which is surely of a considerably later date, most likely added at the same time as the lines of the nimbus cross. The palaeography is Late Byzantine and, furthermore, an original inscription would surely have been more prominently displayed in larger letters; but since the contemporary icons, nos. B.2, 3 and 5, have no inscriptions, the conclusion seems justified that the Christ icon, too, was never meant to be inscribed.

This type of Christ Pantocrator is characterized by full parted hair falling on the left shoulder, rounded beard of medium length, and the arm firmly embedded in the sling and holding a jewel-studded codex. On Byzantine coins this type occurs for the first time on the solidus of Justinian II (first reign 685–695) (fig. 3).[6] However, that it existed long before its first appearance on coins is assured by the relief on the silver cross of Justin II (565–578) in the treasury of St. Peter's in Rome.[7] It is significant that this type of Christ appears on an imperial cross and on coins where the connection with the imperial house is self-evident; we seem thus justified in concluding that the type of icon here was one of special importance to the emperor. Yet one cannot be certain which of the early Christ types is the archetype from which the coins and also this particular Sinai icon stem. Among several possibilities, Chatzidakis has decided in favor of the Christ of the Chalke Gate. This particular image was twice destroyed, in 726 and 814, and consequently we cannot be sure to what extent the later representations inscribed O ΧΑΛΚΙΤΗC reflect the archetype, since all Middle and Late Byzantine representations hark back to the reconstitution of the icon by the empress Theodora after 843.[8]

[5] F. Steenbock, *Der kirchliche Prachteinband im frühen Mittelalter*, Berlin 1965, pp. 70ff., no. 12 and pls. 18–19.

[6] A. Grabar, *L'Iconoclasm byzantin, dossier archéologique*, Paris 1957, p. 16 and figs. 12–14; J. D. Breckenridge, *The Numismatic Iconography of Justinian II. Numismatic Notes and Monographs*, New York 1959, pp. 46ff. and pl. v, 30. Our figure 4 is a coin in the Dumbarton Oaks Collection, Washington. Cf. P. Grierson, *Catalogue of the*

Byzantine Coins in the Dumbarton Oaks Collection II, part 2, *Phocas to Theodosius III*, Washington D.C. 1968, p. 580 and pl. XXXVII,7h.

[7] Grabar, ibid., p. 19 and fig. 75; Christa Belting-Ihm, "Das Justinuskreuz in der Schatzkammer der Peterskirche zu Rom," *Jahrbuch röm.–germ. Zentralmus.* XII, Mainz 1965, pp. 142ff.

[8] For a comprehensive study of this image, cf. Cyril Mango, *The Brazen House*, Copenhagen 1959, pp. 108ff.

The high artistic quality of this icon derives not only from its refined and most skillful application of the encaustic technique, but equally from its hieratic composition and the linear design of its detail. By positioning the figure of Christ on the axis frontally and by opening his eyes wide so as not to fix them on a particular point, the artist achieves an effect of aloofness and timelessness, a pictorial expression of the divine nature. At the same time he avoids strict symmetry and enlivens the pose by turning the body of Christ slightly to the right. There are other noteworthy features: the pupils of the eyes are not at the same level; the eyebrow over Christ's left eye is arched higher than that over his right—a feature which in particular is responsible for the vivid expression of the face; one side of the mustache droops at a different angle from the other; the hair is not parted in the center but on one side, while the beard is combed in the opposite direction and, corresponding with its curve, the hair falls down on the left shoulder but on the other side it is swept back. By using in such a subtle manner abstracting features along with more naturalistic ones, the artist has been able to convey pictorially the dogma of the two natures of Christ, the divine and the human. Many of these subtleties remain attached to this particular type of Christ image and can be seen in later copies, e.g. the mosaic bust in the narthex of Hosios Lukas over the entrance to the catholicon (fig. 4),[9] a comparison which did not escape the Sotiriou. Here, too, the difference in the raising of the eyebrows is most noticeable. Yet it will be observed that the Christ of the mosaic has falling upon his forehead two wisps of hair which are lacking in our icon. Since they also occur in the Christ head on the coins of Justinian II (fig. 3) they may well have been a significant feature in the archetype.

As a representation of Christ this icon has no stylistic parallel that might assist in dating it. Yet it has many

features in common with the icon of the Virgin enthroned (no. B.3). Minute similarities like the gold-lined cross in the nimbus, the punched rosette pattern along its border, and other details seem to indicate that they are not only contemporaneous, but that they are indeed products of the same workshop. That in subtlety of modelling the Christ head surpasses the heads in the Virgin icon is chiefly due to the different scales of the heads. Another common feature is the niche, yet the wall in the Christ icon rises only to the level of his neck and stands well behind him, while in the Virgin icon it encompasses the main figures and almost touches the upper frame. Thus the artist of our icon has created the impression of atmospheric space around Christ's head, while the niche in the Virgin icon is more decorative. We propose a date for both icons in the sixth century, and because the concept of the architectural setting in our icon is still closer to that of classical antiquity, we assume that it is the earlier of the two. Its exceptionally high quality leads us to believe that at this time only Constantinople could have produced it. The attribution to the capital finds support in the fact that this icon type was used for the imperial coinage. Whether our icon could have been made during the reign of Justinian cannot be proved, but this seems a priori not unlikely in light of the fact that the Sinai monastery was founded by this emperor and that he surely would have sent gifts to it.

Bibl.

Sotiriou, *Icones* I, fig. 174; II, pp. 161–162.
M. Chatzidakis and A. Grabar, *La Peinture byzantine et du Haut Moyen-Age*, Paris 1965, p. 19 and fig. 47.
M. Chatzidakis, "An Encaustic Icon of Christ at Sinai," *Art Bull.* XLIX, 1967, pp. 197 ff. and figs. 1–3 and passim.
Weitzmann, "Loca Sancta," p. 35, and fig. 4.

[9] E. Diez and O. Demus, *Byzantine Mosaics in Greece. Hosios Lucas and Daphni,* Cambridge, Mass. 1931, fig. 12.

B.2. (KIEV 1) ICON. PLATES III AND XLII
VIRGIN WITH CHILD
FIRST HALF OF SIXTH CENTURY
KIEV, CITY MUSEUM OF EASTERN AND
 WESTERN ART, NO. 112

H. 35.4 cm; W. 20.6 cm; thickness 0.7–0.8 cm. The back is chipped by a plane and left blank. The icon has been cut

all around except for the right edge. Here the original narrow border, 0.8 cm wide, has been left unpainted for a frame, which, however, could not have been nailed on because the border is too narrow and there are no nail holes. We must, therefore, assume that a broad, grooved frame was laid around the icon, of the same kind that we assume for the Christ, the Virgin, and Peter icons (nos. B.1, 3 and 5). Also like these icons is the remarkable thinness of the wood

and the chipping of the back. Where the blue color of the background reached the frame the paint accumulated and, after the removal of the frame, left a ridge.

There has been some debate as to when the trimming of the icon took place. Kondakov in his early writing (*Памят.*, p. 126) saw in the cutting of the oblique edges a parallel to the form of mummy portraits, where, however, the cutting is not as steeply angled. Moreover, this upper trimming could hardly be original because it was apparently done after the left side was cut off, intending to achieve an approximate symmetry of the oblique cuts. Ainalov claimed that the sawing off was done only recently, an opinion shared by Kondakov in his later writing, and Petrov wanted to make Porphyry Uspensky responsible for it. In my opinion the gable form of the icon has a Gothic appearance and resembles in shape innumerable ducento and trecento paintings. It could well have been made to fit a Gothic frame during the Crusader period, when paintings in Western style made in the Crusader Kingdom reached Sinai in considerable numbers. A pair of triptych wings with the figures of St. Peter and St. Paul at Sinai shows clearly that the lost central panel must have had a gable of approximately the same angle.[1]

Two cracks in the lower part of the icon have resulted in some flaking, especially above the right hand of the Virgin, where a rectangular area has been filled with a brownish color to blend with the purple of Christ's garment. Parts of the nimbus and the edge along the nimbus are also flaked and lay bare either the wood or the ivory-colored gesso. As usual, the encaustic paint is laid upon the ground in several layers creating a rather high relief, and as is quite common the uppermost layers, especially in the flesh areas, come off rather easily. The whole left side of the Virgin's face, especially around the nose and the eye, has flaked to such an extent that the original impression is impaired. A good deal of the uppermost layer of pigment is also lost from the head of Christ and especially from the hair. According to the description of all older Russian scholars, there was a heavy layer of varnish and soot over the surface which dimmed and blackened the gold of the nimbi, as the older reproductions in Kondakov and Petrov still make apparent. From information I gathered in Kiev, the icon was fairly recently cleaned by Mr. Kirikov after having been restored several times before him. It is one of the four early icons that Porphyry Uspensky brought from St.

Catherine's Monastery in the middle of the nineteenth century. It was kept in the Ecclesiastic Academy of Kiev until the revolution, then in the Kiev Central Antireligious Museum, and was transferred in 1940 to the present museum.

The Virgin, holding the Christ Child close to her left shoulder, is dressed in the purple maphorion which, contrary to tradition, does not cover the whole upper part of the body but is thrown back over the right shoulder while its end is taken up again over the right elbow. As in the early Virgin icon at Sinai (no. B.3), a headdress is visible over the ears and underneath the maphorion, similarly rolled in and patterned with horizontal white strokes. Moreover, both Virgins have golden crosses over their foreheads, although the shapes of the crosses are different. Underneath the maphorion the Virgin wears a chiton of a yellowish ochre which is covered with a very delicate gold striation imitating highlights. In both respects, color and highlight, this chiton resembles the garments that the Christ Child wears in icon no. B.3. Moreover, the Virgin's right arm is covered by a purple sleeve with a broad gold striated embroidery. Not belonging to the maphorion or the chiton, it can only belong to a third garment which is worn under the chiton and may simply, in the original meaning of the Greek word, be called a stole.[2] Christ is clad entirely in garments of purple with a shade of brown, in contrast to the more violet purple of the Virgin's maphorion. Over the short sleeve of Christ's tunic a double clavus appears, painted not unlike the Virgin's chiton in a yellowish ochre with gold striation. Christ's mantle is wrapped around his body and is apparently taken back over his right leg, which is seen in profile. The faces are painted in a strong white, enlivened by pink on the cheeks and a very striking red on the lips, the tips of the noses, and around the chins, which cast light shadows of olive grey. The freshness of the skin is matched by the open eyes with large, slightly oval irises in a warm hazel color, their intensity emphasized by the sharp white of the eyeballs.

Each figure has a nimbus covered with gold leaf and framed by a red outline and, close to it, a punched pattern. In the Virgin's nimbus this pattern is more elaborate and consists of small rosettes within a rinceau, framed at the inner side by a dotted line. The nimbus of Christ has merely an outline of punched dots and not the usual cross, indicating an early origin when the cross had not yet become a

[1] K. Weitzmann, "Icon Painting in the Crusader Kingdom," *D.O.P.* xx, 1966, p. 65 and fig. 31.

[2] J. Braun, *Die liturgische Gewandung im Occident und Orient*,

Freiburg i.B. 1907, p. 565. "Das Wort στολή hat im Griechischen die allgemeine Bedeutung 'Kleid' und diente demgemäss zur Bezeichnung aller Arten von Bekleidung."

prerequisite. The background is blue and has a deeper hue along the outline of the nimbi and along the shoulder of the Virgin.

Close to the middle of the oblique cut at the right there remains only a vertical gold stroke, presumably of an inscription which we would expect to have been, in analogy to the other encaustic Virgin icons (nos. B.27, 28, 32, 36), Η ΑΓΙΑ ΜΑΡΙΑ in monogram form. Moreover, there are above Christ's nimbus three gold strokes, radiating downward, which one likewise would assume to be the remnant of a monogrammatic inscription, in this case the lower part of of which the upper part has flaked off. Although no other Christ icon of the early period is preserved with the XP monogram, the device occurs very prominently, e.g. in the fourth-century fresco of the Coemeterium Maius in Rome, and even twice in the lunette of the arcosolium that depicts the Virgin and Child.[3]

A major problem is the reconstruction of the original composition before the icon was cut at three sides. Because of the direction of the gaze and the gesture of the Christ Child toward the left, Ainalov, in the first detailed description of the icon, had assumed that the composition included the adoring Magi, to whom Christ's inviting gesture was directed. This opinion has been accepted by most scholars and only Kondakov (Богом., pp. 163–164) has been more cautious, assuming that the icon was copied from a model which depicted the Adoration of the Magi and that much time had passed between this model and the present copy. In my opinion, there are several features that argue against the actual inclusion here of the worshipping Magi. First, there are compositional considerations. In an icon where the Virgin is the principal figure one would, for hieratic reasons, assume that she would take the central position and not be pushed over to the right as in some catacomb frescoes and miniature paintings that place more emphasis on the narrative. Secondly, her peculiar pose militates against such a composition, for she is turning her right shoulder so far to the fore that were the Magi at the left, it would look as if she had turned her back to them. Thirdly and most importantly, a Virgin in the Adoration of the Magi can only have been seated on a throne. Here, however, the figures are so close to the border at the right that there is no space for a throne, contrary to the interpretation of Wulff and Alpatoff who identified a thin gold line near the right border as the back of a throne. Today there remains no trace of such a gold

line, which in any case would be much too insubstantial to indicate a ceremonial piece of furniture.

There remains the question of whether the icon was composed as a bust of the Virgin or whether she was originally full length, an issue impossible to decide. One can only say that a full-length Virgin is by no means impossible or unlikely. After all, the original Hodegetria, as reflected in a miniature of the Rabula Gospels, was a full-length Virgin,[4] and there is much to be said for Bertelli's reconstruction of the Madonna del Pantheon as an icon of the standing Virgin.[5]

The pose and attitude of the Kiev Virgin are without any known parallel, and all Russian scholars writing about her are correct in saying that she is not to be confused with the Hodegetria. Most characteristic is a certain freedom in her almost contrappostal movement, a turn to the right so that her right shoulder is thrust toward the beholder while her head is turned in the opposite direction. Similar contrappostal movements, though not quite so marked, are to be seen in the Virgin icon no. B.3 where the knees are turned to the left and the glance to the right. In other words, the strong axiality generally favored in Byzantine art has not yet been established, and both icons under consideration belong to a period in which the types of the Virgin were apparently not yet standardized. The freedom of the Virgin's movement is correlated with her human behavior. The Christ Child sits comfortably on her left arm while her right holds him very firmly against her shoulder. The gesture of Christ's open palm rather than the traditional gesture of blessing makes him also seem more human, as does the childlike, happy expression of his face. This naturalness in both figures is strongly underlined by the high degree of plasticity of the faces and hands and by the rosy flesh colors. The welcoming gesture of Christ had induced Ainalov to infer the presence of the Magi, reacting to this gesture; but it must be observed that in the Virgin icon no. B.3 the Christ Child's right arm is also directed to the right, although here in the gesture of blessing, with no worshipper present to take notice. As much as Christ's gesture is directed to the left, the Virgin's pose is to the right, and these movements counterbalance each other in perfect harmony. Moreover, the icon shares with the icon no. B.3 the characteristic that neither the Virgin nor the Christ Child looks at the beholder. In both, the effect is due less to freedom of expression on the part of the artist that on

[3] Kondakov, Богом. I, fig. 91 and opposite color plate.

[4] C. Cecchelli, I. Furlani, M. Salmi, *The Rabbula Gospels*, Olten and Lausanne 1959, pl. fol. 1v.

[5] C. Bertelli, "La Madonna del Pantheon," *Boll. d'arte* 1961, p. 26 and fig. 2.

his deliberate effort to create an impression of aloofness. This is especially clear in icon no. B.3 where the gaze of Virgin and Child is in contrast to that of the two flanking saints, who look straight into the eyes of the beholder.

From the purely artistic standpoint, there seems to be little missing in the composition. The Virgin's nimbus was most likely on a vertical axis, and I would assume that there was the same amount of blue background at the upper left as at the upper right, and that it bore the first half of the Virgin's monogrammatic inscription. If this assumption is correct, a strip of about 3.5 to 4 cm, including the missing border, must be considered lost.

Although iconographically the icon has certain features in common with the Virgin icon no. B.3, its closest stylistic connection is with the Christ icon no. B.1. The faces have the same lively flesh color, the hands the same plasticity, the lips the same intense sealing-wax color, the eyes the same oval, hazel-colored iris, the purple garments the same hue, the clavi on Christ's tunic the same fine gold striation on the yellowish ochre ground, etc. There is the same blue background with its slightly darker ring around the nimbus; and for the rosette pattern punched into the Virgin's nimbus, the Christ icon is the only known parallel. Even such a technical detail as the chipping of the back with a plane is common to both icons. It cannot be proved that both were made in the same workshop, but the many agreements on several levels suggest that we are dealing with contemporary works of the same creative center.

Because of the encaustic technique, so well known from the mummy portraits of the Fayyum, all early Russian scholars related the icon to the tradition of these portraits and they assumed an Egyptian, and more specifically an Alexandrian, origin. More recently Alice Banck expressed her criticism of this attribution.[6] The encaustic technique was common throughout the whole Mediterranean world during the antique and Early Christian periods, and it is only chance that encaustic panels have been preserved almost exclusively in the dry climate of Egypt. Comparisons with the frescoes of Saqqara, stressed by Kondakov (*Богом.*, p. 162 and fig. 89) are too general. Because of the extremely close connection with the Christ icon no. B.1, I believe that our Virgin icon is also the work of a Constantinopolitan atelier of the sixth century—an attribution recently suggested by Lazarev in his latest writing—and that it is conceivably from the Justinian period.

Bibl.

Uspensky, *Втор. Пут.*, p. 164.
Ainalov, "Син. Ик.", p. 361 ff. *and* pl. IV.
Kondakov, *Памят.*, pp. 126 ff. and pl. XLVII.
O. M. Dalton, *Byzantine Art and Archaeology*, Oxford 1911, pp. 316–317.
Petrov, *Альбом*, p. 8 and pl. 3.
N. P. Kondakov, *Иконография Богоматери* I, St. Petersburg 1914, pp. 159 ff., fig. 90 and pl. III.
Wulff and Alpatoff, *Denkmäler*, pp. 30 f. and fig. 12.
Lazarev, *История*, p. 61.
Kitzinger, "Icons," p. 139 n. 26.
Felicetti-Liebenfels, *Byz. Ik.*, p. 29 and pl. 31C.
Banck, *Byz. Art*, pp. 196, 350 and pl. 110.
Lazarev, *Storia*, pp. 92–93 and fig. 69.

[6] "(The icon's) connection with the Alexandrian school of painting cannot be regarded as established beyond doubt."

B.3. ICON. PLATES IV–VI AND XLIII–XLVI
VIRGIN BETWEEN ST. THEODORE AND
 ST. GEORGE
SIXTH CENTURY
GALLERY

H. 68.5 cm; W. 49.7 cm; thickness 1.5 cm. The panel has warped considerably and as a result has a curvature of 4 cm and has split down the middle. In modern times the two parts were crudely fastened together with wire, but in a more recent restoration the wire has been replaced by binding material, which holds the two parts together so that they

no longer rub against each other. Otherwise the damage is limited to smaller areas, with the exception of the portion above the right thigh of the saint at the right and patches of his hair left and right. These are the only spots where modern paint has been applied directly on the bare wood, presumably by the late Pater Pachomios. There are a few other spots where the paint has flaked, e.g. next to the eye and neck of the angel at the left, in the Virgin's nimbus, and above the cushion on the throne; and there are scratches on the Virgin's tunic and on the chlamys of the saint at the right, which has also been damaged by heavy rubbing down the middle so that a great part of the surface is lost. Other-

wise the surface of the encaustic paint which, especially in the faces, has been applied in rather thick layers, is remarkably well preserved.

The paint does not cover the surface to the edges of the panel, but narrow strips have been left unpainted all around. At the edges of the painted surface there was a narrow line in minium, of which traces are visible along the figure of the saint at the left. These borders of bare wood, which were surely covered by a frame, are rather narrow and have, instead of holes to attach an ordinary frame, notches, two on the upper edge and two more, which have become enlarged, on the lower. Moreover, all around the roughly carved reverse of the icon there is a sunken frame of about the width of the unpainted border on the front.[1] All these details suggest that a frame with a deep groove fitted

FRONT

around the icon in such a way that it was flush with the reverse and projected in front. Such a frame was probably wide enough to hold an inscription, as seems to have been common on the early icons (cf. nos. B.16 and 31). The panel was cleaned by Tassos Margaritoff.

The hieratic composition places the enthroned Virgin in the center and a soldier-saint at either side, while two angels in a second plane look up to the hand of God in heaven whence a beam of light is directed towards the Virgin's head. The Virgin is clad traditionally in a purple tunic and a purple maphorion, of a more subtle shading than the reproduction conveys. The only ornament on the maphorion is a thin double line in gold around the face and a golden star over the forehead; there are no stars visible, as is often the case, on the shoulders. Under the maphorion the blue white headdress patterned with white strokes is a familiar feature. There is rouge on the cheeks, lips, and chin. The eyes, set slightly asymmetrically, look away from the beholder, but this lively expression is counteracted by the unrealistic olive green used for the shading of the eyes. The Virgin sits on a red cushion on an ochre throne which has golden highlights and rather sparse stones and pearls. Her red purple shoes—an imperial prerogative—rest on a golden footstool whose front side is studded with dark blue stones and framed with pearls. The Christ Child in her lap is dressed in an ochre tunic and mantle, both with golden highlights; while the right hand blesses, though this gesture is rendered rather inconspicuously, the left holds a scroll.

[1] Cf. the photograph published by Chatzidakis, *Art Bull.* XLIX, 1967, p. 198 and fig. 15.

At the left stands a bearded soldier-saint clad not in armor but in the ceremonial garb of the imperial guard. The carmine tunic, half length and girdled, has dark purple borders and a shoulder patch with golden ornaments, and the long chlamys of light olive grey is, in the manner of Byzantine silks, decorated with a pattern of large white roundels, which also cover the tablion of dark blue purple. A narrow strip below the elbow indicates that there is a corresponding tablion on the back of the chlamys. Over the shoulder the chlamys is held together by a bow fibula, typical of the sixth century, to which we ascribe the icon. The hair and pointed beard are deep brown and the face is reddish brown, as is fitting for a sunburned, weatherbeaten soldier. In contrast, the saint with blond locks at the right has the pallor of a youthful, untried soldier. He wears garments of equal splendor, a light grey tunic with dark purple borders and roundels over the shoulder and knee, a red girdle and a chlamys in lavender with a carmine lozenge pattern extending also over the purple tablion. Both saints wear white socks and black shoes, and it will be observed that shadows are cast from their feet upon the green ground-strip. Both hold ochre and brown crosses of martyrdom and look at the beholder with wide eyes. The Virgin, Christ, and the two saints have golden nimbi outlined in blue and white, and close to the edges of the nimbi are patterns of punched, encircled dots.

The angels are dressed in light grey olive garments and their wings are grey white with gold striation; the wings nearest the light beam form a geometrical pattern. Their faces, turned to the hand of God, are painted with very broad strokes in a free manner which, more than any other part of this icon, shows a continuation of the classical impressionistic manner. As in the Virgin's lips and chin, theirs are an intense red, a color which is especially effective against the chalky white of their skin. Their white nimbi are transparent and through them the two shades of the blue background and the form and color of the niche show clearly. In their outer hands the angels hold scepters of brown and gold, and are thus characterized as archangels.

The whole figure composition is fitted tightly into the frame and set against a niche, which rises almost to the upper edge, not encompassing the figure group but forming a decorative architectural background. The light violet wall of the niche terminates in an ochre cornice with crowning palmettes, which has golden highlights. The strips of color above the cornice give the illusion of light blue sky into which is set a segment of dark blue heaven. The beam of

light issuing from the hand of God is set off by golden outlines.

It was quite customary in Early Christian art to represent the Virgin enthroned flanked by angels, e.g. in the Roman icon from St. Maria in Trastevere.[2] Yet there are already instances in the sixth century where two saints are depicted at either side of the Virgin, as e.g. the fresco in the catacomb of Commodilla, dated 528, where St. Felix and St. Adauctus replace the angels.[3] In our icon the angels are not replaced by the saints but simply moved into the background. The main iconographical problem is the identification of the soldier-saint at the right, since the bearded one at the left is surely St. Theodore Stratelates. For the youthful saint at the right, the Sotirious first proposed either St. Demetrius or St. George—indistinguishable in Byzantine iconography—but later decided in favor of St. George, while Kitzinger, on the basis of the similarity with a fresco of S. Maria Antiqua in Rome ("Icons," pl. XIX,5) identified the saint as Demetrius. The identity cannot be determined by any individual trait of the saint but only on the basis of which of the two saints is more frequently associated with St. Theodore Stratelates. While little material is available from the Early Byzantine period, tenth-century ivories are our richest and most elucidating source. In six cases, all supported by inscriptions,[4] St. Theodore is paired with St. George but not once with St. Demetrius. One is then permitted to conclude that in several more ivories from which the inscriptions have disappeared the pair of soldier-saints, one bearded and the other youthful, represent St. Theodore and St. George. This evidence suggests that the youthful soldier in the icon also represents St. George and not St. Demetrius.

The icon is the work of a superior artist using his artistic means with deliberation and skill. While the two saints, almost motionless in stark frontality and axiality, flank the Virgin like pylons, Mary is depicted with a measured freedom of movement; her knees turn slightly to the left, her eyes turn to the right, away from the beholder, stressing her remoteness from the worldly sphere. The Christ Child, at the geometrical center of the icon, is rendered with an even greater freedom, his legs drawn up and turned to the side in a childlike attitude. This feature contrasts with the modelling of the head, whose very high forehead suggests spirituality and maturity. Thus the distinction between young and old is clearly expressed as an illustration of the παιδαριογέρων or *puer senex*, a familiar topos in mediaeval literature,[5] or, expressed in dogmatic terms, as an illustration of the two natures of Christ, the human (the childlike body) and the divine (the spiritual head).

Moreover, the artist uses different modes to express varying degrees of physical reality. The olive green shadows in the face of the Virgin stress her unreality and therefore her divinity. In contrast, the faces of the soldier-saints, though more abstract in design, are much more natural in the rendering of the flesh color. Still a third mode is used for the angels, emphasizing by their predominantly white garments, faces, and transparent nimbi their ethereal nature. In achieving these effects the painter also uses different techniques: the purple garments of the Virgin are rendered as a flat homogeneous surface, dematerializing the body; the saints' mantles with their straight vertical folds emphasize a three-dimensional tubular quality; and in the garments of the angels, sharp crisscrossing folds and shimmering highlights give the effect of heavenly beings.

The saints reflect the contemporary hieratic style for which the mosaics of St. Demetrius in Salonika have justifiably been cited by the Sotirious and other scholars as the closest parallels.[6] Yet these seventh-century mosaics with the patron saint of Salonika are somewhat more abstract. This may in part be attributed to the difference in medium, but also, in our opinion, to the fact that they are somewhat later in date. On the strength of the similarity to the Salonika mosaics, Kitzinger has argued a seventh-century date for our icon, while the Sotirious proposed the sixth century. On this point we share their opinion, because the classical tradition is so much more alive in our icon than in any of the Salonika mosaics or, for that matter, frescoes like those of S. Maria Antiqua in Rome, executed by Greeks in the seventh century.[7] That classical pathos is still strongly reflected in our icon can be seen by comparing the angel heads with the head of Pylades in the Iphigeneia scene of the Pompeian fresco from the Casa del Citarista now in the Naples Museum (fig. 15).[8] With its emphasis on Christian spirituality, giving pictorial expression to the divinity of

[2] C. Bertelli, *La Madonna di Santa Maria in Trastevere*, Rome 1961.

[3] W. de Grüneisen, *Sainte Marie Antique*, Rome 1911, p. 266 and pl. IC.LVIII; A. Grabar (and C. Nordenfalk), *Early Medieval Painting from the Fourth to the Eleventh Century*, Skira 1957, color plate on p. 46.

[4] Goldschmidt and Weitzmann, *Byz. Elf.* II, pls. V, 20; X,31; XI, 32; XV, 38; XXXVI, 92; L, 138.

[5] E. R. Curtius, *Europäische Literatur und lateinisches Mittelalter*, Bern 1948, pp. 106ff; E. H. Kantorowicz, "Puer exoriens," *Selected Studies*, New York 1965, p. 33 and n. 52.

[6] G. and M. Sotiriou, Ἡ Βασιλικὴ τοῦ Ἁγίου Δημητρίου Θεσσαλονίκης, Athens 1952, pp. 187ff., pls. 60ff.

[7] P. Romanelli and P. J. Nordhagen, *S. Maria Antiqua*, Rome 1964, pp. 34ff. and pls. 21ff.

[8] P. Herrmann, *Denkmäler der Malerei des Altertums*, Munich 1904–1931, p. 158 and pls. 115–116; text fig. 2, pl. 5 and color plate IV.

Christ and the Virgin, with its introduction of the splendor of the imperial court, seen in the garb of the saints, and with its continuation of the Hellenistic tradition, exemplified in the figures of the angels, the icon shows a complexity and richness which we can imagine to have existed in the early period of Byzantine icon painting only in Constantinople. On this point I agree with Kitzinger rather than the Sotirious, whose opinion of a Syrian or Palaestinian origin I once shared but now should like to revise, particularly in view of the attempt of the present study to establish a Palaestinian school of different character. Whether the icon could have been painted during Justinian's reign when the monastery must have received gifts from its imperial founder cannot be proved but only suggested as a possibility. In comparison with the Christ icon (no. B.1) the Virgin icon may perhaps be a little later for but one reason: the niche behind the figures is higher and has lost somewhat the sense of space which is still present in the former icon.

Bibl.

G. Sotiriou, "Icones byzantines du monastère du Sinai," *Byzantion* XIV, 1939, p. 325 and pl. 1.

Idem, "'Εγκαυστικὴ εἰκὼν τῆς μονῆς τοῦ Σινᾶ," *Bull. corr. hell.* LXX, 1946, pp. 552ff. and pls. XXV–XXVI.

P. Toesca "Gli affreschi di Castelseprio," *L'Arte* LI, 1948–1951, p. 17 and fig. 11.

K. Weitzmann, *The Fresco Cycle of S. Maria di Castelseprio*, Princeton 1951, p. 11 and pl. X, 12.

Kitzinger, "Icons," pp. 136 f. and pl. XIX, 4.

Felicetti-Liebenfels, *Byz. Ik.*, p. 26 and pl. 32A.

Sotirou, *Icones* I, figs. 4–7 and color plate; II, pp. 21 ff.

E. Kitzinger, "Byzantine Art in the Period between Justinian and Iconoclasm," *Berichte zum XI. Internat. Byz. Kongress*, Munich 1958, Bericht IV, pp. 30, 47 and fig. 24.

C. Bertelli, *La Madonna di Santa Maria in Trastevere*, Rome 1961, p. 47 and fig. 29.

W. Weidle, *Les Icones byzantines et russes*, Milan 1962, p. 15, no. 3 and pl. A.

K. Weitzmann, "Mount Sinai's Holy Treasures," *National Geographic* 125, no. 1, 1964, p. 120 with figure in color.

Idem, *Frühe Ikonen*, pp. IX–X and pls. 1–3; pp. LXXIX, XCVIII.

Idem, "Various Aspects of Byzantine Influence on the Latin Countries from the Sixth to the Twelfth Century," *D.O.P.* XX, 1966, pp. 7f. and fig. 9.

A. Grabar, *Byzantium from the Death of Theodosius to the Rise of Islam*, London 1966, p. 186 and fig. 203.

F. Gerke, *Spätantike und Frühes Christentum*, Baden-Baden 1967, p. 236 and fig. on p. 214.

C. Delvoye, *L'Art byzantin*, Arthaud, 1967, p. 103 and pl. 29.

Lazarev, *Storia*, p. 92 and fig. 68.

A. Grabar, *Christian Iconography* (Mellon Lectures X), Princeton, 1968, p. 80 and pl. III.

B.4. ICON. PLATES VII AND XLVII
VIRGIN OF INTERCESSION
SIXTH–SEVENTH CENTURY
OLD LIBRARY

H. ca. 65 cm; W. 40.5 cm.[1] Like the other very early icons (nos. B.1–3, 5) this panel is of remarkably thin wood, but unlike them its frame is carved in one piece with the icon proper and not worked separately. This technique must also have existed at a rather early period for it occurs, for example, on the encaustic icon no. B.9 (Kiev II), which we attribute to the seventh century; yet it seems to have been rather rare at that time, becoming common only later. The rather narrow frame is completely preserved at the right side including the top and bottom right corners, indicating that the original height is retained.

Very badly damaged at the top, bottom, and left side, with parts broken away, the icon is split into three major vertical pieces and a small fourth piece is loosely fitted

above the right eye. It is in this most sensitive part of the composition that the damage is most severe, disfiguring the Virgin's face. At a recent date the pieces were nailed, most probably by the late Pater Pachomios, onto a rough board from a wooden crate. While Tassos Margaritoff, the restorer, was in the process of replacing this crude setting, Manolis Chatzidakis discovered that the face and hand were painted in the encaustic technique and could not possibly be of the same period as the rest of the painting.[2]

While considerably rubbed, some of the pink and white layers of wax paint are still visible on the cheeks over the brown gesso ground. Best preserved is the bright cherry red of the mouth and the underside of the chin and some red of the neck, in sharp contrast to the white highlights and deep olive green shadows around the mouth and chin. The same color scheme is also used for the left hand, which nonchalantly crosses the Virgin's breast. The treatment is so like that of the Virgin's face in the preceeding icon (no. B.3) that we must assume, on technical and artistic grounds, that

[1] The Sotirious measured the width as 45 cm.

[2] I am grateful to Manolis Chatzidakis for this valuable information.

both icons are not only approximately contemporaneous, but most likely the products of the same or locally related workshops. As in the Christ icon (no. B.1), only the face and the hands—and here also the book—of a preiconoclastic icon were visible, while the rest was overpainted at a later time. In the scroll held by the Virgin, the encaustic paint shines through in spots under the more recent tempera layer. However, we do not know how much encaustic paint still lies under the overpaint. There were various reasons for the overpainting of icons: in the case of the Christ icon the original paint was still intact beneath the modern layer, so that aesthetic reasons must have prompted the modernization, while in another case, the famous Virgin of Vladimir,[3] the repainting was to cover large damaged and destroyed areas. In the present case the reason for overpainting remains unknown.

At present the Virgin's head and hand are incorporated into a type of Virgin of Intercession generally known as the ΑΓΙΟCΟΡΙΤΙCCA and here a specific variant in which she holds an open scroll with a lengthy versified dialogue;[4] such verses occur with slight variations on several copies of this type. While the epithet of this Virgin type varies somewhat, it is most frequently Η ΠΑΡΑΚΛΗCΙC, as it appears, e.g., on the fresco of Nagoročino from the year 1317–1318, iconographically the closest parallel to our icon.[5] In the fresco she is depicted full length as she is also in the fresco of the Church of the Anargyroi at Kastoria from the end of the twelfth century[6] and elsewhere in fresco painting, and it seems quite likely that the archetype may have been a full-length figure. It seems, nevertheless, that in icon painting the half-length figure was preferred, as indicated by parallels to our icon, especially the much venerated Virgin of Spoleto, dating from the twelfth century and supposedly a gift of the emperor Henry Barbarosa.[7] The repainted layer of the Sinai icon seems to be later than the Spoleto icon and earlier than the Nagoročino fresco, and a date in the thirteenth century was proposed, quite correctly I believe, by the Sotirious.

A priori it seems quite probable that the thirteenth-century painter preserved the original iconography, chang-ing it perhaps in minor details not affecting the essence of the type. But what evidence supports the existence of this type at an early period? The oldest example of it is a mosaic in St. Demetrius in Salonika which places the Virgin alongside a frontal figure of St. Theodore Stratelates (fig. 6). Whereas Kondakov dated this mosaic at the end of the seventh to the early eighth century,[8] the Sotirious proposed a somewhat broader span of time, arguing that it surely could not be later than the ninth century, but more likely was still close to the other devotional mosaic panels in St. Demetrius, which they dated in the seventh century.[9] A preiconoclastic date thus seems assured and consequently it becomes highly probable that this type existed as well in preiconoclastic icons, of which the Sinai icon would be a fragmentary survival. There are slight variations in that the Virgin of the mosaic stands more erect and holds her left hand in a gesture of prayer, but such differences, which do not affect the basic iconographic type, may be due chiefly to the difference in media rather than in time.

The Virgin of the mosaic also holds an open scroll, but its text is much shorter and its content, again a formula of intercession, is not in dialogue form as in the Middle and Late Byzantine examples. The Sinai icon may originally have had a shorter text like that of the mosaic. Turning, the Virgin offers the scroll to someone, and the text requires that this should be Christ, to whom she appeals in supplication for mankind. If the mosaic depicts St. Theodore instead of Christ, it can only mean that we are dealing with a derivative iconography. Actually, there is also a representation of Christ in the mosaic, but only in the form of a small bust relegated to a segment of heaven.

The Virgin of Supplication may be associated with Christ in two ways: either she is part of a composition of only two figures or she is part of a Deesis requiring Christ to be flanked by John the Baptist on the other side. The first alternative seems to us much more likely for the Sinai icon, since the Virgin of the Deesis normally stretches out both hands in prayer towards Christ,[10] whereas in several later frescoes the Virgin holding the scroll is paired with a stand-

[3] A. J. Anisimov, *Our Lady of Vladimir*, Prague 1928.

[4] The text is published by the Sotirious, *Icones* II, 160.

[5] N. Okunev, *Monumenta Artis Serbicae* I, Prague 1928, pl. 10; A. Frolow, *La Peinture du Moyen Age en Yougoslavie* III, 1962, pl. 113,1 and 3.

[6] S. Pelekanides, *Καστορία* I, Thessaloniki 1953, pl. 28, where she is dated eleventh century. In our opinion the style points to the late Comnenian period.

[7] After recent cleaning and restoration published by S. Mercati, "Sulla sanctissima icone del Duomo di Spoleto," *Spoletium* 3, 1956, pp. 3–6 with color plate; S. Der Nersessian, "Two Images of the Virgin in the Dumbarton Oaks Collection," *D.O.P.* XIV, 1960, p. 84

and fig. 11; W. F. Volbach, "Byzanz und sein Einfluss auf Deutschland und Italien," *Lectures. Byzantine Art. An European Art*, Athens 1966, p. 110, fig. 88; Idem, "Byzanz und der Christliche Osten," *Propyläen-Kuntstgeschichte* III, Berlin 1968, pl. 49a and p. 181.

[8] N. P. Kondakov, *Иконография Богоматери* I, St. Petersburg 1914, p. 364 and fig. 240.

[9] G. and M. Sotiriou, *Ἡ Βασιλικὴ τοῦ Ἁγίου Δημητρίου Θεσσαλονίκης*, Athens 1952, p. 195 and pl. 66.

[10] There is a fifteenth-century icon on Sinai (Sotiriou, *Icones* I, fig. 170; II, pp. 155–157) in which the Virgin does hold a scroll but this is a very rare and late exception.

ing Christ, each on a separate pillar however, as e.g. in Nagoročino. This, then, introduces the possibility, though it cannot be proved, that the Virgin icon of Sinai also originally had a counterpart with a bust of Christ and that the two parts formed the wings of a diptych.[11] However, no such counterpart is preserved among the few surviving encaustic icons on Sinai; the Pantocrator (no. B.1) is too large to serve in such a way and the other Christ icon (no. B.6) is too small.

[11] For a fuller study of the diptych with the busts of Christ and the Virgin, cf. Otto Pächt, "The Avignon Diptych and Its Eastern

On the basis of its high quality the Sotirious ascribed the icon to a workshop of Constantinople. This we believe to be very likely indeed for both layers, with the encaustic layer executed in about the sixth or seventh century and the tempera in the thirteenth.

Bibl.

Sotiriou, *Icones* I, fig. 173; II, pp. 160–161.

Ancestry," *De Artibus Opuscula XL. Essays in Honor of Erwin Panofsky*, New York 1961, pp. 402ff. and pls. 130–135.

B.5. ICON. PLATES VIII–X AND XLVIII–LI
ST. PETER
SECOND HALF OF SIXTH–FIRST HALF OF
SEVENTH CENTURY
GALLERY

H. 92.8 cm; W. 53.1 cm; thickness 1.2 cm. The icon is slightly damaged around the edges, especially at the right and the bottom where sections of the unpainted border strips have split off; at the left the border strip is missing altogether, but nothing of the painted area is lost, as indicated by traces of a line in minium defining the outline of the painted area exactly as in the Virgin icon no. B.3. Where the unpainted strip is preserved it measures 1.5 cm in width. This is too narrow for an ordinary frame to have been fastened to it and, furthermore, there are no holes to indicate that such a frame had been nailed on. We thus assume that this icon, like that of the Virgin, fitted into a grooved frame which extended considerably beyond the icon proper (cf. the diagram on p. 19) and was broad enough to hold a dedicatory inscription, which seems to have been customary in early icons. For its large size, the wooden panel is remarkably thin and, even more astonishing, it has not warped. The icon is badly damaged at the bottom where parts of both hands and larger sections of the garment are lost. All over the surface, areas of varying size have flaked off. It is not necessary to enumerate them in detail, since the outlines of the missing areas can easily be detected in the photograph taken with the light falling from the side (fig. 7). Most of the missing areas had been filled in directly on the wood with oil paint, which, therefore, lies

[1] The reverse of B.5 has been published by M. Chatzidakis, *Art Bull.* XLIX, 1967, p. 198 and fig. 14.

deeper than the wax paint on the gesso ground. These restorations were probably made by Pater Pachomios in recent times, and most of them were removed during cleaning by Margaritoff in 1962, although he left some of the earlier restored areas unchanged, especially large sections in the mantle, in order not to disturb the artistic unity. The removal of the recent oil paint is felt particularly in the face where its effect is two-fold: on the one hand, it reveals more sharply the ruinous state of the icon and leaves a spotty effect; on the other, it brings out the original intensity of the facial expression. Furthermore, the recent cleaning has greatly enhanced the original freshness of the color and the vigor of the brush technique. The reverse is roughly chipped, as in the icons nos. B.1 and 3.[1]

The almost life-size half figure of St. Peter shows the Apostle with keys and cross-staff before a niche. He is dressed in tunic and mantle of olive green in many shades ranging from very dark to very light. To provide greater harmony of color, the keys are also rendered in dark blueish green, and even the grey hair has a blue green undertone. In contrast to these cool colors, extremely subtle warm tones of red and brown are predominant in the flesh, turning into crimson in the cheeks, the lips, and the tip of the nose. Only for the brows and the lower eyelids does the painter use touches of olive grey, far more sparingly than in the faces of Christ and the Virgin of icons nos. B.1 and 3. In the face of St. Peter the effect is more lifelike, the color almost that of a sunburn. The wide-open brown eyes immediately attract the attention of the beholder. The head is set against a golden nimbus which, like that of the Christ in icon no. B.1, is quite large and bordered by a narrow white and a broad dark blue

line. The brown cross-staff in St. Peter's left hand has golden highlights over ochre, stressing the importance of the attribute and at the same time harmonizing with the gold of the nimbus.

St. Peter is placed before a niche of a very dark olive color, well chosen as a background for his garments. A cast shadow falls across the left part of the wall and seems more decorative than motivated by a source of light; slit windows are designed in perspective on the pilasters of the niche where no such perspective design is called for. We see here reminiscences of the classical tradition which now serve a merely decorative purpose. Yet the ornamental motifs that crown the niche are very classical indeed: a golden bead and reel, a crimson frieze with gilded ornaments, a grey cyma, and finally a gilded cornice resting on golden consoles. Beyond the niche one looks into the sky where dark blue gradually lightens to a lighter hue and finally to pure white.

Suspended in the upper zone are three medallions, the central one slightly larger than the others, the gold ground of all three having the same narrow white and broad blue borders as does the nimbus of St. Peter. In the central medallion Christ is depicted in a purple tunic and mantle; purplish violet strokes brushed into his blackish hair reveal again the artist's attempt to harmonize the color of the hair with that of the garments. The flesh color—what is left of it —is chalky white and pink, giving a less realistic effect, which is also characteristic of the other two medallion faces. The artist apparently intended to create a contrast to St. Peter's face. Around the head of Christ is a huge white cross outlined in brown and set against the gold of the medallion, thus serving as a nimbus. The face is severely damaged, not by flaking but by scratches, which seem to have been made intentionally by iconoclasts. The medallion at the right depicts the Virgin, clad in a maphorion not of purple, as one would expect, but of two shades of brown. Beneath it her hair is rolled in a blue scarf with white ornamental streaks, as in the Virgin icon no. B.3. Light brown shadows around her eyes and along the ridge of her nose and carmine lips are the only accents in the otherwise chalky face. In this face, too, there are a few scratches that may have been made intentionally. The youth in the left medallion has purple black hair and wears a tunic and mantle of light grey touched with olive. As in the Virgin medallion, the eyes and the mouth form strong color accents in the pallor of the youthful face.

Iconographically, the figure of St. Peter is built on the prevailing tradition according to which the Apostle is characterized by thick white hair and a rather short beard. Normally, however, he is depicted with a lower forehead and with the hair fitting like a tight cap around his skull, like the Peter of the Metamorphosis mosaic of Sinai (fig. 8). The artist of the icon introduces as an individual element the whirling tuft of hair over the forehead, and by combing the beard in a curve he achieves the effect of greater liveliness. Whether the three keys in the hand of Peter have a trinitarian significance can only be surmised.

The head of Christ with long strands of parted hair and a rounded beard is basically the same type as that represented in icon no. B.1. While the Virgin also corresponds to the accepted type, the youthful saint at the left cannot readily be identified. The Sotiriou have proposed two obvious alternatives: Moses or St. John the Evangelist. For the youthful type of Moses in Early Christian art, one can point to the Metamorphosis mosaic at S. Apollinare in Classe in Ravenna,[2] but at the same time it must be noted that although there are three different representations of Moses in the mosaic of Sinai, he is bearded in all three. Moreover, in any Byzantine work of art Moses and the Virgin would hardly appear as equals; the Virgin would be in the center flanked by Moses on one side and another saint on the other.[3] The youthful John the Evangelist, however, appears as a counterpart to the Virgin at the opposite side of the crucified Christ. Thus, although it cannot be definitely proved, John the Evangelist seems to be the more likely identification, and the choice of the three medallions may well be understood as an allusion to the Crucifixion. This also might explain the prominent display of the cross-staff in the hand of St. Peter as a reference to his own death on a cross. However, it cannot be overlooked that, if our association of the three medallions with Christ's crucifixion is correct, one would expect the two lateral medallions to be reversed, unless some special reason called for an exchange of their positions (cf. below).

It did not escape the Sotiriou that the position of the three medallions above the head of St. Peter closely parallels a similar arrangement on some consular diptychs such as that of Anastasios, dated 517, in the Cabinet des Médailles in Paris (fig. 9).[4] This relationship is not merely formal but has a deeper significance. It will be observed that the similarity between the two monuments extends to the rank

[2] F. W. Deichmann, *Frühchristliche Bauten und Mosaiken von Ravenna*, Baden-Baden 1958, pls. XIII and 390; E. Dinkler, *Das Apsismosaik von S. Apollinare in Classe*, Cologne and Opladen 1964, pl. VIII.

[3] Sotiriou, *Icones* I, figs. 157–158, 197; K. Weitzmann, "Icon Painting in the Crusader Kingdom," *D.O.P.* XX, 1966, p. 65 and fig. 32.
[4] R. Delbrueck, *Die Consulardiptychen und verwandte Denkmäler*, Berlin and Leipzig 1929, no. 21.

order of the persons represented in the medallions. Christ takes the place of the emperor in the ivory, the Virgin that of the empress—this is perhaps the reason why the Virgin is at the left side of Christ instead of the right—and John, the co-disciple, if our interpretation is correct, takes the place of the co-consul. Now also the emphasis on St. Peter's attributes becomes more understandable; he clutches the keys in his right hand as the consul the mappa, and in his left he holds the cross-staff as the consul does the scepter. The basic idea of the icon seems then to be that St. Peter holds the highest office under the reign of Christ and the Virgin, with the assistance of a co-administrator, and to convey this idea the artist obviously borrowed from imperial iconography a compositional scheme whose meaning was fully understood in the sixth century, when the ivory diptychs were carved. It must be kept in mind that probably less than a century separates the ivory diptych from the St. Peter icon.

The icon is the work of a superior artist who not only has a sense of color harmony as indicated by his delicate use of shades of olive, but who is also a master of various brush techniques, choosing a free and daring manner for the criss-crossing highlights of the garments to create effects of a flickering surface, and at the same time achieving smooth transitions within the reds and browns in the painting of flesh. By such means he succeeds in drawing the beholder immediately to the expressive face, whose calm and pensive eyes betray at the same time an inner tension. The whirling tuft of hair and the not too carefully combed beard add to the impression of vitality that permeates not only the head but the whole figure, as revealed, e.g., in the firm clutching of the keys. The artist's conception of St. Peter is not one of a rustic fisherman but of a spiritual leader of the Church, aristocratic in demeanor. Peter's head is slightly turned to the left, a movement counterbalanced by the turn of Christ's head slightly to the right. But while this limited measure of freedom of motion is permitted St. Peter and Christ, the Virgin and St. John are rendered in a rigid frontality. This compositional device has its analogy in the Virgin icon no. B.3, where the Virgin and Child in slight motion are framed by the two soldier-saints in strong axiality. The niche is vital to the overall balance and concentration of the composition, seeming at once to enclose Peter's nimbed head and at the same time to be clearly behind the bust. There is a similar ambiguity of spatial relations in the well-known ivory plaque of the archangel in the British Museum where, in reversed manner, the upper part of the body is in

front of the arch while the feet are placed on the steps behind it.[5] In both cases the architecture is used for a decorative and symbolic purpose rather than as a realistic, spatial setting.

While in many respects the style of the St. Peter icon is closely related to that of the preceding icons nos. B.1–3 and all of them show equally strong adherence to the Greco-Roman brush technique, yet in the Peter icon the style has begun to harden and to develop geometrical patterns, especially in the drapery. Instead of being softly modelled, the folds are marked by deep grooves with sharply highlighted ridges. For this reason we seem justified in dating the Peter icon somewhat later than the Christ and the Virgin icons nos. B.1–3. Kitzinger has compared the St. Peter icon with the frescoes of S. Maria Antiqua, especially the group of the Maccabees and the St. Barbara that belong to the middle of the seventh century; he believes that the icon is still later, comparing Peter's face with some of the Apostles of S. Maria Antiqua that belong to the time of Pope John VII (705–707).[6] Yet, in comparison with the Roman frescoes, the drapery in the St. Peter icon still envelopes a massive body, and the highlights still give some illusion of real light effects. On the other hand, in the figure of Solomone at S. Maria Antiqua (fig. 10), the clear structure of the paenula is obscured by the treatment of the part over the breast as an isolated diagonal sash, and the highlights are much less integrated into the modelling of the garments, which hide rather than reveal the body underneath. In other words, the illusionistic elements have hardened and become even more patternized. Moreover, the soft modelling, in the Greco-Roman tradition, of the head of Peter stands out markedly when compared with the sharply delineated faces of the Apostles of S. Maria Antiqua. We thus are inclined to date St. Peter earlier than either of the two groups of the S. Maria Antiqua frescoes and in this we follow the Sotirious and Chatzidakis, all of whom have argued for the earlier date. We thus propose a date in the later sixth or perhaps the early seventh century, i.e. later than icons nos. B.1–3, but earlier than the Roman frescoes.

There has been disagreement also over the place of origin. The Sotirious argue in favor of Alexandria for three reasons: the encaustic technique, generally associated with Egypt; the assumption that Alexandria had preserved most closely the classical tradition; and the similarity, especially of the medallion heads, with the Fayyum portraits. None of these reasons, however, seems to us convincing. First, the

[5] O. M. Dalton, *Catalogue of the Ivory Carvings of the Christian Era*, British Museum, London 1909, p. 9, no. 11 and pl. VI.

[6] Good reproductions in P. Romanelli and P. J. Nordhagen, *S. Maria Antiqua*, Rome 1964, pls. 28-29.

encaustic technique was not confined to Egypt, and it is only chance that most of the material in this technique that has survived comes from the country of the Nile; secondly, art history in general has within the last decades begun to realize that in the sixth century Constantinople still preserved the classical tradition in a greater purity than any other center of the ancient world;[7] and thirdly, the wide-open eyes, so characteristic of many portraits of the Fayyum, are not unique to Egypt but are common throughout late Classical and Early Christian art from the time of Constantine. The consular diptychs (fig. 9) made in Constantinople are clear evidence of this. Thus it seems to us that Constantinople is by far the most likely place to have produced the St. Peter icon for three reasons: its outstanding artistic quality; its close relation to icons nos. B.1–3 with which it seems to be connected by a common workshop tradition; and the borrowing of the compositional scheme from imperial iconography.

[7] K. Weitzmann, "Das Klassische Erbe in der Kunst Konstantinopels," *Alte und Neue Kunst* III, 1954, pp. 41ff. (repr. "The Classical Heritage in the Art of Constantinople," Weitzmann, *Studies*, pp. 126 ff.).

Bibl.

G. Sotiriou, "'Εγκαυστικὴ εἰκὼν τοῦ 'Αποστόλου Πέτρου τῆς μονῆς Σινᾶ," *Mélanges H. Grégoire, Annuaire de de l'Inst. de philol. et d'hist. orient. et slaves* X. 1950, Part II, pp. 607ff. and pls. I–II.
Kitzinger, "Icons," p. 136 and pl. XX, 7.
Sotiriou, *Icones* I, figs. 1–3 and color plate; II, p. 19.
Felicetti-Liebenfels, *Byz. Ik.*, p. 25 and pl. 32B.
E. Kitzinger, "Byzantine Art in the Period between Justinian and Iconoclasm," *Berichte zum XI. Internat. Byz. Kongress*, Munich 1958, Bericht IV, p. 32 and fig. 26.
C. Bertelli, *La Madonna di Santa Maria in Trastevere*, Rome 1961, pp. 86, 89 and figs. 58–59.
M. Chatzidakis, "L'Icone byzantine," *Saggi e memorie di storia dell'arte del Istituto G. Cini*, 2, 1959, p. 16 and fig. 2.
W. Weidle, *Les Icones byzantines et russes*, Milan 1962, p. 16, no. 4 and pl. C.
K. Weitzmann, "Mount Sinai's Holy Treasures," *National Geographic*, 125, no. 1, 1964, p. 113 color plate.
Weitzmann, *Frühe Ikonen*, pp. X, LXXIX, and pl. 5.
A. Grabar, *Byzantium from the Death of Theodosius to the Rise of Islam*, London 1966, p. 186 and fig. 202.
H. Stern, *L'Art byzantin*, Paris 1966, p. 170 and pl. XXXIX.
Lazarev, *Storia*, p. 92 and figs. 66–67.
C. Delvoye, *L'Art byzantin*, Arthaud, 1967, p. 103 and fig. 30.
A. Grabar, *Christian Iconography*, Princeton 1968, p. 78 and fig. 197.
Idem, *L'Art de la fin de l'antiquité et du moyen âge*, Paris 1968, I, p. 598 and III, pl. 46a.

B.6. ICON. PLATES XI AND LIV
BUST OF CHRIST PANTOCRATOR
SIXTH CENTURY
OLD LIBRARY

H. 35 cm; W. 21.2 cm. Thickness 1.1 cm. The rather thin wood is severely warped, resulting in a curvature of 2.5 cm and a split from top to bottom. The two parts are held together by narrow strips of metal above and below. The existence of a now lost frame is indicated by the absence of paint and by holes all around the border where nails once fastened on the separate wooden strips that constituted the frame proper. Such a frame may well have had an inscription (cf. nos. B.16 and 31). The icon is in the most deplorable state of preservation and there are only a few small patches left of the original topmost layer of encaustic paint, on e.g. the blessing hand, the edge of the Gospel book, and parts of the mantle. Practically nothing of the top layer of the face is left, but the under layer and what appears to be preliminary design are sufficiently preserved to determine the iconographic type of Christ. In modern times, presum-

ably Pater Pachomios did some overpainting of the face and he most likely is responsible for the violet brushstroke marking the ridge of the nose. The advanced destruction of the surface, on the other hand, has revealed an interesting technical detail concerning the preparation of the ground: the area intended for the face and the neck, but no other part of the background, is covered by canvas, which must have been considered especially suitable for fastening thick layers of encaustic paint. For the background, sheet gold is used with slightly overlapping edges. The reverse is blank.

Christ is dressed in a tunic and mantle of purple, and his right hand emerges from the mantle's sling, blessing with two fingers crossed in precisely the same manner as the Christ of no. B.1. In his left hand, although it is not visible, he carries the Gospel book, the cover of which was decorated with gold, while the edges of its pages are delicately painted in light grey. The triangular face of Christ is framed by a double row of almost black curled locks, discernible above his left ear, and the pointed beard of the same color strongly accentuates the geometrical form of the head. Behind the head, the outlines of the bars of a cross are

visible but there is no outline of a circular nimbus. In both respects the type resembles one of the two Christ heads on the gold coins of Justinian II.[1]

This particular type is in art-historical writing generally described as "Syro-Palaestinian," but Grabar has demonstrated that this as well as the other Christ type with full rounded beard and flowing hair appear concurrently on the coins of Justinian II in Constantinople.[2] The differences between the two facial types are consequently to be understood as indicative not of local distinctions, but rather of iconographical types with different meanings, human nature being stressed in our icon type while divine nature is emphasized in the majestic, full-bearded one. This parallelism of the two types occurs, even before the coins, on two miniatures of the Rabula Gospels from 586 A.D. Here, the more divine type is employed for the Ascension, the more human one for Christ between two groups of monks,[3] indicating the different purposes for which the two types were used.

[1] J. D. Breckenridge, *The Numismatic Iconography of Justinian II*, Am. Num. Soc., New York 1959.

If, then, there is no reason to connect our icon with a Palaestinian workshop on iconographical grounds, there is also none on stylistic ones. Admittedly, the poor state of preservation permits no detailed comparisons and therefore no final judgment. Yet noteworthy is the delicate and very painterly treatment of the blessing hand, which is comparable to that of the early Pantocrator (no. B.1) but not like that of the more roughly painted Ancient of Days (no. B.16). Also the smooth surface of the purple garment, softly modelled without sharp highlights, can be compared with the other Christ and with the Virgin enthroned (no. B.3). This would argue for its having originated in Constantinople, where we believe the Pantocrator Christ and the Virgin icons to have been executed, while at the same time none of the specific trademarks of the Palaestinian workshops are discernible. Quite conceivably both Christ icons could have been painted in the capital and, if so, the parallelism of the two types would be shown to antecede the coins of Justinian II by as much as a century.

[2] A. Grabar, *L'Iconoclasme byzantin*, Paris 1957, pp. 36ff. and figs. 15–16.

[3] Ibid., p. 43 and figs. 78–79.

B.7. ICON (FRAGMENT). PLATE LIV
BUST OF VIRGIN
SIXTH–SEVENTH CENTURIES
OLD LIBRARY

H. 64.3 cm; W. 17.8 cm. The icon is split vertically; only the left and smaller half is preserved. Less than half of the surface of the old encaustic paint remains and comparatively more is left in the lower part of the fragment. Narrow strips about 3 cm wide at the top and the bottom and an even narrower strip at the left edge have been left unpainted. Yet these three strips are too narrow for a frame to have been nailed onto them. Moreover, as in icon no. B.3, these border strips correspond with a sunken frame on the reverse, and similarly a broad frame with a groove fitted the icon in such a way that the back of the frame was flush with the back of the icon while on the front the frame projected.

The frame probably had an inscription, quite likely a dedication as in the case of icon no. B.16. As a result of these observations our previous idea that this icon could have been the center of a triptych of which the Elijah panel (no. B.17) was one wing must be abandoned.

The details are obscure but this much is clear: the icon depicted a frontal bust of the Virgin clad in a purple maphorion. The pose of the hands and whether there was a Christ Child in the picture can no longer be determined. Nothing of the face is discernible and only part of the maphorion that frames the head suggests where it should be. The golden nimbus shows a zigzag pattern in black at its outer edge and the monogram $\overline{\text{MHP}}$ should be matched by $\overline{\Theta Y}$ at the other side of the head. Both ornament and inscription are later additions. The original inscription, if there was one, must have been in much larger letters, most likely in the form of monograms reading H AΓIA MAPIA rather than MHTHP ΘEOV.

The background is light grey in the lower part and blue above. This suggests some kind of architectural background at shoulder height and sky above. Most probably there was a niche, as in icons nos. B.1, 3 and 5.

There is not enough of the surface left for a detailed stylistic analysis. The rather sharp-edged folds are not unlike those on the garment of St. Peter, icon. no. B.5, and this would support a date at the end of the sixth or early in the seventh century.

Bibl.

K. Weitzmann, "An Encaustic Icon with the Prophet Elijah at Mount Sinai," *Mélanges offerts à Kazimierz Michalowski*, Warsaw 1966, pp. 713 ff. and fig. 3.

B.8. ICON (FRAGMENT). FIGURE 11
VIRGIN MONOGRAM
SIXTH–SEVENTH CENTURIES
OLD LIBRARY

H. 14.3 cm; W. 7.6 cm. All that remains is the upper left corner of what must once have been an icon of considerable size with a figure estimated to be life-size. Preserved, in monographic form, are the words H ΑΓΙΑ, to which there must have corresponded the monogram for MAPIA in the upper right corner (cf. no. B.40). This inscription is painted in huge golden letters on a dark blue ground in encaustic and set into the spandrels created by a large nimbus which is thinly outlined in red and encloses an area in blue. Since it is

unlikely that the whole nimbus in a Virgin icon would be in any color other than gold, or yellow as a substitute for gold, it seems more likely that the blue is part of a second and broader outline of the nimbus. The very earliest icons, like the Christ and the Virgin nos. B.1 and 3, likewise have such a second outline in blue although not quite as wide. Another feature that this nimbus shares with the two early icons is a punched rosette pattern along the inner side of its outline; in our case the pattern is even more elaborate: It is somewhat unusual that the punched pattern is on a colored rather than a gold background.

The fragment belonged in all probability to an icon with a frontal bust of the Virgin somewhat like that of no. B.7.

B.9. (KIEV II) ICON. PLATES XII AND LII–LIII
ST. SERGIUS AND ST. BACCHUS
SEVENTH CENTURY
KIEV. CITY MUSEUM OF EASTERN AND
 WESTERN ART, NO. 111

H. 28.4 cm; W. 41.8 cm (with frame 42.5 cm); thickness 5–6 mm. A separate frame was fastened with handmade nails onto a border which, as can still be recognized, was left unpainted. This frame may well be the original one, which in analogy to others (cf. nos. B.16, 31) one would expect to have been painted. The left side of the frame is recessed by an angular cutting and one would assume a corresponding recess at the right where the inner side of the frame is damaged. These recesses served to hold a lid which when attached would be flush with the frame. We find the same kind of protection in the icon of the Three Hebrews (no. B.31) except that there the frame is recessed on all four sides.

The icon is split horizontally into two parts which at present are held together by two pieces of wood screwed against the back. The crack goes through the eyes of the left-hand figure, damaging particularly the left eye, and runs below the eyes of the figure on the right. Color has flaked off along the crack and the missing parts have been restored with oil paint in modern times. The icon proper, the surface of which has suffered various degrees of damage, is painted in encaustic technique over a thin layer of gesso. A piece of

paint has broken out of the cross held by the saint on the left and the surface under the torque of the one on the right has been retouched, as has a large area of the lower part of the face and the right eye, damaged by the crack mentioned above. As in all encaustic paintings it is difficult to judge how much of the top pigments have come off. The icon was brought by Porphyry Uspensky from St. Catherine's Monastery on Sinai in the middle of the nineteenth century and deposited in the Ecclesiastical Academy of Kiev. After the revolution it was in the Kiev Central Antireligious Museum and was transferred in 1940 to the present museum. At the present writing the icon is undergoing some restoration in Moscow.

The two busts of youthful martyrs are inscribed in the upper corners CЄPΓIO[C] and BAXOC in black ink, added at a later time. Yet they would have been identifiable without these inscriptions on the basis of one typical attribute, the special type of torque, the maniakion. Each is dressed in a brown chiton with a dense striation of rather thick gold lines, by means of which the artist wanted to suggest a solid gold garment.[1] It is adorned with a carmine clavus and a border of the same color around the sleeve, which, however, is visible only in the case of Sergius. Both wear a white chlamys, that of Sergius having pink and that of Bacchus grey blue folds; over the right shoulder it is fastened with a golden clasp made of three balls. The upper edges of a tablion are visible above the hands, that of Sergius being carmine and that of Bacchus a grey that

[1] This gold striation is surely original and not a later addition as Wulff and Alpatoff suggested.

suggests a blueish purple. Around the neck they wear a golden torque, the so-called maniakion, which identifies the two martyrs as high court officials. Sergius held the office of πριμικήριος τῶν Κεντηλίων σχολῆς and Bacchus that of σεκουνδουκήριος (Migne, *P.G.* 115, col. 1005). Each maniakion is decorated with three great cabochon stones, two rectangular and the central one oblong; they are blueish in color and painted to look transparent. In their pale hands, of which only the excessively long thumb and forefinger are visible, the saints hold the crosses of martyrdom, painted brown with golden highlights but surely meant to be massive gold. The youthful faces are whitish with some subtle pink on the cheeks and olive green used for shadows, giving them the overall effect of pallor. Their wide-open, almond-shaped eyes have dark brown irises with black pupils and gaze at the beholder without emotion. The brows, the noses, and the tight lips are almost geometrically designed in carmine brown. The dark brown hair, rendered in conventionalized rows of locks highlighted with yellow and green lines, reaches deeply onto the forehead. The immovability of the heads is emphasized by the huge gold compass-drawn nimbi.

Tightly fitted between the nimbi is a medallion with a frontal head of Christ; the face, in the same flesh color as that of the martyrs, is framed by long black hair and a pointed black beard. Medallion and nimbus coincide and there is no cross. All three nimbi are outlined in red and punched by simple dots close to the edges, and in addition the nimbi of the martyrs have a punched pattern of six pointed stars alternating with circles and double points. It can be demonstrated that the gold was painted first, because it shows where portions of the hair have flaked off. The shoulders and the nimbi are surrounded by broad strokes of blue whereas the rest of the background shows a lighter blue becoming very pale toward the top and suggesting, in the tradition of classical painting, the atmosphere of the sky.

Sergius and Bacchus—martyred together under Maximianus and having the same feast day of October 7—are always depicted as a pair and distinguished from other youthful soldier-saints by the maniakion. The Kiev icon shows the types so fixed iconographically that they appear centuries later unchanged, except for stylistic modifications, in a Byzantine ivory casket in the Museo Nazionale in Florence, as was already recognized by Strzygowski (*Orient oder Rom* fig. 48). This casket belongs to the tenth century and to a group certainly produced in Constantinople.[2]

Christ's hair flows over his shoulders, a motif that has been associated with the classical Zeus-like type, whereas the pointed beard is found frequently in a type that has been called Syro-Palaestinian. Grabar, however, has clearly shown that these two types are not geographically exclusive but occur side by side in Constantinople on coins of Justinian II and in miniatures of the Syrian Gospels of Rabula.[3] In our icon we have actually a mixture of both types, a not infrequent occurrence.

Stylistically the icon displays a considerable degree of abstraction effected by strong symmetry, axiality, and an effort to give the impression of remoteness to the faces. These features Kondakov interpreted as a loss of quality compared with earlier works in the classical tradition, but Ainalov as well as Wulff and Alpatoff stressed, in my opinion rightly, the refinements within the mode of expression which speak for a painter of considerable artistic power. It will be noted that the two saints are not composed on strict geometrical axes, but that they turn slightly towards each other, Sergius rather more than Bacchus. Moreover, in spite of an intentional similarity between the two, there are subtle psychological differences: Sergius has a slightly more emaciated and thus more ascetic face than Bacchus, whose face is somewhat fleshier. There are differences in the eyelids and the design of the mouths which can be interpreted along the same line and reveal the artist's capacity for characterization within the self-imposed limits of an hieratic style.

In many respects the two saints are related stylistically to the figure of St. George in the Virgin icon no. B.3. The form of the faces, the treatment of the curly hair, and the flesh color correspond rather closely, except that in the head of St. George the colors are applied in a freer manner that is still closer to the classical tradition. The flesh color of St. George is in striking contrast to the sun brown color of St. Theodore, proving that the pale color of St. George as well as that of Sergius and Bacchus is not merely an abstract convention but an indication of the tender age of adolescence. The shape and color of the crosses of martyrdom are likewise very close in the two icons, but the one in the hand of St. George is held with a firmer grip. Furthermore, we may compare some technical details such as the depiction of garments in brown with gold striation. Christ's garments in the Virgin icon are treated in this manner and so is the clavus on Christ's chiton in icon no. B.1, though here the

[2] Goldschmidt and Weitzmann, *Byz. Elf.* I, p. 56 and pl. LVIII, 99d.

[3] A. Grabar, *L'Iconoclasme byzantin*, Paris 1957, pp. 36ff. and figs. 12–16; p. 43 and figs. 78–79.

gold lines are more delicate. Most striking is the similarity in the punching of the nimbi, a technique for which only the two Sinai icons mentioned above offer direct parallels, the Christ icon an even closer one than the Virgin icon because in it one finds the somewhat more elaborate star pattern of our icon, while in the Virgin icon the punching is confined to a circle pattern. Other comparable features are the dark blue strokes around the nimbi and the gradual lightening of the atmospheric blue of the background. In spite of these similarities, there is in every respect a higher degree of abstraction in the Kiev icon, suggesting that, although it is in the same artistic tradition, it is somewhat later in date. At the same time the increasing emphasis on hieratic effects links the two martyrs with the various Demetrius figures in the mosaics of St. Demetrius in Salonika,[4] where, partly though not wholly due to the technique, the abstraction is even more forceful, i.e. the eyes even more wide-open and staring. Kitzinger related our saints to the frescoes in S. Saba in Rome from the early eighth century ("Icons," fig. 10a–b) and Lazarev to the frescoes of S. Quirico and S. Giulitta in S. Maria Antiqua dated between 741 and 752. In both cases a comparison is difficult since the considerable sensibility and refinement of our icon is absent in the frescoes, where the comparable heads look more stylized. In the light of our various comparisons it would seem that Ainalov's date in the sixth century, based chiefly on a comparison with the Justinian mosaic in S. Vitale in Ravenna, a date suggested also by Wulff and Alpatoff, is too early and that Lazarev's date in the eighth century is too late. The seventh-century date proposed when Strzygowski first published the icon, and concurred in by Kondakov, seems to me to have the greatest probability.

Constantinople is by far the most likely place of origin because of the many stylistic and technical features linking the icon with the Christ and Virgin icons of Sinai.[5] But even before these other icons had become known, Ainalov had ascribed the Sergius and Bacchus icon to the capital mainly on the strength of its high quality. Others, like Strzygowski and Felicetti-Liebenfels, have proposed Syria, respectively the Christian Orient, in part on iconographical grounds because of the Christ type which had conventionally—but as explained above unjustifiably—been called Syro-Palaestinian, and partly for geographical reasons. Felicetti-Liebenfels had pointed to the famous Sergius and Bacchus

Church in Bosra, erected in 511, from which region he supposed our icon to have come, but by the same reasoning one could of course point to the famous church of these two martyrs erected between 527 and 536 by Justinian and Theodora in Constantinople. Sergius and Bacchus were very popular saints, however, and there is no basis for ascribing the icon to any of the many churches dedicated to them. Most scholars, beginning with Strzygowski and Ainalov, have related our icon to the mummy portraits of the Fayyum, more on the basis of the technique—which, however, was not, as often assumed, confined to Egypt—than on the basis of the style in particular, and there seems to be no cogent reason to ascribe the Kiev icon to Egypt.

Bibl.

Uspensky, *Втор. Пут.*, p. 164.
J. Strzygowski, "Zwei enkaustische Heiligenbilder vom Sinai," *Byzantinische Denkmäler*, Vienna 1891, pp. 117, 120–122.
Idem, *Orient oder Rom*, Leipzig 1901, pp. 123ff. and fig. 47.
Ainalov, *Эллинистические основы Византийского искусства*, S. Petersburg 1900, p. 155 (in English: *The Hellenistic Origins of Byzantine Art*, ed. C. Mango, New Brunswick 1961, p. 210 and fig. 101).
Idem, "Син. Ик.," pp. 352 ff. and pl. III.
Kondakov, *Памят.*, 124ff. and fig. 52.
N. P. Likhachev, *Материалы для Истории Русского Иконописания*, Atlas, St. Petersburg 1906, pl. II.
A. Muñoz, *L'Art byzantin à l'Exposition de Grottaferrata*, Rome 1906, p. 13 and fig. 4.
O. M. Dalton, *Byzantine Art and Archaeology*, Oxford 1911, pp. 316–317.
W. de Grüneisen, *Le Portrait, traditions hellénistiques et influences orientales*, Rome 1911, p. 61 and pl. VIII.
Petrov, *Альбом*, p. 7 no. 2 and pl. 3.
Wulff and Alpatoff, *Denkmäler*, pp. 11ff. and fig. 3.
A. Grabar, *Martyrium*, Paris 1946, II, p. 26; III, pl. LX, 1.
Lazarev, *История*, pp. 71, 296.
Kitzinger, "Icons," p. 139 n. 26 and pl. XXI, 9.
Felicetti-Liebenfels, *Byz. Ik.*, p. 24 and pl. 30A.
A. Grabar, *L'Iconoclasme byzantin*, Paris 1957, p. 81 and fig. 71.
Kiev Museum Catalogue, p. 22 and fig. 5 (with some additional bibliography).
Banck, *Byz. Art*, pp. 115, 351 and figs. 113–114 (in color).
A. Grabar, *Byzantium from the Death of Theodosius to the Rise of Islam*, London 1966, p. 186 and fig. 201.
Lazarev, *Storia*, p. 93.
W. F. Volbach, *Byzanz und der Christliche Osten*, Propyläen Kunstgeschichte III, Berlin 1968, p. 179 and pl. 42.
A. Grabar, *L'Art de la fin de l'antiquité et du moyen âge*, Paris 1968, I, p. 611 and III, pl. 150b.

[4] A. Grabar, *Byzantine Painting*, Skira, 1953, color plate p. 48.

[5] For the various arguments which led to an attribution of these two icons to the capital, cf. pp. 15 and 21.

B.10. ICON. PLATES XIII AND LV–LVI
ASCENSION OF CRIST
SIXTH CENTURY
GALLERY. GLASS CASE

H. 45.7 cm; W. 29.5 cm. The icon is 1.5 cm without and 2.5 cm with its red frame, cut from the same piece of wood. At the left and right the frame has grooves along its inner side to hold a sliding lid which could be inserted from the top where the frame is recessed. This device indicates that the icon was meant to be portable and consequently was privately owned. It has split vertically into two parts, held together by a metal clamp in the center and two wires at the top and bottom, both of which have, however, been removed by the most recent restoration of Tassos Margaritoff. As the result of this split a considerable area of the rather thick layers of encaustic paint has flaked at either side, so that most of the figure of Christ, the entire figure of the Virgin with the exception of a small strip at the left, three Apostles of the group at the right and the major part of a fourth are lost. In modern times Pater Pachomios repainted the missing parts directly on the bare wood with oil colors without restoring the gesso ground or retouching the old parts, so that the old and new areas are clearly defined. The old surface has suffered from rubbing and has a dense craquelure, especially in the gold ground.

The largest intact area comprises the six Apostles at the lower left. They are all clad in white tunics with folds of a light steel color and white mantles with brown folds, the same colors that are used in what is left of the Apostle group at the right. Next to the Virgin stands Paul, bald-headed and with a full brown beard; his feet and the lower part of his tunic have been restored but otherwise his figure is original and his vivid pose, which suggests that he is shrinking under the impact of the vision, makes him the most important among the Apostles. Of the two youthful Apostles behind him, the first holds his right arm in the sling of his mantle, a quiet pose in contrast to that of Paul. The Apostle at the extreme left energetically raises his arm towards the ascending Christ. This pose is repeated by the first Apostle in the second row who is to be identified by his dishevelled white hair and white beard as St. Andrew, the only Apostle who, in addition to Peter and Paul, is individualized in Early Christian art. Whether the second Apostle

was bearded cannot be ascertained but the third one has a brown rounded beard. Of the group at the right, only the one nearest the frame is original. He looks up to Christ and his youthful face seems to have a downy beard; his left hand is hidden under his mantle while his excessively big right hand makes a gesture of surprise. The Apostle above looks down to him while raising his arm and pointing to the ascending Christ. Of a third Apostle only the youthful head and part of the left shoulder are preserved. The Apostles are nimbed with haloes simply marked by a double line incised on the gold ground. The outer Apostles overlap a dark blue border surrounding the gold ground. Originally St. Peter surely stood to the left of the Virgin, and the youthful Apostle now in that place is not the only error made by Pachomios.

Between Paul and the frontal Virgin with her hands before her breast in a gesture of prayer there is, overlapping the left shoulder of Paul, a piece of blue drapery that obviously could have belonged neither to Paul nor to a frontal Virgin. The only possible explanation is that the original Virgin was depicted in profile to the left and that she raised her veiled hands and looked up to the ascending Christ. Such a Virgin type occurs, although in mirror reversal, in the Ascension miniature of the Chloudov Psalter in Moscow (fig. 12), a manuscript of the ninth century.[1] The Virgin's original appearance in profile in our icon is confirmed by an almost obscured detail: within the small segment of the Virgin's nimbus can be discerned the chin and the slightly parted red lips of the original head, turned to the left and slightly upward.

Also very little is left of the original paint of the Christ in the mandorla. Preserved are the right blessing hand which reaches beyond the dark blue mandorla, the left hand holding a scroll that rests on Christ's left thigh, a piece of the mantle which seems to have been brown and certainly had dense gold striation for the highlights, and finally a piece of the gold nimbus. The head and almost the whole body of Christ are restored and it can no longer be determined whether he had originally been seated on a throne or a rainbow, although the latter seems more likely in view of the narrowness of the mandorla. On the other hand, almost completely intact are the four flying angels lifting up the mandorla. Like the Apostles, they wear white tunics with steel-colored folds and white fluttering mantles with brown

[1] N. P. Kondakov, Миніатюры греческой рукописи псалтири девятого вѣка изъ собранія А. И. Хлудова въ Москвѣ, Moscow 1878; Weitzmann, Byz. Buchmalerei, pp. 55–56 and pls. LXI–LXII (here the older bibliography); Lazarev, История, pp. 72–73, 88, 297 and pl. VII;

A. Grabar, "Quelques Notes sur les psautiers illustrés byzantins du IXe siècle," Cah. arch. XV, 1965, pp. 61ff.; Lazarev, Storia, p. 116 and fig. 88.

folds. The wings have both colors, steel blue and brown. There is great elegance in the movement of the angels as they throw back their heads.

The closest iconographic parallels are the ampullae of Monza and Bobbio[2] on which the Ascension occurs several times with slight variations; variations, however, no greater than those between this group of ampullae and our icon, and there can be little doubt that all of them reflect a common archetype. Most striking is the shrinking pose of Paul which finds its parallel in ampulla I (fig. 13).[3] There is only the slight variation that Paul's right arm is held down and touches his thigh in the icon, while in the ampulla it is raised in a gesture of astonishment. However, in the ampulla the identity of this Apostle as Paul, in spite of the close agreement of the pose, is by no means certain. The hair covering most of the forehead speaks rather for Peter. That the Apostles at the extreme left and right of the icon point upward has its parallel in ampulla x,[4] although there they gesture less energetically: in general, the figures in the painting are more expressive than in the rather commercially produced silver phials. In this same ampulla St. Andrew is clearly characterized as in the icon by his dishevelled hair, but instead of being behind Paul he is in the center of the second row of the group of Apostles on the left. In the ampullae xiv and xvi[5] attention is centered on the Virgin in profile with raised arms and in a very vivid pose, although her expressive hands are uncovered. As mentioned before, it is not clear in the icon whether Christ had been seated on a throne or on a rainbow. Here the ampullae are of no assistance; although the Christ on the throne occurs much more frequently, ampulla II[6] represents Christ on a rainbow. As far as the flying angels are concerned, most ampullae render only the two lower ones in full length whereas the upper ones protrude from behind the mandorla, yet

ampulla XI[7] has all four in full length just as in the icon, and this, there can be little doubt, reflects the archetype.

There are only two details that are not paralleled in the ampullae: the veiling of the Virgin's hand and the scroll in Christ's hand, since on the ampullae he always holds a codex. Yet both these features are found in the miniature of the Chloudov Psalter (fig. 12), although the scroll is held somewhat differently and the Virgin is in mirror reversal.

The connection with the ampullae, souvenirs of the holy places, brings our icon into the orbit of Jerusalem, not only iconographically but also stylistically. The closest stylistic parallel is a reliquary box in the treasure of the Sancta Sanctorum in Rome (fig. 14),[8] on whose painted lid we encounter the same figure style, though somewhat coarser, and especially the same facial expression with the sideward glance, effected by the sharp white and black dots for the eyeball and the pupil. Yet our icon stands much more directly in the "impressionistic" tradition of classical antiquity and may therefore be somewhat earlier in date. The reliquary casket has with good reason been dated in the seventh century and thus our icon may have been produced in the sixth century and is, if we are not mistaken, the earliest of the numerous Palaestinian icons on Mount Sinai.

Bibl.

Sotiriou, *Icones* I, figs. 10–11; II, pp. 25–26.

K. Weitzmann, "The Survial of Mythological Representations in Early Christian and Byzantine Art and Their Impact on Christian Iconography," *D.O.P.* xiv, 1960, pp. 62ff. and fig. 35.

D. T. Rice, *Art of the Byzantine Era*, New York 1963, p. 40 and fig. 30.

K. Weitzmann, "Eine vorikonoklastische Ikone des Sinai mit der Darstellung des Chairete," *Tortulae. Studien zu altchristlichen und byzantinischen Monumenten, Röm. Quartalschrift*, 30. Suppl., 1966, p. 323 and pl. 82b.

Idem, "Loca Sancta," p. 43 and fig. 27.

[2] A. Grabar, *Les Ampoules de Terre Sainte*, Paris 1958, pp. 58–59.
[3] Ibid., pl. III.
[4] Ibid., pl. XVII. Weitzmann, "Loca Sancta," p. 43 and fig. 28.
[5] Grabar, *Ampoules*, pls. XXVII and XXIX. Weitzmann, "Loca Sancta" p. 43 and fig. 26.
[6] Grabar, *Ampoules*, pls. V and VII.
[7] Ibid., pls. XIX and XX.

[8] H. Grisar, *Die römische Kapelle Sancta Sanctorum*, Freiburg 1908, pp. 113ff. and fig. 59.; Wulff and Alpatoff, *Denkmäler*, pp. 33ff. and fig. 14; C. R. Morey, "The Painted Panel from the Sancta Sanctorum," *Festschrift Paul Clemen*, Düsseldorf 1926, pp. 151ff.; C. Cecchelli, I. Furlani, M. Salmi, *The Rabbula Gospels*, Olten and Lausanne 1959, fig. p. 34 (in color). Weitzmann, "Loca Sancta," p. 36 and passim, fig. 32.

B.11. (KIEV III) ICON. PLATES XIV AND LVII
ST. JOHN THE BAPTIST
ABOUT SIXTH CENTURY
KIEV, CITY MUSEUM OF EASTERN AND
WESTERN ART, NO. 113

H. 46.8 cm; W. 25.1 cm. The wood is quite thin, 5 mm at the edges to 6.7 mm in the center, and shows no warping,

an extremely rare feature shared by the icon of St. Peter no. B.5 and some other early icons. The lateral borders, originally as narrow as those preserved at the top and the bottom, are cut off, as is a thin strip of the painted ground at the right, no wider than the space between the Christ medallion at the upper left and the white framing line. The border, unpainted, indicates that the icon had a separately worked frame. In spite of two holes in the upper border, the

frame was not nailed to it, since such fastening would require holes also in the bottom border, where there are none. Moreover, there are two more holes at the sides within the painted area proper, which, like the upper two, point to a fastening of the icon onto some ground in a later period. Originally, as indicated by the narrowness of the border, the icon had a broad, grooved frame like the icons nos. B.1, 3 and 5 which extended considerably beyond the limits of the icon. There is no indication that, as Kondakov asserts (*Памят.*, p. 127), the icon had a gilded frame, and the fact that no gold is used elsewhere makes it highly unlikely. There is a deep crack and some splintering of wood at the top. Large areas of the paint have flaked off and, since no gesso was used, the bare wood shows in many places. There are no later overpaintings and the restoration by Kirikov in 1958 is confined to a consolidation. This is one of the four early icons that Porphyry Uspensky brought to Kiev in the middle of the nineteenth century from Sinai. Until the revolution it was in the Ecclesiastical Academy of Kiev, then in the Kiev Central Antireligious Museum and in 1940 it was transferred to the present museum.

John the Baptist, standing frontally, is dressed in a long brown tunic with violet clavi and a himation of the same color, both highlighted by yellow strokes. The himation is thrown over the left shoulder, reappears under the right elbow and is taken over the left arm in such a way that there can be seen a black girdle, studded with dots that may suggest metal buttons. Above the tunic but underneath the wide himation John wears the melote, a cape of sheepskin, which is fastened in a knot over the chest and falls freely from the back, visible underneath the right elbow, but largely flaked so that its full size can no longer be determined. It is painted in grey and olive with white highlights in a very fluffy and realistic manner. Both the girdle with the metal mounts and the sheepskin are attributes of a desert hermit and are used also to characterize Elijah as we see him in the Sinai mosaic.[1] In the face of John a grey olive is the dominating flesh color, augmented by brown strokes to mark the wrinkles and by sharp white highlights, whereas the flesh color of his arm and hands is light pink, outlined in a dark red. Thick hair in brown and black falls down upon his forehead and onto his shoulders and he has a shaggy beard. His feet are shod in black sandals.

The right arm is raised, but the hand is mostly lost. Yet one can justifiably assume that the original gesture was like

that of John the Baptist on the Maximianus Cathedra in Ravenna, who raises the index finger while the third and fourth fingers are bent to touch the thumb (fig. 15).[2] In his left hand John holds an open scroll curled up at its end which has written in red majuscule the familiar text John 1:29: + Є[ΙΔΕ] Ο |ΑΜ[ΝΟ]C |ΤΟΥ [ΘΕΟ]Υ Ο|[ΑΙΡѠ]Ν | [ΤΗΝ] Α|[ΜΑ]ΡΤΙ|[ΑΝ] ΤΟΥ |ΚΟC-ΜΟΥ.

In the two upper corners are medallions of Christ and the Virgin, both of whom look down towards John. Christ is dressed in light purple garments with a yellow brown clavus and the Virgin is dressed in a maphorion of the same light purple. In contrast to the drab flesh color of John, that of Christ and the Virgin is yellow brown with white highlights, and Christ's face is framed by brown and black hair and a short beard. All three figures have yellow nimbi of varying shades, and Christ's nimbus has the cross marked by brown double lines which extend, as not infrequently in Early Christian art, beyond the halo's circumference. A dark blue line at the left side of John's nimbus must be understood as a shadow since no such dark color is visible at the other side, a detail that clearly is a survival of classical painterly technique also observable in other details. Another shadowlike area is the dark brown triangle between the scroll, tunic, and himation which must be understood as the himation's inner side. The changes in the background from dark to lighter blue with strokes of light passing through it suggest the kind of illusionistic treatment of the background that occurs in some miniatures of the Vienna Genesis,[3] but because of extensive flaking the effect of this luminous technique can no longer be fully appreciated. Moreover, John stands on a grey, curved piece of ground above which there are two strips of olive color and a larger area of brown violet, but these colors cannot be clearly related to specific elements of landscape.

Although John is facing the spectator, he is not looking at him, for his head is turned to the left and his eyes are slightly lifted toward Christ to whom his raised hand is pointing. Although their eyes do not meet, one is aware of a contact between them. This implies a narrative content which is somewhat obscured by the fact that John is made the dominating figure in order to make this his icon, while Christ is reduced to a medallion bust. With John 1:29 begins the pericope read on January 7, the feast of the σύναξις τοῦ προδρόμου καὶ βαπτιστοῦ ἰωάννου, and one narrative

[1] Clearly visible in the color reproduction in K. Weitzmann, "Mount Sinai's Holy Treasures," *National Geographic* 125, no. 1, 1964, pl. 109. K. Weitzmann, "Introduction to the Mosaics and Monumental Paintings," in: G. H. Forsyth and K. Weitzmann,

The Monastery of St. Catherine at Mount Sinai. The Church and Fortress of Justinian. Plates. Ann Arbor 1973, pls. CVI and CXLII.

[2] C. Cecchelli, *La Cattedra di Massimiano*, Rome 1936–1944, pl. XIV.

[3] Cf. especially the miniature with the blessing of Ephraim and Manasseh; H. Gerstinger, *Die Wiener Genesis*, Vienna 1931, pict. 45.

illustration of it, in the eleventh century lectionary of Dionysiu, cod. 587 (fig. 16)[4] shows John pointing, though in the opposite direction, at Christ with two disciples, while on the left there is a group of Pharisees to whom John points out the Lamb of God. From such a narrative composition our icon must ultimately derive. Ainalov and other Russian scholars have repeatedly pointed to the John of the Maximianus Cathedra (fig. 15) as the closest parallel, chiefly because of the similarity of the raised, pointing hand. Such a gesture, however, requires a Christ above, whose loss in the ivory is a further reduction of the narrative content, actually to such a degree that the gesture has become obscure. It was only logical that the carver would turn John's head toward the beholder, thereby departing even further from the original narrative. It is true that both figures of John have the melote, the sheepskin knotted over the breast, but otherwise the connection is not quite so close as has been suggested: in the ivory John holds the disk with the lamb instead of the open scroll, he lacks the himation, and there is no contrappostal stance. In some respects our figure of John is, iconographically, closer to that of the mosaic icon in the Patriarchate of Istanbul,[5] although the latter is hardly earlier than the eleventh century. In this icon John likewise holds the open scroll with the same verse, and his right hand, raised in the same gesture as in the Ravenna ivory, points at a bust of Christ of which, however, only the extended right hand is preserved emerging out of a segment of sky. The style of this mosaic icon has, of course, changed, but like the Kiev icon it has maintained elements of the narrative tradition.

However, I know of no parallel where the bust of the Virgin is associated with this scene. Wulff and Alpatoff have explained it as a mere formal addition for reasons of symmetry, an explanation which a priori seems questionable. More likely, there is a liturgical reason for it. Christ, the Virgin, and John the Baptist appear together in the Deesis, i.e. the prayer of intercession in the liturgy, a subject that began to take a pictorial form at approximately the same time our icon was painted. The earliest known example of a Deesis is the mosaic of the triumphal arch in the church of the Sinai monastery which can be dated in the sixth century.[6] In neither the icon nor the mosaic have we yet the established canonical form of the tenth century,

according to which Christ, seated or standing in the center, is flanked by the Virgin and John. Yet our icon has two features in common with the mosaic, one formal and one conceptual. In each case the flanking figures take the form of medallions, and in the Sinai mosaic the medallions of John and the Virgin flank not a figure of Christ but of the Lamb of God, at which the inscription of the scroll in our icon hints. Conceptually, in each case, both John the Baptist and the Virgin are present because of their common roles as the chief intercessors.

Stylistically the icon is closely connected with the classical tradition in several ways. First, the relaxed stance and the torsion of the figure reveal a freedom of movement soon to be superseded by a more rigid frontality. Secondly, the treatment of the highlights, by the irregularity of their lines, gives an impression of fleeting light. And thirdly, one is struck by the realism of John's face. With its swollen eyelids, sagging bags under the eyes, the thick hair casting a shadow over the low forehead, it is a lifelike image of a hermit of the desert. Moreover, there is an expression of suffering in the oblique eyes to be found similarly in the medallion bust of John the Baptist in the Sinai mosaic, which, apparently, was inspired by a tragic mask,[7] a most proper model for the tragic prophet. The face of John is, doubtlessly, more elaborate and more carefully executed than the almost sketchily treated drapery. Ainalov ("Син. Ик." pp. 374f.) drew the parallel with mummy portraits on the one hand and the work process in mosaic decoration on the other, where the faces and the figures are often executed by different hands. However, it does not seem likely that in the case of the icon two painters were actually employed, since greater care in the execution of the heads is quite normal, even where only one artist was engaged.

Constantinople must, in my opinion, be excluded as the place of origin since the style lacks any relation to those icons nos. B.1–5 which for various reasons we attribute to the capital. Most scholars who have ventured to make a suggestion have proposed Egypt, primarily because of the encaustic technique of the icon, and its presumed relationship to encaustic mummy portraits. In addition, the parallel to the figure of John of the Maximianus Cathedra looms large in support of this attribution. But neither iconographically, as mentioned above, nor stylistically is this

[4] S. M. Pelekanides, P. C. Christou, Ch. Tsioumis, S. N. Kadas, *The Treasures of Mount Athos. Illuminated Manuscripts* I, Athens 1974 fig. 256.

[5] G. A. Sotiriou, Κειμήλια τοῦ Οἰκουμενικοῦ Πατριαρχείου, Athens 1937, pp. 24ff. and pls. 10–11.

[6] K. Weitzmann, "The Mosaic in St. Catherine's Monastary on

Mount Sinai," *Proc. Am. Phil. Soc.* CX, 1966, p. 402. Forsyth and Weitzmann, *op. cit.*, pls. CIII, CXXIII, CLXXIV-CLXXVII.

[7] K. Weitzmann, "The Classical in Byzantine Art as a Mode of Individual Expression," *Byzantine Art. An European Art. Lectures*, Athens 1966, p. 171 and figs. 132 and 134 (repr. in Weitzmann, *Studies*, p. 172 and figs. 153–154). Forsyth and Weitzmann, *op. cit.* pl. CXXIV.

connection close enough to establish a firm basis for an Egyptian and more specifically an Alexandrian attribution. Although the ascription of the Maximianus Cathedra itself to Egypt has been questioned, its ivory plaques, nevertheless, clearly show elements that can be associated with a group of ivories made in Egypt. With them the Cathedra ivories share a tendency toward straight outlines and, simultaneously, toward flattened bodies. These characteristic features can be observed even more clearly in the four standing Evangelists on a pair of book covers in the Freer Gallery in Washington;[8] for stylistic purposes, these offer a better basis for comparison since they are (1) encaustic paintings and (2) works of art whose Egyptian origin cannot be disputed. However, the very features that in the Freer covers are so typically Egyptian, i.e. the straight outlines, the flatness of the bodies, and a more decorative delineation of the folds of the garments, are absent in our icon. This raises doubts about the probability of the icon having come from Egypt, doubts implied in the most recent writings of A. Banck, and V. Lazarev.

Within the material of the Sinai icons there are some connections with the Apostles in the Ascension icon no. B.10, where we find a similar agility of movement, a comparable treatment of the irregular highlights (compared with those on the more patterned garments in the Freer covers), and especially the same sharp glances effected by the dotted iris and the white of the eyeball, clearly marked in the Christ and Virgin medallions of our icon. Since the Ascension icon, for stylistic as well as iconographical

reasons, has been attributed to Palaestine, I prefer Palaestine to Egypt as the place of origin of the John icon also. This ties in with our observation that the closest parallel to the impressionistic background is a miniature in the Vienna Genesis,[9] a sixth-century manuscript generally attributed to Syria-Palaestine, whereas the contemporary Cotton Genesis, generally considered to be Alexandrian, displays much more abstracted backgrounds in its miniatures.

As to the date, most scholars propose the sixth century while Wulff and Alpatov prefer a slightly earlier date, the turn from the fifth to the sixth century. If any icon possibly reaches back as far as the end of the fifth century, it is this John icon and it may well be the earliest one we have from Sinai, preceding the Ascension icon by a few decades.[10]

Bibl.

Uspensky, *Втор. Пут.*, p. 164.

Ainalov, "Син. Ик.", pp. 368ff and pl. v.

Kondakov, *Памят.*, pp. 127ff. and pl. xliv.

N. P. Likhachev, *Материалы для истории Русского Иконописанія*, Atlas, S. Petersburg 1906, pl. iii, no. 3.

O. M. Dalton, *Byzantine Art and Archaelogy*, Oxford 1911, pp. 316–317.

Petrov, *Альбом*, p. 9 and pl. 5.

Wulff and Alpatoff, *Denkmäler*, pp. 18f. and fig. 8.

Lazarev, *История*, p. 61.

Kitzinger, "Icons," p. 139 note 26.

Felicetti-Liebenfels, *Byz. Ik.*, p. 26 and pl. 31b.

Kiev Museum Catalogue, p. 20, no. 2 (with additional bibl.).

Banck, *Byz. Art*, pp. 296, 350 and pls. 111 (color) and 112.

Lazarev, *Storia*, pp. 92–93 and fig. 70.

W. F. Volbach, *Byzanz und der Christliche Osten*, Propyläen Kunstgeschichte iii, Berlin 1968, p. 179 and pl. xi (color).

[8] C. R. Morey, *East Christian Paintings in the Freer Collection*, New York 1914, pp. 63ff. and pls. xi–xiii.

[9] Cf. note 3.

[10] Kondakov (*Памят.*, p. 128) suggested that our icon was originally placed in the second row, i.e. the epistyle, of an iconostatis. This suggestion must be discarded, however, because there is no evidence that in the preiconoclastic period painted icons were ever used in the decoration of an iconostasis. According to V. Lazarev ("Trois fragments d'epistyles peintes et le templon byzantin," Δελτ. Χριστ. 'Αρχ. 'Εταιρείας, 1966, pp. 117ff.), such a usage did not occur before the thirteenth century.

B.12. ICON. PLATE LVIII
STANDING CHRIST
ABOUT SIXTH–SEVENTH CENTURIES
OLD LIBRARY

H. 38.3 cm; W. 20.2 cm; thickness 1.2 cm without, and 2.1 cm with frame. The frame consists of separate strips which are contemporary and painted dark purple. There was an inscription on the frame in white letters (cf. no. B.16)

of which only a few traces are visible at the upper right. While the surface in general is badly flaked in various places, the head appears to have been purposely scratched out, most likely by a pious Moslem, a fate that has befallen several Sinai icons. Yet there remains a narrow strip of the gold nimbus, with traces at the top of the upper bar of the nimbus cross, thereby identifying the figure as Christ.

Standing in frontal position, Christ raises his right hand turned outward in blessing, a gesture not infrequent in the

Christ of the Last Judgment. In his left hand he holds a Gospel book bound in brilliant red. He wears a blue tunic much darkened under varnish, with a clavus of the same bright red as the book, and a chlamys in ochre with carmine brown folds, a substitute for purple, the colors of both garments appropriate for Christ.

Most striking is the illusionistic landscape in which Christ stands. With an understanding for the change of color under atmospheric conditions, the artist follows the convention developed in classical art of dividing the background into three color zones. The green foreground consists of little hillocks on which grow plants, one of them with white blossoms. The middle zone is brown, and the

third, above Christ's shoulders, consists of blue mountain ridges with a few craggy peaks. The sharp highlights that mark the various mountain ridges give at first the false impression of water, but there can be little doubt that blue mountains are intended, for which the miniature of the Blessing of Joseph in the sixth-century Vienna Genesis provides a close parallel.[1] This miniature also has the characteristic three background zones of green, brown, and blue.

The painter had no strong sense of proportion: Christ's left arm and hand are considerably larger than his right arm and blessing hand. Moreover, it is apparent that the painter had first intended to design a smaller figure, because to the left and right of the hem of the tunic there appears a pair of smaller feet that could only belong to another smaller figure of Christ in the same pose, later replaced by the larger one. The execution of the whole icon is rather rough and reveals a quick manner, as seen, for instance, in the sketchy treatment of the highlights. Yet because of its clear understanding of the atmospheric landscape, the icon may still belong to the sixth century and can hardly be later than the seventh.

[1] H. Gerstinger, *Die Wiener Genesis*, Vienna 1931, p. 109 and pict. 45.

B.13. LEFT WING OF TRIPTYCH. PLATES XV
 AND LIX
ST. THEODORE
ABOUT SIXTH–SEVENTH CENTURIES
GALLERY. GLASS CASE

H. 25.6 cm; W. 7.1 cm. The right edge is rounded and the upper and lower right corners are broken where dowels once existed, providing evidence that we have here the left wing of a triptych. The surface in encaustic technique is somewhat rubbed, especially in the lower regions. The back is undecorated.

Standing frontally at ease is a soldier-saint who is identified by the inscription ΑΓΙΟΣ ΘΕΟΔⲰ [POC] in white letters on a dark grey ground set in a separate strip at the top of the plaque. He is dressed in golden armor with a floral design indicating the rank of a high officer. Of the much flaked garments the tunic seems to have been red and the mantle carmine, the trousers dark brown and the

leggings whitish. In his right hand he holds a black spear terminating in a cross and with his left he leans on a shield that is almost completely flaked. His thick black hair and black pointed beard are typical of Theodore Stratelates and his head is set against a gold nimbus. The fiery red of the background and groundstrip gives an intensely decorative effect.

When Theodore is depicted with another soldier-saint, it is usually St. George, whom we therefore suspect appeared on the lost right wing. Not in armor but in the costume of court officials they appear together in icon no. B.3, where they flank the Virgin enthroned with Child. Thus it could be surmised that also in this icon the missing central plaque contained a Virgin, though not necessarily of the same type.

Stylistically the figure deviates from the larger group of Sinai icons that we are inclined to localize in Palaestine. The proportions of the rather thick head, the wide-open eyes gazing at the spectator, are more typical of Egyptian painting. To these criteria may be added the similarity to an

almost contemporary little triptych wing in encaustic technique in Berlin, which comes from the Fayyum and depicts the busts of a female saint and of St. Theodore of a similar type, although with a shorter beard.[1] As in our icon, the inscription is on a separate strip above the head, and in both instances the figure is set against a red background.

[1] J. Strzygowski, *Eine Alexandrinische Weltchronik*, Vienna 1901, p. 197 and fig. 35; O. Wulff *Altchristliche Bildwerke. Beschreibung der Bildwerke der Christlichen Epochen* III, part 1, Berlin 1909, p. 301

Thus we believe an Egyptian origin for our triptych wing to be highly likely.

Bibl.

Sotiriou, *Icones* I, fig. 15; II, pp. 29–30.

no. 1606 and pl. LXXIII; Wulff and Alpatoff, *Denkmäler*, p. 15 and fig. 5 and p. 257.

B.14. CENTER OF A TRIPTYCH. PLATES XVI AND LX
ST. THEODORE AND THE DECANOS LEO
ABOUT SEVENTH CENTURY
GALLERY. GLASS CASE

H. 38.2 cm; W. 19.7 cm. As the result of a vertical split a major portion of the plaque to the left is lost. If the original composition contained only the two figures now visible, about a third of the plaque would be lost. However, the hole above the head of the saint, larger than the others, may have been made for a string or wire used to hang the icon on the wall. If this hole marks the middle of the plaque, then half of it must be lost. One would, in this case, have to assume the loss of another worshipping figure corresponding to the one preserved and likewise turning towards the central saint.

All around the border a strip was left unpainted. The strip at the top is considerably wider than the others and only the top and bottom strips have holes. These factors indicate that the plaque once formed the center of a triptych, the wings attached by means of dowels to ledges nailed upon the top and bottom. The encaustic paint has suffered badly from flaking and rubbing. The reverse of the rather coarse piece of wood (2 cm thick) is blank.

The once dominating figure, of which less than half is preserved, does not represent Christ, as the Sotirious believed, but a soldier-saint in frontal position leaning with his left hand upon a shield. The black hair and beard framing the face are typical of St. Theodore, and the figure resembles very closely the soldier-saint on icon no. B.13 who is thus inscribed. Our saint is dressed in a purple tunic with

[1] G. and M. Sotiriou, Ἡ Βασιλικὴ τοῦ Ἁγίου Δημητρίου Θεσσαλονίκης, Athens 1952, Album pls. 60–71.

long sleeves, ochre-colored armor (instead of gold) with blue leather strips, and a whitish chlamys with grey and carmine shades over the shoulder and a light blue shade at its inner lining. His left hand rests firmly on the edge of his shield of red and orange, and it is safe to assume that in the other hand he held a spear, as St. Theodore does in the other icon.

The considerably smaller figure to the right is dressed in a stylish secular costume. His lower garment is pale yellow with olive-colored folds; a pearl-studded purple border runs around the sleeves, the hem, the neck and down the chest, and the belt is also pearl studded. He wears around his shoulders a blue mantle with a pearl-studded black border, and his shoes are red. His large, youthful, pinkish face is framed by blond locks and set against a green, white-edged square nimbus, indicating that he is still among the living. His hands are held in a gesture of worship or supplication and at the same time, perhaps intentionally, touch St. Theodore's shield. The inscription in white letters reads, if our restoration is correct, ΛЄ[Ѡ ΔЄ]ΚΑΝΟC. We may therefore assume that Leo wears the kind of garment appropriate to his office of decanos. Thus we are dealing with a kind of votive panel similar to those in mosaic in St. Demetrius in Salonika.[1] They have essentially the same compositional layout as our icon and were thought to be reflections of lost painted icons long before the rather unique Sinai panel became known. Among the various mosaics in which St. Demetrius is worshipped by donors, the earliest one preserved especially invites comparison (fig. 17)[2] since in it two donors, a young man and a child, approach from the right and a third from the left with outstretched arms. Their hands are covered, and they are set in

[2] Idem, pl. 62.; A. Grabar, *L'Iconoclasme byzantin*, Paris 1957, pp. 85ff. and fig. 84.

a landscape, as is the Leo of our icon, who stands upon a light green strip of ground and whose square-nimbed head is set against dark green trees or plants, silhouetted against a light blue sky.

This comparison with the mosaics from Salonika may justify a similar date for the Sinai icon, i.e. not later than the seventh century, but it does not explain the style, which is rather rough and with weak proportions, especially in the oversized head and hand of the donor. At the same time the coloring is rich and the technique painterly, particularly in the tunic of Leo and the mantle of St. Theodore, and this speaks for a center in which the classical tradition still had

considerable force. The place of origin still needs to be determined.

If indeed the icon was, as we believe, the center of a triptych, what possibly could have been the subject of the missing wings? Our suggestion would be that each of them had an additional donor, presumably other members of Leo's family. When open, the proportions of the triptych and its composition would not have been unlike the Salonika mosaic described above.

Bibl.

Sotiriou, *Icones* I, fig. 16; II, p. 30.

B.15. (KIEV IV) ICON. PLATES XVII AND LXI
ST. PLATON AND UNIDENTIFIED
 FEMALE MARTYR
SIXTH–SEVENTH CENTURIES
KIEV, CITY MUSEUM OF EASTERN AND
 WESTERN ART. NO. 114

H. 54.2 cm; W. 48.6 cm; thickness 7–8 mm. Contrary to the rule for early icons, the frame is cut out of the same wood (said to be sycamore) as the icon proper and not made separately. The lateral and the lower sides of the frame are grooved and the top frame is mostly cut away to permit a sliding lid. In both these respects the icon finds a parallel in the Ascension icon no. B.10, indicating that both were designed to be portable and hence required special protection. Part of the panel at the right side, along the cheek of the female, has split off and is now replaced by a new piece of wood on which part of the long hair, the chlamys, and the background have, not too skillfully, been repainted with thin oil colors whereas the icon proper is painted in the encaustic technique. Moreover, the whole surface is very badly damaged. In a few spots, such as the area close to the bottom where the hands of both persons are almost gone, the entire layer of paint has flaked off, in others only portions of the top layers. In some places the brown gesso is visible, as e.g. in the upper half of the female's face and the left eye of the male. Furthermore, on both heads parts of the edges of the hair have flaked off, damage that makes the faces seem disproportionately large in relation to the sparse hair around them. As far as the general artistic impression is concerned, the greatest loss is that of large gilded areas of which only tiny bits are still visible, enabling one to

ascertain that the background, the nimbi, the cross between them, and the three rays issuing from above were solidly covered with gold. The nimbi, the cross, and the rays are still discernible, for they are rendered in slight relief, anticipating the later use of stucco for decorative background elements. It was customary to begin painting an icon by laying the gold and extending it slightly into the areas reserved for the figures. When the gold flaked off it apparently took with it portions of the overlying hair, and this explains the particular damage around the heads. During some restoration the eyes and the ridges of the noses were overpainted and some spots were filled with a neutral color, but although the original encaustic surface is untouched as a whole, it lacks the original freshness because a certain amount of the top pigments has flaked off. This is one of the four early icons that Porphyry Uspensky took to Russia from Mount Sinai and deposited in the Ecclesiastical Academy in Kiev. After the revolution it was for a time in the Kiev Central Antireligious Museum and in 1940 was transferred to the present museum.

The busts of two martyrs, characterized as such by the crosses they hold, are rendered side by side facing the spectator. Both wear carmine tunics with black shoulder patches decorated with golden stars whose points—eight in the left and six in the right star—end in white dots. For the sake of variation, the colors of the chlamys differ, that of the male saint being ochre and that of the female light grey green. Each chlamys is held by a simple round clasp in brown, meant to be the undertone for gold, and has a purple tablion of which the upper edge is visible. Each cross of martyrdom, depicted in a reddish brown which, quite assuredly, is meant to be the underpaint for gold, is held in

the right hand. The four arms of the crosses end in crossbars, a frequent occurrence in early crosses—as e.g. those in the hands of Sergius and Bacchus (no. B.9)—but in the present case they are unusually large and those of the female's cross end in black points. The whitish color of the martyrs' flesh is enlivened by yellow pink chiefly for the cheeks and the chin, and as usual some olive is used for shading, while the mat carmine of the mouth and the tip of the nose stands out. The almond-shaped eyes, with their round brown irises, sit very high in the face leaving little space for the forehead, which is largely covered by hair, the male's black and cropped and the female's blond and long.

Both saints have oval-shaped nimbi, recognizable merely by their raised ridge. This unusual form most likely resulted from lack of space, since it was the artist's design to place between the heads a large cross reaching down to the shoulders. This cross has unusually short arms which could not be fully developed because of the interfering nimbi. This is the well-known *crux gemmata*, whose pearls and cabochoned stones executed in low relief and painted in red and presumably also blue can still be made out.[1] From the very top three broad light beams descend upon the cross and the nimbi, enhancing greatly the symmetry and the hieratic effect.

At the top of the icon, set against the gold ground, is a dark blue strip serving as background for the inscription in white letters, which is unfortunately so damaged that only the name of the male saint can be made out with near certainty while that of the woman is too fragmentary to permit even speculation as to her identity. Petrov, earlier, proposed to identify the two saints as Constantine and Helen and to reconstruct the few letters accordingly. The *crux gemmata* between them makes this proposal seem quite convincing at first glance, but Strzygowski has already repudiated it with good reasons.[2] The two saints do not wear the imperial insignia and what can be read of the inscription also argues against this identification. Ainalov proposed two possible readings: + O ΑΓΙ [OC] ΠΛ[Α]ΤωΝ or ΠΑ[Μ]BωΝ. While there is a rather obscure saint by the name of Πάμβω, Platon is by far the better known of the two. Admittedly one can read only as much as O ΑΓΙ [OC] ΠΛ [ΑΤω]Ν and a remnant of the second to the last letter might well be part of an omega, but

the greater hagiographical probability of St. Platon can be supplemented by iconographical evidence. Platon was martyred at Ancyra under Galerius and his calendar day is November 18, at which date his image appears in several illustrated menologia. In one of them, codex 5 in the Athos monastery Dochiariu (fig. 18),[3] he is represented as a youth with dark hair, clad in a tunic with a shoulder patch and a chlamys, holding the cross of martyrdom precisely as the saint in our icon, whom I therefore no longer hesitate to identify as Platon of Ancyra.

The identity of the female martyr, however, remains a mystery. In the life of St. Platon there is no mention of any female who might have played an important role or have been martyred with him.[4] Nor is any female martyr, unrelated to St. Platon, known to have been martyred on the same day, November 18, so that she might, as occasionally happened, have been placed on the same icon simply because she shared the same calendar day. The Kiev icon was perhaps made for a church in which a female saint was venerated in addition to St. Platon. Whether there was such a church still remains to be determined. As Procopius tells us (I.IV.27), Justinian founded a martyrion dedicated to St. Platon; this was a much revered building but small and not likely to have been shared by any other saint.

From what little we know about icon painting of the capital, the style does not seem to point to Constantinople. Yet the icon is not without artistic merit. The composition is quite well balanced and there is a serious attempt toward psychological differentiation, as Platon looks straight into the beholder's eyes while the female saint turns her head towards him, suggesting a degree of human attachment. What distinguishes this icon from the others I have attributed to Constantinople is the unnaturalness of its facial proportions: the eyes and the cheekbones are set much too high in the faces and the noses are too elongated. These features become especially clear when we compare the Sergius and Bacchus icon no. B.9, in which the organic structure of the human bodies and therefore the heritage of the classical tradition are clearly felt in spite of the greater stylization of the poses. At the same time, the Platon icon, despite the insecurity of its facial proportions, does not seem to be later than the Sergius and Bacchus icon, an opinion shared by Kitzinger, Banck, and others. On the

[1] For a discussion of it in connection with our icon, cf. Strzygowski, *Byzantinische Denkmäler*, pp. 129ff.

[2] Op. cit., p. 118.

[3] Only a few miniatures of this manuscript have so far been published. H. Brockhaus, *Die Kunst in den Athosklöstern*, Leipzig 1891, p. 229 and pl. 27; G. Millet, "La Vision de Pierre d'Alexandrie,"

Mélanges Diehl II, Paris 1930, p. 105 and pl. IV; F. Dölger, *Mönchsland Athos*, Munich 1943, p. 174 and fig. 95; S. Der Nersessian, *Late Classical and Medieval Studies in Honor of A. M. Friend, Jr.*, Princeton 1955, p. 227 and pl. XXIV, 4.

[4] Migne, *P. G.* 115, cols. 404ff.

contrary, the human quality as expressed especially in the slightly inclined head of the female, the softness and greater fleshiness of both faces, are more in the tradition of the St. George figure in the Virgin icon no. B.3. Furthermore, the figure of the female saint overlaps that of St. Platon, revealing a sense of spatial depth absent in the Sergius and Bacchus icon and clearly a heritage of the classical tradition. In other words, the differences in the Platon icon are to be attributed not to a later date but rather to a different place of origin. The long noses, high-set eyes, and correspondingly low foreheads one finds, although less strongly pronounced, in some of the icons we have attributed to the Palaestinian school, such as the Virgin and John under the cross in icon no. B.36, the Virgin no. B.40, and St. Irene no. B.39. But all these are somewhat later, and our icon perhaps represents an earlier stage within this local group.

In this connection I should like to point to a small ornamental motif that is a kind of workshop device—the rosettelike star used as decoration for the shoulder patches. Such rosette stars do appear as a pair in the sky of the Constantinopolitan Christ icon no. B.1, but occur more frequently, mixed with other simplified rosette patterns formed of mere dots, in the Palaestinian group where they fill not only the sky in a *horror vacui* (cf. nos. B.29 and 30), but form an allover pattern in the garments (nos. B.31, 40, 41). As a pattern for a shoulder patch, the rosette does not appear on any embroidered chiton of a work of art connected with Constantinople, while it fits into our group of Palaestinian icons. Admittedly these are only hints and I am not prepared to ascribe the Platon icon with certainty to Palaestine, but rather prefer to leave this attribution within the realm of probability. There may, of course, have been other centers producing encaustic icons, although Palaestine always remains a first choice where Sinai is concerned because of the monastery's close relations with Jerusalem. Strzygowski (*Orient oder Rom*, p. 123) points to a Coptic textile[5] as closely related and implies thereby the possibility of an Egyptian origin for our icon. As to its date, Ainalov proposed the sixth century while I prefer to place it between the Virgin icon no. B.3 and the Sergius and Bacchus icon no. B.9, leaving open the question of whether it belongs to the sixth or to the seventh century.

[5] R. Forrer, *Die Graeber- und Textilfunde von Achmim-Panopolis*, Strassburg 1891, pl. XVI.

This Kiev panel is the earliest example of a group portrait in bust form in the history of icon painting and, as such, is in the direct lineage of prototypes from classical antiquity where this form was quite common. Ainalov (p. 346) compared it with the well-known portrait busts from Pompeii depicting the baker Paquius Proculus and his wife.[6] Certain features that the icon shares with the Pompeian fresco, such as the placing of the female forward and overlapping the male, and the turning of her head towards him as a sign of affection while he looks straight ahead, derive ultimately from a similar early archetype. Here the icon painter obviously perpetuates traditional formulae. The assumption of Wulff and Alpatoff that we have in the Kiev icon either brother and sister or a couple is hardly justified, and whatever element of human relation survives in the icon derives from the prototype rather than from the relationship between the two martyrs. Their flat and thus dematerialized bodies, their more conventional behavior, their staring open eyes and their setting against a gold ground which stresses the hieratic nature of the icon have in large measure succeeded in offsetting what remained of the humanizing element; it would soon, as in the Sergius and Bacchus icon, be lost entirely.

Bibl.

Uspensky, *Втор. Пут.*, p. 164.
J. Strzygowski, "Zwei enkaustische Heiligenbilder vom Sinai," *Byzantinische Denkmäler* I, Vienna 1891, pp. 115ff. and pl. VIII.
Idem, *Orient oder Rom*, Leipzig 1901, p. 123.
Ainalov, "Син. Ик.", p. 344 and pl. I.
Kondakov, *Памят.*, pp. 124–125.
N. P. Likhachev, *Матеріалы для Исторіи Русского иконописания*, Atlas, S. Petersburg 1906, pl. I.
A. Muñoz, *L'Art byzantin à l'exposition de Grottaferrata*, Rome 1906, p. 12 and fig. 3.
O. M. Dalton, *Byzantine Art and Archaeology*, Oxford 1911, pp. 316–317.
W. de Grüneisen, *Le Portrait, traditions hellénistiques et influences orientales*, Rome 1911, p 61 and fig. 73.
Petrov, *Альбом*, p. 6 no. 1 and pl. 2.
Wulff and Alpatoff, *Denkmäler*, p. 8 and fig. 2.
Lazarev, *История*, pp. 71, 296.
Kitzinger, "Icons," p. 139, no. 26.
Felicetti-Liebenfels, *Byz. Ik.*, p. 23 and pl. 30B.
Kiev Museum Catalogue, p. 22 and fig. 4 (here additional bibliography).
Banck, *Byz. Art*, pp. 296, 351 and pl. 115.
Lazarev, *Storia*, p. 93.

[6] L. Curtius, *Die Wandmalerei Pompejis*, Leipzig 1929, pl. XII (in color).

B.16. ICON. PLATES XVIII AND LXII–LXIII
CHRIST ENTHRONED
ABOUT SEVENTH CENTURY
GALLERY

H. 76 cm; W. 53.5 cm. The icon is rather thick (2.3 cm) and has a slightly raised frame. Upon this another frame of four separate pieces of wood (2.7 cm thick) is nailed. With the exception of the bottom strip, it must be contemporary because the inner edge of both frames is painted the same red and adorned with the same yellow dots as the border of Christ's nimbus. In a number of places the encaustic paint is entirely gone revealing the bare wood. This is true of most of the nimbus, a portion of the mandorla above Christ's blessing hand, his left knee, the major part of the open book, almost the whole background in three of the four spandrels, and minor spots elsewhere. In addition, the surface has lost a good deal of the topmost layer of pigment. Of the inscription on the right side of the frame only a few letters remain; whether it extended originally across the bottom is uncertain because this piece of wood has been replaced. The back is blank and rather roughly carved.

Christ enthroned is clad in an undergarment with long sleeves, a tunic with red clavi and a himation—all three ochre colored with chestnut-colored folds crossing the body in a firm and clear design. Highlights in the form of dense gold striation once covered the whole surface of all three garments, but most of the gold has come off. Only over the left shoulder and below the right knee is it comparatively well preserved. The right blessing arm is thrust out and the left hand holds the open Gospel book resting upon the left knee. On the book the usual verse, John VIII:12, was inscribed, as indicated by a few legible letters in black on white ground: + Є[ΓѠ Є]IM[I ΤΟ ΦѠC ΤΟV KOCMOV]. Christ's head is set against a yellow nimbus with a black cross and a broad red border with yellow dots. In so far as the pose is concerned, the Christ is the type of the Pantocrator. However, not in conformity with this type are the white hair and beard framing the chalky white and reddish face with its very pronounced cherry red lips. The white-haired Christ is the "Ancient of Days" (Dan. VII:7 and 22). This type of Christ, however, is not in accord with the inscription + Є[MMA]NOVHΛ, which calls pictorially for a very youthful Christ. The inscription is in gold letters set among the gold stars that fill the dark blue

aureola (in both instances little is left of the original gold). We are presented here with three manifestations of Christ: the Ancient of Days, representing the Christ from All Eternity, the Pantocrator, the Ruler of the World, and the Immanuel, the Incarnate Logos. There is an eleventh-century miniature in the Paris Gospel book, cod. gr. 74 (fig. 19),[1] which has, in addition to the author portrait of St. John, three separate medallions with precisely the same three manifestations of Christ. The first is merely inscribed \overline{IC} \overline{XC} signifying the Pantocrator, the second ὁ παλαιὸ(ς) ἡμε(ρῶν) and the third ἐμμα(ν)ουή(λ). Our icon can thus be understood as a conflation of three originally independent types.

Similar conflations of the manifestations of Christ occur elsewhere in Byzantine monuments of various media and periods. The coins of John Tzimisces show a Pantocrator bust with the double inscription \overline{IC} \overline{XC} and ЄMMANOVHΛ.[2] This type has repeatedly, though not quite correctly, been described as a "bearded Immanuel;" it would be more precise to speak of a "Christ of two manifestations." Since the concept of the coin is so similar to that of our icon, one might ask whether the icon type may not have been the ultimate source of the coin. That such a conflation of the "Ancient of Days" with the Pantocrator had taken place already in Early Christian art prior to our icon is suggested by an ivory plaque in Berlin from the early sixth century (fig. 20)[3] where an enthroned Pantocrator is obviously represented with unusually long hair and beard and the general features of an old man.[4]

In the Sinai icon Christ, in illustration of Isaiah LXVI:1, "The heaven is my throne and the earth is my footstool," is seated upon a brightly colored rainbow outlined in white and his feet rest on a partially visible sphere marked by white striation. Around the mandorla are four creatures who are characterized as cherubim in accordance with Ezekiel X:12: " ... and their wings ... were full of eyes round about...." Only the one in the upper left is fairly well preserved. His human head, with its dark hair bound in a fillet, emerges from a pair of green wings with white striated highlights and red eyes. At the upper right, a bold curved outline and brush strokes indicating neck feathers leave no doubt that this is a representation of the eagle. Consequently one would expect to find below, in the zone that now is almost totally destroyed, the heads of the lion and the ox set on similar pairs of wings.

[1] H. Omont, *Evangiles avec peintures byzantines du XIe siècle* II, Paris (n.d.), pl. 142; E. H. Kantorowicz, "Puer exoriens," *Selected Studies*, New York 1965, p. 33 and pl. 11 fig. 2.

[2] J. Sabatier, *Description générale des monnaies byzantines* II, Paris

1862, pl. XLVIII.

[3] F. Volbach, *Elfenb.*, p. 67 no. 137 and pl. 42.

[4] O. Wulff, *Altchristliche und byzantinische Kunst* I, Berlin 1918, p. 195 and fig. 198, characterizes the Christ as "greisenhaft."

While chapter x:14 mentions a different set of faces (a cherub instead of the ox), one must turn to chapter I:10 to find the generally accepted set of the four.

The upper two cherubim compare quite well with those that surround Christ in the mandorla in Coptic frescoes, a close parallel being the fresco of chapel XVII in Bawit.[5] The angel's face in three-quarter view as well as the eagle's head in straight profile turned to the right are very similar indeed, but the most basic difference is the placing of the heads: in the Coptic fresco they are in the center of a cloudlike wing formation with which they are not anatomically connected, whereas in the icon the heads sit organically upon pairs of wings. One finds this more naturalistic concept in the mosaic of Hosios David in Salonika from the fifth century,[6] and in this respect our icon is rooted more deeply in the Byzantine than the Coptic tradition. Moreover, in the detailed representation of the Vision of Ezekiel found in most of the Coptic frescoes and the Ascension miniature of the Rabula Gospels of 586 A.D., wheels of fire are depicted.[7] In the frescoes of Bawit this motif is much reduced, while in the Salonika mosaic it is missing altogether. Although the bottom of the icon is much destroyed, there does not seem to have been enough space for the depiction of the wheels, and thus we presume that they never existed here. In this respect, then, the icon follows the older Greek rather than the Coptic tradition. In every respect the icon is a striking example of a rather simple composition filled with great complexity of content. Combined are three manifestations of Christ, one of them based on Daniel, and the elements of two further prophetic visions (Isaiah and Ezekiel).

[5] M. J. Clédat, Le Monastère et la nécropole de Baouit (Mémoires. L'Institut français d'archéologie orientale du Caire XII), Cairo 1904, pls. XLI–XLIII.

[6] W. F. Volbach, Early Christian Art, New York 1961, pls. 134–135 (in color); W. F. Volbach and J. Lafontaine-Dosogne, Byzanz und der Christliche Osten. Propyläen Kunstgeschichte III, Berlin 1968, pl. 2 and p. 166 (here further bibliography).

The inscription on the frame, in white capital letters on blue ground reads: ΗΠΕΡ (sic) CΟΤΗΡΙΑC (sic) ΚΑΙ ΑΦΕCΕΟ (sic)|[C Α]ΜΑΡΤΙΟΝ (sic) [. . . ΤΟΥ ΔΟΥ] ΛΟΥ CΟΥ ΦΙΛΟΧΡΙCΤΟΥ.

For the style of the icon no precise parallels have so far been found. On the one hand it is not as painterly as the early masterpieces (nos. B.1–5) attributed to Constantinople, and on the other it shows none of the trademarks of the Palaestinian group, being rather better in quality than these. Moreover such a characteristic element as the dense gold striation of Christ's garment helps to determine neither the date nor place of origin, since this technique occurs with similar intensity on the gala dress of Juliana Anicia in the Vienna Dioscurides, a Constantinopolitan manuscript of the early sixth century,[8] i.e. earlier than our icon and belonging to the more painterly tradition of the capital. Mr. Chatzidakis saw similarities between our icon and the fragment of an Immanuel icon in the Benaki Museum of Athens that surely is of Egyptian origin.[9] Thus an Egyptian origin for our icon must be considered a possibility, although the connections are not strong enough for proof and iconographically there is a stronger connection with the Greek than with the Coptic tradition. For the date we propose the seventh century.

Bibl.

Sotiriou, *Icones* I, figs. 8–9; II, pp. 23–25.
Galassi, "Una icona dell'Emmanuele al Sinai," *Felix Ravenna* LXIII, 1953, p. 26.
A. Grabar, *Christian Iconography*, Princeton 1968, p. 120 and fig. 287.

[7] C. Cecchelli, I. Furlani, M. Salmi, *The Rabbula Gospels*, Olten and Lausanne 1959, pl. fol. 13v. For additional examples, cf. W. Neuss, *Das Buch Ezechiel in Theologie und Kunst*, Münster 1912, figs. 11, 12, 16, etc.

[8] H. Gerstinger, *Codex Vindobonensis med. gr. 1 der Österreichischen Nationalbibliothek*, Graz 1965–70, pl. fol. 6v.

[9] M. Chatzidakis, "An Encaustic Icon of Christ at Sinai," *Art Bull.* XLIX, 1967, p. 204 and fig. 19.

B.17. RIGHT WING OF A TRIPTYCH. PLATES XIX AND LXIV
FRONT: PROPHET ELIJAH
BACK: CROSS IN MANDORLA
ABOUT SEVENTH CENTURY
OLD LIBRARY

H. 61.2 cm; W. 21.3 cm; thickness 1.6 cm. Of the two dowels, characteristic of triptych wings, the one at the lower

left is preserved while the other at the upper left is broken off, as it most frequently is. Also typical of triptych wings is the rounded inner—here the left—edge, while the edge at the right is recessed to overlap a corresponding indentation of the other wing when closed. The surface of the encaustic paint is very rubbed on both sides, but especially on the front in the area of the face, where the layers of paint were thickest. Yet the thickness of the paint was not the sole reason for the flaking, since other parts of the panel—the

shoulders, the blessing hand, as well as the nimbus and background—are also damaged. The loss of the lower part of the open scroll results from a knot in the rather rough wood. The face was retouched by Pater Pachomios but his paint was removed in 1963 by Tassos Margaritoff.

The wing is filled tightly with a frontal standing figure of the prophet Elijah, identified by the gold capital letters + ΗΛΙΑC on the blue ground left of the nimbus. At the right side one would expect, in monogram form, the word Ο ΠΡΟΦΗΤΗC, but the surface is too rubbed to be certain it was there.

Most frequently, as in the Transfiguration mosaic of Sinai,[1] Elijah wears the melote, a cape of sheepskin, but here he wears a long brown tunic with a narrow dark blue clavus and a brown himation, both densely covered with gold striation indicating very patterned highlights. Of the face, the palm of the right hand, and the feet only an underlayer of reddish violet remains, which must have been intended to produce an effect of impressionistic richness. The patriarchal face with its white hair and beard has some grey shadows; it is set against a gold nimbus with a green edge. The large sandaled feet stand firmly on the blue grey groundstrip, and between them is an object that looks like a brown box designed in reverse perspective. While Elijah blesses with his right hand, the left, each finger clearly outlined in red brown, holds an open scroll on which is written in bold black letters: +ΖΗΛΩ(Ν) ΕΖΗΛΩΚΑ Π(ΑΝΤΟΚΡΑΤΟΡΙ ?). These words from III Reges XIX:10 or 14 (both verses begin identically) were spoken by the prophet after his flight into the cave of Mount Horeb.

On the reverse is depicted half of a *crux gemmata*, the other half of which filled the outer side of the lost left wing, so that it could be seen as a whole only when the wings were closed. The cross is yellow as a substitute for gold and its arms end in pairs of small knobs. The surface is studded with green and red stones and small pearls. The cross is encompassed by a blue aureola consisting of three concentric ovals reflecting the Trinitarian concept and set against a yellow background. As each oval is lighter towards the inside and darkens towards the outside, the impression is

that of a light source in the center of the cross, and this impression is strengthened by the fact that rays emanate from this center, penetrating all three ovals. This emanation of light in a mandorla has its parallel in the Metamorphosis mosaic of Sinai, and thus the *crux gemmata* in this setting is meant to be an abstraction of the Metamorphosis itself, similar to that in the apse mosaic of S. Apollinare in Classe.[2] Between the upper arm of the cross and the ray one can see the two letters $\overline{\mathrm{XC}}$, corresponding to the $\overline{\mathrm{IC}}$ of the lost wing, and between the lower arm and the ray, hardly visible to the naked eye, the one letter V, part of an inscription that must have read $\overline{\mathrm{(VC}} \ \overline{\Theta)\mathrm{V}}$ (cf. the reverse sides of nos. B.22 and 23).

The symbolically suggested Metamorphosis on the outside of the wings and the reference of the inscription on the scroll to Mount Horeb are clear indications of Sinaitic connections, which must be taken into consideration when speculating about the subject of the center and the left wing. In the case of the wing there is no doubt: it must have been a figure of Moses also holding an open scroll most likely with the passage Exod. XXIV:12 or XXXIV:1: καὶ εἶπεν Κύριος πρὸς Μωυσῆν ᾿Ανάβηθι πρός με εἰς τὸ ᾿όρος. Less certain is the subject of the lost central panel, although it probably was the Virgin, the title saint of the monastery before its rededication to St. Catherine centuries later.

Stylistically the most characteristic feature is the dense gold striation which, not only in the technique as such but in its decorative pattern, has a parallel in the Christ on the rainbow (no. B.16), though here it is not as well preserved and no longer gives the original impression. While this may indicate that the two icons are approximately contemporaneous, it is not a sufficient indication that both are from the same center, although this possibility is not to be excluded. It seems certain that our triptych was made for Sinai but whether it was actually made at the monastery and, if so, where the artist came from, are still open questions.

Bibl.

K. Weitzmann, "An encaustic Icon with the Prophet Elijah at Mount Sinai," *Mélanges offerts à Kazimierz Michalowski*, Warsaw 1966, pp. 713ff.

[1] Sotiriou, in: *Atti del VIII Congresso Internazionale di Studi Byzantini*, III (1951), Rome 1953, pl. LXXVIb. K. Weitzmann, "Introduction to the Mosaics and the Monumental Paintings," in: G. H. Forsyth and K. Weitzmann, *The Monastery of Saint Catherine at Mount Sinai. The Church and Fortress of Justinian*. Plates, Ann Arbor 1973, pls. CVI and CXLII.

[2] F. W. Deichmann, *Frühchristliche Bauten und Mosaiken von Ravenna*, Baden-Baden 1958, pls. 383–393; idem, *Ravenna. Hauptstadt des Spätantiken Abendlandes*, I. *Geschichte und Monumente*, Wiesbaden 1969, pp. 270ff; E. Dinkler, *Das Apsismosaik von S. Apollinare in Classe*, Cologne-Opladen 1964, especially pp. 77ff.

B.18. RIGHT WING OF A TRIPTYCH. PLATE LXV
ST. DAMIAN
ABOUT SEVENTH CENTURY
OLD LIBRARY

H. 35.3 cm; W. 10 cm; thickness 1.2 cm. In the upper left a hole for the necessary dowel offers proof that this was the right wing of a triptych. There must have been a corresponding hole at the lower left where a piece of wood has splintered off. The surface of the encaustic paint is badly rubbed down the middle, the lower half of the face is completely rubbed away, and on the upper half the thick preparatory ground is gone, revealing the bare wood.

The frontal standing saint is identified by the inscription as St. Damian. Written in big gold uncials the word O AΓIOC is set at the top against a black ground and the word ΔAMIANO(C) appears on the upper strip of an intense crimson border which frames the upper part of the figure on three sides. The saint is clad in a long purple tunic and a brown himation which was densely covered with gold striation, most of which is now lost. In his covered left and free right hands he holds a long, white tubular instrument

box with purple strings around it. Of the head nothing more can be said than that Damian had the black hair and beard of the accepted iconography. His head is set against a gold nimbus, now almost entirely flaked, which contrasted with a mellow ivory-colored background. Wearing black shoes Damian stands on a grey groundstrip which extends to his right elbow and almost to the height of his left shoulder.

The back shows half of a simple cross, the other half of which adorned the lost left wing. Above the crossarm one can read the letters X̄C̄ and below a big ornate ω, so that, when closed, the inscription read ĪC̄ X̄C̄ Ā ω̄.

There can be no doubt that the left wing must have depicted St. Cosmas, but for the subject of the lost center one cannot make any suggestion.

The brilliant and sensitive coloring indicates that we are dealing with a work of art of high quality. The technique of the heavy gold striation and its patternization link this icon with that of Christ on the rainbow (no. B.16) and with the prophet Elijah (no. B.17) and we are inclined to date our plaque in the seventh century.

B.19–20. TWO WINGS OF A TRIPTYCH. PLATES LXVI–LXVIII
FRONT: TOP, ANNUNCIATION;
BOTTOM, ST. PETER AND ST. PAUL
WITH THECLA
BACK: CROSSES
ABOUT SIXTH–SEVENTH CENTURIES
OLD LIBRARY

Each of the two wings measures 64.8 cm in height and 17 cm in width. The inner edges are cut obliquely to facilitate the turning of the wings, which were fastened by metal hinges of which one, most likely original, is still preserved. The outer edges have recesses cut to match, to assure tight closing. In addition, a ledge is nailed on the outer edge of

the right wing. The surface paint in encaustic technique is partly flaked and partly rubbed off, especially in the faces where apparently the paint was thickest. Yet enough

remains to indicate the iconography of the individual figures and their identity is insured by inscriptions.

Enclosed by simple red borders, the two upper compartments are filled with an Annunciation group, the angel approaching from the right. Inscribed + ΓABPIHΛ in yellow (as a substitute for gold) on blue ground, he is dressed in a blue mantle, whereas the color of his tunic can no longer be discerned. In his left hand he holds a scepter and his right surely was directed towards the Virgin. His wings are chestnut colored with green tips and the ground strip is also green. The Virgin is inscribed with a monogram which must be read H AΓIA MAPIA as is usual in many early Virgin icons of Sinai. Clad in a blue tunic and a purple maphorion, she turns to the right and must once have held a spindle in her hand because in the lower right corner there is a chalice-shaped wicker basket holding purple wool. She is considerably smaller in size than the angel but has a larger, red-edged nimbus which equalizes their height. She stands before a throne with a red cushion, placed before a green wall with slit windows.

At the lower left, St. Peter, inscribed O AΓIOC

ΠΕΤΡΟΣ and dressed in a grey tunic with black clavi and a red himation, faces the spectator in frontal position. His right hand is held before his breast, but what he held in his left is no longer discernible. He stands in front of either a wall or a niche which, like the architecture in the Annunciation, is dark green and panelled.

Balancing the figure of St. Peter in the scene at the right is a standing central figure with a similar red-edged nimbus, accompanied by a second figure looking up, part of whose pink face is still preserved. They are identified by the inscriptions ΠΑΥΛ[ΟΣ] in the upper left and ΘΕΚΛΑ in the upper right corner, but which is which? Because of its dominating position, the figure in the center was identified in a previous study (cf. bibliography) as Paul and the subsidiary one as Thecla, but a closer study has proved that it is the other way around. This not only agrees better with the location of the inscriptions, but the narrow-waisted proportions of the central figure, the red skirt with a knotted belt, the blue tunic with highlights indicating breasts, clearly indicate a female. Consequently, the figure at the left, which could have had only a very narrow nimbus if any, must be Paul. Only his bust in a blue tunic with a red clavus is visible above a brown ledge which apparently indicates mountainous ground and rises on the other side of Thecla to a higher horizon line. At the right, a brown bull emerges from behind Thecla's hip, turning his head around toward her. The *Acts of Paul and Thecla* tell of her being attacked by several wild beasts, an episode depicted in various Early Christian monuments, among them the silver casket from Çirga in Isauria.[1] The closest parallel is to be

found on some terracotta ampullae (fig. 21)[2] that depict Thecla in a similar long skirt, though the upper part of her body is naked. Grouped around her are a lioness licking her foot, a bear attacking her, and two bulls above trying to tear her apart. The form and position of the bulls in particular agree with the bull in the icon, and these ampullae suggest that in our painting there must also have been a second bull, pulling in the other direction. A vertical streak of red color across the bull at the right most likely indicates the fire that burned through the ropes fettering Thecla, setting her free. Whether either or both of the other two animals also existed in our icon can no longer be determined.

On the back of each wing there are two very simple yellow crosses on red ground, one above the other, divided by a broad border line. The two crosses of the right wing preserve, in each case, only the upper line of the inscription \overline{IC} \overline{XC}, the lower line, which presumably had the older version \overline{VC} $\overline{ΘV}$ (cf. no. B.22), having now disappeared.

What little can be said about the style points to a date probably not later than the sixth or the seventh century. The proportions of the figures are slightly thickset, with the one exception of Thecla, who is more slender and at the same time in a lively pose. The highlights in the garments are not yet as linearized as in the figures of the four saints of icon no. B.33, which belongs to the same group, and thus our diptych may be somewhat earlier.

Bibl.

K. Weitzmann, "Fragments of an Early St. Nicholas Triptych on Mount Sinai," Τιμητικὸς Γ. Σωτηρίου, Δελτ. Χριστ. 'Αρχ. 'Εταιρ. Περ. Δ, Τομ. Δ, 1964–1965, Athens 1966, p. 14 and fig. 10a–b.

[1] A. Grabar, "Un Reliquaire provenant d'Isaurie," *Cah. Arch.* XIII, 1962, pp. 49ff. and fig. 4; H. Buschhausen, "Frühchristliches Silberreliquiar aus Isaurien," *Jahrb. Österr. Byzant. Gesellschaft* XI–XII, 1962–1963, pp. 137ff; idem, *Die spätrömischen Metallscrinia und frühchristlichen Reliquiare*, pt. 1, *Katalog*, Vienna 1971, pp. 190ff. and B pls. 13–19.

[2] Wilpert, "Menasfläschchen mit der Darstellung der hl. Thekla zwischen den wilden Tieren," *Röm. Quartalschrift* XX, 1906, pp. 86ff. with figure; O. M. Dalton, *Catalogue of Early Christian Antiquities*, British Museum, London 1901, p. 156 no. 882 and pl. XXXII; Grabar, op. cit., p. 56 and fig. 10; idem, *Martyrium*, Paris 1946, II, p. 24 n. 1 and pl. LXIII,7.

B.21. ICON. PLATE LXIX
STANDING ARCHANGEL
SIXTH–SEVENTH CENTURIES
OLD LIBRARY

H. 70.3 cm; W. 40.9 cm; thickness 1.5 cm without, and 3.2 cm with, frame. The almost totally flaked icon consists of two wooden boards, held together by a frame nailed onto a border strip which has been left unpainted for this purpose.

Moreover, at the top and at the bottom the frame was reinforced by two additional narrow ledges. Instead of preparing the surface with a layer of gesso as a ground for the paint, the artist covered the wood with canvas upon which the gesso was then applied—a procedure not unique in early icon painting. Were it not that the icon is painted in encaustic and therefore must be early, it would hardly have been worthwhile to include a panel in such ruined condition in the present volume. On the lateral frames are metal

hinges with their joints at the inner edges of the frame in order to fasten wings which, when closed, would fill the area within the frame. But as these hinges cover letters of the inscription, they do not seem to be original. Moreover, it is highly unusual to have such hinges on the frame, for normally the central panel of a triptych has ledges only at the top and bottom and the wings are either attached by means of dowels inserted into the ledges or by hinges screwed into the icon proper. This evidence seems to indicate that the wings were a later addition.

It can still be determined that the subject of the icon was an archangel in frontal position, his wings so widely spread that they touch the grey blue border. A few traces of color indicate that his garment was light blue with white highlights and his wings brown with green tips. In his raised right arm the archangel holds a golden scepter, but the object in his other hand is no longer identifiable. A broad nimbus, apparently gold originally, surrounds the large head. The color of the background is greyish but this may be due to discoloration; at any rate, the original color can no longer be determined.

The only remnant of the inscription is an O that surely is the beginning of O [ΑΓΙΟC ΑΡΧΑΓΓΕΛΟC], and then the name must have followed, either ΜΙΧΑΗΛ or ΓΑΒΡΙΗΛ. An inscription, presumably of dedication as in the case of the Christ Immanuel icon (no. B.16), was written in black uncial letters on the orange red ground of the frame, but only a few letters are preserved, on the left side and at the right corner of the frame—not enough to attempt a reading and reconstruction.

One can only speculate about how the archangel was dressed. The few traces of light blue garment may be an indication that he was dressed simply in a tunic and a himation, as was quite customary in the Early Byzantine period (cf. the angels in the Virgin icon no. B.3 and the famous ivory plaque in the British Museum[1]). In other words, the archangel may have worn neither an imperial chlamys like the archangels in mosaic who flank the apse in S. Apollinare in Classe in Ravenna,[2] nor a loros like the archangels in the bema of the Church of the Dormition at Nicea.[3] Obviously nothing can be said about the date of this icon and only the fact that it is painted in encaustic identifies it as a product of the preiconoclastic period.

There is at Sinai a pair of triptych wings (nos. B.19–20) that correspond in size to the area within the frame of the angel icon. They represent the Annunciation in the upper register and SS. Peter and Paul, the latter with the martyrdom of St. Thecla, in the lower. Yet it seems very unlikely that these wings were originally made to flank our icon, not only for the reason that the present hinges are later, but also for palaeographical and iconographical ones. The letters in the frame are quite different from those used in the inscriptions of the wings. (In the wing inscription, for instance, the two loops of the B touch each other while they do not in that of the frame.) Moreover, from the iconographical point of view it would seem unlikely that in Early Byzantine art an Annunciation should have been chosen to flank the figure of an archangel. An Annunciation on the wings would more likely have flanked a figure of Christ or of the Virgin.[4] If indeed these two wings ever did flank our archangel icon they were, in our opinion, so assembled at a later time. In this case, they were chosen merely because their measurements suited our icon, which was not originally meant to be the center of a triptych.

[1] O. M. Dalton, *Catalogue of the Ivory Carvings of the Christian Era*, British Museum, London 1909, p. 9 no. 11 and pl. VI.

[2] F. W. Deichmann, *Frühchristliche Bauten und Mosaiken von Ravenna*, Baden-Baden 1958, pls. 402–403; E. Dinkler, *Das Apsismosaik von S. Apollinare in Classe*, Cologne and Opladen 1962 pls. XIV–XV.

[3] P. A. Underwood, "The Evidence of Restorations in the Sanctuary Mosaics of the Church of the Dormition at Nicea," *D.O.P.* XIII, 1959, pp. 235ff. and figs. 6–9.

[4] Yet by the eleventh century this sense of hieratic order may no longer have been so strict, if our reconstruction of a triptych with the St. Nicholas story is correct: we proposed that there was a bust of this church father on the lost central panel, and that this panel was flanked by a pair of wings bearing a representation of the Annunciation (K. Weitzmann, "Fragments of an Early St. Nicholas Triptych on Mount Sinai", Δελτ. Χριστ. Άρχ. Έταιρ., 1966, pp. 1ff. and fig. 5.

B.22. RIGHT WING OF A TRIPTYCH. PLATES
 LXX–LXXI
FRONT: PRAYING MONK AND SHEPHERDS
 FROM A NATIVITY
BACK: CROSS
ABOUT SIXTH–SEVENTH CENTURIES
OLD LIBRARY

H. 30.1 cm; W. 8.1 cm. The encaustic panel is rather thin (0.7 cm) and, as frequently happened, is broken at the upper and lower left corners, where once dowels fitted into holes in the ledges along the top and bottom of the central plaque. The purpose of the holes at the upper and lower right is unclear, since they are not sufficient in number to be explained by a later remounting. The left edge of the panel is rounded to facilitate its turning. There is a split at the top. The surface of both sides, especially the upper half of the front, is so rubbed that in parts the bare wood has become visible.

In the upper of the two registers, which are framed and separated by a simple red border, a nimbed monk with white hair and beard faces the beholder, his arms raised in prayer. He wears the costume of the Early Christian monks, a brown tunic with white clavi down to the feet and white borders on the long sleeves, and a red phelonion, which is so badly flaked that its form can be distinguished only by the white outline separating the garment from the blue background. A wavy line at the height of the ankles suggests a strip of ground, the color of which can no longer be determined. An identifying inscription probably existed left and right of the nimbus, but no traces of it remain. The color of the red-edged nimbus is no longer clear.

The lower zone is occupied by three shepherds, compactly fitted into the narrow panel but well arranged in a plausible spatial relationship. On the groundline, a white-haired shepherd in a lively pose walks to the left; he wears a blue tunic tucked up over his hips and a short, purple red mantle slung around his left shoulder. Behind him at the left, on higher ground, stands a middle-aged shepherd with a short black beard; he, too, raises his right hand and moves to the left while turning his head to the other shepherds. His simple tunic of dark brown falls free. The third shepherd, a youthful figure, stands to the right, also on the higher plane, and he thrusts out his right arm behind the neck of the second shepherd. The first shepherd holds a black staff whose precise form can no longer be determined, but whether the other two held staffs or other attributes is uncertain. In the lower left corner is seen a sheep, and the few strokes behind it indicate that there was a flock. As in the upper zone, the background is a deep blue, while the color of the groundstrip is lost.

All three shepherds must be pointing to the star of Bethlehem and listening to the good tidings announced by an angel. The central panel, then, must have contained a representation of the Nativity with the star above and the announcing angel in the upper right corner. As for the left wing, it is reasonable to assume that, like the right one, it was divided into two zones with a second orant saint above and most likely the three Magi below.

The reverse is filled with a thin cross whose arms terminate in pairs of knobs and whose center is marked by stems ending in similar knobs. It is fastened with a spike to a square base with legs designed in perspective. This clearly suggests the imitation of metal, an impression strengthened by the thick yellow paint, of which, however, only a few traces are left. In its present flaked state, the form of the cross stands out merely as a silhouette against the darker reddish ground. The same is true of the inscription in the spandrels, which reads I(HCOV)C X(PICTO)C V(IO)C Θ(ЄO)V, and the seven-dotted rosettes which fill the ground.

The design of the human figures is not refined, but the thick outlines are sure and the motion is vivid and expressive. The modelling of the pinkish flesh and the garments is achieved by rough, energetic highlights. With no comparative painted material available beyond this and other Sinai icons, certain similarities can be observed with some contemporary ivories, chiefly some pyxides on which the Annunciation repeatedly occurs. A bearded shepherd on the pyxis of Werden (fig. 22),[1] which we should like to attribute to the Syro-Palaestinian school of about the sixth century, shows a similar liveliness of motion and undulating body contours. Our icon may be slightly later, and we should like to ascribe it to the Palaestinian group of which the seven-dotted stars on the reverse are a trademark.

[1] Volbach, *Elfenb.*, p. 80 no. 169 and pl. 54.

B.23. RIGHT WING OF A TRIPTYCH. PLATE LXX
FRONT: STANDING FIGURE (LOST)
BACK: CROSS
ABOUT SIXTH–SEVENTH CENTURIES
OLD LIBRARY

H. 29.6 cm; W. 9 cm. The dowels and the rounded edge
at the left side of the obverse, which is almost completely
flaked, prove that this was the right wing of a triptych. What
little paint is left on the reverse indicates that the icon was
painted in encaustic.

The only trace of paint left on the front shows a foot in
a red shoe beneath the edge of a long garment. Red shoes
are an imperial prerogative and as such worn either by an
empress or by the Virgin adapting this element of the
imperial regalia. In this instance, a standing Virgin seems to
be the more likely subject, and if this is so, it is reasonable to
assume that the other wing had a representation of the
angel Gabriel, completing an Annunciation scene, a theme
used frequently for the decoration of triptych wings (cf. e.g.
nos. B.19–20 where the positions of the two figures are
reversed).

The reverse is occupied by a slender yellow cross of
metallic sharpness and color. It is fastened with a thin spike
on a base, imitating the montage of an actual metal cross.
In shape, with pairs of knobs at the ends of the arms and
stems ending in similar knobs issuing from the center, it is
very similar to the cross on the reverse of triptych wing
no. B.22, with which it also shares the dark reddish ground
and the space-filling ornament in the form of rosettes of
seven yellow dots, except that here the central dot is red.

Furthermore, it shares with the other wing the inscrip-
tion I(HCOV)C X(PICTO)C V(IO)C Θ(ЄO)V, in
addition to which it has, also in white uncial letters, a
three-line inscription at the bottom, which is unfortunately
too much obliterated to suggest even a tentative reading.
The only identifiable letters in the second row are a liga-
tured iota and omega. These are followed by an upsilon and
seemingly a sigma, likewise ligatured: $\overline{\text{IΩ}}$[ANNHC]
$\overline{\text{V}}$[IO]C. In other words, there seems to be mentioned a
certain "Johannes, son of . . ." and thus we are probably
dealing with a dedicatory inscription such as occurs on the
frame of icon no. B.16.

The ornament indicates that this is a product of the
Palaestinian school, as is the related triptych wing no.
B.22.

B.24. LEFT WING OF A TRIPTYCH. PLATES XX
 AND LXXII–LXXIII
ST. ATHANASIUS AND ST. BASIL
ABOUT SEVENTH CENTURY
GALLERY. GLASS CASE

H. 42.9 cm; W. 13.9 cm. The rather thin wooden plaque
(1.4 cm), rounded at the right edge, shows at the upper and
lower right corner damages caused by the breaking away of
the dowels that connected this wing to the central plaque of
a triptych. A vertical split has almost divided the plaque into
two halves, and wire and string have been used to prevent a
total split. In addition, a part of the nimbus of the upper
bust is lost, and a square piece underneath with the upper
part of the face has been cut away and replaced in modern
wood with the design of brow, eyes and nose, a repair
presumably made by the late Pater Pachomios. The surface
is rubbed in various spots, particularly on the lower bust
from the beard to the wrist of the right hand.

The triptych must have fallen apart after comparatively
short use, because the reverse has at a right angle the text of
a liturgical prayer formula that would only have been
written after the wing had become separated from the
central plaque. The prayer reads:

+ ΔΟΞΑ ΤΩ Π(ΑΤ)ΡΙ (ΚΑΙ) ΤΩ V(I)Ω ΚΑΙ ΤΩ
ΑΓΙΩ ΠΝ(ЄVΜΑΤ)Ι ЄΙC ΤΟV|C ΑΙΩΝΑC ΑΜΗΝ
Θ(Є)Ω ΤΟ ЄΝ ΤΡΙΑΔΗ ΑVΤΩ ΠΡΟCΚV|ΝΗCΩΜЄΝ
ΑΔΟΝΤЄC ΚΑΙ ΒΟΩΝΤЄC ΑCΩΜЄΝ CO(I) ΤΩ
ΜΟΝΩ ΔЄCΠΟΤΗC.

The script is in sloping uncials of a form common in Sinai
manuscripts of about the eighth and ninth centuries.

A red border surrounds and divides the two busts,
broader and adorned by a white, graciously designed
rinceau between them. The upper bust is inscribed in white
letters on dark blue ground Ο ΑΓΙΟC ΑΘΑΝΑCΙΟC and
not ΑΝΑCΤΑCΙΟC (cf. Sotiriou, who identifies the person
represented as the early abbot of Sinai by that name who
lived at the beginning of the seventh century). Anastasios
should be represented not as a bishop but as a regular
monk,[1] and furthermore the headdress (part of it remains
above the left ear) is not the normal dark cowl of the
monastic garb but the tight, white cap typical for the

[1] Sotiriou, *Icones* I, figs. 155–156.

48

patriarchs of Alexandria and therefore proper for Athanasius. He wears a light blue tunic with carmine stripes, a light brown phelonion, and an omophorion with carmine, quadrifoil crosses. In this covered left hand he holds a very thick Gospel book of almost square format, typical of the earliest codices, which is adorned with red stones and blue white pearls. His right hand, with long curved fingers, steadies the book.

The lower bust is inscribed + O ΑΓΙΟC ΒΑCΙΛΕΙΟC, and the impressive head, with black hair and fairly long black beard, foreshadows the established type of Basil in the Middle Byzantine period. The phelonion is carmine in color and the omophorion, rather short as in the upper portrait, has spiky black crosses, of which only one remains; the pose of the figure and the shape and colors of the book agree with the corresponding features of Athanasius.

Chalky highlights against ochre-colored skin and intensely red lips and cheeks, combined with a glance to the side, avoiding the spectator, give vividness and spontaneity to the face. This is in sharp contrast to the more static,

Coptic portraits with their blank gaze, like that of the Apa Abraham in the Berlin Museum, an almost contemporary icon which has been connected, we believe unjustifiably, with our Basil portrait.[2] A hieratic element has been introduced into the Sinai icon by the use of gold for the nimbi, of which, however, only a few traces remain, and an ornamental effect has been achieved by decorating the nimbi with a yellow rinceau pattern, rare in preiconoclastic icons. Technique and style as well suggest the product of the Palaestinian school, of which the seven-dotted palmettes in the background are also typical.

Bibl.

G. Sotiriou, "Icones byzantines du monastère du Sinai," *Byzantion* XIV, 1939, p. 326 and pl. II.

Idem, *Icones* I, figs. 20 and 22; II, pp. 35–36.

A. Grabar, *Christian Iconography*, Princeton 1968, p. 74 and fig. 185; p. 82 and fig. 217.

Idem, *L'Art de la fin de l'antiquité et du moyen âge*, Paris 1968, I, p. 595 and III, pl. 144d.

[2] Ibid. II, p. 35. For the Apa Abraham icon, cf. K. Wessel, *Koptische Kunst*, Recklinghausen 1963, p. 187 and title plate in color.

B.25. RIGHT WING OF A TRIPTYCH. PLATES XX AND LXXIV
STANDING PROPHET (ELIJAH?)
ABOUT SEVENTH CENTURY
GALLERY. GLASS CASE

H. 34.3 cm; W. 6.3 cm. The plaque is split vertically and about a third of it is lost. Rather thin (1.2 cm), it once served as the right wing of a triptych as indicated by the rounding of the left edge and the provision for the dowels in the corners.

Less than half of the surface still has traces of the old encaustic paint, chiefly along the split; for the remainder of the standing figure only the preliminary drawing of the folds, done in chestnut color, remains. The frontally standing saint is dressed in a whitish tunic with shades of green, red clavi, and a white himation. The face, framed by parted white hair and beard, is grey in color with thick white highlights and vivid piercing eyes, surrounded by a dark brown shade, and the right hand is raised in a gesture of blessing. The yellow nimbus with a black and white edge is set against a dark blue background of which only a few traces are left, and at the bottom there is a groundstrip of green.

Since the identifying inscription is gone one cannot be sure about the identity of the saint. Dress, facial type, and gesture suggest either an Apostle or a Prophet. There is, indeed, a close similarity to the facial features of the Prophet Elijah on another triptych wing (no. B.17). Since this latter figure, if we are not mistaken, formed the right wing of a triptych on the center panel of which was probably portrayed a bust of the Virgin (cf. p. 43), it seems not unlikely that, for iconographic as well as external reasons, the Prophet of our fragmentary wing also is Elijah. In this case, the lost wing at the left would undoubtedly have had, as a corresponding figure, the Prophet Moses. This specific Sinaitic iconography would point to a monument which, if not produced in Sinai, was at least made for Sinai.

The style can be judged only by the face. The sharp white of the eye next to the piercing pupil, the eye set in a dark ring, the sideward glance are all features typical of the Palaestinian group (cf. the Chairete icon no. B.27). A seventh-century date is suggested in accordance with Sotiriou.

Bibl.

Sotiriou, *Icones* I, fig. 14; II, p. 29 (here considered as a survival of Alexandrian painting).

B.26. ICON (FRAGMENT). PLATE LXXIV
ST. JOHN (OF UNCERTAIN IDENTITY)
ABOUT SEVENTH CENTURY
OLD LIBRARY

H. 34.4 cm; W. about 6.5 cm; thickness 0.9 cm. The plaque still retains its original height, but is split off at both sides so that there is no way of knowing whether the figure, of which a little more than half is preserved, was accompanied by any others. There are holes in the upper and lower unpainted borders which surely must have had strips of wood nailed on them, but without the lateral frames one cannot determine whether these strips were designed to attach wings or whether a frame was nailed all around as, e.g., in the icon with the Three Hebrews in the Fiery Furnace (no. B.31). Were it not for rather extensive preliminary drawing, the few spots of encaustic paint would no longer reveal the form of the figure. The reverse is blank.

The youthful saint with short hair wears a long green tunic and what look like a chlamys, of which the color can no longer be determined, fastened over his right shoulder. Two features indicate Persian costume: a red cylindrical hat and the vertical broad piece of brown cloth, visible under the girdle, which resembles the later monastic megaloschema (cf. again the Three Hebrews icon). The right hand is raised in a gesture of blessing and the left holds a scroll. The head is set against a yellow, black-edged nimbus, and the whole figure stands in a pink niche with a clearly marked cornice, a niche comparable to those of icons nos. B.1, 3 and 5.

For a youthful saint in Persian costume one would first of all think of Daniel, were it not that the inscription in white letters on dark blue ground reads [IⲰ] ANNHC. The identity of this John in Persian costume needs still to be determined.

Too little remains to permit a judgment on style. The chalky pink flesh with sharp white highlights resembles the face of the Christ on the rainbow (no. B.16). A date in the seventh century is thus a reasonable proposal.

B.27. ICON. PLATES XXI AND LXXV
CHAIRETE
ABOUT SEVENTH CENTURY
OLD LIBRARY

H. 20.1 cm; W. 11.6 cm. Two vertical splits have separated the icon into three parts: the left section, now lost, must have depicted the rest of the figure of Christ and could not have been very wide; the two remaining parts are held together at the top and bottom by two metal strips. The surface is very darkened and the front and back of the rather thin plaque (1.2 cm) are both rubbed.

In the scene, usually inscribed XAIPⲈTⲈ in middle Byzantine monuments, Christ meets the two Maries after his resurrection (Matt. XXVIII: 9–10).[1] Approaching from the left, he is clad in a light blue tunic with dark blue clavi and a mantle of chestnut color as a substitute for purple, adorned with golden squares outlined in red. In his left hand he holds a scroll while his right is raised in a gesture of speech towards the standing Mary. His face is framed by the dark hair and short pointed beard typical of the so-called Palaestinian type (cf. p. 27). The flesh color of all three figures is dark and has sharp highlights. Both Maries are clad in red, long-sleeved tunics and paenulae of purplish red. The Mary in the foreground, bending to touch Christ's foot with her left hand and raising her right in a gesture of worship, is surely Mary Magdalene. The second Mary, however, standing upright with both arms extended in a gesture of worship is not Mary the mother of James, as the Gospel text would suggest, but the Mother of God, as clearly indicated by the monogrammatic inscription which reads H ΑΓΙΑ ΜΑΡΙΑ, in white letters on blue ground. This deviation from the Gospel text is not unique in Early Byzantine art, and occurs e.g. in a miniature of the Rabula Gospels from 586 A.D.[2] The literary source for this unbiblical iconography is found in liturgical texts, including a hymn of Rhomanos.

On the reverse, not much more than the two large letters \overline{VC} can be seen at the lower right. This presupposes that the back, in the usual manner, had a cross, whose four spandrels were filled with the letters \overline{IC} \overline{XC} \overline{VC} $\overline{ΘV}$. (= Ἰησοὺς Χριστὸς Υἱὸς Θεοῦ). Stylistically the icon belongs to the Palaestinian group. It shares with the earlier Ascension icon (no. B.10) the expression of the faces with the needle-pointed whites of the

[1] For the inconography, cf. J. D. Breckenridge, "Et Prima Vidit," *Art Bull.* XXXIX, 1957, pp. 9ff.

[2] C. Cecchelli, I. Furlani, M. Salmi, *The Rabbula Gospels*, Olten and Lausanne, 1959, pl. fol. 13a.

eyes, and both sides of the icon have dotted rosettes—a trademark of this school. The dotted red outline of the golden nimbi also occurs often in this group. Yet the figures are stiffer in their movements than those of the Rabula miniature and their generally more decorative quality speaks for a somewhat later date.

Bibl.

Weitzmann, "Jephthah Panel," p. 346 and fig. 9.
Idem, "Eine Vorikonoklastische Ikone des Sinai mit der Darstellung des Chairete," *Festschrift für Johannes Kollwitz. Tortulae. Studien zu altchristlichen und byzantinischen Monumenten. Röm. Quartalschrift*, 30. Suppl., 1966, pp. 317ff. and pl. 80.
Idem, "Loca Sancta," p. 43 and fig. 25.

B.28. ICON. PLATE LXXVI
HALF-FIGURE OF VIRGIN WITH CHILD
ABOUT SEVENTH CENTURY
OLD LIBRARY

H. 40 cm; W. originally about 32 cm. The icon is split vertically and a major part of the panel along this split has broken away. There is also a large hole below the Virgin's right elbow. The two pieces are now nailed onto a modern panel of wood at approximately the right distance from each other. Older nail holes all around the border point either to an earlier mounting or the addition of a separate frame, common in early icons. The encaustic surface is so blackened that it looks as though the icon was once exposed to fire, resulting in the loss of the topmost layers of paint and revealing in many spots the bare wood; whatever color is left has become indistinct. The back is undecorated.

The half-length Virgin faces the beholder and holds with both hands an oval red shield, on which, as a few traces reveal, is represented Christ enthroned. The color of the Virgin's paenula can no longer be determined, although most likely it was purple brown, while her tunic still shows traces of chestnut color. In the fashion of all preiconoclastic Virgins on Sinai she is inscribed H ΑΓΙΑ ΜΑΡΙΑ in black letters on yellow ground.

The type of the Virgin holding an oval shield with the enthroned Christ occurs in such preiconoclastic paintings as the frescoes from Bawit in Egypt and S. Maria Antiqua in Rome and one of the miniatures inserted in the Etschmiadzin Gospels, which comes from an earlier manuscript.[1] Its wide geographical distribution suggests that this iconographic type is not confined to Egypt, although here the material is the richest, and therefore our icon need not

necessarily be Egyptian as the Sotirious believe. The same is true of the old-fashioned inscription H ΑΓΙΑ ΜΑΡΙΑ (p. 7). Above the shoulders of the Virgin are two medallion busts of yellow-nimbed archangels who each hold the scepter in one hand and a no longer recognizable attribute in the other; they, like the Christ, are set against an intense red background. These angels medallions, rather small and tightly fitted into the ground, were an afterthought of the painter himself, since under the flaked surface there have come to light ornamental stars corresponding precisely with those in the upper corners.

In later Sinai icons the type of the standing Virgin holding a seated Christ in a suspended position occurs quite frequently, although the oval shield is abandoned in posticonoclastic art. In these examples she is the Virgin ἡ τῆς βάτου,[2] and thus it becomes quite possible, although it cannot be proved, that our icon is meant to be associated with the Virgin of the Burning Bush.

The rather dense and softly rounded folds of the Virgin's garment, the dotted edges of the nimbus and of the oval shield, the seven-dotted palmettes above the Virgin's shoulder and within the oval shield, and especially the ornamental flourishes of the stars in the upper corners—all these are trademarks that also occur on the encaustic Abraham and Isaac and Jephthah panels on marble in the bema (nos. B.29–30), works for which we have suggested a seventh-century date. On the strength of these comparisons we propose the same date and also a Palaestinian origin for our Virgin.

Bibl.

Sotiriou, *Icones* I, fig. 28; II, pp. 42–43.
Weitzmann, "Jephthah Panel," p. 345 and fig. 8.

[1] N. P. Kondakov, *Иконографія Богоматери* I, St. Petersburg 1914, figs. 206–208, 212–213.

[2] Sotiriou, *Icones* I, fig. 155.

B.29. PAINTING ON MARBLE. PLATES
 LXXVII–LXXVIII
SACRIFICE OF ISAAC
SEVENTH CENTURY
LEFT PILASTER IN FRONT OF THE APSE

H. at left 154 cm, at right 153 cm; W. at top 81 cm, at bottom 82.5 cm. The encaustic panel is painted on the marble revetment of the pilaster flanking the apse at the left, covering entirely two narrow vertical slabs. The whole surface and especially the figure of Abraham is badly flaked, revealing the preliminary drawing in red brown and even the graceful, symmetrical venation of the bare marble underneath. The flesh areas—the faces, hands, and feet—are almost completely gone, The logical explanation for this is that the thickest layer of paint is exposed to flaking more than any other part of the surface. The cornice of a wooden baldachin covers part of the base of the altar and an iron loop for hanging up a lamp has been inserted at Isaac's knees.

Abraham is stepping up a small, dark brown hillock; he turns his head away while with his left hand he grasps Isaac's hair and with his right he prepares to plunge a knife into the boy's neck. Both figures are inscribed vertically: at the upper left ABPAAM and between the column of fire and the altar ICAAK. Abraham wears a long tunic and a mantle of light ochre brown, the mantle being so badly flaked that the bare marble and the preliminary drawing can be clearly seen. By contrast the long tunic of the kneeling Isaac, red and ornamented with ochre circles, is well preserved. The red, brown, and ochre tones are so predominant that the painting almost gives the impression of a monochrome. The nimbus of Abraham, the top of the altar, and the ram standing erect behind Abraham are light ochre; the zone below the black dividing line which suggests a wall rather than a mountain ridge is a light ochre with a shade of olive, as is the largely flaked top of the altar. The same color of a darker hue is used for the zone above, the groundstrip, and, leaning more to a brown, for the structure that supports the altar. Even the strips of the tripartite arc of heaven are various ochre and brown tones, as are the three rays directed towards Abraham, the

stars and the inscriptions. Red is used for the altar cloth, the folds of which are marked in ochre, the fire above Isaac, the border of the panel, and the inner edge of Abraham's nimbus. The only departures from this subdued color scheme are a few intense spots of olive black: the conelike tree, the handle of the knife, the hair of Isaac, and the opening in the lower part of the structure supporting the altar. A thick black line is used to frame the panel (along with an outer red line) and to outline the segment of heaven and the nimbus, which is filled with white dots.

In Early Christian art the Sacrifice of Isaac is depicted with a considerable variety of poses, both for Abraham and for Isaac,[1] and while for every pose in our panel a parallel can be found in East Christian art, there seems to have survived no precise parallel which combines them all. Normally Abraham should look up towards heaven where the hand of God, not rendered in our panel, commands him to spare his son. In the Octateuchs, e.g., Abraham turns to the hand of God which appears behind him, whereas in the Cosmas manuscript in the Vatican, cod. gr. 699, whose biblical scenes derive from the same archetype, he looks forward because the hand of God has been moved from the left to the right upper corner of the miniature.[2] The averted face occurs similarly in the sixth-century ivory pyxis in Trier.[3] The pose of Isaac finds its closest parallel in the Octateuchs where the boy is on his knees with hands fettered behind his back. The only difference is in the tunic, which in the Octateuchs is knee length and in the Sinai panel ankle length. A further similarity is the manner in which Isaac's head is pulled back by the hair, baring his throat to the dagger, although the knife in our panel is held less menacingly behind his neck. In this way the artist intended, perhaps, to express either the approach or the passing of the most critical moment. The latter seems more probable because it expresses clearly Isaac's salvation. In spite of these slight variations, there seems to be little doubt that iconographically our scene belongs to the same tradition as the Octateuchs which seem to derive from an Antiochian archetype.[4]

Even so there are a few details which cannot be explained by this manuscript tradition and some are unique. A huge flame burns not on the altar but directly beneath

[1] For the most recent study of the iconography of the Sacrifice of Isaac, cf. H. J. Geischer, "Heidnische Parallelen zum frühchristlichen Bild des Isaak-Opfers," *Jahrbuch für Antike und Christentum* x, 1967, pp. 127ff.

[2] K. Weitzmann, *Illustrations in Roll and Codex*, Princeton 1947, pp. 141ff. and figs. 128–129.

[3] Volbach, *Elfenb.*, p. 77 no. 162 and pl. 53; Weitzmann, "The Survival of Mythological Representations in Early Christian and Byzantine Art and Their Impact on Christian Iconography," *D.O.P.* xiv, 1960, p. 58 and fig. 27.

[4] K. Weitzmann, "Die Illustration der Septuaginta," *Münchner Jahrbuch der Bildenden Kunst* iii/iv, 1952–1953, pp. 103ff. (repr. Weitzmann, *Studies*, p. 54).

the arc of heaven. Moreover this fire does not consume the faggot that still lies beyond the altar ready for the sacrifice. The separation of the altar and the fire suggests an explanation from a nonbiblical text. Among various Jewish legends enumerated by Ginzberg,[5] we read that: "On the third day of his journey, Abraham . . . noticed upon the mountain a pillar of fire reaching from the earth to heaven, and a heavy cloud in which the glory of God was seen." This pillar of fire was visible only to Abraham and Isaac, and not to Ishmael and Eliezer, who had accompanied them. The position of the fire in the Sinai panel and its columnar shape distinguish it clearly from an altar flame like the one to be seen in the Octateuch miniature, and thus we assume that it was the Sinai painter's intention to represent the visionary fire column of the legend, reaching up to heaven. Normally Isaac kneels in front of the altar, but there are instances in Early Christian art where he is kneeling on top of it, as e.g. in the mosaic of S. Vitale.[6] However, in the mosaic the altar is stone, erected in an open landscape, whereas in the Sinai panel we see clearly the altar table of a Christian church, the altarcloth of which is decorated with a marked black cross enclosed by *gammadiae*, and with a lower border of white disks. The location of the Ravenna mosaic in the presbytery of the church alongside Abraham's Hospitality implies a typological meaning foreshadowing Christ's eucharistic sacrifice. In the Sinai panel this typology is carried a step further by placing Isaac on the top of the altar where normally the chalice stands. The altar rises out of a polygonal two-storied structure that looks like a conventional walled city. The center of the lower story shows the huge open city gate, and two small windows in the upper story suggest houses. This structure was meant to represent the city of Jerusalem. According to Gen. XXII:2 the sacrifice took place in the land of Moriah and according to II Chron. III:1 Solomon built the temple at Jerusalem on Mount Moriah. While biblical scholarship has denied that these two places with the same name are identical,[7] there can be no doubt that Jewish legends and the Early church fathers alike not only considered them the same, but they explicitly state that it was revealed to Abraham that the temple would be erected on the spot of Isaac's sacrifice.[8] This representation of the city of Christ's

death greatly strengthens the typological aspect of our panel. Other allusions to Christianity may be seen in the Trinitarian connotation of such details as the tripartite heaven and the three rays.[9]

Stylistically, a comparison between Abraham and the figure of Moses of the Metamorphosis in the Sinai mosaic—which, as one must realize, can be seen simultaneously—reveals such differences that it seems impossible that both could belong to the same period.[10] The proportions of the encaustic figure are unsure, the legs too long in relation to the upper part of the body, and the organic understanding of the whole is weak. These shortcomings could be explained in part by a difference in quality, since it seems quite probable that the master of the Abraham panel, executed in encaustic technique, was trained as a painter of icons, i.e. works of art of a smaller scale. More decisive, however, is the treatment of the drapery with accumulated folds and dense ornamental highlights, contrasting to the fewer folds and highlights of the Moses figure, where they are used more economically and with greater force to define the physical reality of the body underneath.

At the same time the more decorative treatment of the Abraham figure and other details show a closer relationship to the group of icons which includes that of the Three Hebrews (no. B.31). The similarity lies not only in the ornamentalization of the linear highlights but in small details like the circle pattern of Isaac's tunic, which appears similarly, although the circles are formed of small dots, on the lacernae of the Hebrews. Another decorative feature, the large petalled stars in the form of elaborate rosettes, occurs in the Virgin icon (no. B.28) also of this group. These stars loom large in the composition and as they are set against a sky darker than the ground below, the impression is almost that of darkness. Still another detail also to be found in the Virgin icon and others of this group (no. B.27) is the black nimbus outline with white dots.

Moreover, our panel shares with icons like that of the Three Hebrews the tight fitting of the figures into the frame in a *horror vacui*, in marked contrast to the mosaic where the figures of Moses and Elijah move quite freely in the space surrounding them. But in its densely filled background our panel reveals the compositional talent of its painter

[5] L. Ginzberg, *The Legends of the Jews* I, p. 278 and v, p. 250 n. 236.

[6] F. W. Deichmann, *Frühchristliche Bauten und Mosaiken von Ravenna*, Baden-Baden 1958, pls. 315 and 327; idem, *Ravenna. Haupstadt des spätantiken Abendlandes*. I. *Geschichte und Monumente*, Wiesbaden 1969, p. 238.

[7] E. Kautzsch and A. Bertholet, *Die Heilige Schrift des Alten Testamentes*, 4th ed., Tübingen 1922, I, p. 45.

[8] Ginzberg, op. cit. I, p. 285 and v, p. 253 n. 253.

[9] Usually the rays emanate from the hand of God, but there are instances in the Octateuchs, though not in this particular scene, in which the rays issue directly from heaven. Cf. the Octateuch of Smyrna, D. C. Hesseling, *Miniatures de l'octateuque grec de Smyrne*, Leiden 1909, pl. 3 fig. 9.

[10] Mrs. Sotiriou, however, believes the mosaic and the panel to be contemporaneous.

in the way the trunk of the tree follows the curve of Abraham's back, and in the parallel of the treetop and the pillar of fire. One may also notice the coordination of the diagonals of the bodies of Abraham and Isaac, on the one hand, and of Abraham's turned head and dagger, on the other.

From these comparisons we draw two conclusions: (1) that out panel is a later addition to the program of the apse decoration in mosaic which was laid out and executed towards the end of Justinian's reign; and (2) that it is not the work of a Constantinopolitan artist, as we believe the mosaic to be, but of an icon painter of the Palaestinian school to which the group of icons mentioned above has

been ascribed, and that it is of the same period as this group, i.e. about the seventh century.

Bibl.

M. G. Sotiriou, "Τοιχογραφία τῆς Θυσίας τοῦ Καθολικοῦ τῆς μονῆς Σινᾶ," *Ἀρχ. Ἐφημ.* 1953–1954, pt. III (1961), pp. 45ff. and pl. I.
Weitzmann, "Jephthah Panel," p. 341 and fig. 3.
A. Grabar, *Byzantium from the Death of Theodosius to the Rise of Islam,* London 1966, p. 185 and fig. 200.
G. H. Forsyth and K. Weitzmann, *The Monastery of Saint Catherine at Mount Sinai. The Church and Fortress of Justinian.* Plates. Ann Arbor 1973, pls. CXXX, CXXXIIA, CXXXIIIA, CLXXXVIII, CXCIIA, CXCIIIA.
Weitzmann, "Loca Sancta," p. 47 and fig. 39.

B.30. PAINTING ON MARBLE. PLATES LXXIX–LXXXI
SACRIFICE OF JEPHTHAH'S DAUGHTER
SEVENTH CENTURY
RIGHT PILASTER IN FRONT OF THE APSE

H. 156 cm; W. 82.5 cm. The location of the painting of the Sacrifice of Isaac on the left pilaster in front of the apse suggested that a corresponding encaustic panel might exist on the pilaster to the right. The mosaics in the lunettes of the presbytery in San Vitale in Ravenna show the Sacrifice of Isaac in conjunction with other subjects from the Old Testament, all of which were chosen as prefigurations of Christ's eucharistic sacrifice, and thus it was expected that if indeed there were a scene on the other pilaster in the bema of Sinai, it also should be a eucharistic prefiguration. However, the right pilaster facing St. Catherine's tomb—a marble chest under a marble baldachin[1]—was covered by a Cretan icon of the sixteenth or seventeenth century with the representation of a frontally standing St. Catherine. This icon was set in a massive rococo marble frame 2.75 m in height and 1 m in width. During the second campaign in 1960 I lifted this icon out of its frame, and underneath was revealed an encaustic panel of precisely the same style as the Isaac panel.[2] After it was cleaned by Carroll Wales, the lower part of a soldier drawing his sword was recognizable—not enough to identify the figure for which no parallel seems to exist in any Early Christian altar room decoration. During the third campaign in 1963 permission

was granted for the removal of the marble frame, a task entrusted to, and carried out by, Ernest Hawkins (from October 24 to November 5).[3] The marble frame was fastened with iron pins, some of which had to be sawed through while others could be removed fairly easily. A few of them had fractured the marble plaques so that pieces of marble were lost along the edges, where repairs were made by Mr. Hawkins with plaster. The right side is even more damaged than the left, and at no point does the marble slab reach the right edge of the pilaster. Moreover, hot lead poured around the iron pins had run down the surface causing further damage, chiefly along the edges of the panel. The center of the surface is in parts even better preserved than the Isaac panel and in fresher colors because it was protected by the icon of St. Catherine. As in the other panel, the greatest damage caused by flaking has occurred in the flesh areas of both figures where the paint was thickest. In many places the red preliminary drawing is visible as well as the bare marble with its symmetrical venation.

Only after the removal of the marble frame did the scene become identifiable through the inscription in large uncial letters: Ο ΑΓΙΟС written in crossform at the left of the soldier's head and ΗΕΦΘΑΕ at its right. The scene is the sacrifice of Jephtha's daughter (Jud. XI:30–40) in a composition clearly laid out as a companion panel to the scene of Isaac's sacrifice. Like Abraham, Jephthah stands on a brown hillock and moves up to the left as the former does to the right so that both are turning towards the altar,

[1] Weitzmann, "Jephthah Panel," fig. 2.
[2] Ibid., fig. 5.

[3] Cf. Mr. Hawkin's description of the cleaning and preservation in his own words, ibid., pp. 343–344.

which stands in the bema between the pilasters. The dominating color scheme is the same, based on various shades of ochre, reds, browns and olives. Jephthah wears a reddish brown suit of armor with leather strips of the same color, and his tunic is ochre brown. Over the shoulders he wears a red mantle, with a light ochre circle pattern that matches Isaac's tunic, secured over the right shoulder by a round clasp. His head is inclined and what little pigment of the face is left indicates that he had a short, dark beard. He wears a high, pointed ochre brown helmet with a long neckpiece falling over his shoulders; his red-outlined nimbus is of the same color. With his right arm Jephthah has just drawn his sword out of the black sheath hanging at his side, and he is pulling back the head of his little daughter by her long hair, about to cut her throat. Enough remains of the girl's face with its huge, open eyes to suggest her fright, as drops of blood on the blade increase the impression of gruesome realism.

The body of the daughter is almost completely flaked, and only the left arm dangling limply can be made out. At the height of Jephthah's right knee is a horizontal double line which can be understood only as the top of the altar. This leaves only enough space for the daughter to be in a kneeling position; in this respect also there is thorough correspondence with the Isaac panel. The altar itself is a precise replica of that in the corresponding panel: it has red hangings with the same lower border of white disks on black ground and with black *gammadiae* designed to enclose a cross. Once more a Christian altar is intended, and this scene must likewise be understood as a prefiguration of Christ's eucharistic sacrifice. To complete the parallelism, the altar of the Jephthah panel is also atop a two-storied architectural structure which differs only in small details. The opening of the gate in the lower story is filled with red instead of black and the same is true for the openings in the upper story, which take the form of niches rather than square windows. A red line above the dividing cornice suggests a rail. Most likely this architecture is meant to represent Jephthah's house in conformity with Jud. XI:31: "Whatsoever cometh forth of the doors of my house to meet me when I return in peace from the children of Ammon shall surely be the Lord's." The miniature scale of this architecture is stressed by the black-booted foot of Jephthah resting on the cornice of the building. It is difficult to say whether this feature is to be understood as a compositional shortcoming or a conscious effort of the artist to connect the hero with his property.

[4] For the relevant passages of the Greek and the Syrian church fathers, cf. ibid., pp. 351f.

As in the Abraham panel there is, at the height of Jephthah's shoulders, a straight dividing line suggesting a precinct wall rather than a mountain ridge. This wall of ochre brown is also in this case of a lighter tone than the sky above, which here is dark olive ochre. Likewise comparable is the tripartite arc of heaven with three rays issuing from it which here, for reasons of symmetry, is placed in the upper left corner. A huge six-petalled star in light ochre above Jephthah's head is the only one visible in this panel, but there may have been others, as in the Abraham panel, which are lost today due to the heavy flaking at the upper left and the loss of a piece of marble at the upper right. Additional ornamental fillings in the form of small dotted rosettes are also typical of the group of icons with which our panel is allied (cf. nos. B.24, 27, 28, 36).

There is no other Early Christian church known in which the Sacrifice of Jephthah's Daugher occurs as a eucharistic prefiguration, and there is good reason to believe that it was rarely chosen for such a purpose. Greek church fathers like John Chrysostom and Theodoret intrinsically condemn Jephthah's infanticide and Anastasius Sinaita, in comparing it with Abraham's sacrifice, shows the difference rather than the similarity. Yet Syrian church fathers, like Aphraates and especially Ephraem, the Syrian, in his seventieth Nisibean hymn not only condone the deed of Jephthah but indeed have high praise for it.[4] One may well ascribe to the influence of the Syrian church fathers the selection of this scene for a prominent place within the church decoration and the depiction of Jephthah nimbed and inscribed as a saint.

The Jephthah episode is depicted in considerable detail in the Greek Octateuchs, but the sacrifice, the most important scene, is missing. Yet it is not improbable that it once existed in the fuller archetype, since a thirteenth-century Bible in the Arsenal Library in Paris, made for St. Louis in the Holy Land under the strong influence of the Octateuchs, does contain a representation of the sacrifice that iconographically shares several similarities with the Sinai panel.[5]

Bibl.

Weitzmann, "Jephthah Panel," pp. 341ff.

G. H. Forsyth and K. Weitzmann, *The Monastery of Saint Catherine at Mount Sinai. The Church and Fortress of Justinian.* Plates. Ann Arbor, 1973, pls. CXXXI, CXXXIIB. CXXXIIIB. CLXXXIX–CXCI, CXCIIB, CXCIIIB.

[5] Ibid., p. 349 and fig. 14.

B.31. ICON. PLATES XXII AND LXXXII–LXXXIII
THE THREE HEBREWS IN THE FIERY FURNACE
ABOUT SEVENTH CENTURY
GALLERY. GLASS CASE

H. 35.5 cm; W. 49.6 cm; thickness 1.1 cm. One hori-
zontal strip of the wooden panel, about 3 cm in height, is
lost above the heads. The original frame (1.6 cm in width)
consists of four separate strips of wood, still fastened in
part with the old, handmade nails. Its inner edges are not
sloped as usual, but are recessed by an angular cutting
which creates a narrow ledge for a lid to rest on, so that
when closed the lid does not touch the surface of the paint
and is flush with the frame. The surface of encaustic paint,

particularly around the middle of the figure at the right,
is so thoroughly rubbed that in spots the horizontal grain
of the bare wood is visible; yet, fortunately, no important
detail is obscured or lost.

The three Hebrews stand in frontal position in the order
in which they are mentioned in Dan. III:24, and are com-
forted by an angel who approaches from the left. Enough
of the inscriptions, written in white letters on the blue
ground, is preserved to the left and right of each nimbus
to establish their identities. They read from left to right:
[O AΓIOC ANA]NIAC and [O A]ΓIOC [AZ]APIAC so
that the third must be [O AΓ]IOC [MICAHΛ]. Azarias's
dominating position in the center is further stressed by
his orant gesture with raised arms turned outward, while
the two flanking Hebrews hold their hands before their
breasts in prayer. They are dressed in the usual Persian
costume: black shoes, long trousers, a short belted tunic
which in the figures on the left and the right is tucked up
over the thighs, and the so-called lacerna, the mantle over
the breast which is held by a golden clasp with a pearl-
dotted black border. Light blue, carmine, chestnut, and
ochre are the colors used for the garments in an even, cal-
culated decorative distribution. The angel wears an ochre
tunic with red clavi and a blue mantle, colors that cor-
respond to the blue garments of the second and third
Hebrews; his wings are brown with white tips. The three
Hebrews wear one additional piece of clothing: a vertical
broad red band that must have been fastened on or around
the neck and becomes visible under the opened lacerna.
This is not a part of the traditional Persian costume and

resembles the megaloschema, worn by monks. The angel
puts his left hand comfortingly on the shoulder of Ananias
and holds in his right a long staff that terminates in a cross
with which he touches the foot of Misael, indicating pro-
leptically that the Hebrews were saved by the Christian
cross. This same feature occurs on the ivory cover from
Murano, now in Ravenna (fig. 23),[1] a sixth-century work
which we believe has justifiably been attributed by many
scholars to a Syro-Palaestinian school. The Hebrews of the
icon stand in a sea of red flames designed in the form of
spirals. There is no indication of a furnace, lacking also in
the Murano ivory, and the flames border a narrow strip of
green ground with ochre highlights on which the angel
stands. All four figures have golden nimbi, framed in red.

The inscription on the frame, palaeographically con-
temporary with those within the icon, contains in white
letters on dark blue ground excerpts from verses 49 and 50
of Chapter III of Daniel:

Top: O ΔE AΓΓEΛOC K(VPIO)V CVNKATEBH
TOIC ΠEPI TON AZAP

Right: [IAN EIC THN KAMINON?]

Left: THN ΦΛOΓA THC [KAMI]

Bottom: NOV ωC ΠN(EVM)A ΔPO[COV]
ΔIAC[VPIZON...]

The style is marked by an expressive use of highlights
that are not only decorative but help, in the well-understood
classical tradition, to model the body and to bring out its
corporeal value, as is especially apparent in the figure of
the angel. In this as well as in the color scheme and the
dotted-circle pattern covering the lacernae of the Hebrews,
the style of the icon is related to the encaustic marble
panels of Abraham and Jephthah in the bema of the church
(nos. B.29 and 30). Such comparisons suggest a seventh-
century date and a Palaestinian origin, for which there is
additional evidence, such as the sideward glance of the
Hebrews, the sharp whites of the eyeballs, and the high-
lights on the rather pale yellowish faces.

Bibl.

Sotiriou, *Icones*, I, figs. 12–13; II, pp. 26–38.
H. P. Gerhard, *Welt der Ikonen*, Recklinghausen 1957, p. 65 and pl. III
(3rd ed. 1970, p. 67 and pl. III).
D. T. Rice, *Art of the Byzantine Era*, New York, 1963, p. 24 and fig. 15.
Weitzmann, "Jephthah Panel," p. 347 and fig. IV.
Idem, *Frühe Ikonen*, p. x, pls. 8–9; pp. LXXIX and XCVIII.
Idem, "Some Remarks on the Sources of the Fresco Paintings of the
Cathedral of Faras," *Kunst und Geschichte Nubiens in Christlicher
Zeit*, Recklinghausen 1970, p. 330 and fig. 325.
Idem, "Loca Sancta," p. 50 and fig. 40.

[1] Volbach, *Elfenb.*, p. 64 no. 125 and pl. 39.

B.32. ICON (TWO FRAGMENTS). PLATES XXIII
 AND LXXXIV
CRUCIFIXION
SEVENTH–EIGHTH CENTURIES
GALLERY. GLASS CASE

The icon is split vertically into two parts; of the piece
on the right-hand side, a strip of about 4.8 cm in height
has been sawed off across the bottom. Left fragment:
H. 36.3 cm; W. 8.9 cm. Right fragment: H. 31.5 cm;
W. 14.5 cm. Thickness 1.1 cm. The two parts are presently
joined by modern dowels. On the left fragment the surface
paint is quite well preserved, with the exception of the
Virgin's face. Only the area around the nose and part of
the cheek are old and for the rest the preliminary drawing
is laid bare. Moreover, a thick varnish has caused partial
discoloration, especially turning blue to green and in
certain parts, such as the nimbus, it forms a thick crust. In
contrast, the surface of the right fragment has been rubbed
off to such an extent that the bare wood shows through at
almost every point. Yet in spite of this advanced deteriora-
tion all essential iconographical details can still be discerned,
with the exception of one, and unfortunately the most
important—the face of Christ. Nothing can be said about
its original features, especially whether the eyes were open
or closed. A red-brown painted border of about 2 cm in
width framed the picture originally, but at the right the
frame has been cut off, and at the bottom of the right-hand
piece a section of the scene as well. The holes in the re-
maining border suggest that a separate frame was nailed
upon it as in nos. B.16 and B.31 and, as in these icons, the
frame may have had an inscription.

Christ on the cross, dressed in a purplish colobium,
stands quite erect on a suppedaneum, his arms held straight
horizontally. The original flesh color, a chalky white, is
still preserved, especially on his left arm. The dark olive
color of the right arm and the legs and a few traces over
the breast indicate that Christ was originally intended to
be nude, except for only a loincloth, of which traces in
white and light blue are laid bare by the flaking of the
colobium. We have here a parallel case to the crucified
Christ in the miniature of the Gregory of Nazianzus,
Paris cod. gr. 510, dated between 880 and 886, where the
nude Christ appears similarly under the partially flaked
colobium.[1] Blood flows quite freely from the wounds in
both hands and also down the suppedaneum into the cave

in the red-colored hill of Golgotha and then into what seems
to be the top of Adam's cranium. All that can be said of
Christ's head is that it was somewhat inclined. The cross,
very dark in color, has the usual square crossbar, but the
painter has rounded the ends by drawing white curved
lines over them. Above Christ's head a semicircular segment
of blue heaven fills the space down to the edge of his
nimbus, and this segment is overlapped by a red sun-disk
at the left, only partially preserved, and a blue moon-disk
at the right. Both disks contain frontal faces which are
turned slightly outward and from which rays issue. Angels
with spread wings lean over each arm of the cross; both
wear yellowish tunics and blue mantles and spread their
hands in gestures of astonishment.

At the left stands the Virgin, dressed in a blue tunic
and a purple brown maphorion and wearing the imperial
red shoes. Her right hand extends toward Christ while
with her left she covers her cheek in an expression of sorrow.
Opposite her stands John, clad in a blue tunic with red
clavi and an ochre olive mantle. His head, framed by white
hair and a full white beard, is inclined, and the traces of
color around his eyes suggest that he looked downward,
while with two fingers of his right hand he points upward
to Christ on the cross. With his uncovered left hand he
holds a squarish, thick codex with a red cover that suggests
a leather binding. Both figures have yellow nimbi as
substitutes for gold ones, outlined in black and white.

The three figures are placed before a mountainous
landscape which is sharply divided into three color zones:
a green groundstrip with yellow striations that suggest
vegetation (cf. no. B.31); a mountain zone in blue, reflecting
the classical tradition where colors change under atmo-
spheric conditions; and a zone of intense red, in which
there are also lines indicating mountain ridges. A pinker
red would have suggested a sunset in the classical tradition,
but this association is no longer preserved in our icon and
color is used in a more purely decorative way.

Above the Virgin's nimbus the inscription in monogram
form written in black letters reads H ΑΓΙΑ ΜΑΡΙΑ, the
typical preiconoclastic epithet (cf. nos. B.27, 28, 36). The
inscriptions of Christ and John are lost. Across the segment
of sky the inscription H CT[ΑVΡω) CIC can be made out.
It is written in rather small red letters and in a style some-
what different from that of the Virgin's monogram, and
therefore may well be later.

According to our present knowledge this is the earliest

[1] Omont, *Miniatures*, p. 13 and pl. XXI.

Crucifixion icon in existence. Iconographically the colobium-clad Christ fits well into the preiconoclastic tradition, especially of Palaestine. Moreover the icon is one of the earliest examples of the Christ standing on a suppedaneum. This motif appears on the enamel and niello Crucifixions of the so-called Fieschi-Morgan Staurothek in New York[2] and on the numerous niello crosses that belong in the Syro-Palaestinian realm.[3] Although their date is uncertain, they seem to belong to roughly the same period and artistic province as our icon. A novelty is the introduction of the busts of angels over the crossarms. There are four such busts in a fresco at S. Giovanni e Paolo in Rome that has been dated in the ninth century.[4] But since such angels already appear in eighth-century Latin manuscripts of the pre-Carolingian period such as the sacramentary of Gellone and the Irish Gospels in St. Gall[5]—manuscripts that presuppose an older Eastern tradition—their appearance in our icon does not contradict the early date we should like to assign to it. A unique feature is the representation of John under the cross as an old man.[6] He turns to the beholder and points with two fingers at Christ, prefiguring the John under the cross in the mosaic of Daphni,[7] which thus

reflects on these two points a preiconoclastic type, although in the mosaic he is no longer bearded.

The thickset proportions and the rough rendering of the highlights relate to the icon of the Three Hebrews (no. B.31). Yet the Virgin of our icon is slightly more abstract and ornamentalized and her facial expression somewhat more conventionalized. In these respects there is a closer affinity to the four saints on the triptych wings (no. B.33) with which it shares a small ornamental detail, the dotted pattern left and right of the clavi of the Virgin and St. Nicholas. We assume a seventh- or eighth-century date for our icon, i.e. somewhat closer to the triptych wings than to the Three Hebrews icon, and it surely belongs to the same center of production, which we believe to be Palaestine.

Bibl.

Sotiriou, *Icones* I, fig. 24; II, pp. 38–39.
H. Skrobucha, *Meisterwerke der Ikonenmalerei*, Recklinghausen 1961, p. 61 and pl. III.
R. Haussherr, *Der Tote Christus am Kreuz* (Diss.), Bonn 1963, p. 129.
K. Wessel, *Die Kreuzigung*, Recklinghausen 1966, p. 34 and fig. on p. 36.

[2] M. Rosenberg, *Geschichte der Goldschmiedekunst* IV. *Niello bis zum Jahre 1000 nach Christi*, Frankfurt 1924, pp. 61ff.

[3] K. Wessel, "Die Entstehung des Crucifixus," *Byz. Zeitschr.* LIII, 1960, pp. 97ff.

[4] P. Germano, "Die jüngsten Entdeckungen im Hause der HH. Johannes und Paulus auf dem Coelus," *Röm. Quartalschr.* V, 1891, pp. 290ff. and pl. VII.

[5] P. Thoby, *Le Crucifix des origines au Concile de Trente*, Nantes

1959, p. 32 and pl. X,22–23.

[6] Sotiriou pointed to a similar case in the tradition of the Metamorphosis representation, namely a miniature in the Gregory of Nazianzus in Paris, Bibl. Nat. gr. 510 (Omont, *Miniatures*, pl. XXVIII) that also shows John with white hair and beard. There is good reason to believe that this representation is based on a preiconoclastic model. For some early examples, cf. Wessel, op. cit., p. 105 n. 49.

[7] E. Diez and O. Demus, *Byzantine Mosaics in Greece. Hosios Lucas and Daphni*, Cambridge, Mass. 1931, fig. 99.

B.33. PAIR OF TRIPTYCH WINGS. PLATES XXIV AND LXXXV–LXXXVII
ST. PAUL, ST. PETER, ST. NICHOLAS AND ST. JOHN CHRYSOSTOM
ABOUT SEVENTH–EIGHTH CENTURIES
GALLERY. GLASS CASE

H. 41.5 cm; W. (left wing) 13 cm, (right wing) 13.2 cm. The two panels are damaged at their outer corners where once dowels existed and their outer edges are rounded, both features providing evidence that the panels are the wings of a triptych. When the two wings were later mounted into a modern frame, their positions were reversed. The surface is in fairly good condition, showing damage and abrasions in comparatively few spots. The backs of the wings are blank.

Each wing is divided into two zones, the upper occupied by the two princes of the Apostles and the lower by two prominent church fathers. Each figure stands in frontal position in a slightly swaying pose in front of a low, olive-colored wall with a niche. These walls are decorated with what look like slit windows and they terminate in cornices; all these ornamental features and highlights are colored in light ochre. Such niches are quite common in miniatures with Evangelist portraits where the context suggests a derivation from the proscenium wall of the Roman theatre.[1]

Peter, inscribed +O ΑΓΙΟC ΠΕΤΡΟC, in ochre letters on a dark blue ground and dressed in a blue tunic with red clavi and a carmine mantle, holds a scroll with both hands and in addition carries firmly in his left a pair of keys on a large ring. The big head with its white hair and beard is thickly painted in chestnut-colored outlines,

[1] K. Weitzmann, *Geistige Grundlagen und Wesen der Makedonischen Renaissance*, Cologne 1963, p. 25 (repr. "The Character and Intellectual Origins of the Macedonian Renaissance," *Studies*, p. 196).

as is the face where black lines are also used for the brows. In both panels, gold is used for the nimbi, which are surrounded by thick chestnut-colored lines. Paul, inscribed + O AΓIOC ΠAVΛOC, stands firmly on his left leg, balancing the figure of Peter who rests his weight on the right. Also for the purpose of balance, the colors of the garments are exchanged: Paul wears a carmine tunic with black clavi and a blue mantle. In his left hand, he firmly holds a thick codex which he touches with the other hand. The red cover, jewelless but with an ornamental design in gold (mostly flaked), suggests a leather binding with an ornamental pattern typical of pressed leather. The facial colors are the same as Peter's except that the beard and the thin hairline around the bald head are black.

At the lower right stands John Chrysostom, inscribed + O A(ΓIOC) ÏωANNHC O XPVCOCTOMOC, holding a similar codex in the same pose as Paul. He wears an ochre tunic with folds shaded in olive, carmine clavi, decorated in two places by a dot pattern, and a carmine phelonion. The omophorion slung over the left shoulder is decorated with carmine quadrifoil crosses. The face is framed with short black hair and beard. His companion is St. Nicholas, inscribed +O AΓIOC NIKOΛAOC, whose pose and garments correspond to his exactly, except that the stance and the colors are reversed. A slight variation occurs in the gestures of the right hands: one touches the codex and the other blesses, and a most obvious contrast is Nicholas's white hair and pointed beard.

Whereas the facial features of Peter and Paul correspond to the established types formulated in the Early Christian period, both John Chrysostom and Nicholas deviate markedly from their accepted types of the posticonoclastic period. The familiar portrait of John Chrysostom shows him with a very high forehead and exaggerated emaciated features, especially hollowed cheeks, while in our icon his face is round with no suggestion of the ascetic. A close parallel to our type occurs, however, in the Paris manuscript of the Sacra Parallela of John of Damascus, cod. gr. 923 (fig. 24)[2] where it appears more than seventy times. This manuscript dates in the ninth century and may have been written during the iconoclastic period, probably in the Sabas monastery near Jerusalem, and its extensive picture cycle clearly reflects a preiconoclastic tradition. Although

more stylized and obviously somewhat later than our icon, both manuscript and icon represent the same preiconoclastic Palaestinian tradition.

Even more unusual is the portrait of Nicholas. The accepted type shows him with a high forehead, a little spiral lock at its peak, and a round, indented beard. In contrast, the Nicholas of our icon shows the hair pressing down onto the forehead and a pointed beard. The only other example of an early Nicholas portrait is the rather stylized bust in cloisonné enamel on the Fieschi-Morgan Staurothek in the Metropolitan Museum, which has been variously dated between the seventh and ninth centuries.[3] Here the short rounded beard already shows rather a closer relationship to the post- than to the preiconocloastic type, of which our icon, at the present state of our scholarship, seems to be the only survivor.

Sylistically the figures are closely related to the icon of the Three Hebrews (no. B.31) in design, color, use of highlights, and in other respects, but their execution, although with no loss of expressiveness, is somewhat coarser. The proportions of the figures are thicker set, the heads especially are disproportionately large, and the bodies tend to be flattened within straight outlines. These are features well known from Coptic art, and yet we do not believe that out icon could be a product of Egypt under Coptic influence. In contrast to the frescoes of Bawit,[4] to cite a typical, more or less contemporary example, the icon figures show a greater vividness in the use of highlights, and the eyes a sharper focus on the outside world, as opposed to the blank gaze of unawareness that is typical of Coptic works. Like the closely related Three Hebrews icon, we believe our pair of wings to belong to the Palaestinian school, but to a somewhat later period, about the seventh to eighth centuries, a time when Palaestine and Egypt were both under Moslem rule and had developed closer ties in artistic matters.

Bibl.

Soriou, *Icones* I, figs. 21 and 23 (color); II, pp. 36ff.

K. Weitzmann, "Some Remarks on the Sources of the Fresco Paintings of the Cathedral of Faras," *Kunst und Geschichte Nubiens in Christlicher Zeit*, Recklinghausen 1970, p. 332 and fig. 332 (John Chrysostom).

Idem "Loca Sancta," p. 50 and figs. 41 and 45.

[2] Weitzmann, *Byz. Buchmalerei*, pp. 80ff. and pl. LXXXVI. I no longer consider the place of origin to have been Italy, as was here suggested. In the meantime André Grabar (*Les Manuscrits grecs enluminés de provenance italienne IXe–XIe siècles*, Paris 1972, pp. 21ff.) has defended my original attribution to Italy. Weitzmann, "Loca Sancta," p. 51 and fig. 44.

[3] O. M. Dalton, "Byzantine Enamels in Mr Pierpont Morgan's Collection," *Burlington Magazine* XXI, 1912, pp 65ff and pl. VI (St.

Nicholas is reproduced in fig 6 of pl VI); M. Rosenberg, *Geschichte der Goldschmiedekunst. Zellenschmelz* III: *Die Frühdenkmäler*, Frankfurt 1922, pp. 31ff. and figs. 53–57; K. Wessel, *Byzantine Enamels*, Shannon 1969, p. 42 and fig. 5.

[4] J. Clédat, *Le Monastère et la Nécropole de Baouit* (Mémoires. L'Institut français d'archéologie orientale du Caire), Cairo 1904–1906, 1909, 1916.

B.34. RIGHT WING OF THE SAME TRIPTYCH AS NO. 35. PLATE LXXXVIII
ST. JOHN THE EVANGELIST
SEVENTH–EIGHTH CENTURIES
OLD LIBRARY

H. 23.4 cm; W. 8.7 cm. The plaque is rounded at its left edge as is typical of right wings of triptychs and the damage at the upper and lower left corners can be explained by the fragility of the dowles connecting the wings to the central plaque, which easily break off. The right side, damaged at the top, is cut obliquely along its edges so that it fits tightly when closed with the left wing, also cut obliquely. More

than half of the surface is flaked and the remaining areas are badly rubbed, yet the essential features of the figure, which tightly fills the frame, can still be made out.

The back shows traces (mainly the horizontal bar) of a green cross corresponding to the somewhat better preserved cross on the back of icon no. B.35.

At the ends of the bar and at its intersections with the vertical stem there are big knobs painted in red; above the bar there is a steeply arched line which, however, does not continue below. The background is painted in a whitish grey and surely once bore an inscription (cf. its companion piece no. B.35).

In frontal position but turned slightly to his right is a bearded saint clothed in a red tunic with broad white highlights and black clavi and in a grey violet mantle. His heavy feet, standing firmly on a strip of green ground, are bare. His pink face is framed by grey olive hair and beard with white hairlines. The massive head is set against a gold nimbus outlined in brown, white, red, and black. His left hand holds a codex bound in red leather, patterned with a diamond and circles, while the attitude of the right hand is not absolutely clear. If I interpret certain brushstrokes

correctly, it is held before the breast and points at the book without touching it. A red border, set off by a black line, frames the panel.

Set agains a neutral grey green ground left and right of the nimbus are huge letters of a partly flaked inscription which I reconstruct:

$$\therefore \quad O \ A\Gamma IOC \ [I\omega AN]NHC.$$

Of the letters at the left only the underpaint is discernible while the final letters of John's name at the right are in gold. It may be observed that the inscription begins not with the customary cross, but with a dotted rosette.

Icon no. B.35, the left wing of our triptych, is even less well preserved, but clearly shows traces of a female saint turned in the opposite direction. This must be the Virgin and her pairing with John can only mean that the lost central panel represented Christ on the cross. In established Byzantine iconography John under the cross is depicted as youthful, yet a precedent for this white-bearded type is found in a slightly earlier Sinai icon (no. B.32) which—it may not be coincidental—belongs to the same workshop tradition.

The triptych we have thus reconstructed with Christ on the cross occupying the central plaque and the Virgin and John on the wings is rather unusual in that normally the Virgin and John share the central plaque and stand directly under the cross while the wings are filled with other saints. Such a composition is found in a great number of tenth-century ivory triptychs of which, in most cases, only the central plaque is preserved,[1] while in the few complete triptychs various saints appear on the wings.[2] It does not seem likely that the space under the cross in the missing center panel of our triptych was left empty, and I think it most probable that Longinus and Stephaton were depicted there in somewhat smaller scale, as they appear on two ivory plaques in Munich and Baltimore.[3] In these ivories the Virgin and John stand next to, and not underneath, the cross, and one can easily imagine how such a composition could be divided and distributed over the three panels of a triptych.

Stylistically the figure of John has the closest affinity to the four saints of the triptych wings no. B.33. He shares with them the heavy proportions, a bold brush technique, and such minor details as the pattern of the red book, the four identical nimbus outlines, the use of gold only for the nimbus and the inscription—details which may be understood as workshop devices. We thus propose the same seventh–eighth century date, and consider the plaque a product of the same Palaestinian workshop tradition.

[1] Goldschmidt and Weitzmann, *Byz. Elf.* II, pls. II, 6; VIII, 25–27; IX,28a; XVII,40; XXXIII,83; XXXIX,101–102; XL,103–108; LIV,156; LVIII, 172; LXIV,194.

[2] Ibid., pl. XV,38a; XVI,39; LIV,155a.

[3] Ibid., pl. VI, 22a and XLIV,117.

1. Reverse of Icon B. 1

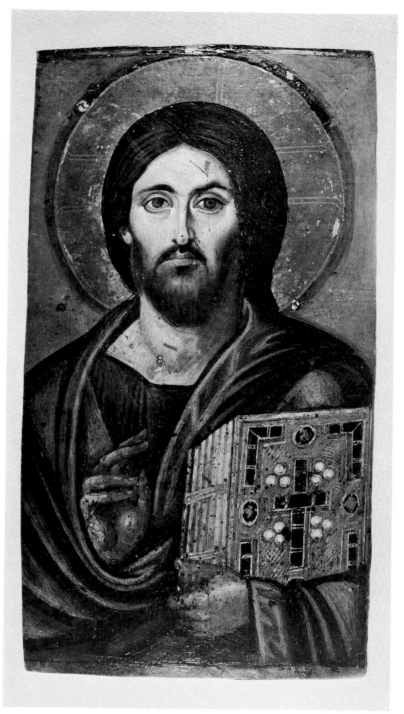

2. Icon B. 1 before cleaning

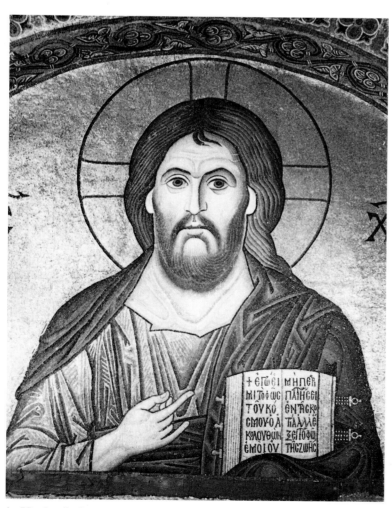

4. Hosios Lukas. Narthex. Mosaic: Bust of Christ

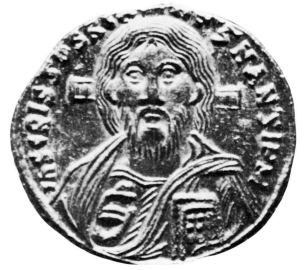

3. Washington, D.C. Dumbarton Oaks.
Solidus of Justinian II

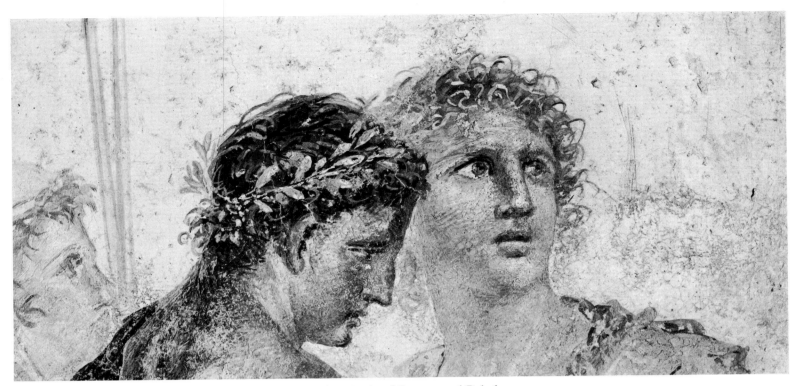

5. Naples. Museo Nazionale. Pompeian Fresco (detail): Heads of Orestes and Pylades

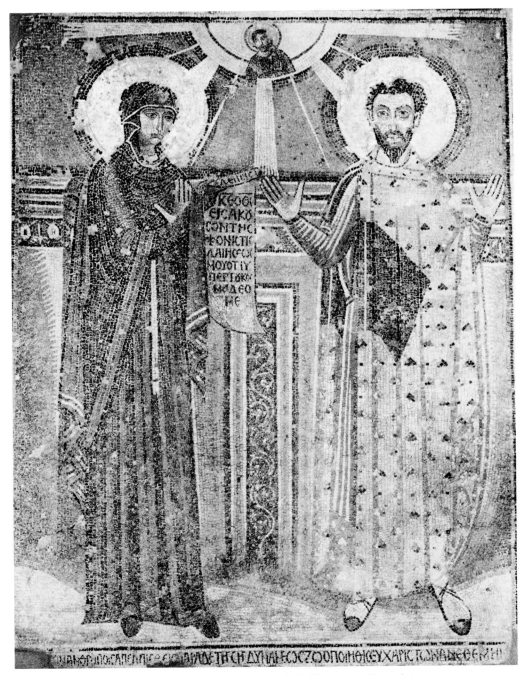

6. Salonika. St. Demetrius. Mosaic: Virgin and St. Theodore Stratelates

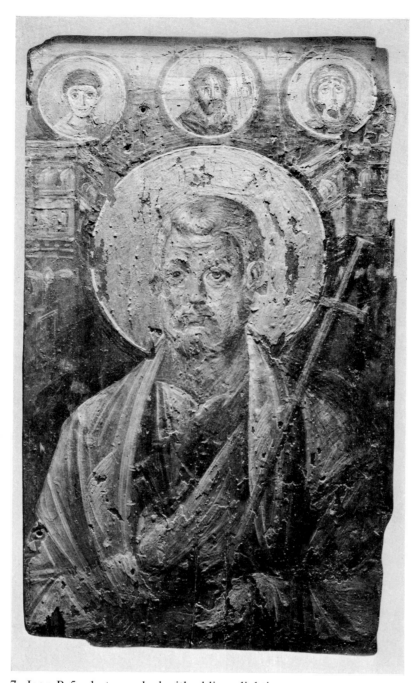

7. Icon B.5, photographed with oblique lighting

8. Sinai. Apse mosaic: Head of St. Peter

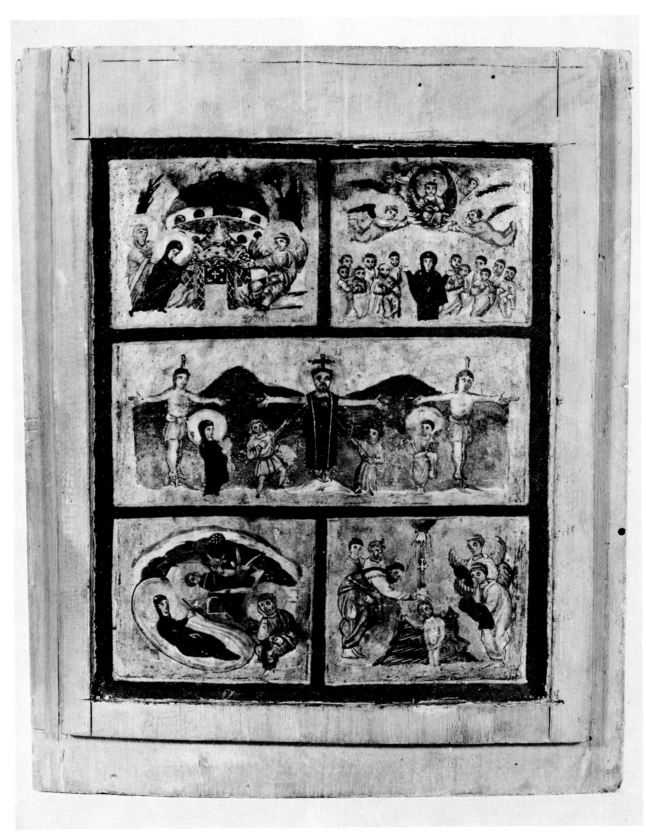

14. Vatican. Museo Sacro. Lid of reliquary box: Scenes from the Life of Christ

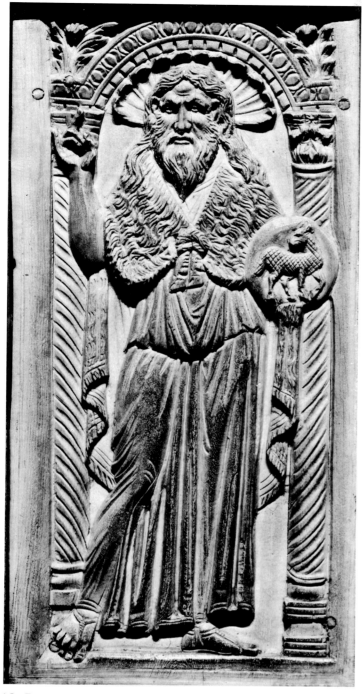

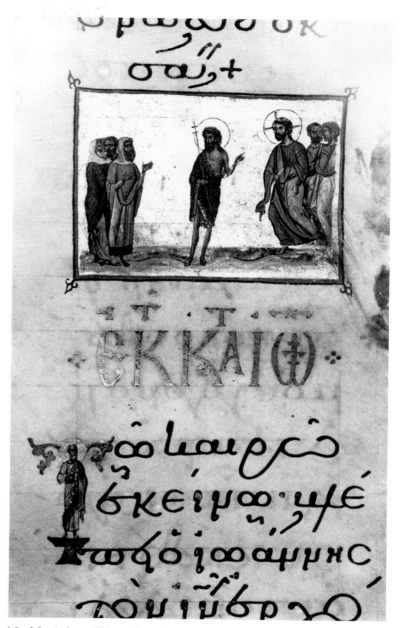

16. Mt. Athos. Dionysiu. Cod. 587. Fol. 142r: John the Baptist preaching

15. Ravenna. Archepiscopal Palace. Cathedral of Maximianus: John the Baptist

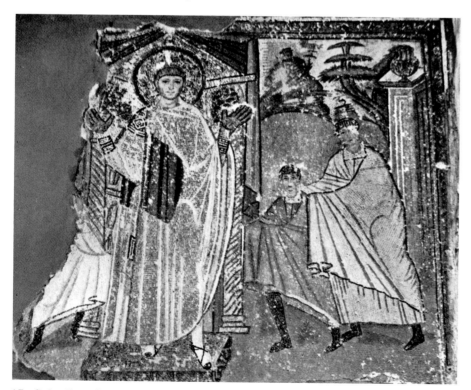

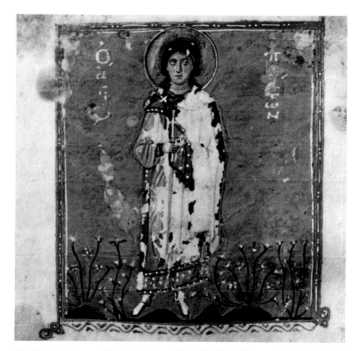

18. Mt. Athos. Dochiariu. Cod. 5. Fol. 48v: St. Platon

17. Salonika. St. Demetrius. Mosaic: St. Demetrius with donors

19. Paris. Bibliothèque Nationale. Cod. gr. 74. Fol. 167r: Title miniature to Gospel of St.John

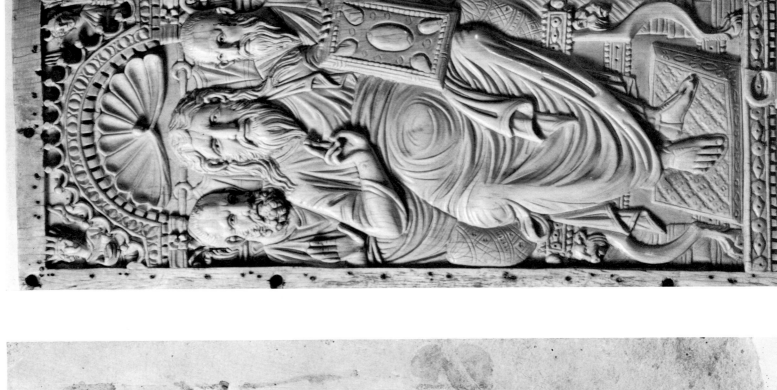

20. Berlin. Staatliche Museen. Ivory: Christ enthroned

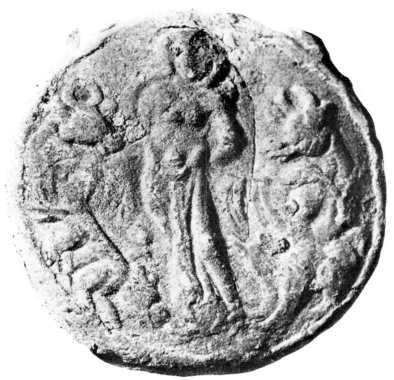

21. Ampulla with St. Thecla

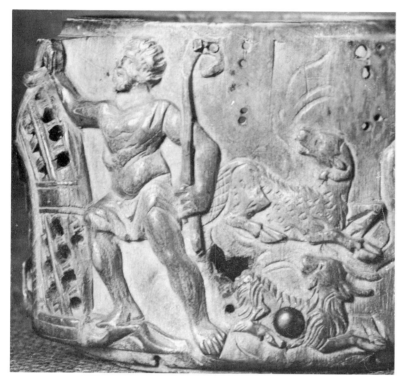

22. Werden. Abbey Church. Ivory pyxis: Shepherd from the Nativity

23. Ravenna. Museo Nazionale. Ivory. Murano diptych (detail): The Three Hebrews in the Fiery Furnace

24. Paris. Bibliothèque Nationale. Cod. gr. 923. Fol. 102r: St. John Chrysostom

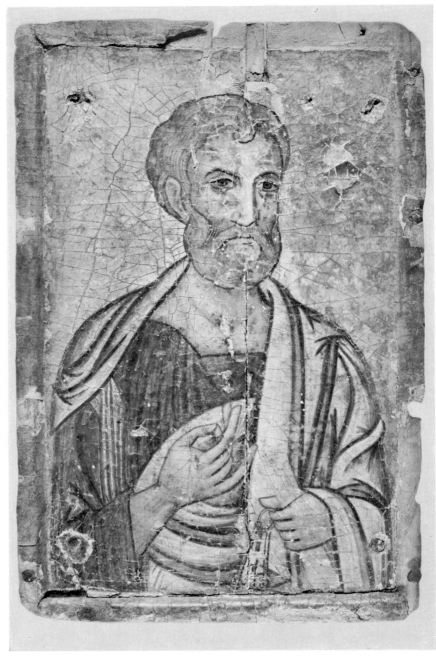

25. Sinai. Icon: St. Peter

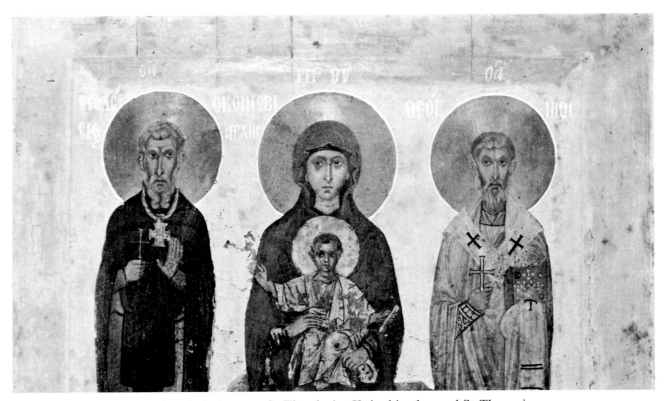

26. Sinai. Icon (detail): The Virgin between St. Theodosios Koinobiarches and St. Theognios

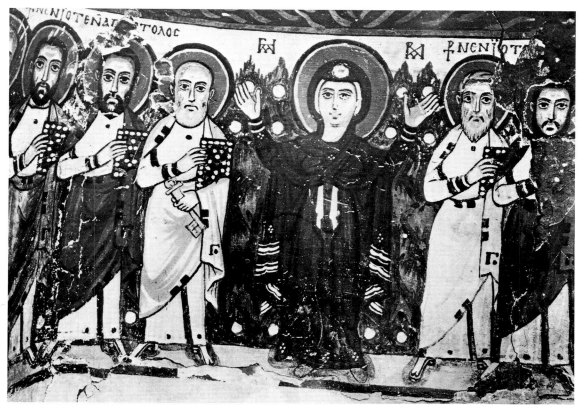

27. Bawit. Chapel XVII. Fresco (detail): Ascension

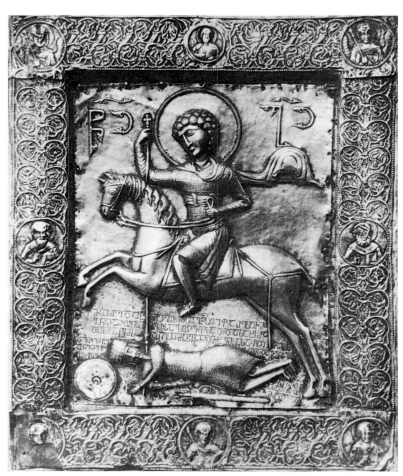

28. Nakipari (Georgia). Silver icon: St. George

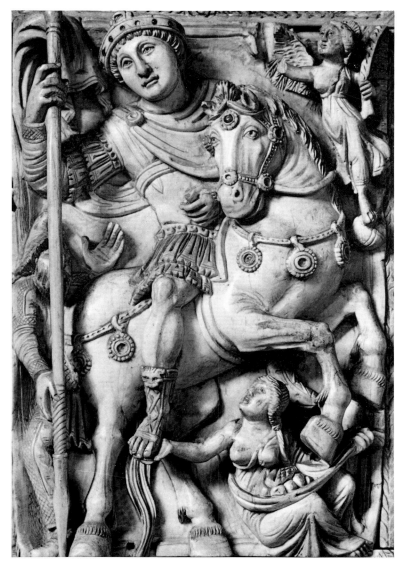

29. Paris. Louvre. Ivory. Barberini diptych (detail):
Anastasios I or Justinian I

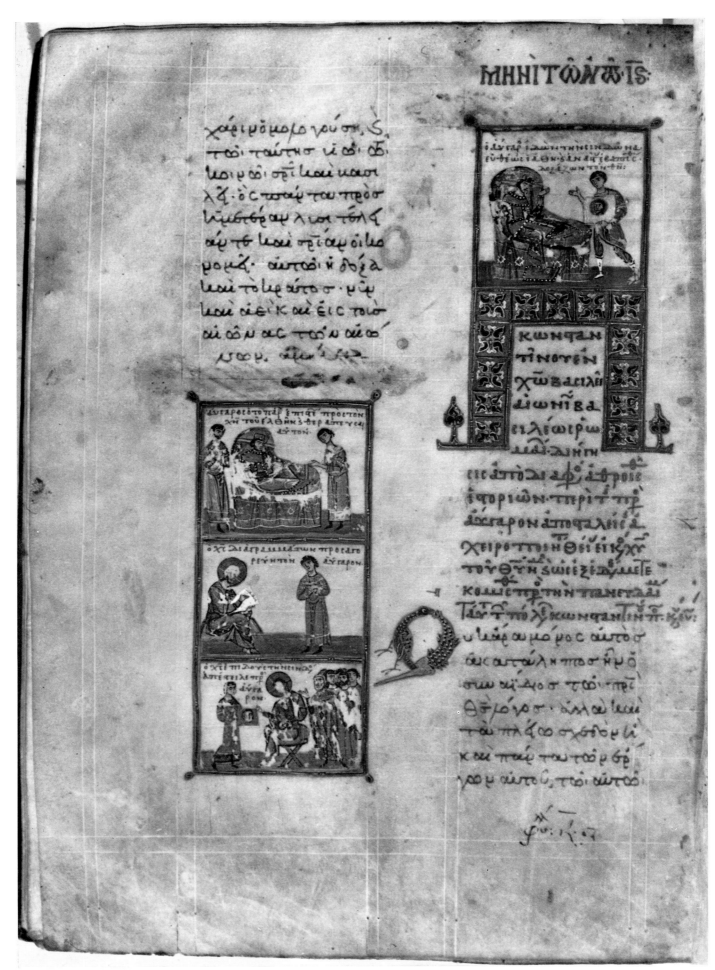

33. Moscow. Historical Museum. Cod. 382. Fol. 192v: King Abgarus and the Mandylion

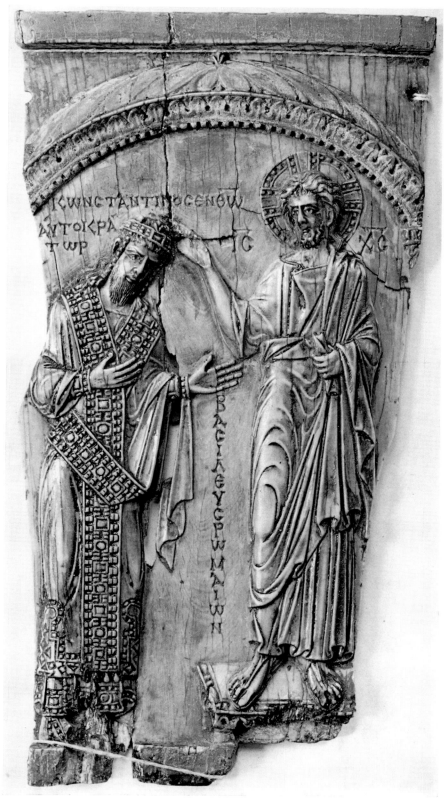

34. Moscow. Pushkin Museum. Ivory: Christ crowning
 Constantine VII Porphyrogennetos

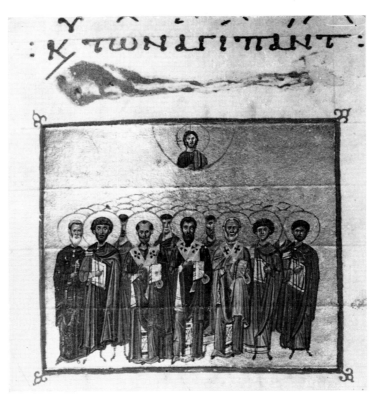

35. Mt. Athos. Dionysiu. Cod. 587. Fol. 40v: All Saints

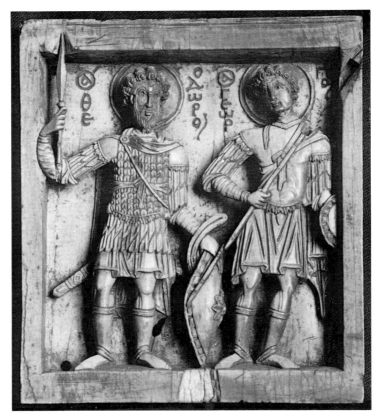

36. Venice. Museo Archeologico. Ivory: St. Theodore
 and St. George

B.35. LEFT WING OF THE SAME TRIPTYCH AS
NO. 34. PLATE LXXXVIII
VIRGIN
SEVENTH–EIGHTH CENTURIES
OLD LIBRARY

H. 23.3 cm; W. 9.8 cm. This wing is about 1 cm wider than its companion piece (no. B.34), or as much as the overlap of its oblique outer edge over the other wing when the triptych is closed. At the upper left a corner has been broken off, while at the upper right a stump of the dowel remains. As is usual, its inner edge is rounded. On both sides only a small part of the painted surface is preserved, and almost nothing is left down the middle.

All that can be recognized on the front is a female figure turned, from the beholder's viewpoint, to the right, her left hand extended with outstretched fingers. The evidence provided by the plaque itself does not suffice to identify this figure; only the fact that the corresponding wing represents John the Evangelist leaves no doubt that it is the Virgin, turning to Christ on the cross, who we assume occupied the lost central plaque. Presumably her

right hand was raised toward her cheek in a gesture of mourning (cf. no. B.32). Her tunic shows traces of carmine red and the mantle traces of blue, reversing the colors normally used for the Virgin's garments. Her nimbus is rather large and, as in the plaque of St. John, it retains traces of gold.

The back has a green cross, identical to that of the other wing but slightly better preserved. Due to the narrowness of the wing, the cross bar is unusually short in comparison to the vertical bar of which the length can still be judged by the red knobs at its upper end and the height of the oval arch that frames the upper half of the cross. In the spandrels one reads in black letters on white ground the inscription $\overline{\text{IC}}$ $\overline{\text{XC}}$ which continues within the arch $\overline{\text{NI}}$ $\overline{\text{KA}}$ and underneath the cross bar CTAVPO[C] XPICTI[ANOC?]

The harsh design of the Virgin's hand, the only feature by which to judge the style, may be compared with the only slightly more articulate hands of the two monks on icon no B.37 and the still rougher design of the Virgin's hand on icon no. B.40; both icons are in the same Palaestinian workshop tradition.

B.36. ICON. PLATES XXV AND LXXXIX–XC
CRUCIFIXION
EIGHTH CENTURY
GALLERY. GLASS CASE

H. 46.4 cm; W. (at the widest point) 25.5 cm; thickness 1.1 cm. The badly damaged panel consists of four pieces of wood. As frequently occurs, there is a split through the middle, the result of warping, and the two parts are held together by metal strips hammered around the edges, a method often used by the monks. A second split runs through the figure of the good thief and down the side of the Virgin. A third split separates a piece with the figure of John and it has been crudely reattached with wire. A narrow strip with most of the lateral border has split off at the left side, while at the right, a major portion is missing including the figure of the bad thief. To give the impression of the original dimensions, the right-hand portion has been set against a wooden panel. This was probably done by Father Pachomios, who also drew a few lines on the panel to suggest the full outlines of the figure

of John. In spite of the primitiveness of these restorations, it is to the monastery's credit that it tried to preserve every scrap of an old icon. As the border around the picture is unpainted, there must originally have been nailed upon it a specially cut frame, painted and possibly adorned with an inscription (cf. nos. B.16 and 31). The medium is tempera.

Christ is clad in a red brown instead of a purple colobium, which is adorned with golden clavi, and he stands erect on a suppedaneum. His straight arms are nailed to a rather narrow brown cross outlined in red, the crossbar of which is rounded at the end, a rare feature having a parallel in the earlier Sinai Crucifixion (no. B.32). The head with its short, rounded, brown beard does not quite fit either of the two traditional types as they are distinguished in the miniatures of the Rabula Gospels and elsewhere.[1] The unusual features of Christ's face are the closed eyes and the fillet with three golden crosses in the hair which, unquestionably, is meant to depict the crown of thorns. The flesh color of Christ as well as that of the other figures is a rather homogeneous whitish color with brown contours and brown interior design. While blood flows from all of

[1] A. Grabar, *L'Iconoclasme byzantin*, Paris 1967, p. 43 and figs. 78–79.

Christ's wounds, the very pronounced blood stream from the side wound is paralleled by a stream of water, both of which collect on the top of the mountain on the left. In the upper spandrels there were originally four busts of angels, two at either side, of which one at the right is now lost. These angels wear light blue tunics and light brown mantles, colors that are repeated in their wings. But contrary to the earlier icon (no. B.32) where these busts are above the crossbar as if leaning upon it, here they are raised and arranged on a diagonal to give the impression that the angels have flown down from heaven. The earlier form of the busts is in no way changed and they seem to be flying merely because of their position. All the nimbi are yellow but have a few traces of gold, and those of the three main figures are distinguished by a pearl pattern on the red outline. Lack of space did not permit a segment of sky to be shown top center, and the sun, usually depicted in this spot (cf. no. B.32), has been moved to the left side. The disk encloses a fiery red, frontal face from which rays are directed toward the center rather than away from it. The corresponding moon is lost and probably resembled that of the earlier icon no. B.32, which is blue and also has a frontal face.

The artist used four different scales for the human figures, grading them according to their importance. The Virgin and John are about a head shorter than Christ. The Virgin wears red shoes and is clad in a red tunic and a brown maphorion, a color which, like that of Christ's colobium, substitutes for purple. While her right hand is held in a rather stiff pose before her, she lifts her left holding a handkerchief and points at her cheek. Perhaps the artist wanted to suggest that the kerchief was for wiping away tears, but he obviously did not succeed in conveying an expression of sorrow. The youthful John, looking up towards Christ, wears a light blue tunic and a light pink mantle with carmine folds; his right arm rests in a sling of the mantle while his left is buried in its folds. This latter gesture is quite unusual, for John in other Early Byzantine monuments of this type of Crucifixion normally carries the Gospel book, as in some Palaestinian monuments like the Monza ampullae[2] and the painted cover of the reliquary box in the Sancta Sanctorum in Rome (fig. 14).[3]

The thief that has survived at the left is a head shorter than the Virgin and John. An elbow and the end of the bar of the cross are all that remain of the one on the right;

these indicate that this figure must have been a symmetrical counterpart of the other one. The youthful thief, with long hair falling upon the shoulders, is dressed in a short loincloth of a light pink color. The indication of the breasts as female and the long hair are so pronounced that it seems obvious that the painter wanted to represent the bad thief as a woman. The proof of this rests on a slightly later Crucifixion icon (no. B.50) where the female breast is even more pronounced and in strong contrast to that of the other thief. This thief is crucified in a peculiar manner by having his or her arms bent back over the bar of a T-shaped cross and supposedly fettered. Here the artist uses a third type of the crucifixion, unlike that of the two early Palaestinian monuments mentioned above but having a parallel in icon no. B.50.

Finally there are, rendered in diminutive size, the three soldiers casting dice; they are sitting on the ground at the foot of the cross, the end of which is tapered and driven like a spike into the ground. It is tempting to compare these soldiers with those of the miniatures of the Rabula Gospels,[4] the most prominent example of East Christian art with the same motif. This comparison shows again more striking differences than similarities as far as the general arrangement is concerned. While all three soldiers are bearded in the miniature, in the icon only the central one, clad in red, has a short dark beard. The youthful one at the left is clad in a pink tunic, and the one at the right wears one of light blue color. These two soldiers carry the black swords of the Rabula Gospels, but, in addition, each of the three has a shield. The shield of the soldier on the left is lying on the ground and is dark carmine in color; the one in the center, thrown around the shoulder, is light pink, and the fiery red shield at the right is visible behind that soldier's back. Moreover, each soldier has his lance stuck into the ground.

The crucifixion is placed in a gorge between two rocky mountains that are rendered, in the conventional manner, like piled-up cubes of basalt; crags encompass the soldiers to the left and right and higher ones frame the Virgin and John. The background now appears very dark blue, yet it seems very doubtful that the artist had tried to suggest the darkness mentioned in Matt. XXVII:45 and Luke XXIII:44; it is more likely that the blue has considerably darkened under the influence of varnish and that it was meant to suggest the normal blue of the sky.

[2] A. Grabar, *Les Ampoules de Terre Sainte*, Paris 1958, pls. XIV, XVI, XVIII.

[3] H. Grisar, *Die römische Kapelle Sancta Sanctorum*, Freiburg 1908, pp. 113ff. and fig. 59; C. R. Morey, "The Painted Panel from the Sancta Sanctorum," *Festschrift Paul Clemen*, Düsseldorf 1926, pp. 151ff.

[4] C. Cecchelli, I. Furlani, M. Salmi, *The Rabbula Gospels*, Olten and Lausanne 1959, pl. fol. 13a.

Above the tabula ansata we read the inscription O ΒΑCΙΛΕVC ΤΟΝ (sic) ΗΟV|Δ[ΑΙωΝ]. The letter Δ, however, is placed on the tabula proper and came to light only after the flaking of a gold surface, which therefore must have been added as an afterthought. Of the inscription of Christ only the ĪC̄ at the left is preserved, while the X̄C̄ is lost. Our icon is the earliest known example with the names of the thieves ΓΕCΤΑC and ΔΗΜ[ΑC] hitherto known mainly from the Middle Byzantine frescoes of Cappadocia.[5] The Virgin is inscribed with the preiconoclastic monogram Η ΑΓΙΑ ΜΑΡΙΑ, known from other early Sinai icons (cf. nos. B.19, 27–28, 32). It is notable that in the inscription ΪωΑΝΝΗC the Ο ΑΓΙΟC is missing, which would not have been the case in later representations of John under the cross.

In the iconographical development of the Crucifixion our icon takes a place of considerable importance. First of all, it is the earliest monument we know today in which the dead Christ is shown with closed eyes, a feature marking a new trend that emphasizes that the human suffering of Christ has just ended. Similarly it is the first example that depicts Christ with a crown of thorns; thus, another element of Christ's passion has been pictorialized, although in a very stylized way. Rejecting the thesis of Grondijs that this iconographic element originated in the eleventh century,[6] J. R. Martin[7] and others have pointed at the Pantocrator and the Chloudov Psalters, both to be dated in the ninth century, as the earliest examples of it known to them. The importance of the icon lies not merely in that it permits a revision of the date of the earliest representation of the dead Christ, but in the fact that it establishes that this type existed already during the period of iconoclasm and was not a posticonoclastic invention. The Beltings have associated this type with the writings of Anastasios Sinaites. Here we find the same distinction between streams of water and of blood issuing from Christ's wound, a feature of which the fresco in S. Maria Antiqua in Rome cited below was hitherto considered to be the earliest example.[8]

While the poses of the Virgin and John were somewhat conventional, a variety of types for the two thieves existed in Early Christian art. The Monza ampullae include no fewer than three: one in which the arms are held sideways and fastened to the crossbar,[9] a second in which only the hands are thrust to the side,[10] and a third which shows, as does our icon, the hands tied behind the back.[11] It is significant that only this third type is associated with the figure of Christ clad in a colobium, whereas types one and two show the thieves flanking a cross with only a bust of Christ on top of it. There must therefore have been several types current in early Palaestinian art, and our icon is related to the one in which the thieves flank the colobium Christ; this, in all probability, is the latest of the three Palaestinian types.

Stylistically, our icon has all the trademarks of the Palaestinian group. The faces with their piercing eyes correspond to the icon of the Chairete (no. B.27). Christ has the same golden diamonds adorning his mantle; the dotted outline of the nimbi is another common characteristic; the palaeography of the Virgin's monogram is identical and so is the covering of the background with rosettes of four dots. In addition, the color scheme, emphasizing red brown shades, is typical of the Palaestinian school. At the same time, a comparison with the Chairete icon indicates that ours is a somewhat later product. Its figures are more thickset and characterized by a certain immobility, the more rounded faces are less expressive, and in the body of the thief in particular there is a fleshiness that obscures the clear structure of the body. The question of how much later is the date of our icon is more difficult to answer. The treatment of the colobium with its long parallel folds receding over the right thigh is similar to the colobium of Christ in S. Maria Antiqua in Rome which can be dated in the period of Pope Zacharias I (741–752). The fleshy faces of the Virgin and John may also be compared. Whether the Roman fresco painter was a Greek, in which case we would assume that he came from Palaestine, or a Roman under Palaestinian influence, is difficult to decide. But the similarities between the two monuments sufficiently justify, in our opinion, a date for the icon not far removed from that of the Roman fresco, i.e. in the eighth century.

[5] G. de Jerphanion, *Les Eglises rupestres de Cappadoce*, Texte I, 1925, p. 224; Album I, 1925, pl. 51 (church of Qeledjlar); M. Restle, *Byzantine Wall Painting in Asia Minor*, Recklinghausen 1967, I, pp. 131ff. and II, fig. 258.

[6] L. H. Grondijs, *L'Iconographie byzantine du Crucifié mort sur la croix*, Brussels (n.d.).

[7] J. R. Martin, "The Dead Christ on the Cross in Byzantine Art," *Late Classical and Mediaeval Studies in Honor of A. M. Friend, Jr.*, Princeton 1955, pp. 189ff.

[8] W. de Grüneisen, *Sainte Marie Antique*, Rome 1911, p. 100 and pl. IC.XVII (color); J. Wilpert, *Die römischen Mosaiken und Malereien IV–VIII Jahrh.* II, p. 687; IV, pl. 180; P. Romanelli and P. J. Nordhagen, *S. Maria Antiqua*, Rome 1964, pp. 36ff., pls. 32, 34–35 and color plate VII.

[9] A. Grabar, op. cit., pls. XIV, XVI, XVIII.

[10] Ibid., pls. XII, XIII.

[11] Ibid., pls. XXII, XXIV.

Bibl.

Sotiriou, *Icones* I, fig. 25; II, pp. 39–41.

K. Wessel, "Frühbyzantinische Darstellung der Kreuzigung Christi," *Riv. Arch. Crist.*, XXXVI, 1960, p. 62.

R. Haussherr, *Der Tote Christus am Kreuz* (Diss.), Bonn 1963, pp. 129ff.

Weitzmann, *Frühe Ikonen*, p. XI, pls. 6–7, pp. LXXIX and XCVIII.

Idem, *Byzantine Art. An European Art, Lectures*, Athens 1966, p. 153 and fig. 117.

Idem, "Various Aspects of Byzantine Influence on the Latin Countries from the Sixth to the Twelfth Century," *D.O.P.* XX, 1966, p. 9 and fig. 14.

Idem, "Eine vorikonoklastische Ikone des Sinai mit der Darstellung des Chairete," *Tortulae, Studien zu altchristlichen und byzantinischen Monumenten. Festschrift Johannes Kollwitz, Röm. Quartalschr.* 30. Suppl., 1966, p. 324 and pl. 83.

H. Belting and C. Belting-Ihm, "Das Kreuzbild im Hodegos des Anastasios Sinaites," ibid., p. 36 and pl. 83.

K. Wessel, *Die Kreuzigung*, Recklinghausen 1966, p. 22 and fig. p. 27.

K. Weitzmann, "The Ivories of the So-Called Grado Chair," *D.O.P.* XXVI, 1972, p. 69 and fig. 42.

Idem, "Loca Sancta" p. 40 and fig. 19.

B.37. RIGHT WING OF A TRIPTYCH. PLATES XXVI AND XCI
FRONT: ST. CHARITON AND ST. THEODOSIOS
BACK: HALF OF A CROSS
ABOUT EIGHTH–NINTH CENTURIES
GALLERY. GLASS CASE

H. 22.2 cm; W. 9.4 cm; thickness 0.5 cm. The plaque is split vertically into two halves crudely held together by sheets of metal nailed around the top and the bottom. Damage caused by dowels in the upper and lower left corners and the rounding of the left edge indicate that we are dealing with the right wing of a triptych. After this montage was damaged, the wings were fastened by metal hinges to the center, as indicated by the two holes at the height of the shoulders of the two figures. Paint has flaked off all around the edges and along the central split, but otherwise the surface is in fairly good condition. A very heavy varnish has had a discoloring effect, turning, for instance, the blue background into dark green.

Bordered all around by a strip of intense carmine are the superimposed busts of two monks. They are depicted in frontal position with their hands raised in a gesture of prayer. The gown of the upper one is red brown with a black fold design, while that of the lower saint has a darker purplish hue with white highlights which are the last remnant of the classical tradition. Both wear black shoulder pieces and the black stole, the megaloschema, decorated with white hem lines and dotted crosses. Their nimbi are yellow, for lack of gold paint, and are outlined in red.

The back is filled with half a cross, the other half of which was on the left wing so that it could be seen as a whole only when the wings were closed. It is painted yellow on a reddish brown ground and has pairs of knobs at the ends of its arms while shoots with similar knobs issue from its center. In all these points it follows the tradition of crosses nos. B.22 and 23, but our cross is, on the one hand, simpler and coarser and, on the other, decoratively more emphatic because the shoots sprout out in oversized lilies and totally fill the spandrels usually reserved for the monogram inscriptions. These inscriptions therefore had to be reduced to $\overline{\text{IC}}$ $\overline{\text{XC}}$, of which only the latter half is preserved, and placed alongside the crossarms.

The monk in the upper half of the front is inscribed O ΑΓ(ΙΟC) ΧΑΡΙΤΟΝΟC and the one in the lower O ΑΓ(ΙΟC) ΘΕѠΔΟCΙΟC. Both are saints from Palaestine. This is, to our knowledge, the earliest extant representation of the holy monk Chariton of Iconium who, after the death of Aurelian, retired to Palaestine and became an abbot there. Theodosios, among the many of this name, is no doubt the one with the epithet "Coenobiarches" who had founded a monastery near the lavra of St. Saba. Sallust, the patriarch of Jerusalem, had appointed him head of all the monks living in monastic communities, while St. Sabas had been made the superior of all hermits living in Palaestine. Thus there is good reason to assume that on the missing left wing St. Sabas corresponded to the figure of St. Theodosios, and in all likelihood the second saint on the missing wing was another of the famous monks of Palaestine; the first name that comes to mind is Euthymios the Great. The subject of the lost central panel can no longer be determined, and it is mere hypothesis that it may have been the Virgin.

The style is that of an artist who has reduced a painterly model to a linear design, simplifying and yet striving for more decorative effects and an expressive characterization. This is especially apparent in the strong black outlines of the faces and the heads, more rounded in the case of Chariton and more angular in that of Theodosios, who also has a longer beard and a more emaciated face; perhaps the

artist wanted to express by such means the fact that Theodosios had died in 529 at the advanced age of a hundred and six. The sharp glance of the saints to the right suggests an acute awareness of the outside world, yet one would have expected them to turn in the other direction, i.e. towards the figure who occupied the center of the triptych. The same piercing eyes occur in other icons that we have attributed to the Palaestinian school (nos. B.27 and 36), although in these instances they are associated with more agile and less stereotyped figures. We would therefore conclude that this triptych wing is also a product of the Palaestinian school, but somewhat later. We propose a date around the eighth to the ninth century. Thus iconographical and stylistic evidence are in full accord. The Sotirious saw some Coptic influence in the busts of the

monks and cited a fresco from the Red Monastery at Sohag as a parallel, but in our opinion this comparison illustrates rather the basic differences between the Palaestinian and the Egyptian styles. In the latter, the figures are still more summary in their outlines, flatter and more thickset, and their huge open eyes gaze straight ahead; i.e. on all accounts the Coptic figures are more abstract and stylized than those of the Palaestinian school.

Bibl.

Sotiriou, *Icones* I, fig. 29; II, p. 43.

H. P. Gerhard, *Welt der Ikonen*, Recklinghausen 1957, p. 65 and pl. IV. 2nd ed., 1970, p. 73 and pl. V.

K. Weitzmann, "The Ivories of the So-Called Grado Chair," *D.O.P.* XXVI, 1972, p. 74 and fig. 47.

Idem, "Loca Sancta," p. 50 and fig. 42.

B.38. TWO WINGS OF A TRIPTYCH (back of a later icon). PLATE XCII
ST. THEODOSIOS AND ST. THEOGNIOS (?)
EIGHTH–TENTH CENTURIES
OLD LIBRARY

H. 49.3 cm; W. 31.3 cm. These two wooden panels once formed the wings of a triptych but they were reused and an icon with the bust of St. Peter, of a date at the earliest in the fifteenth century, was painted on their reverse (fig. 25). At that time both panels were cut at the bottom, so that the feet of the two standing figures were lost. The panel at the right retains its original width of 19.2 cm, but that at the left has been cut at both sides and its width reduced to 12 cm. The wings were apparently reused after the triptych was severely damaged and the central panel probably lost. Two wooden braces were nailed across the panels to prevent the newly painted icon on the other side from warping; this partially destroyed the legs below the knees and almost totally ruined the faces. In the right-hand panel a groove was planed out to hold the upper brace more securely, but in the left-hand panel, where the cutting was shallower, the area of the inscription was spared, thus permitting the identification of the saint. Yet in the area between the braces enough is left of the original paint to determine the types of saints, their poses and attributes, and to judge the style of the painting. This induced a modern restorer, quite surely Pater Pachomios, not only to fill out lacunae in the draperies, but to paint entirely new faces. Of

the old heads not more than a few traces of the foreheads and tips of the beards are preserved.

The monk at the left wears, fastened over his chest, a chestnut-colored gown, the mandyas, revealing underneath the broad embroidered black stole, the megaloschema. In his right hand he holds a simple cross, in this case not meant to be the usual sign of martyrdom, and in his left a huge codex with a golden cover, rendered here in yellow and adorned with precious red and green stones and pearls. What distinguishes this monk from many others is a golden cross on a golden necklace, both, once more, painted yellow. A huge yellow nimbus, outlined in red and white, is set against a blue background on which is written the inscription in unusually small white letters: ΘΕΟΔΟCΙΟC. This is easily explained: the original inscription continued Ο ΚΟΙΝΟΒΙΑΡΧΗC in a second vertical line of which only a trace of the letter alpha at shoulder height is preserved. The Ο ΑΓΙΟC surely was at the left side of the nimbus.

The bishop at the right is dressed in a brown phelonion and an omophorion with large black, petal-shaped crosses. He, too, holds a huge codex of exactly the same type. Of the old inscription only an omikron in the upper left and an iota and omikron at the end are original. Pater Pachomios restored this inscription Ο ΑΓΙΟC ΓΡΗΓΟΡΙΟC Ο ΘΕΟΛΟΓΟC. This reading, however, is questionable because a particular trait of the original face, i.e. the end of the beard, militates against such an identification. The facial characteristics of Gregory were fixed, his beard invariably

slightly parted and rounded. The beard of the bishop of the icon, however, is lyre shaped, not a solid mass but separated into several strands. A likely identification can only be suggested by an instance where Theodosios is associated with a bishop of this type. There is at Sinai an as yet unpublished icon of the twelfth century (fig. 26)[1] that shows the Virgin with Child enthroned and flanked on her right by Theodosios the coenobiarch; he, too, holds a cross in his right hand and, significantly, also wears a golden cross on a golden necklace. At the left of the Virgin stands a bishop with a white beard similar to that of our bishop. He is inscribed O AΓIOC ΘEOΓNIOC, which we therefore believe to be the identification also of the corresponding figure on our panel. St. Theognios was bishop of Bethelia in Palaestine and, thus, is appropriately associated with Theodosios the coenobiarch, likewise a prominent Palaes-

tinian saint. The parallel to the later Sinai icon suggests, furthermore, that the missing center panel of our wings may likewise have carried a representation of the Virgin, presumably also enthroned.

Stylistically the harsh design of the folds, the stiff and thickly outlined hands, the dotted pattern of the megalo-schema, and the preference for red and brown all point to the Palaestinian group and find parallels in the style of the triptych wing with St. Chariton and St. Theodosios (no. B.37). The naturalistic faces of Pater Pachomios obscure the fact that our wings cannot be as early as the sixth or seventh centuries. The Fretsaw ornament of the sleeve and the long epigonation which is visible where the phelonion is lifted by the right arm indicate a later date. We propose a date in the eighth or the ninth century and do not exclude a date even as late as the tenth.

[1] The icon is in the Old Library and measures 22.9 cm × 21.3 cm. The inscriptions are modern (eighteenth century) but the icon has since been cleaned, revealing the original names identical and intact underneath.

B.39. ICON. PLATES XXVI AND XCIII
ST. IRENE
EIGHTH–NINTH CENTURIES
OLD LIBRARY

H. 38.3 cm; W. 24.5 cm; thickness 2.4 cm (with frame 3.7 cm). The surface is fairly well preserved; serious flaking is visible only at the lower left corner where the donor figure is severely damaged. The brown varnish, however, has led to discoloration. A black line sets the picture area off against a border which holds the frame. Both border and frame are painted in red, and the frame, nailed to the border by old, handmade nails, seems to be original.

The saint, in frontal position, is dressed in a chiton originally of blue which has turned green, a maphorion of carmine—a color also used for the broad border of the chiton—and red shoes. She holds in her left hand a hand-kerchief and in her right a black cross of martyrdom. Her nimbus is the only area where gold is used; it is outlined in red and black and adorned with white dots. The saint stands on a small strip of yellow ground and against a green wall which reaches the height of her shoulder. The sky above, also discolored and presumably a light blue originally, is lightest near the nimbus. The inscription, in white letters, reads H AΓIA HPEINH, and apparently

refers to the St. Irene who was martyred under Licinius and whose calendar day is May 4.

At St. Irene's feet, in very small scale, kneels the donor in proskynesis, a black-haired young man, wearing a light brown tunic and a black mantle, who is inscribed NIKOΛAOC [CAB?]ATIANOC.[1]

The figure of the saint is disproportionate, the body being very thickset and the head much too large. Black lines are used to outline the yellowish face and hands and red lines for the eyes, nose, and mouth. The thick black lines on the chiton that resemble clavi are actually groove-like folds. Barely visible are the thin red clavi that cross the knees and are accompanied by sets of six dots, exactly as in the figures of St. Nicholas of icon no. B.33 and the Virgin of no. B.41. There are other features which connect our saint with those Sinai icons that we have attributed to a Palaestinian workshop. Among these are the dotted rosettes on the chiton, similar to those on the garment worn by the Virgin under the cross in icon no. B.36, and the dotted nimbus line which occurs in the same Crucifixion and related icons. To the face of the donor one may compare some of the Apostles in the Ascension icon no. B.42.

The Sotirious compared this icon with that in the Louvre depicting Christ and St. Menas.[2] Similarities do indeed exist in the proportions of the figures and the harsh

[1] While slight traces of the first three letters seem to suggest CAB, the reading, nevertheless, is not assured. In the Sotirious' reading, [. . .]AKANOC, the K is surely incorrect.

[2] Felicetti-Liebenfels, *Byz Ik.*, fig. 26 in color; K. Wessel, *Koptische Kunst*, Recklinghausen 1963, p. 186 and pl. XIV in color.

linear design; even such details as the dotted rosettes and the dots along the clavi find parallels in the figure of St. Menas and also the figures of saints in the frescoes of Saqqara.[3] Yet the connection is in my opinion still closer to a whole group of Sinai icons that for various reasons have been attributed to Palaestine. The eyes of St. Irene, although fixed, do not stare quite so blankly as in the

[3] J. E. Quibell, *Excavations at Saqqara 1906–1907* II, Cairo 1908, pl. XLIV.

Coptic icon. The similarities in both directions, however, make it clear that during the period to which I should like to ascribe our icons, i.e. the eighth to ninth centuries, Palaestinian and Coptic painting were exposed to mutual influences.

Bibl.
Sotiriou, *Icones* I, fig. 32; II, pp. 45–46.

B.40. CENTER OF A TRIPTYCH. PLATE XCIV
HALF FIGURE OF THE HODEGETRIA
ABOUT EIGHTH–NINTH CENTURIES
OLD LIBRARY

H. 18.1 cm; W. 13.3 cm; thickness 0.5 cm. This plaque was surely the center of a triptych. At the top there is preserved—and this is rare—the wooden ledge to which the wings were attached by dowels. On the underside of this ledge at the left the hole for the dowel is clearly visible. It is noteworthy that this ledge, which bears a zigzag ornament, was fastened not by means of nails, but rather by wooden pegs, just as pegs of ivory were used in the similarly constructed ivory triptychs.[1] The lower ledge is lost, but the holes by which it was fastened are visible, and the wood was left unpainted where it was covered by the ledge. While the figure of the Virgin is fairly well preserved, the surface of the Christ figure is quite rubbed and below his blessing hand paint has flaked off in an oval shaped area. The reverse is undecorated.

The Virgin is clad in a light brown tunic and a paenula of dark chestnut color as a substitute for purple. Christ's garments are light brown, but while his tunic has light red highlights, those of his mantle are yellow, obviously imitating gold striation. Christ's oval nimbus is light grey with white crossbars which, like the nimbus proper, are thickly outlined in black. Christ is inscribed $\overline{\text{IC}}\ \overline{\text{XC}}$ and the Virgin in monogrammatic form H ΑΓΙΑ ΜΑΡΙΑ (cf. nos. B.27, 32, 36). The thick, black letters are set against a yellow brown background that fills the upper half of the picture, while the lower half is olive colored, suggesting architecture, most likely a niche as was customary in preiconoclastic icons (cf. nos. B.1, 3, 5). The frame, overlapped slightly by Christ's nimbus, is painted fire red.

[1] Cf. the ivory triptych in Liverpool. Goldschmidt and Weitzmann, *Byz. Elf.* II, p. 66 and pl. LIV no. 155a.

Although not so inscribed, the group has all the characteristics of the type known as the Hodegetria. The Virgin holds her right arm before her breast and her left around the Christ Child, who, however, does not actually sit on her arm but is depicted in a more or less suspended pose. As in many Hodegetria icons, Christ holds a scroll in his left hand and blesses with his right; in addition, one foot is seen *en face* and the other in profile. In all these details the icon reflects the Hodegetria archetype closely.

The poses are rather stiff, the faces without expression, the garments schematically drawn, and the hands and feet of a harsh wooden character. Even so, the icon has preserved the trademarks of the Palaestinian style as indicated by the chalky color of the flesh, the heavy outlining of the facial features, and the color scheme centered heavily on reds and browns. Typical also are the dotted pattern on the Virgin's paenula and in the background as well, and the palaeography of the inscriptions. On all these points the icon may be compared with the Crucifixion plaque no. B.36, and especially with its Virgin figure. But this comparison shows our icon to be of inferior quality and presumably also of a somewhat later date, not so much for reasons of quality but because of an increasingly abstract and decorative tendency, which at the time our icon was made had developed even more strongly in Coptic art. A peculiar decorative effect is produced by the dot ornament on the cap the Virgin wears beneath her paenula. Normally one finds such a dotted pattern on the edge of her nimbus, which is strangely missing in our icon.

Bibl.

K. Weitzmann, "The Ivories of the So-Called Grado Chair," *D.O.P.* XXVI, 1972, p. 79 and fig. 57.
Idem, "Loca Sancta," p. 50 and fig. 43.

B.41. CENTER OF TRIPTYCH. PLATES XXVII AND XCV
NATIVITY OF CHRIST
EIGHTH–NINTH CENTURIES
OLD LIBRARY

H. 32.6 cm; W. 19.7 cm. The plaque once formed the center of a triptych, as is indicated by the wider borders at the top and the bottom with their symmetrically placed holes for the attachment of the wings. A red border frames the picture except for the strips that were once covered by the ledges. At the left side, however, most of the red paint has been flaked away by the turning of the wing. The bottom strip is covered, for unknown reasons, by a piece of old parchment. The upper part of the icon down to the center of the manger is heavily flaked, and smaller spots of flaking may be observed over the entire surface.

The whole width of the rather narrow plaque is occupied by the Virgin on a mattress, which has been placed diagonally in order to fit it within the space. The Virgin lies rather stiffly and holds her hands in front of her without making specific gestures; she is clad in a steel blue tunic, a paenula of carmine suggesting purple, and red shoes. Gold is used only in her nimbus, and in those of Joseph and of Christ. The beige mattress is richly ornamented with circles enclosing rosettes and an allover pattern of rosette petals. The suspended mattress is set against a ground of red masonry which is fused into a coherent unit with the manger. In the front of the manger is a niche; it is mostly flaked but still bears a trace of black as well as two white lines indicating the chains of a hanging lamp that once lighted the deep niche of the altarlike structure (cf. the similar manger in icon no. B.45. The Christ Child lies in swaddling clothes on the black top of the manger; a grey ox leans over its edge from the left and a brown ass from the right. A segment of blue sky is set off by a white outline against the equally blue background, and it surely contained in its center the star of Bethlehem, now flaked away. At the upper right corner, the fragmentary inscription [H] ΑΓΙΑ [M]A [P]IA, in yellow letters can still be made out—one of the latest examples in our group of this form of inscription for the Virgin (cf. icons nos. B.27, 32, 36, 40).

In the foreground, the bathing of the Christ Child by two midwives is represented in the usual manner. The midwife at the left, dressed in a short blue tunic and seated on a carmine-colored rock, holds the Child, inscribed I͞C X͞C, as if she were just letting him down into the chalicelike basin. The Christ Child tries to steady himself by holding onto the bare leg of the woman, who is identified by an inscription in white letters as + CΑΛΟΜΗ. The second midwife, dressed in a long, carmine garment pours water, which the Christ Child seems to be testing for temperature, into the basin, and a large amphora stands on the wavy ridge of the dark green ground, highlighted in yellow. Smaller than the Virgin but larger than the midwives is Joseph, who sits in a pensive mood on a wooden stool in the lower right corner. He is white haired, dressed in a blue tunic and carmine mantle, and inscribed + Ї͠ωCΗΦ in black letters.

The scene is conflated with the adoration of the shepherds, who approach from the left and raise up their heads and hands to the star of Bethlehem. They are both youthful, the one on the left being dressed in a carmine tunic and the other in an olive-colored one, and they hold short staffs. Two miniature-sized white sheep are visible at their feet.

Iconographically there are several features that link this representation of the Nativity with the Early Christian tradition. First of all there is the altarlike manger with niche that appears on the painted lid of the reliquary of the Sancta Sanctorum, a pilgrim souvenir from Jerusalem assignable to the seventh century (fig. 14).[1] The original altar stood in the cave sanctuary of the Nativity Church in Bethlehem, and on the reliquary lid, as well as in icon no. B.45, the altar is, as expected, depicted within a cave, which is lacking in our icon. The wavy groundline that overlaps the manger, and the curved outline of the right side of the masonry indicate, however, that the model must also have included a cave, which the painter, for lack of space, could not develop any further. Another early feature is the youthfulness of both shepherds, common on Early Christian sarcophagi,[2] but rare in Middle Byzantine art, where one of the shepherds is almost always a decrepit old man leaning on a staff.[3] In Early Christian art Joseph is seated on the ground, and repeatedly in Middle Byzantine art on a donkey saddle;[4] it is rare for him to be shown seated on a stool. A wooden stool, although somewhat different in shape from the one here, is to be seen on an ivory plaque of the Nativity at Dumbarton Oaks in

[1] C. Cecchelli, I. Furlani, M. Salmi, *The Rabbula Gospels*, Olten and Lausanne 1959, fig. in color on page 34.

[2] M. Schmid, *Die Darstellung der Geburt Christi in der bildenden Kunst*, Stuttgart 1890, pp. 2ff., nos. 2, 4–6, 8, etc.

[3] For ivories of the tenth century, cf. Goldschmidt and Weitzmann, *Byz. Elf.* II, pl. II,4–5; V,17. In general: Millet, *Rech. Ev.*, pp. 93ff.

[4] E.g. Millet, *Rech. Ev.*, figs. 41 (Paris gr. 550), 62 (Hosios Lucas).

Washington that has been variously dated between the period around 600[5] and the eleventh century.[6] This may not be without significance, since this ivory has the same altarlike manger with niche as the icon under discussion.[7]

Stylistically, as far as the stocky proportions of the figures, the rough highlights, and the heavy outlines are concerned, the icon is in the tradition of the icon wings with the four standing saints (no. B.33). In every aspect, however, these features have hardened, and we have here a later product of the same workshop. Typical are certain details such as the dotted pattern along the thin clavi of the Virgin's chiton and the black, red, and white lining of the nimbi, both of which occur in icon no. B.33.

The dissolution of space and the tendency toward a two-dimensional projection of the figures, effecting an ornamental distribution, are typical of that phase where the classical tradition had worn thin and the revitalization of art by the Macedonian Renaissance had not yet taken

place. From this point of view, our icon may be compared with the Nativity on the enamel cross in the treasure of the Sancta Sanctorum that shows a similarly suspended Virgin,[8] the same types of midwives bathing the Christ Child, and Joseph pensively sitting in the same corner, presumably also on a stool. According to Stohlman,[9] this cross was made in Italy for Pope Pascal I (817–824) but under the influence of a Palaestinian model, and he points quite correctly to the painted reliquary lid of the Sancta Sanctorum referred to earlier. Thus I believe our icon to be a late product of the Palaestinian school from the eighth or perhaps even as late as the ninth century.

Bibl.

K. Weitzmann, "Some Remarks on the Sources of the Fresco Paintings of the Cathedral of Faras," *Kunst und Geschichte Nubiens in Christlicher Zeit*, Recklinghausen 1970, p. 331 and fig. 329.
Idem, "Loca Sancta," p. 37 and fig. 10.

K. Weitzmann, "The Ivories of the So-Called Grado Chair," *D.O.P.* XXVI, 1972, pp. 58, 62, 66 f., 85 and fig. 2; *Catalogue of the Byzantine and Early Mediaeval Antiquities in the Dumbarton Oaks Collection* III, K. Weitzmann, *Ivories and Steatites*, Washington, D.C. 1972, pp. 37ff. no. 20 pl. XIX–XX and color plate 3. Idem "Loca Sancta" p. 38 and fig. 15.
[8] H. Grisar, *Die römische Kapelle Sancta Sanctorum und ihr Schatz*, Freiburg 1908, pp. 58ff.
[9] F. Stohlman, *Gli smalti del Museo Sacro Vaticano*, Città del Vaticano 1939, pp. 16ff., pp. 47ff. and pls. XXIV–XXVI.

[5] A. Goldschmidt, *Elfenbeinskulpturen* IV, Berlin 1926, p. 35 and pl. XLI,124 (there published as still in the Collection Chalandon, Paris).

[6] Volbach, *Elfenb.*, pp. 101ff., nos. 237ff., dates the whole group to which our Nativity plaque belongs, without mentioning this plaque, in the eleventh century, proposing Sicily as a possible place of origin.

[7] In a most recent discussion of this ivory and the whole group to which it belongs, I have proposed a date in the seventh to eighth centuries and a Syro-Palaestinian origin. If this is correct, ivory and icon would indeed be closely linked in both time and locality. See

B.42. CENTER OF A TRIPTYCH. PLATES XXVIII
AND XCVI, XCVIII
BELONGING TO WINGS NOS. 43–44
ASCENSION OF CHRIST
NINTH–TENTH CENTURIES
OLD LIBRARY

H. 41.8 cm; W. 27.1 cm; thickness 1.4 cm. The plaque is slightly warped and a split runs through the figure of Christ, but otherwise it is well preserved. The red border around the composition leaves strips bare at the top and bottom where ledges were nailed on to hold the wings (nos. B.43–44), and at the sides where the dowelled wings turned. The back of the plaque is undecorated.

The Ascension is depicted in the traditional manner, with Christ in a dark blue aureola being carried to heaven by four angels. Dressed in a blue tunic and crimson mantle, he is rendered in a seated position although no seat is

indicated. He is blessing with his right hand and rests a huge codex firmly on his left knee. The red nimbus with the white cross is outlined by a row of pearls. To the usual \overline{IC} \overline{XC} is added the inscription in white letters V[IO]C Θ[EO]V, which is seen repeatedly in the spandrels around the crosses on the backs of early tryptych wings (nos. B.22, 23). Of the four angels, the two upper ones, dressed in crimson tunics and olive-colored mantles, emerge from behind the aureola, while the two lower ones, dressed in blue tunics and crimson mantles, do not fly horizontally as usual but are represented in an ambiguous pose between standing and flying. All of the angels have brown and red wings; the two upper ones have blue and the two lower ones red nimbi outlined in pearls, as are all nimbi in this picture. The nimbi are highlighted so as to give the effect of transparency, a feature carried over from earlier icons (no. B.3). Christ's mandorla is also meant to be transparent, for the arms of the angels behind it—though not their

bodies—are visible through it, the color of their flesh changing to a blueish hue. The edge of the mandorla, which the angels hold like a hoop, is rendered to suggest solid material. Above the angels' shoulders are a tiny red sun-disk and a blue moon-disk. A yellow background is substituted for gold.

The ends of the mantles of the lower angels form a lyre-shaped pattern directly over the head of the Virgin, stressing her important place in the center of the lower half of the composition. Clad in a crimson tunic and grey-blue maphorion, she faces the beholder in an orant pose; yet she does not look straight ahead but rather to the side. The twelve Apostles stand at the foot of a mountain, represented in a pattern of red scales, and they are arranged in two symmetrical rows around the Virgin; they are clad in garments of colors restricted to steel blue and various shades of red. Yellow, red, and brown are the predominant colors of the entire panel, with the addition of only two shades of blue.

The iconography of this Ascension scene can in all essential points be explained by the older Palaestinian monuments, i.e. the early Sinai icon of this subject (no. B.10) and the Monza phials (fig. 13). As in the latter, the scroll has been replaced by a codex in Christ's left hand, and the rendering of the half-hidden upper angels is also similar. The frontal orant type of the Virgin, too, recalls the ampullae, but here, as in the Ascension miniature of the Rabula Gospels,[1] she looks straight at the beholder. The Virgin is flanked in our icon by the princes of the Apostles, white-haired Peter holding a scroll at her right, and bald-headed Paul holding a codex at her left. In the early monuments of the Palaestinian tradition, there is apparently no rule for placing these two either on the left or the right of the Virgin. Most frequently however, e.g. in the Rabula miniature, the seventh-century lid of the reliquary box from the treasure of the Sancta Sanctorum (fig. 14),[2] and in most ampullae,[3] it is Paul who stands at the Virgin's right side, but there is at least one ampulla where the order

is reversed.[4] Of the other Apostles, just as in the other early Sinai icon (no. B.10), only Andrew can be identified with certainty by his dishevelled hair; in the early example he stands in the second row, but here he takes a more conspicuous place next to Peter in the front row. There are two unbearded youthful Apostles in the group. In established Middle Byzantine iconography these are always to be identified as Thomas and Philip. The same two are quite possibly represented in our icon, but one cannot be sure, for in the apse mosaic at Sinai,[5] the two unbearded apostles are Thomas and John; and in S. Vitale in Ravenna,[6] James and Simon, as well as John and Thomas, are among the beardless Apostles. The gestures of the Apostles, either pointing upward or shading their eyes against the light of the mandorla, vary in the numerous examples of the Ascension cited above; in the present case they are used with little understanding and are artistically weak. The Apostle shielding himself from the light turns his head away from it, and the Apostle at the upper left points toward his eye instead of heaven.

Special mention must be made of two features related to the Virgin. First, she stands on a pearl-studded hexagonal footstool that one normally finds together with the throne in the Annunciation scene or in an iconic representation such as the Hodegetria, of which the miniature in the Rabula Gospels may be cited as an early example.[7] In a scene like the Ascension, which takes place in the open, such a piece of furniture is not called for and can only be explained as an effort to increase artistically the elevated status of the Virgin. Second, it will be noted that the Virgin stands before a tree or rather a bush with yellow branches and red blossoms. Indications of a landscape setting in this scene are not infrequent, and a representation of the Mount of Olives is, of course, iconographically significant. The most outstanding example is the miniature of the Rabula Gospels in which a whole mountain range is depicted. There are several trees and white flowers in the background of the Ascension in Chapel XVII of Bawit (fig. 27).[8] In our

[1] C. Cecchelli, I. Furlani, M. Salmi, *The Rabbula Gospels*, Olten and Lausanne 1959, pl. f. 13b.

[2] Ibid., fig. p. 34 (color). Cf. Bibliography to no. B.10 n. 8.

[3] A. Grabar, *Les Ampoules de Terre Sainte*, Paris 1958, ampulla no. 11, pl. XIX; no. 14, pl. XXVII; no. 16, pl. XXIX.

[4] Ibid., ampulla no. 10, pl. XVII. Grabar refrains from naming the flanking Apostles apparently for the reason that one of them holds a codex, an attribute he associates only with the Apostle-Evangelist. But that Paul also can carry a codex is proved by the miniature in the Rabula codex and now by the new Sinai icon where the identification cannot be doubted.

[5] G. A. Sotiriou, "Τὸ μωσαϊκὸν τῆς Μεταμορφώσεως τοῦ

Καθολικοῦ τῆς μονῆς τοῦ Σινᾶ," *Atti dell' VIII Congresso di studi bizantini* II, Palermo 1951, pp. 246ff. and pls. LXXVIIb and LXXIXa; K. Weitzmann, "Introduction to the Mosaics and Monumental Paintings," in G. F. Forsyth and K. Weitzmann, *The Monastery of Saint Catherine at Mount Sinai. The Church and Fortress of Justinian*. Plates. Ann Arbor 1973, pls. CX, CXII, CXLVI, CXLVIII, CLVI B.

[6] F. W. Deichmann, *Frühchristliche Bauten und Mosaiken von Ravenna*, Baden-Baden 1958, pls. 334, 335, 336, 339.

[7] C. Cecchelli, I. Furlani, M. Sàlmi, op. cit., pl. f. 1b.

[8] M. J. Clédat, *Le Monastère et la nécropole de Baouit* (Mémoires. L'Institut français d'archéologie orientale du Caire XII), Cairo 1904. pl. XL.

icon the setting is similar but, unlike the Coptic example, there is only one bush, which frames the Virgin with flaming red blossoms. The representation of the blossoms as flames is, in our opinion, an attempt by the artist to establish an association with the burning bush of Mount Sinai. This is the way in which the burning bush is pictorialized on later Sinai icons. Heretofore the earliest example known to us was in a thirteenth-century Crusader icon,[9] and the motif was therefore assumed to be a Western invention. But if the interpretation of our icon is correct, the motif must have originated in the East several centuries earlier than the Crusader icon.

Stylistically as well as iconographically our icon is in the tradition of those Sinai icons that we attribute to a Palaestinian school. A typical Early Christian element lingering on in it is the red letter H on the mantles of the Apostles in the front row and also on the mantles of the two lower angels. This is one of the letters found repeatedly on Apostles' garments in the mosaic of the Arian Baptistery in Ravenna.[10] The emphasis on red and brown hues is typical of the Palaestinian school, and so is the peculiar rendering of the linear highlights (cf. no. B.33). Yet in these highlights certain deviations occur: over the

thighs of the lower angels, the light collects in a bulbous swirl, and over the thigh of Andrew the artist uses a zig-zagging waveline. Slight as these changes are, they already reflect the new Middle Byzantine style and justify considering this Ascension a rather late product of the Palaestinian school. Also typical are the sharp outlines of the faces, although in the earlier examples (cf. nos. B.33, 37) they had not obliterated the modelling of the flesh. In our icon, however, the faces are chalky white and crudely drawn in strong red lines without any transitional shading. The outlining, too, of the faces is harsh in comparison with the earlier examples and has the character almost of a woodcut. The stare of the eyes is uniform. A high degree of ornamental stylization may be observed in the hemlines of the tunics of the two lower angels; they form rows of dark rosettes, which give the impression of pompoms sewn on individually. For all these reasons we propose a date as late as the ninth or tenth century. We admit such a date to be rather hypothetical, for it is based essentially on the notion of a gradually hardening style, and we realize that there are no dated monuments to confirm this morphological process in detail.

[9] K. Weitzmann, "Icon Painting in the Crusader Kingdom," *D.O.P.* XX, 1966, p. 67 and fig. 35.

[10] Deichmann, op. cit., pls. 261, 263–265, 267.

B.43–44. TWO WINGS OF A TRIPTYCH. PLATES XXIX AND XCVII–XCVIII
BELONGING TO CENTRAL PLAQUE NO. 42
ST. THEODORE AND ST. GEORGE
NINTH–TENTH CENTURIES
GALLERY. GLASS CASE

H. 38.6 cm. The left wing measures 13 cm in width, the right one 13.5 cm. The inner sides of the wings are rounded to facilitate turning, and on top remain parts of the wooden dowels which fastened the wings to the ledges of the central plaque. The outer edges of the wings are cut obliquely in order to effect a tighter closing.

The measurements are in accord with those of the preceding Ascension panel, and we believe it to be the original central plaque to which the wings were once attached. The

Ascension panel is 3.2 cm higher than the wings, which accounts for the height of the two ledges, each measuring 1.6 cm. The joined wings are 6 mm narrower than the central plaque; this slight divergence can easily be explained as an allowance for the mounting.

The plaque with St. Theodore has flaked in only a few spots, but that with St. George is very badly damaged, especially along its outer edge, leaving only about two thirds of the surface intact. The backs of the wings are even more flaked and darkened, but the basic design can still be made out. Extending over both wings and placed against an olive-colored background is a yellow cross outlined in red with pairs of knobs at the ends of the arms. The upper spandrels contain the usual letters $\overline{\text{IC}}$ $\overline{\text{XC}}$, and the lower ones are filled with half-palmettes. Whether some letters (possibly $\overline{\text{VC}}$ $\overline{\text{ΘV}}$) once existed here, too, can no longer be ascertained.

The two saints on horseback, inscribed Ο ΑΓΙΟC ΘΕΟΔⲰΡΟC and Ο ΑΓΙΟC ΓΕⲰΡΓΙΟC, are represented

in very much the same pose, and both mounts turn their heads to one side and raise the left forefoot in a parade step. They are identical except in color, Theodore's horse being light brown and George's yellow brown. In addition to crimson saddlecloths, one rounded and the other square, there are rich trappings, including a crimson sash knotted around the neck of Theodore's horse and, below, a cross painted yellow as a substitute for gold, of which there is none in this triptych. Both saints are clad in Roman armor and wear crimson chlamides. At the same time, the saddles have stirrups; as these became known to the Byzantine world only through the Arabs, a date for the triptych in the Early Byzantine period must be excluded. Rather small round shields hang on the saints' shoulder straps, and while each left hand holds the reins, each right one is raised and holds a long lance by its crossmounted end, piercing with it the enemy on the ground. Thus far the two saints are very much alike, with only slight variations to avoid an impression of mechanical duplication. Consistent with accepted iconography, Theodore has a black beard and George is rendered as a youth (cf. no. B.3). Theodore looks to the right, i.e. to the center of the triptych, and George faces the beholder. The most essential difference between the two is in the nature of the victims. Theodore's lance pierces a dragon, a chestnut-colored serpent whose coiling body is knotted, while George's victim is a white-bearded man clad in a dark red tunic and mantle but having no distinguishing attributes. In each case blood spurts from the wounds. Both victims are set against crimson rocky hillocks on which the horses prance. The next of the four zones of the background consists of a grey green meadow with red flowers of the same kind as those behind the Virgin in the central plaque. Then, above the horses' backs, there is a neutral pink zone and finally one of dark blue. As the latter suggests sky, the pink one may be understood as an ornamentalized strip of sunset, familiar in late classical and Early Christian painting. Finally, there is in each of the upper right corners an angel, and although the one at the right is mostly flaked, enough is left to indicate that the two were almost identical. Each holds

a scepter in his left hand and points with his right across his chest to heaven.

While George is normally associated with the slaying of the dragon, he is by no means the only saint on horseback involved in this type of venture. Representations of Theodore slaying the dragon appear in various regions about the time of our icon, and are not merely local cult images. He appears thus, e.g., in a Coptic miniature in the Vatican, cod. Copt. 66, which is to be dated within the tenth and eleventh centuries;[1] in a stone relief on the façade of the Church of the Holy Cross in Akhtamar, Armenia,[2] usually, and apparently correctly, dated between 915 and 921, where he is associated with two other saints, St. George and St. Sergius; in a Byzantine enamel plaque in the Hermitage in Leningrad where he has dismounted and tied the horse to a tree while he kills the dragon,[3] a work dated in the twelfth or the thirteenth century; and on numerous Venetian glass pastes.[4]

Representations of St. George killing a human being are rarer. A rider saint performing this action is usually identified with St. Merkurius killing Julian the Apostate, but with regard to St. George this iconography is most common and may well have originated in Georgia,[5] where St. George received special veneration. In the corpus of Tschubinaschwili there are eleven icons in silver repoussé with George on horseback, and no fewer than eight of them show him killing a bearded man,[6] whereas he is shown killing the dragon only twice[7] and in one instance no adversary is depicted.[8] In one of these icons (fig. 28),[9] which gives the name of the goldsmith as Asan and which can be dated in the first quarter of the eleventh century, the transfixed enemy is inscribed "the godless king Diocletian." In two of the Georgian icons the emperor wears no crown,[10] so we seem to be justified in calling the man in our icon also Diocletian. It is indeed quite likely that the appearance of this iconography in an icon made for, or perhaps even executed in, Sinai is due to Georgian influence. At the time the icon was made, there was a colony of Georgian monks residing at Sinai, and of the approximately one hundred Georgian manuscripts there, mostly

[1] H. Hyvernat, *Album de paléographie copte*, Paris and Rome 1888, pl. XVI.

[2] S. Der Nersessian, *Aght'amar, Church of the Holy Cross*, Cambridge, Mass. 1965, p. 19 and pl. 50.

[3] A. Frolow, "Emaux cloisonnés de l'époque post-Byzantine," *Cah. Arch.* I, 1945, p. 99 and pl. XXIV, 2; Banck, *Byz. Art*, pl. 190 (color).

[4] O. Dalton, *Byzantine Art and Archaeology*, Oxford 1911, p. 616 and fig. 390.

[5] J. Myslivec, "Saint-Georges dans l'art chrétien oriental,"

Byzantinoslavica V, 1934, pp. 304ff., reproduces on pl. IV a Georgian silver icon showing the transfixing of an emperor.

[6] G. N. Tschubinaschwili, *Georgian Repoussé Work, VIII–XVIII Centuries*, Tbilisi 1957, pls. 92–98 and 103.

[7] Ibid., pls. 99–100, 102.

[8] Ibid., pl. 101.

[9] Ibid., pl. 93. Cf. also the icon reproduced by Tschubinashwili in *Byzanz und der Christliche Osten. Propyläen Kunstgeschichte*, III, Berlin 1968, pl. 360 and p. 332.

[10] Ibid., pls. 98 and 103.

service books, the majority belongs to the ninth and tenth centuries.[11]

Yet in one respect the St. George of our icon differs from all the other representations of him killing Diocletian. Instead of attacking the enemy from a galloping horse, he assumes a victor's pose without exerting any physical effort and, correspondingly, the enemy, although bleeding, is not crushed but sits upright and touches with his raised hand as a gesture of submission the very lance that has defeated him. We are familiar with this kind of symbolic defeat from imperial iconography, the best known example of which is the Barberini diptych in the Louvre (fig. 29),[12] on which either Anastasius I or Justinian is depicted in a similar pose, though here the enemy, a barbarian, is not underneath the spearhead but stands behind the lance. However, there is the same motif of the vanquished enemy touching the lance as a sign of submission. Moreover, it will be noted that the angel of the icon is in the same place in the composition as the Victory in the ivory plaque. This is another example of the influence of imperial iconography on early icon painting (cf. nos. B.3 and 5), but in this particular case we are confronted with an inversion of the symbolic victory, for the emperor is the defeated and not the victor.

Stylistically, as far as design and coloring are concerned, the icon wings are so closely related to the preceding panel of the Ascension that there is no need to repeat the characteristic features. What needs to be pointed out, however, is the fact that some of the typical trademarks of the Palaestinian school are present in the wings but are not in the central panel. There are, e.g., the white circles on the crimson chlamys, for which one can cite the Three Hebrews icon as a close parallel (no. B.31), the dotted rosettes (nos. B.27, 28), and, in general, the liberal use of a dotted-line pattern, most conspicuous on the edges of the nimbi (no. B.36) and elsewhere. In our wings the dot pattern is also applied to the edge of the shield, the armor, the saddlecloth, etc. If our theory about Georgian influence proves to be correct, this would add historical support to the stylistic evidence and would further strengthen a ninth- or tenth-century date for the wings.

Bibl.
Sotiriou, *Icones* I, figs. 30–31; II, pp. 44–45 (here attributed to Egypt).

St. John's University, Collegeville, Minnesota 1973, pp. 11 ff. and figs. 8–9.

[11] Kenneth W. Clark, *Checklist of Manuscripts in St. Catherine's Monastery, Mount Sinai*, Washington 1952, pp. 19–21; K. Weitzmann, *Illustrated Manuscripts at St. Catherine's Monastery on Mount Sinai*,

[12] Volbach, *Elfenb.*, p. 36, no. 48 and pl. 12.

B.45. CENTER OF TRIPTYCH (FRAGMENT).
PLATES XXX AND XCIX–CI
NATIVITY, PRESENTATION, ASCENSION, PENTECOST
SECOND HALF OF NINTH CENTURY TO TENTH CENTURY
GALLERY. GLASS CASE

H. 35.6 cm; W. 14.2 cm; thickness 0.9 cm. This is the preserved left half of a panel which, as frequently happened, has split down the middle. Since the two lower scenes are strongly symmetrical in their composition, we can expect the figure of Christ to have been on the central axis, a line 12.5 cm from the lateral edge of the panel, so that the original width must have been about 25 cm. A strip bordering the panel, wider at the top and bottom, was left unpainted to allow room for the ledges to which the wings were fastened. One crack has split the head of Joseph at the upper right, and the most serious damage to the surface

affects the Virgin of the Ascension. A flaked spot at the upper left must have contained the star of Bethlehem, now lost. There is other minor damage, but most of the surface is rather well preserved and the colors are very fresh.

The uppermost of the three registers into which the panel is divided has two scenes, with the Nativity on the preserved left half. The Virgin is lying on a light blue mattress, which, in order to fit it into the available space, is placed on a sharp diagonal. In this as well as in the Ascension scene she wears brownish garments as a substitute for purple. Her left leg is not visible and must be understood either as being tucked up under her or hidden in the bed clothes. Obviously the not overly competent painter has not succeeded in making the Virgin's pose clear. While touching her knee with her right hand she raises the left in a gesture that usually means surprise or astonishment. She glances at Joseph, who is dressed in a light blue tunic and a red brown mantle with a hood, a rather unusual garment which gives the white-haired old

man a monkish appearance. While touching his left knee with one hand he supports his head with the other in a pensive pose. In all early representations of this scene, Joseph sits on a rock, but in our icon he sits on a cushion which rests on a pink double-arched structure. This is, though misinterpreted, the donkey saddle familiar from Middle Byzantine art.[1] Both Joseph and the Virgin have golden, red-lined nimbi, as does Christ in the other two scenes. Between Mary and Joseph stands the manger in red stone with an open niche in which a lamp hangs, clearly an attempt to render the altarlike manger as venerated in the Nativity Church. On top of this structure lies the Christ Child in golden swaddling clothes; a fire red ox and a grey ass bend over the child to lick it. This group is set against the black interior of the cave which is framed by craggy light pink rocks. The special emphasis on the locus sanctus is also expressed in the inscription: instead of the common title H ΓΕΝΝΗCΙC, it reads ΕΝ CΠ[Η]ΛΕΑ in black letters on the gold ground.[2]

Of the scene at the right only the figure of Joseph remains, dressed as in the Nativity except that he is not wearing a hood. Hands hidden under his mantle, he carries two white doves as gifts to the temple. If one tries to visualize the depiction of the Presentation within the limits of the available space, it becomes quite doubtful whether, in addition to the Virgin, the altar, and Simeon, there was still room for the prophetess Anna. Her omission would not be without parallel in Byzantine art.[3]

In the Ascension of the central register, unfortunately, the center is almost effaced, but the essential iconographical features are still recognizable. The Virgin is standing in profile to the right, in contrast to her position in the early Ascension (no. B.10), and her hands are unveiled. Christ, in a red brown tunic and golden mantle, is depicted in a seated position, but as in icon no. B.42, neither a rainbow nor a throne is indicated. In his veiled left hand he holds a fire red Gospel book and with his right he makes the gesture of blessing. His black hair and round beard fit neither of the two standard types of Christ (cf. p. 27). As on the back of triptych wing no. B.17, his mandorla is divided into three concentric ovals suggesting a Trinitarian significance, and white rays issue from it in all directions. It is lifted up

by two angels with stiffly outstretched arms, of whom only the one at the left is fully preserved. He wears a blue tunic and white carmine mantle with a fluttering end, and his wings, red brown and dark olive, spread outward, the inner ones framing the mandorla in a decorative manner. Of the Apostles only the group at the left is preserved; they stand in single file, and are headed by Peter. His left hand is closed as if holding an object, presumably a scroll, which, however, is omitted; of the other Apostles only the third from the left, Andrew, can be identified by his dishevelled hair. The second from the left points at the ascending Christ and at the same time puts his left hand on Andrew's shoulder to attract his attention. The only youthful Apostle in this group shades his eyes against the glare of the heavenly apparition. The colors of the Apostles' garments are basically the same as in Ascension icon no. B.42, i.e. reds and browns alternating with light blue. Yet in this icon the blue is more amply used and a light pink is introduced, giving a brighter impression to the composition as a whole. This impression is carried further by the use of a gold ground instead of yellow as in the other icon. Furthermore, the limited use of a blackish olive color and a very dark brown, especially marked in the hair, gives strong contrasting effects. A dark, stubby, mushroom-shaped tree frames the composition at the left and there was surely a corresponding one at the right.

In the Pentecost at the bottom, the Apostles are repeated in the same order as in the Ascension. Opposite Peter is Paul and between their heads is a golden dove outlined in black. Only one of the Apostles holds an attribute, a book with a fiery red cover, while some of the others close their left hands as if holding codices or scrolls that have been omitted by the artist. The Apostles are shown seated, but with no indication of benches or footstools. Heaven, in the form of a medallion, encloses a bust of Christ from which tongues of fire issue in broad streams. Of the inscription only H AΓIA remains while the word ΠΕΝΤΗΚΟCΤΗ is lost.

Iconographically these feast scenes are most closely related to the works of the Palaestinian school. The Virgin on the diagonally placed mattress and the seated and brooding Joseph find parallels on the Monza ampullae,[4]

[1] Cf. e.g. the miniature of the Nativity in the so-called Phocas Lectionary in Lavra on Mt. Athos; K. Weitzmann, "Das Evangelion im Skevophylakion zu Lavra," *Seminarium Kondakovianum* VIII, 1936, p. 89 and pl. II,2.

[2] The Sotirious read the inscription [Γ]ΕΝ[Η]C[IC] [CΠΗ]ΛΕΑ, but there is not enough space for such a lengthy inscription. Moreover, the first three letters clearly read ΕΝC and do not permit the insertion

of an H.

[3] Cf. e.g. the tenth-century ivory diptych in Milan. Goldschmidt and Weitzmann, *Byz. Elf.* II, p. 37 no. 42 and pl. XVIII,42a. For the problem of the abbreviated scene of the Presentation, cf. also Weitzmann, "An Ivory Diptych of the Romanos Group in the Hermitage," *Византийкий Временник*, XXXII, 1971, p. 144 and fig. 2.

[4] A. Grabar, *Ampoules de Terre Sainte*, Paris 1958, pls. V and VII.

and even more similar is the lid of the reliquary box of the Sancta Sanctorum (fig. 14),[5] where the manger with its open niche and the child lying stiffly in swaddling clothes upon it agree in almost every detail, including the encompassing dome-shaped cave.

The Ascension, too, belongs to the same Palaestinian tradition as icon B.42, where we have already pointed out parallels to the Monza phials and the Sancta Sanctorum lid. As in icon B.42, here Peter is at the right side of the Virgin instead of the left, as is more common in the earlier examples. The Virgin in profile also has parallels in earlier Palaestinian examples, e.g. the encaustic icon no. B.10. Compositionally the Ascension here differs from the earlier examples cited above only in that the Apostles are in single file instead of in two rows. A similar arrangement occurs in the Coptic frescoes of Bawit (fig. 27), but an element of the composition such as this, which has been determined by the availability of space, can hardly be used to distinguish different provenances.[6] The strip like divisions in our icon forced the artist to broaden the compositions and limit their height in such a way that he had to render the Virgin in smaller scale than the Apostles, when she was customarily represented larger (icon B.42).

In the scene of the Pentecost, too, lack of space has forced the artist to expand width at the expense of height, so that the medallion of Christ is pushed up into the scene of the Ascension and the dove appears between instead of above the heads of the Apostles. It will be observed that the Apostles are aligned on a slightly curved instead of a strictly horizontal groundline, indicating that the artist used a model in which the Apostles were seated on a semicircular bench, an iconography common in mid-Byzantine miniature, icon, and monumental painting, to cite the mosaic of Monreale as one of many examples.[7] With such models our icon also shares the rendering of the fiery rays as curved lines, as they would appear to one looking into a cupola like that of St. Mark's in Venice.[8] We deal here with the projection of a cupola onto a two-dimensional plane, the earliest example of which occurs in the Pentecost miniature in the Gregory manuscript in Paris, cod. gr. 510,

dated between 880 and 886.[9] While normally the rays issue from a segment of heaven, in this miniature they emanate from the Hetoimasia in a medallion, a feature which, as the mosaic of St. Mark's shows, must have been in the original cupola on which the Venetian copy depends. In our icon, the Hetoimasia is replaced by a bust of Christ. This seems to be a later version and a few parallels to it can be found in mid-Byzantine miniatures.[10] At about the same period an image of Christ also appears in Latin Pentecost representations; a miniature in a sacramentary from St. Bertin of around the year 1000 is apparently one of the earliest examples, although here not a bust but a figure of Christ enthroned appears in the medallion.[11] According to our present knowledge, our icon is the earliest example of the introduction of Christ into a Byzantine Pentecost. Whereas the Nativity and Ascension are based essentially on the Early Palaestinian tradition, the Pentecost reflects a mid-Byzantine development which seems to have originated in Constantinople.

Since the four surviving scenes of our icon panel belong to the cycle of the great feasts, it seems justifiable to assume that the lost wings, too, had feast pictures and that these were similarly arranged in three registers. Yet in triptychs of later periods only the inner sides of the wings were used for scenic decoration; the outsides bore either ornamental crosses (nos. B.19–20, 22) or, though not before the Middle Byzantine period, the figures of saints (no. B.55). Thus we can assume that the missing wings had space for six scenes, and although there are twelve feasts in the standard cycle, our entire triptych could only have represented ten, four in the center and three on each wing. One can be quite sure that in the upper registers of the wings the Annunciation was at the left, preceding the Nativity, and that the Baptism was at the right, following the Presentation in the Temple. But for the other four scenes, six themes are available: the Transfiguration, Raising of Lazarus, Entry into Jerusalem, Crucifixion, Anastasis, and Koimesis. Unfortunately, after the top row the scenes cannot be read in sequence across the rows of the opened triptych, for the Ascension and the Pentecost which follows are one above the other. Of the two

[5] C. Cechelli, I. Furlani, M. Salmi, *The Rabbula Gospels*, Olten and Lausanne 1959, fig. in color on p. 34.

[6] The Sotirious are inclined to assume Egypt as the place of origin of our icon.

[7] O. Demus, *The Mosaics of Norman Sicily*, London 1949, pl. 75a.

[8] O. Demus, *Die Mosaiken von S. Marco in Venedig*, Vienna 1935, figs. 2–3.

[9] Omont, *Miniatures*, pl. XLIV.

[10] E.g. in the twelfth-century Gregory manuscript in Paris, cod. gr. 550, in an initial on fol. 37 (Omont, *Miniatures*, pl. CIX) and in the

twelfth-century lectionary, cod. 692, in the Morgan Library in New York, where on fol. 57r the bust of Christ appears on top of the page written in cruciform shape, while a pair of Apostles enthroned appears in the upper spandrels of the cross: *Illuminated Greek Manuscripts from American Collections. An Exhibition in Honor of Kurt Weitzmann.* The Art Museum, Princeton University, ed. Gary Vikan, Princeton 1973, p. 137 and fig. 61.

[11] S. Seelinger, "Das Pfingstbild mit Christus im 6.–13. Jahrhundert," *Das Münster* IX, 1956, p. 148 and fig. 4.

scenes to be eliminated, one was most likely the Koimesis, since it is not included on the earliest known dodecaorton, an icon at Sinai from the first half of the eleventh century.[12] The other scene to be dropped for formal reasons may have been the Metamorphosis, for the space available vertically would have caused compositional difficulties; this, however, remains hypothetical.

Yet it would be rather misleading to speak of an abbreviated feast cycle. It is more likely that we have here an icon of a period before the dodecaorton had become generally accepted, and fewer scenes seem to have been customary in early triptychs. A wing in Moscow from about the seventh century shows the Nativity and Baptism,[13] thus indicating a triptych which could have had only six or eight scenes, depending on whether the central plaque had two or four. This is also true of a tenth-century wing at Sinai (no. B.55) which depicts the Baptism and the Anastasis. All the evidence indicates that the dodecaorton crystallized during the tenth century;[14] for example, among the Byzantine ivories of the tenth century, two triptychs of the painterly group have only four and eight scenes respectively,[15] while a diptych in Leningrad of the Nicephoros group from the end of the tenth century includes all twelve.[16]

Thus we conclude that the iconography of the Ascension prevents this icon from being dated any earlier than the second half of the ninth century, while the cycle of feasts represented—not yet standardized—indicates a date no later than the end of the tenth century. We believe these dates to be in agreement with the stylistic evidence.

Essentially the style continues the trend of thick, dark, simplified outlines as found in the Ascension icon no. B.42. This is particularly true for the faces, in which the eyes seem to be set in black rings, the whites standing out sharply and causing a piercing look, a characteristic already noted in earlier icons of the Palaestinian group (nos. B. 27 and 36). Other devices connecting this icon with the Ascension no. B.42 are the rolled hemline of the garment of the flying angels and the treatment of the highlights, notably the exceptional wavy line with dots on the thigh of the Apostle next to Peter in the Ascension. On the other hand, the one stylistic detail that cannot be explained by the tradition of the Palaestinian group is the hemline of the tunic of the second Apostle from the left in the Ascension. There are three bell-shaped folds of a very decorative nature. Parallels to this peculiar form can be found in Byzantine manuscripts from the end of the ninth and the tenth centuries, as e.g. some miniatures of the Paris Gregory manuscript, cod. gr. 510,[17] and the Vatican Bible, cod. Reg. gr. 1.[18] This indicates that, just as with the iconography, elements of mid-Byzantine Constantinopolitan style had penetrated the local Palaestinian tradition. On all grounds we believe this icon to be somewhat later than the Ascension icon no. B.42.

Bibl.

Sotiriou, *Icones* I, figs. 17–19, pp. 33–35.

H. Skrobucha, *Meisterwerke der Ikonenmalerei*, Recklinghausen 1961, p. 57 and pl. II.

A. Grabar, *Christian Iconography*, Princeton 1968, p. 102 and fig. 261.

Weitzmann, "Loca Sancta," pp. 37, 45, and figs. 11, 33.

[12] Sotiriou, *Icones* I, figs. 39–40.

[13] Wulff and Alpatoff, *Denkmäler*, p. 32 and fig. 13.

[14] K. Weitzmann, "Byzantine Miniature and Icon Painting in the Eleventh century," *Proceedings of the XIIIth International Congress of Byzantine Studies*, Oxford 1967, pp. 217ff.

[15] Goldschmidt and Weitzmann, *Byz. Elf.* II, pl. II,4 (Paris, Louvre);

VI,22 (Munich).

[16] Ibid., pl. XLV, 122.

[17] Omont, *Miniatures*, pl. XXXVII (Abraham in the scene of the Sacrifice of Isaac); pl. LVIII (angel in Ezekiel's Vision).

[18] *Miniature della Bibbia Cod. Vat. Reg. Greco 1*, Milan 1905, pl. 1 (Moses); pl. 8 (one of the Levites).

B.46. FRAGMENT OF ICON. PLATE CII
CHRIST ENTHRONED
ABOUT SEVENTH CENTURY OR LATER
OLD LIBRARY

H. 75.3 cm; W. 11.2 cm. Only a strip along the left border remains of an originally quite large icon. The panel was painted in encaustic technique, but most of the surface has flaked or has been rubbed off. In typical early Byzantine fashion a separate frame had been nailed onto an unpainted border, and two pieces of the frame, painted in red, are still preserved.

Nothing is left of the figure that once occupied the center of the icon, but to judge from the remaining traces of a lyre-shaped throne set against a gold ground, it could only have been a Christ enthroned. The one visible leg of the throne, painted in brown, is heavily studded with pearls and rows of blue and red stones. A very high crimson cushion rests on the throne, bulging out in a large curve,

and above the cushion one side of the lyre-shaped back is still visible in outline. Because of heavy flaking, the color cannot be determined with certainty, but it was probably the same brown as the leg of the throne. At the outer edge it has a narrow ornamental strip formed of white horizontal strokes. The upright part of the back and a crossbar both end in pinecone-shaped knobs. The shape of this throne is quite similar to the jewel-studded lyre throne set against a golden ground in the narthex mosaic of Hagia Sophia in Istanbul, in which the emperor Leo the Wise kneels before the seated Christ.[1] One could easily imagine a similar type of Christ in this icon.

[1] T. Whittemore, *The Mosaics of St. Sophia at Istanbul* I. *Preliminary Report*, Oxford 1933, pl. XIII.

B.47. LEFT WING OF A TRIPTYCH. PLATE CII
FRONT: ST. COSMAS BACK: THREE CROSSES
EIGHTH CENTURY OR PERHAPS LATER
OLD LIBRARY

H. 45 cm; W. 12.2 cm. The damage at the upper and lower right suggests the loss of the dowels that fastened this wing to the central plaque of a triptych. At the upper right the damage was so severe that a piece of wood had to be replaced. This damage must have taken place at an early date because there are traces of alterations along the right edge which indicate that the wing was later attached by means of hinges. The surface of the thin layer of paint is so flaked on both sides of the panel that part of the preliminary drawing on the bare wood is visible.

The frontal standing saint with a whitish red-edged nimbus is clad in a long, chestnut-colored tunic with a white clavus and a red mantle, and in his right hand he holds a long scalpel, typical for physician-saints. Consequently the object in his other hand is not a scroll, for which it might be mistaken, but a box of medical instruments. In addition, he supports with his left arm and presses against his breast a white, jewel-studded codex. Since he is on the wing of a triptych he must be one of a pair, and this suggests the Anargyroi; quite assuredly this figure is Cosmas, who always stands at the left as seen by the spectator. The black hair and the short black beard framing the rather youthful face are in keeping with the Anargyroi on other icons.[1] However, unlike later representations of the physician-saints, shown wearing a kind of professional mantle with an opening cut for the neck, this saint wears the normal tunic and mantle, and thus recalls the early Damian figure no. B.18.

The back of the wing shows three white crosses with rounded arms and shoots at their crossings, placed in circles of black with white dots. The background is uniformly chestnut colored, and while the spandrels are filled with little circles, between, above, and below the rondels are little crosses that can be read as X, standing for XPICTOC.

The style is rather rough. The figure of the saint lacks corporeality and an easy stance. The folds of the garments are reduced to straight black lines and the chalky white color of the flesh shows no modelling. The dotted rosettes on the tunic and in the background point to the Palaestinian school, of which the panel is a late product, although it would be hazardous to suggest a more specific date.

[1] Sotiriou, *Icones* I, figs. 84 and 85; II, pp. 96ff.

B.48. ICON. PLATE CIII
VIRGIN ENTHRONED WITH CHILD
ABOUT EIGHTH CENTURY (?)
CHAPEL OF HAGIOS ANTONIOS

H. 19.8 cm; W. 11.5 cm. The panel is quite thin (0.6 cm) and slightly warped. The top and the bottom of the frame are wider than the sides, a peculiarity normally indicating that the plaque was the center of a triptych. However, the absence of holes for the fastening of ledges rules out such a use—the one large hole in the top was apparently intended for hanging the icon. The whole right border and a section of the ground containing part of the throne are split away. Moreover, the entire surface is badly rubbed so that in many places the bare wood is visible.

Some of the damage, especially in the lower right corner, has obviously been caused by fire. At one time a very heavy varnish on the icon left very dark brown spots, especially on the red frame at the left where they look deceptively like dark letters. Yet there is no clear indication of writing such as one finds repeatedly on frames of early icons (cf. nos. B.16 and 31). The back of the panel is covered with a yellowish diaper pattern and pearl-like dots on a black ground. This could well be contemporary with the painting on the front.

The Virgin sits on a throne in strict frontality, holding the Christ Child in front of her. She is dressed in a blue chiton and carmine paenula, with red shoes, while the garments of the Christ Child are entirely in gold. The hair around the child's forehead has completely flaked off (as in the heads of icon no. B.15) and so have parts of his hands, although it is still discernible that the left held a scroll and the right was raised in front of the breast in a gesture of blessing. The massive golden throne with a high back is covered all over with punched rosette and circle patterns, the latter being repeated on the Virgin's nimbus and the golden footstool. A high cushion, in red with white dotted circles, is placed much too high for the Virgin to sit on, and thus it has a more decorative and hieratic than practical function. Only brown lines with a grisaille-like effect set the throne off against the golden background. Over the upper left corner of the throne the word MHP is written with broad red strokes; the corresponding OV at the right is now lost. Since the letters are painted over the circle pattern, they must be a later addition. Presumably they replace an older inscription, H AΓIA MAPIA, quite likely in monogram form as was the custom in other early Sinai icons (nos. B.27, 32, 36, 40).

In a very hieratic composition the Virgin steadies rather than holds the child, who is depicted, as she is, in a seated position. The linear, brown design of Christ's garments has been rubbed off, exaggerating the flatness of his gold-draped body. Even in its original state, however, the child could not have given the impression of actually being seated because he is raised so high that only his feet touch the Virgin's lap. Thus the effect surely intended by the artist is that of suspension, emphasizing the immateriality of Christ's body. This degree of dematerialization is shared by other enthroned Virgins with Child, such as those of the mosaics in S. Apollinare Nuovo in Ravenna[1] and the cathedral of Porec (Parenzo),[2] or the fresco in the Commodilla catacomb in Rome.[3] Although the icon is seemingly not as early as these sixth-century monuments, it belongs to the same iconographic tradition.

Certain stylistic details also connect the icon with a rather early tradition. Punched patterns on the edge of the nimbus are found in the Christ, the Virgin, and Sergius and Bacchus icons, nos. B.1–3 and 9, but in our icon they are used also for the throne and the footstool, creating an effect close to an allover pattern. Typical also are the dotted circles on the cushion, which are also used for the decoration of the lacerna in the icon of the Three Hebrews (no. B.31). Most characteristic are the chalky white flesh color painted in a few broad brushstrokes, the heavy brown shadows—especially around the eyes—and the white dots that give the eyes a piercing look. In all these details the closest parallel is the icon of the Chairete (no. B.27), although the brush technique in this icon is more rigid. For all these reasons we assume for it a somewhat later date—around the eighth century—and Palaestine once more as the most likely place of origin.

[1] N. P. Kondakov, *Иконографія Богоматери* I, St. Petersburg 1914, p. 172 and fig. 95.

[2] Ibid., p. 176 and figs. 97–99.
[3] Ibid., p. 182 and fig. 101.

B.49. ICON. PLATES XXXI AND CIV
ST. MERCURIUS
TENTH CENTURY (?)
OLD LIBRARY

H. 42.2 cm; W. 32.7 cm; thickness 1.7 cm. About one third of the panel has been sawed off diagonally at the lower left. Most of this missing piece was retrieved recently when Mr. Margaritoff in cleaning a later icon of the bust of St. Arsenios found its damaged lower left corner to have been repaired with a part of the missing piece from this icon (fig. 30). Now restored to its original place, a neutral filler has been introduced for the still missing portion and on it the hindquarters of the horse and the end of the saint's mantle are roughly hatched in. The surface as a whole is quite well preserved and has maintained the striking color contrasts.

The stately saint on horseback is dressed in olive-colored armor, with a double row of leather strips in darker and lighter blue over his raised arm, and underneath a tunic which, inconsistently, is carmine over the hips and strong red at the elbow. He wears yellow leggings and a chlamys of the same color with highlights, brown folds, and a red circle pattern. Red boots fit into white stirrups. Behind the left shoulder, a sword and a small shield can be seen, the shield outlined in dots as are the red straps over the breast. The face is a chalky white color and framed by dark brown hair in which a string of pearls indicates a crown of martyrdom. The saint sits on a red saddle upon a black saddlecloth, borne on a parading white horse. To complete his armor he wears over the upper thigh a short black quiver filled with arrows. With a red lance he pierces an enemy, part of whose bleeding white-haired head is still visible. An angel in the upper right corner, dressed in a red tunic and a yellow brown mantle and carrying a red cross-staff, points with his right hand at the saint, obviously ordering him to kill the enemy. In the upper left corner the hand of God reaches from the sky, offering a red crown of martyrdom, enveloped in a beam of light rays. The scene is set in an olive-colored landscape with plants of the same color and of carmine brown—a color also used for a barking dog between the horse's forelegs. Another quadruped lies peacefully between the hind legs. The dark blue background is filled densely with dotted white rosettes with central red

points. The yellow frame, set off by a red and black outline, is decorated with a red rinceau.

The inscription in white letters reads Ο ΑΓΗΟC ΜΡΚVΡΗΟC. The vowel missing from the saint's name indicates that the inscription was written by a painter seemingly more familiar with Arabic than with Greek.

The story depicted on the icon is the killing of the emperor Julian the Apostate as told by Malalas,[1] among others, and depicted in narrative fashion in some detail in the manuscript of Gregory of Nazianzus in Paris, gr. 510, from the end of the ninth century.[2]

The lack of a sense of proportion, the simple geometric design of the face, and the preoccupation with decorative effects—features which as such have no counterparts in any other Sinai icon—find their closest parallels in Coptic manuscripts datable in the ninth and tenth centuries, among which several miniatures of saints on horseback have survived. A volume with homiletic writings, partly dated 962 A.D., shows St. Mercurius in much the same pose killing the emperor Julian, who is lying on the ground,[3] and a ninth-century Synaxary in the Morgan Library, cod. 581, with St. Ptolemy of Nikentori[4] shows a similar degree of stylization. The adaptation of a popular style has not gone quite so far in this icon as in the miniatures, but the resemblances seem close enough to attribute the icon also to a Coptic atelier of about the same period as the miniatures.

[1] Migne, *P.G.* 92, col. 748.
[2] K. Weitzmann, "Illustration for the Chronicles of Sozomenos, Theodoret, and Malalas," *Byzantion* XVI, 1942–1943, p. 114, pl. III.

[3] H. Hyvernat, *Album de paléographie copte*, Paris and Rome 1888, p. 14 and pl. XVII.
[4] *Manuscrits coptes de la Bibliothèque du Couvent de el-Hamouly*, Paris 1911, pl. XVI.

B.50. ICON. PLATES XXXII AND CV–CVI
CRUCIFIXION
ABOUT FIRST HALF OF NINTH CENTURY
OLD LIBRARY (FORMERLY IN THE CHAPEL OF
 CONSTANTINE AND HELEN)

H. 47.1 cm; W. 34.4 cm;[1] thickness 1.3 cm. As the result of warping the plaque has a curvature of 2.5 cm. Except for a strip of crimson, the broad border was left unpainted so that a frame could be fastened on it. Such separately worked frames are common in the early period (e.g. nos. B. 12, 16, 21, 31) and frequently bear inscriptions. The most severe damage affects the chin and neck of Christ,

the Virgin's back, and the lower part of the thief behind her. Furthermore, in the lower region of the panel the figure of John and the hill of Golgotha have suffered damage. A heavy brown varnish has made the once radiant golden background now look tarnished.

The crucified Christ stands erect on the suppedaneum; his head, which to judge from a few brushstrokes had a downy brown beard, is slightly inclined, and his full brown hair falls over his left shoulder. The rather fleshy body is modelled with pink and olive green strokes, but shows no linear design on the abdomen or chest, a pattern that begins to develop in the second half of the ninth century.[2] The hips are covered with a short, light blue loincloth, sufficiently

[1] The measurements given by the Sotirious, 39 x 25 cm, are incorrect.
[2] J. Weitzmann-Fiedler, *Die Aktdarstellung in der Malerei vom*

Ausgang der Antike bis zum Ende des romanischen Stils, Strassburg 1934, pp. 16ff.

transparent to let the flesh color shine through. The dark brown cross rises from a cubelike, light brown hill of Golgotha. Close to it stands the Virgin, dressed in a tunic and paenula of a striking velvety crimson, and she touches her chin with the back of her left hand while the right makes a gesture of worship. The youthful John, standing farther from the hill, is dressed in rather unusual colors: a yellow tunic and a pink mantle with crimson folds and a blue border at the seam and around the neck. His left hand is hidden under the mantle and his right hand touches his temple. From behind his shoulder emerges an unsupported Gospel book with a red binding. The flesh color of the Virgin and John is the same as that of Christ, except that some rouge is added to their cheeks. The three nimbi are marked by red double lines on the gold ground, and it should be noted that the cross nimbus of Christ is not coaxial with his head. Three angels at either side of Christ emerge above the rim of the sky and approach him with veiled hands. Their tunics are yellow and their mantles, like their hair, are red. A large blue moon, too big to be completely contained within the frame, and a small red sun fill the upper corners. The difference in their sizes seems to be deliberate, and the greater emphasis on the moon obviously suggests the darkening of the sky (Mark xv:33). The figures of the two thieves are rendered on a very small scale to fit them into a composition in which their inclusion may not originally have been planned. Their flesh color is a simple light brown and both wear light carmine loincloths.

The Virgin is inscribed $\overline{\text{MHP}}$ $\overline{\Theta V}$—apparently the earliest example among the Sinai icons of the substitution of this inscription for the older H ΑΓΙΑ ΜΑΡΙΑ—and ÏωΑΝΝΗC is inscribed, without the usual Ο ΑΓΙΟC, next to the disciple's head. Under the crossbar one reads the words spoken by Christ (John xix:26–27), ÏΔΟV Ο $\overline{\text{VC}}$ COV and ÏΔΟV H $\overline{\text{MHP}}$ COV. All these inscriptions are written in a small uncial in the same dark brown used elsewhere in the icon, and therefore must be considered contemporary.

Iconographically this Crucifixion stands at the crossroads between the Early and Middle Byzantine periods, showing traditional features and at the same time some details that point to the future but do not yet conform to the types established after the end of iconoclasm. As is

characteristic of a work of a transitional period, some elements appear to be unique. In several respects the closest iconographical parallel is the somewhat earlier Crucifixion icon no. B.36. What is most striking in both is that Christ's eyes are closed, in obvious contradiction to the phrase from John's Gospel spoken by Christ. Icon no. B.36 provides the earliest known example of this detail. Another element is the depiction of the two thieves with their hands bound behind their backs. This is one of several methods of crucifixion that occur in early Palaestinian art (cf. p. 63) and later in some of the frescoes in Cappadocia, notably chapel 6 of Göreme.[3] It will be observed that in our icon the thief above the Virgin is characterized as a female; the rendering of the breasts, particularly in comparison with the body of the other thief, leaves no doubt about this. At the same time the figure has a downy beard, an error not present in the earlier icon no. B.36 where one thief is also characterized as a female, not only by the rendering of the breasts but also by the long hair that falls in many strands upon the shoulder. The inscription ΓЄCTΑC on the earlier icon confirms that this is intended to be the bad thief (Gospel of Nicodemus, chap. x), who in this icon turns his head away from Christ, expressing dejection, while the other thief turns towards Christ. One might have expected to see the good thief on Christ's right side, i.e. the side of the elect, and the fact that both icons unexpectedly reverse the positions of the thieves indicates an archetypal link between the two. To equate the bad and the female is in keeping with monastic thinking and may well point to monastic workshops as the likely places of origin of both icons. Still another affinity between the two icons is the placing of the busts of angels in one case on an imaginary and in the other on an actual skyline; however, the types of the angels are different.

In spite of the archetypal connections between this and the earlier icon, there are many and very decisive differences. Most important, the colobium of the earlier icon has been replaced here by a short loincloth. Unlike the usual one of the Middle Byzantine period that falls evenly over both hips, this one is slit over Christ's right side, baring the upper thigh. Such a slit is quite common in Carolingian art, especially in the ivory carvings of various schools,[4] with the difference that the split is always on the left side. Another peculiarity is that the double streams

[3] G. de Jerphanion, *Les Eglises rupestres de Cappadoce*, Paris 1925, *Text*, p. 102 and *Plates* I, pls. 30,2 and 31,2; M. Restle, *Byzantine Wall Painting in Asia Minor*, Recklinghausen 1967, I, p. 109, and II, pl. 53.

[4] A. Goldschmidt, *Die Elfenbeinskulpturen* I, Berlin 1914, pls. xx,41; xxxii,78 and 80a; xxxvi,85–86; xxxvii,88, etc.; li,115. It also occurs

in Carolingian manuscripts, e.g. the prayer book of Charles the Bald in Munich (J. Reil, *Christus am Kreuz in der Bildkunst der Karolingerzeit*, Leipzig 1930, pl. ix) and in fresco painting, e.g. the Chapel of S. Lorenzo at S. Vincenzo al Volturno (M. Avery, *The Exultet Rolls of South Italy*, Princeton 1936, pl. cxc).

of blood and water issuing from Christ's wound in the early icon, and clearly marked as such, have here become four streams of blood. This suggests some symbolic, cosmic meaning such as that the four streams of Christ's salvation-bringing blood—like the four rivers of Paradise—reach into the corners of the world.[5]

Unconventional also are the gestures of both figures under the cross. The flaccid gesture of the Virgin's left hand is, as already pointed out by the Sotirious, somewhat like that of the mourning Virgin in some Cappadocian Crucifixion frescoes, such as those of Qeledjlar and the ancient church of Toqale,[6] although here the pensive touching of the chin has a somewhat different meaning. Actually, the gesture of the icon Virgin is more like a frequent gesture of John on tenth-century Crucifixion ivories of the so-called triptych group.[7] This raises the question of whether the icon painter could have taken over this gesture from a figure of John—all the more likely since he seems to be experimenting with the gestures of John and apparently not following one particular mode. Here John's left arm is hidden under his mantle, unlike the earlier icon no. B.36, where the full arm is shown with the hand lifting the mantle. Frequently John holds the Gospel book with a covered hand, but in this icon a codex is awkwardly placed behind his right shoulder, unsupported and clearly an afterthought. The right hand, emerging from behind the shoulder and touching the temple, is also an afterthought. Another deviation from the accepted Crucifixion iconography is the attitude of the angels; normally, as in icon no. B.36, they extend their hands in a gesture of worship, but here they rush down with veiled hands, very much like those angels who in the Koimesis are eager to accept the Virgin's soul and carry it to heaven. It seems indeed likely that in this detail the painter was actually inspired by a composition of the Koimesis. The impression is that of an artist who is experimenting and groping for new forms of expression.

While an iconographic connection with Palaestine is suggested by the similarity of this icon to Crucifixion icon no. B.36, its style is so different that it cannot be explained as a direct continuation of the Palaestinian tradition as defined by a whole group of Sinai icons. The Sotirious have pointed to connections with the art of Cappadocia and Egypt and suggested that the icon may have come from a monastery in Egypt. It can indeed be related to the Cappadocian frescoes in terms of iconography, but not in terms of style. First of all, the frescoes are later in date and already show the reflection of the style of Constantinople, with its greater corporeality and more strongly patterned highlights as represented by the well-known manuscript of the Homilies of Gregory of Nazianzus in Paris, cod. gr. 510, from the years 880–886.[8] As far as Egypt is concerned, I know of no comparable work of art. At the present state of our knowledge, I must admit an inability to suggest any particular place or even province of origin. Only in a very general way can it be said that this icon, in spite of artistic weaknesses, shows a painterly treatment of the flesh and of the transparent loincloth that is more subtle than anything in the icons of our Palaestinian group. Very different also are the almost pastel colors in John's garments which anticipate the coloring in some tenth-century icons, as e.g. no. B.55. These innovations I have pointed out can hardly be attributed to the painter of this icon, but must be assumed to have been developed in a more competently executed model, quite possibly a Constantinopolitan work from a time between the two destructive phases of the iconoclastic period, i.e. at the turn of the eighth to the ninth century. Such a date would also explain certain similarities with Carolingian art that involve not only the iconographic details but also the style. The fleshiness of Christ's body and its rather thickset proportions are typical of the ivories of the so-called Ada School,[9] and the drapery, especially that of John with its straight, parallel folds and the curving zigzag of the mantle's edges, may be compared to that of John in the fresco of the chapel of S. Lorenzo at S. Vincenzo al Volturno, dated in the time of Abbot Epiphanius (826–843).[10] This does not suggest that the icon could possibly be Western. The relationship must be explained by the dependence of the Carolingian works on contemporary Byzantine models of which this icon seems to be the sole survivor.

[5] Cf. e.g. the miniature of a twelfth-century codex in Stuttgart where the four rivers of Paradise fill the crossarms of a cross whose center is occupied by the sacrificial lamb (E. Schlee, *Die Ikonographie der Paradiesesflüsse*, Leipzig 1937, p. 163 and pl. IV, fig. 21. Cf. also pp. 151ff. concerning the parallelism of blood and the rivers of Paradise).

[6] Jerphanion, op. cit., *Text*, p. 224 and *Plates* I, pl. 51,1; *Text*, p. 282 and *Plates* I, pl. 66,1; Restle, op. cit. I, p. 131 and II, pl. 258.

[7] Goldschmidt and Weitzmann, *Byz. Elf.* II, pls. LIV, 155–LV, 161.

[8] N. Thierry, *Eglises rupestres de Cappadoce, Corsi di cultura sull'arte ravennate e bizantina*, Ravenna 1965, pp. 582ff.

[9] Goldschmidt, op. cit. I, pls. V,8; X,18; XV,31.

[10] Avery, op. cit., pl. CXC.

Bibl.

Sotiriou, *Icones* I, fig. 26; II, p. 41.

R. Haussherr, *Der Tote Christus am Kreuz* (Diss.), Bonn 1963, p. 130.

K. Weitzmann, "Various Aspects of Byzantine Influence on the Latin Countries from the Sixth to the Twelfth Century," *D.O.P.* xx, 1966, pp. 12ff. and fig. 22.

H. Belting and C. Belting-Ihm, "Das Kreuzbild in 'Hodegos' des Anastasios Sinaites," *Tortulae, Studien zu altchristlichen und byzantinischen Monumenten, Festschrift Johannes Kollwitz, Röm. Quartalschr.* 30. Suppl., 1966, p. 37 and pl. 6a.

K. Wessel, *Die Kreuzigung*, Recklinghausen 1966, p. 37 with figure on p. 38.

B.51. ICON. PLATE CVII
CRUCIFIXION
ABOUT SECOND HALF OF NINTH CENTURY
OLD LIBRARY

H. 16.6 cm; W. 13.9 cm; thickness 0.9 cm (with frame 1.3 cm). A separately worked frame, of which only the left and right sides are preserved, is nailed over an unpainted border. This seems to exclude the possibility that the plaque could once have been the center of a triptych, as the holes in the very broad upper and lower border might suggest, unless the frame was added later. There are traces of damage along the right side of Christ's body, in the lower part of his face, in various spots in the background, and in the bottom line of the inscription. A heavy varnish has led to discoloration.

The composition, set against a golden ground, is confined to Christ on the cross, the Virgin, and John. Christ is dressed in an olive grey loincloth that quite likely was blue before it was discolored by the varnish. John's tunic is the same color, while his mantle is of pink with carmine folds, both draperies being strongly highlighted. The Virgin's garments are painted a dark red brown which substitutes for purple. The flesh color of all the figures is a simple flat yellow brown. Christ's cross, rising from a minute hill symbolizing Golgotha, is much too thin below the suppedaneum in comparison to the crossarms; both of these are shaded in a darker brown. Christ's golden nimbus with a black cross cuts into the inscription which frames the scene and is written on the black ground in white letters now yellowed under the varnish.

The four lines written in verse read:

+ TIC[1] OV KΛONEITAI K [AI] ΦOBEITAI KAI TPEM(EI)

ЄΠΙ ΞVΛOV CЄ KP[ЄMAMEN]ON ω CωTЄP BΛЄΠωN

PIΓNVNTA TON XЄITωNA THC NЄKPωCЄωC: AΦΘAPCI(AC) ΔЄ TH CTOΛH[2] CKЄΠ(ACMЄNON?)[3]

Who will not be confounded, be in fear and tremble
When he sees You, O Saviour, hanging on the cross
Who rended the garments of death
But is covered with the robe of incorruption.

Iconographically, the composition has eliminated all narrative elements of icons nos. B.36 and 50 and confined itself to the three essential protagonists, a simplification that existed earlier (no. B.32) but became generally accepted only in the tenth century. Yet it is distinguished from the almost canonical rendering of this theme in the later period by a number of elements that are unique and establish this icon as the product of a transitional period, like icon no. B.50 but in quite different ways. It shares with the two earlier icons the short, dark beard and the closed eyes of Christ; like B.36 it has the very stylized crown of thorns, marked here by rows of dots along the fillet instead of crosses as in the earlier example; and as in B.50, short streams of blood issue from Christ's wound, but because of the damage, it can no longer be determined with certainty how many there were. Possibly there were four.

The gestures of both the Virgin and John are quite unusual. Normally the Virgin touches her head with her left hand as an expression of grief while her right is extended in a gesture of worship; but here the right hand touches the lips while the left hand limply holds a handkerchief. In his veiled left hand John holds a Gospel book bound in red as if he were going to offer it to Christ, a feature for which I know no parallel. Moreover, while he commonly raises his open hands towards Christ, it is unique for him to point a finger towards him. This is the usual gesture of the

[1] The Beltings read (˝Oσ)τις at the beginning, but (1) there is not enough space for two more letters; (2) the traces left point clearly to the conventional + with which an inscription normally begins; and (3) the meter does not allow for an additional syllable.

[2] Here the reading of the Beltings is more correct than that of the Sotirious.

[3] The restoration of the last word by the Beltings as (αστόν?) cannot be right because then one syllable would be missing in the fourth line. I therefore propose σκεπασμένον.

centurion, and it seems quite possible that the painter was inspired by a representation of the witnessing soldier. Equally uncommon is John's striding pose, with the left foot forward as though just entering the scene. The Sotoriou have seen in this highly dramatic behavior an influence from the Passion play Χριστὸς Πάσχων.

In comparison with the earlier Crucifixion icons, the style of this one is characterized by the greater plasticity of the figures, the fluttering draperies that reveal a nervous energy, and the greater degree of emotionalism in the faces. The body of Christ is more modelled, as marked by the design of the ribs and the rounded abdomen.[4] The legs are not aligned side by side on the suppedaneum as one slightly overlaps the other. This change can be traced to Carolingian art where the ivories of the so-called Ada group still adhere to the older principle,[5] while miniatures from the middle and the second half of the ninth century clearly show the overlapping of the legs.[6] The change cannot be demonstrated for Byzantine art of this period because datable monuments are lacking, but the later form appears fully developed on a tenth-century ivory of the painterly group in the Metropolitan Museum in New York.[7] Typical of the drapery are the windblown trumpet folds at the hem of John's tunic and on Christ's loincloth, where they are very uncommon. They appear in Byzantine miniature painting for the first time in such fully developed form in the Paris Gregory of Nazianzus, cod. gr. 510, from 880 to 886,[8] and may also be found in the Vatican Bible, cod. Reg. gr. 1, from the early tenth century.[9]

The aim of the artist is clearly to emotionalize the drama of the Passion and to harmonize formal elements like the whirling design of the drapery with the expression of sorrow in the Virgin's face, the tense gestures of John and the emphasis on compassion for the dead Christ, which is stressed by the crown of thorns and the profuse bleeding of the wounds. It is not likely that these various innovations were invented by the painter of the Sinai icon, whose many shortcomings are revealed in the rendering of the organic structure of the bodies and in the unconvincing arrangement of the garments, and whose line is expressive but not very sensitive. He must have had available a good model by a progressive artist, either itself a contemporary creation of Constantinople or one based on such. In this respect the icon depends more closely on the style of the capital than does icon no. B.50. There are a few small links, nevertheless, to the Palaestinian tradition; iconographically, there is the motif of the closed eyes combined with the peculiar form of the crown of thorns, and stylistically, there is such a minor detail as the four dotted rosettes on the Virgin's garments, a motif that appears to be a workshop device. The icon shares both elements with icon no. B.36. Thus it does not seem altogether impossible that we have here a product of a Palaestinian workshop, from a time immediately after the end of iconoclasm, and under the renewed influence of the reinvigorated art of the capital.

Bibl.

Sotiriou, *Icones* I, fig. 27; II, p. 42.

R. Haussherr, *Der Tote Christus im Kreuz* (Diss.), Bonn 1963, p. 130.

H. Belting and C. Belting-Ihm, "Das Kreuzbild im 'Hodegos' des Anastasios Sinaites," *Tortulae, Studien zu altchristlichen und byzantinischen Monumenten, Festschrift Johannes Kollwitz*, Röm. Quartalschr. 30. Suppl., 1966, p. 37 and pl. 6b.

[4] As a parallel to the rounded body, cf. the crucifixus of the Hrabanus Maurus manuscript in the Vatican, cod. Reg. lat. 124, a product of Fulda from the second quarter of the ninth century. Cf. J. Weitzmann-Fiedler, *Die Aktdarstellung in der Malerei vom Ausgang der Antike bis zum Ende des romanischen Stils*, Strassburg 1934, pp. 27–28 and pl. II,18.

[5] A. Goldschmidt, *Die Elfenbeinskulpturen* I, Berlin 1914, pl. V,8; XV,31.

[6] A. Boinet, *La Miniature carolingienne*, Paris 1913, pl. XCVIII,A (Gospels of François II) and pl. CXXXII,B (Sacramentary of Metz).

[7] Goldschmidt and Weitzmann, *Byz. Elf.* II, pl. II, 6.

[8] Omont, *Miniatures*, pl. XXXVII and especially LVIII (angel in Ezekiel's Vision).

[9] *Miniature della Bibbia Cod. Vat. Reg. Greco 1*, Milan 1905, pls. 1 and 8.

B.52. ICON. PLATES XXXIII AND CVIII
ST. ZOSIMAS AND ST. NICHOLAS
FIRST HALF OF TENTH CENTURY
OLD LIBRARY

H. 20.6 cm; W. 14.1 cm; thickness 1.7 cm. As the result of warping so considerable that the vertical axis has been raised 1.4 cm, flaking has occurred, especially along this axis. Affected were the gold ground, a fairly large area of the monk's garment between the left knee and foot, the right elbow of the bishop, and a few other spots. Varnish has altered some of the color values, turning blue to olive green and the white of St. Nicholas's omophorion to yellow.

The figures are identified by red inscriptions as

O OCIOC ZOCIMAC and O A(ΓIOC) NIKOΛAOC. The letters are very round, imitating an early type of hieratic uncial. The bare-headed monk is dressed in a brown tunic, a purple brown mandyas and a black megaloschema. He stands frontally with his hands raised toward the spectator. St. Nicholas is dressed in a steel blue sticharion and phelonion, and also in an epitrachelion and omophorion with black crosses. With his veiled left hand he holds a Gospel book, richly studded with red stones and pearls; with his blessing right hand he points towards the book. The flesh color shows a vivid contrast between red brown and olive-colored shadows. The olive color is also very strong in the grey hair and the beards, that of St. Nicholas being full and rounded and that of St. Zosimas long and shaggy. The nimbi are marked by an incised compass line filled with red; the same red is used for the inscriptions and the broad frame.

The facial features of St. Nicholas point to a period when the standard Middle Byzantine type is beginning to crystallize. No longer does the saint's hair fall upon his forehead as in the seventh- to eighth-century icon no. B.33, but it recedes, and the resulting high forehead increases the impression of spiritual power; at the same time the hair does not yet show the little spiral locks in the middle of the forehead, which are marked in icon no. B.61 and later become typical of all Nicholas portraits. Furthermore, the beard, pointed in the earlier icon, has become rounded, but has not yet the characteristic indentation of the later type. With the earlier panel Nicholas shares the early type of omophorion which does not fall symmetrically down but is thrown over the left shoulder. While the change from the older to the newer type took place in the Latin West in about the second half of the ninth century,[1] both existed side by side for quite some time in Byzantine art, as evidenced by the ivory triptych in the Louvre, known as the Harbaville Triptych, which belongs to the middle of the tenth century.[2] Like the omophorion of icon no. B.33, that in our panel is decorated with lobate crosses. Furthermore, it should be pointed out that on the Harbaville Triptych the lobate crosses occur only on the older type of omophorion while the crosses on the more modern, symmetrically falling omophorion are straight armed.

Stylistically the figure of St. Nicholas may be compared to the three frontal bishops, Basil and the two Gregories, in the Gregory manuscript in Paris, cod. gr. 510, dated between 880 and 886, whose figures are more solid and whose heads have heavily outlined hair and the traditional gaze of the wide-open eyes.[3] The Sinai icon is executed in a more painterly style, especially in the rendering of the faces, and therefore seems to be of a slightly later date. This view is supported by a comparison with the Nicholas figure in the Vatican Bible cod. Reg. gr. 1 which can be dated in the early tenth century.[4] Here we see the same face without the spiral locks and a very similar beard. Yet the painterly manner of the Vatican miniature is more subtle than that of our icon. Whereas these parallels are strong enough to justify a date for the icon in the beginning or the first half of the tenth century, there is not sufficient reason to ascribe it to an atelier of Constantinople where the two manuscripts were made. It is true that the painterly quality of the icon, as indicated chiefly by the sharp highlights in the faces as well as on the garments, can be understood only as a reflection of the style of the capital in the period of the Macedonian Renaissance; yet there is an absence of the crumpled folds with broken highlights that are typical of the style of Constantinople. Instead, we find here a tendency toward straight parallel folds and highlights, especially in the figure of St. Nicholas. There is also a marked difference in the color scheme. We find the same predilection for steel blue in the garments of Nicholas and other saints of two more icons by the same hand (nos. B.53 and 54). This predominance of steel blue is most outstanding in the miniatures of the Job manuscript in Venice, Marciana cod. gr. 538, which is dated in the year 905.[5] Here, too, the system of highlights with long, parallel lines is very marked. While this relationship further supports the early tenth-century date for our icon, the similarities are not close enough to ascribe the icon to the same center as the manuscript, for which we proposed a place of origin somewhere in central Asia Minor. The affinities go only so far as to suggest for each a place of origin east of Constantinople under the strong influence of the capital.

From the iconographical point of view, Palaestine also must be taken into consideration because of the importance attached to St. Zosimas, a monk of the Palaestinian desert. His importance rests primarily on his role in the life of St. Mary of Egypt, having given her a cloak to cover her nakedness and, later, administered Holy Communion to her shortly before her death in the desert. Thus he is almost exclusively depicted performing these two acts, particularly the second and more important one, which we see in

[1] J. Braun S.J., *Die liturgische Gewandung*, Freiburg 1907, p. 645.
[2] Goldschmidt and Weitzmann, *Byz. Elf.* II, pl. XIII,33b.
[3] Omont, *Miniatures*, pl. XXVII.
[4] *Miniature della Bibbia Cod. Vat. Reg. Greco 1 e del Salterio Cod. Vat. Palat. Greco 381*, Milan 1905, p. 5 and pl. 5; C. Mango, "The

Date of Cod. Vat. Regin. Gr. 1 and the 'Macedonian Renaissance'," *Acta ad Archaeologiam et Artium Historiam Pertinenta* IV, 1969, pp. 121ff.
[5] Weitzmann, *Byz. Buchmalerei*, pp. 51ff. and pls. LVII–LVIII.

miniatures of Constantinopolitan manuscripts like the Theodore Psalter in London, cod. add. 19352, on fol. 68r,[6] in frescoes in Cappadocia,[7] in S. Maria Antiqua[8] and S. Maria Egiziaca[9] in Rome and elsewhere. Since the calendar lacks a separate commemoration for St. Zosimas, there is a good reason why he should not be depicted alone. Perhaps a local tradition of the fathers of the desert justified depicting him equal to St. Nicholas. I know of no other example of the pairing of the two.

Possibly this icon is one of a set. It will be noted that both saints look to the right of the panel, suggesting that the icon was placed at the left while the eyes of a pair of saints in a corresponding icon at the right would have been turned to the left. The extent to which the artist is concerned with directing the glance of the eyes towards the center may be seen in the other two icons by the same hand (nos. B.53 and 54). Moreover, in the lost companion piece to this icon a holy father would have been standing at the left and another monastic saint at the right, for the inner figures would have had to be of higher rank. The corresponding church father would almost certainly be one of the familiar triad i.e., Basil, John Chrysostom, or Gregory of Nazianzus. There may actually have been a third, central icon with two additional standing church fathers. An arrangement like this would have a close parallel in the miniature of the Lectionary, cod. 587, in the monastery of Dionysiu on Mount Athos from the middle of the eleventh century (fig. 31).[10] Here the miniature of the holy fathers has in the front row four church fathers who can be identified from left to right as Basil, Nicholas, John Chrysostom, and Gregory of Nazianzus. They are flanked at either side by monastic saints, none of whom can be identified with certainty, though they must be of the rank of the fathers. Zosimas is not an equal and thus our postulated set could hardly have served as a picture of the feast of the holy fathers. It rather resembles the series of saints at the bottom of the triptych wings (no. B.58) where St. Basil is surrounded by three monks, and where four or five more church fathers must be assumed at the bottom of the missing central panel (fig. B, p. 98). As far as the companion figure to Zosimas in our set is concerned, the possibility should not be excluded that it was not another monk but St. Mary of Egypt, with whose life Zosimas is so closely associated.

The back of the icon has, painted on gesso ground, a simple red cross, monumental in appearance, which is characterized by the huge half palmettes reaching up to the cross bar. This is typical of the crosses which decorate full pages in manuscripts like the Paris Gregory[11] and the Regina Bible;[12] it shares with them also the inscription \overline{IC} \overline{XC} \overline{NI} \overline{KA}, which in the Middle Byzantine period replaced the older inscription \overline{IC} \overline{XC} \overline{VC} $\overline{\Theta V}$ (cf. nos. B.22–23). The discs on stems in which three of the crossbars terminate are typical for the crosses on the backs of tenth-century ivories, where usually they are adorned with rosettes that may or may not be connected with the cross by short stems.[13] Thus there can be little doubt that this cross on the icon is contemporary.

Bibl.

Weitzmann, *Frühe Ikonen*, pp. XII, LXXX, and pl. 13.

[6] S. Der Nersessian, *L'Illustration des psautiers grecs du Moyen Age* II: *Londres, Add.* 19352, Paris 1970, pl. 36, fig. 110.

[7] G. der Jerphanion, *Les Eglises rupestres de Cappadoce* I, 1925, pl. 59,4; II, 1928, pl. 85,4.

[8] J. Wilpert, *Die römischen Mosaiken und Malereien der Kirchlichen Bauten vom IV.–XIII. Jahrh.*, Freiburg 1916, IV, pl. 227,2.

[9] J. Lafontaine, *Peintures médiévales dans le temple de la Fortune Virile à Rome*, Brussels and Rome 1959, pp. 43ff. and pls. XIV–XVI.

[10] Weitzmann, "The Mandylion and Constantine Porphyrogennetos," *Cah. arch.* XI, 1960, p. 168 and fig. 7 (repr. Weitzmann, *Studies*, p. 230 and fig. 216). S. M. Pelekanides, P. C. Christou, Ch. Tsioumis, S. N. Kadas, *The Treasures of Mount Athos. Illuminated Manuscripts* I, Athens 1974, fig. 247.

[11] Omont, *Miniatures*, pls. XVII–XVIII.

[12] *Miniature della Bibbia*, pp. 4–5 and pls. 3 and 6.

[13] Goldschmidt and Weitzmann, *Byz. Elf.* II, pls. XIII,33b; XVII,41b; XXVIII,72b; LXIII,53b, 31f; and elsewhere.

B.53. ICON. PLATE CIX
VIRGIN BETWEEN JOHN THE BAPTIST AND
 ST. NICHOLAS
FIRST HALF OF TENTH CENTURY
OLD LIBRARY

H. 21 cm; W. 16.2 cm; thickness 1 cm. The warping of

the comparatively thin plaque has split it into two halves, now glued together. Due to this split and a crack close to it the Virgin in the center is the most damaged of the three figures. Little remains of her head, and large portions of her garments have flaked off, especially on her lower left leg where the gesso ground has fallen away, exposing the wood. Part of the head of John the Baptist is lost, as are a few areas of his garment. The figure of St. Nicholas is on the whole

well preserved, showing only a few spots of minor damage. A heavy varnish has been applied to the icon apparently to save it from further flaking; as a result some colors have been darkened and others altered.

In the center stands the Virgin, dressed in a blue tunic and a purple brown paenula, both colors so darkened that the original hues are hardly recognizable. Shod in red shoes (only the right foot is preserved), she stands on a simple brown footstool which raises her slightly above the flanking saints. In her left arm she cradles the Christ Child, clad in simple brown garments, while with her right she holds his left foot as if to steady him. More often the Virgin uses her left hand to support Christ, but here she also holds a hand-kerchief, a rare occurrence when she is represented with the Child. Christ's right hand, almost completely destroyed, was obviously extended in a gesture of blessing, whereas his left holds a pink scroll. John the Baptist wears a brown tunic and a mantle of dark brown shimmering with olive. Such use of changeant colors becomes common in the tenth century as the result of a renewed interest in, and close study of classical models. John holds a cross-staff in his left hand while his right is extended in a gesture of blessing towards Christ. Dishevelled dark brown hair falls in long locks upon his shoulders. In contrast to the somber colors of John's garments are the sticharion and phelonion of St. Nicholas, who flanks the Virgin at the other side. Both garments are light blue; the present darkness of the color is due merely to the heavy varnish, which has also produced the olive-toned discoloration. The almost identical figure of St. Nicholas in icon no. B.52, painted by the same artist, gives a still better impression of the original color; here, too, varnish has darkened the color, albeit to a lesser extent. The parallelism between the two Nicholas figures goes much further. In both icons the bishop wears thrown over his left shoulder the older type of omophorion, decorated with lobate crosses. In the left hand he holds the jewel- and pearl-studded Gospel book towards which his blessing right hand is directed. His face shows a vivid red flesh color contrasted with deep olive-colored shadows, similar to the coloring of the faces of the Virgin and the Christ Child in our icon. In the face of John the olive tone is absent. Here the artist has used only red and brown to harmonize the face with the dark brown hair, while in the face of St. Nicholas the olive-colored

shadows harmonize with the olive grey hair and beard. All the hands are rosy pink, contributing to the general realistic impression as best seen in the figure of St. Nicholas. The nimbi are marked on the gold ground by incised lines which are filled with red paint, while the cross in Christ's nimbus is painted in red. The inscriptions are written in rounded red uncials typical in the tenth century. They read: M(H)T(H)P Θ(ЄO)V; O A(ΓIOC) [I]ω(ANNHC) [O ΠP]ωΔPOMOC and O A(ΓIOC) NIKOΛAOC. The same very strong red is also used for the elevated frame.

The type of Virgin is that of the Hodegetria, quite popular in the tenth century, as a number of ivory plaques, some of approximately the same size, indicate. But while in all the ivories of the Romanos group the Virgin holds her right hand before her breast in a rather hieratic pose,[1] the use of this hand to steady the Child is found in the ivories of the Nicephoros group.[2] This slightly more human element occurs as early as the sixth century in a miniature of the Rabula Gospels,[3] and thus may well indicate the more original type of Hodegetria.

A representation of the Virgin framed by two saints evokes the Deesis, and in all probability the composition here was inspired by that supplication group, in which the Virgin and John the Baptist flank Christ. For such a triad with the Virgin in the center there is no established iconography and the saints associated with her vary greatly.[4] The closest parallel in concept is an ivory plaque of the Romanos group in Dumbarton Oaks, Washington, in which the Hodegetria is flanked at her right once more by John the Baptist and at her left by a bishop who however is not St. Nicholas but, to judge from the facial type, St. Basil.[5] Another combination, from the tenth century, is an ivory triptych in Moscow, where the Hodegetria, occupying the central plaque, is flanked on the left wing by St. Nicholas of a type quite similar to that in the icon under discussion and on the right by John Chrysostom.[6] It will be noted that in both ivories the flanking figures turn their heads and bow towards the Virgin, while in the icon John and Nicholas look at her only out of the corners of their eyes. Presumably the icon presents an earlier stage of development, while the ivories, a few decades later, reflect a more advanced stage in which the poses and gestures are more appropriate to the concept of supplication.

[1] Goldschmidt and Weitzmann, *Byz. Elf.* II, pls. XX, 46–XXI, 51.

[2] Ibid., pl. XXXIV, 86.

[3] C. Cecchelli, I. Furlani, M. Salmi, *The Rabbula Gospels*, Olten and Lausanne 1959, pl. fol. 1b.

[4] E.g. Sotiriou, *Icones* I, fig. 164, 177.

[5] H. Peirce and R. Tyler, "Three Byzantine Works of Art," *D.O.P.*

II, 1941, pp. 11ff. The review by K. Weitzmann in *Art Bull.* XXV, 1943, p. 164, corrects the identification of the bishop. S. Der Nersessian, "Two Images of the Virgin in the Dumbarton Oaks Collection," *D.O.P.* XIV, 1960, pp. 69ff. and fig. 1.

[6] Goldschmidt and Weitzman, *Byz. Elf.* II, pl. XXIX, 73.

In all stylistic details this icon is so similar to the one depicting St. Nicholas and St. Zosimas (no. B.52) that there can be no doubt that they were painted by the same hand. This is particularly obvious when one compares the two Nicholas heads. One need only point to such a detail as the strange, shell-shaped ears. Moreover, even the heavy varnish does not obscure the sameness of the colors of the garment and of the treatment of the highlights. Thus this icon must also be dated in the beginning or in the first half of the tenth century. It should be noted that the two icons are, but for a few millimeters, the same height. Were it not for the fact that each icon has a figure of St. Nicholas, one might have been tempted to ascribe both to the same set. Apparently the artist used a rather standard size, because there is a third icon by him which agrees exactly in height with ours (no. B.54).

B.54. ICON. PLATES XXXIII AND CIX
VIRGIN BETWEEN ST. HERMOLAOS AND ST. PANTELEIMON
FIRST HALF OF TENTH CENTURY
CHAPEL OF HAGIOS IOANNES PRODROMOS

H. 20.6 cm; W. 16.2 cm. The icon is firmly mounted in the north wall of the John Prodromos Chapel. A vertical crack has split the panel into two halves, causing the heaviest damage in the center and affecting the faces of both the Virgin and the Child as well as the lower half of the Virgin figure. Two smaller cracks at the left have caused damage to the bearded saint's face and feet; while the youthful saint remains well preserved in the upper part of his figure, some flaking has occurred around his knees and his left foot is lost. A very heavy brown varnish has darkened colors, altering some of them to some degree.

In the center stands the Virgin, dressed in a blue tunic and purple brown paenula, both colors having almost blackened. In front of the Virgin appears the Christ Child in a seated pose. Although the Virgin's hands are not clearly visible, the direction of her arm indicates that her left hand touches Christ's left foot and her right hand Christ's right shoulder. In this way the Child could not be firmly held, as the artist intended to give the impression of suspension. Christ is clad in brown garments the folds of which hide his left arm, while his right hand, now destroyed, most likely made a gesture of blessing. Each flanking saint is dressed in a girdled, light blue tunic with a black diamond pattern. Hermolaos, at the left, wears a dark olive mantle of the type worn by physician-saints, while Panteleimon wears a dark blue mantle of the same type. The flesh color appears dark brown as the result of the discoloring varnish, but originally it was pink and red, comparable in color to the hand of St. Nicholas in icon no. B.52. By representing Panteleimon with dark brown locks and Hermolaos with grey olive hair and beard, the artist has created the same effect of contrast as in the parallel icon no. B.53 between John the Baptist and St. Nicholas. Each physician-saint holds in his right hand an ornate scalpel which would normally be matched by a medical case in his other hand. But while Panteleimon's left hand is covered, Hermolaos holds a jewel-studded codex like that held by St. Nicholas in the other two icons by the same artist (nos. B.52 and 53). The Virgin stands on a brown, pearl-studded footstool, but since all three figures are isocephalically arranged, the Virgin had to be rendered in somewhat smaller scale, contrary to the normal relation between size and rank order. Except for a three-layered groundstrip in dark green, lighter green, and light brown, the background is gold, against which the three large nimbi are marked by incised lines filled with red, whereas Christ's nimbus is heavily outlined in black and contains a cross outlined in red. The same strong red is used for the elevated frame and for the inscriptions MH(TH)P Θ(ЄO)V O A(ΓIOC) ЄPMѠΛAOC and O A(ΓIOC) ΠANT[Є]ΛЄIMѠN, executed in the same rounded uncials we have seen in the two related icons.

There are two types of standing Virgin with the Christ Child suspended in front of her: one is the Blacherniotissa, who lifts her hands like an orant; the other, who either holds the Christ Child or the aureola surrounding him and may be represented standing or seated, was called by Kondakov ἡ Νικηποιός.[1] Among the variants of the Nikepoios, there is one in which the Virgin holds the child in very much the same manner as in this icon. The type occurs on a number of icons on Mount Sinai,[2] and in one case it is inscribed as

[1] N. P. Kondakov, *Иконографія Богоматери* II, Petrograd 1915, pp. 124ff.

[2] Sotiriou, *Icones* I, figs. 163, 177 (slight variant), 197 and a considerable number of other Sinai icons not yet published.

ἡ βάτος.³ Thus we are dealing here with the Virgin of the Burning Bush who in the early period still appears without the realistic detail of the bush consumed by flames in the background,⁴ the one possible exception being the Virgin of the Ascension in icon no. B.42, which is most likely somewhat earlier.

Of the two physician-saints who flank the Virgin, St. Panteleimon is by far the more important. The eminence of St. Hermolaos rests solely on the fact that in the life of St. Panteleimon he is mentioned as the priest and hermit who had taught young Panteleimon τὴν κατὰ Χριστὸν ἰατρικὴν τέχνην and baptised him. Whereas a certain Euphrosynos was apparently his more professional teacher, Hermolaos taught him the spiritual powers that enabled him to perform miracles.⁵ Thus Hermolaos appears in Byzantine art only in association with Panteleimon even when included in a group of physician-saints. In a medallion on the southern wall of the transept of the Martorana he is represented with St. Kyros and St. John standing below him, while on the north wall the corresponding medallion, now lost, surely represented St. Panteleimon above the standing Saints Cosmas and Damian.⁶ It will be noted that in the mosaic, Hermolaos, white haired as in the icon, is dressed in a monk's garb, and although he holds a jewel-studded book, he does not display a scalpel or any other medical instrument. In an enamel medallion of the Pala d'Oro in San Marco, where Hermolaos is likewise grouped with Panteleimon and other physician-saints, he does not wear a monastic costume but an ordinary mantle, and while he holds a codex he is once more depicted without a medical

implement.⁷ Our icon therefore must be considered a deviation from the established iconography. Here Hermolaos is turned into a full-fledged physician, wearing the professional mantle and holding the scalpel, but at the same time there is a compromise with the traditional type in that he holds a codex and wears the priestly stole, the epitrachelion, whose cross-ornamented ends are visible under his mantle. Since there is no independent Vita of St. Hermolaos, his calendar day is the same as that of St. Panteleimon, July 27. Probably in recognition of his age, the more honored side at the right of the Virgin is assigned to Hermolaos, although St. Panteleimon outranks him in importance and popularity.

The color, design, script, and size of this icon are so much in agreement with those of the two preceding icons nos. B.52 and 53, that we must assume it to be by the same artist. For an analysis of style and for a discussion of date and provenance, I refer to what has been said in connection with no. B.52. Admittedly the place of origin of this and the related icons is still an open question. The choice of the Batos type for the Virgin makes it quite probable that the icon was made for Sinai. It may have been destined for one of the outlying chapels dedicated to St. Panteleimon. This suggests as place of origin an artistic center with which Sinai was in close contact and from which an artist might have gone to the Sinai monastery. Here he could have worked in a style that need not have been rooted in the Sinaitic tradition. This theory would explain the presence in the monastery of three icons by the same hand, all of which were apparently painted within a short period.

³ Ibid., fig. 155.

⁴ K. Weitzmann, "Icon Painting in the Crusader Kingdom," *D.O.P.* xx, 1966, p. 67 and fig. 35. Here is reproduced a Crusader icon of the thirteenth century which to our knowledge is one of the earliest examples of the Virgin of the Burning Bush. But this bust of the Virgin shows her as an orant and without the child.

⁵ H. Delehaye, *Synaxarium Ecclesiae Constantinopolitanae*, Brussels 1902, cols. 847ff. Cf. also the Metaphrastes vita: Migne, *P.G.* 115, cols. 448ff.

⁶ O. Demus, *The Mosaics of Norman Sicily*, London 1949, p. 81 and pl. 57.

⁷ W. F. Volbach and H. R. Hahnloser, *La Pala d'Oro*, Florence 1965, p. 68 and pl. LVIII nos. 158–159.

B.55. RIGHT WING OF A TRIPTYCH. PLATES XXXIV AND CX
FRONT: BAPTISM AND ANASTASIS
BACK: ST. DAMIAN
FIRST HALF OF TENTH CENTURY
OLD LIBRARY

H. 28 cm; W. 8.6 cm; thickness with the frame (cut from the same piece) 1.3 cm. The plaque proper is only a few mm thick. The frame of the inner, scenic side has at the

left top and bottom holes for dowels, indicating that the plaque once formed the right wing of a triptych. A split through its length has caused severe damage. A large section of the paint between the segment of the sky and the head of the Christ of the Baptism has flaked, baring the wooden ground, as has a narrow strip in the lower scene, obliterating most of the left leg of Christ. In addition, small bits of paint have chipped away all along the crack. On the outer side the damage is less severe despite flaking directly down the saint's face, as well as in a larger section of the garment over

the left leg. However, this more exposed side shows additional damage caused by rubbing in various spots of the surface. The colors have to a large extent preserved their original freshness and only a brown varnish on the gold ground has altered the genuine impression.

The upper half of the inner side is occupied by a representation of the Baptism, inscribed I ΒΑΠΤΙC[IC] in white letters on the black border which frames both scenes. Christ, whose body is depicted in a light flesh color and outlined heavily in brown, stands up to his shoulders in the light blue bell-shaped Jordan with parallel ripples of dark blue crossing his body. John the Baptist is dressed in a chestnut-colored tunic and mantle. He stands elevated on the dark brown ground so that his extended right hand, now lost, could reach the head of Christ. On the other side of the Jordan on light brown ground stand two angels, dressed in light blue tunics and pink mantles. A crimson clavus is painted horizontally across each breast and their wings are the same dark brown as the ground under John's feet. The angels gaze at the segment of heaven, mostly destroyed, from which rays of light must have issued and a dove presumably descended. The iconography is the standard one for the Middle Byzantine period, with Christ making the gesture of blessing the holy water of the Jordan, but both the usual river personification and the cross monument are absent.

In the Anastasis of the lower register Christ steps forward, grasping Adam's right arm. Both are dressed in light blue tunics with crimson clavi and pink mantles. Adam is kneeling on an open sarcophagus from which he has just risen, and behind him Eve, dressed in a crimson paenula, stands with her veiled hands raised in a gesture of prayer. Under the feet of Christ one sees what should be a gate of hell, usually depicted by a pair of valves lying in crossform, but the light blue color of this object, the same as that of the sarcophagus, suggests that the painter meant it to be the lid of the sarcophagus. In reversal of the upper scene, applying the chiasmic principle, the painter has used dark brown for the right side of the ground, and light brown for the mountain at the left, whose rocky formation is defined by thick black outlines. As in the upper Baptism scene, gold is used for the background and the nimbi, marked only by incised lines, while the cross in Christ's nimbus is delineated in red.

The Anastasis is very abbreviated, being confined to Christ, Adam, and Eve. Iconographically this represents the oldest type of the Anastasis in which Christ confronts Adam and Eve instead of dragging Adam along behind him—a type invented only during the Macedonian Renaissance.[1]

On the outer side a saint is represented in a stately, frontal pose. He is dressed in a long, light blue tunic and a chestnut-colored mantle of the very type worn by the physician-saints. In his veiled hand he holds a box of medical instruments, of the same color as his mantle; its top terminates in two cylinders between which are visible three scalpels, not unlike the one he holds in his right hand. This is precisely the shape of the box held by Cosmas and Damian in some tenth-century ivories.[2] The background is also chestnut colored, except for a rectangular area of gold, outlined in black behind the saint's head, upon which the nimbus is incised. No identifying inscription is visible, but since by far the most popular physician-saints are Cosmas and Damian and since we are quite certainly dealing here with the right-hand figure of a pair, assuming a companion figure on the left wing, it appears likely that it is St. Damian who is represented on this wing and that it was St. Cosmas on the wing that has been lost. Representations of the two saints on later Sinai icons show them with very short beards;[3] on the Byzantine ivories, however, Cosmas and Damian have fuller beards,[4] comparable to that of the saint of our icon. As the ivories of the tenth century precede in date the Sinai icons just cited, there may well be reflected here a stylistic evolution from a fuller to a shorter beard.

In terms of color the effect of the icon is determined by the light hues, especially the light blue and brown of the garments. This is typical of the miniature paintings of the Gregory manuscripts in Paris, cod, gr. 510, dated between 880 and 886,[5] and of the Gospel book in the Walters Art Gallery, cod. 524, and its cut-out miniatures in the Amberg Collection, from the first half of the tenth century.[6] With the latter this icon shares a certain lack of refinement, apparent in the unsure treatment of the highlights. This may well indicate that neither is Constantinopolitan, but the place of origin of neither can be determined with certainty. Characteristic of the icon are the full round faces with their spotty highlights—that of John the Baptist, especially, in

[1] K. Weitzmann, "Das Evangelion im Skevophylakion zu Lawra," *Seminarium Kondakovianum* VIII, 1936, pp. 88ff.

[2] Goldschmidt and Weitzmann, *Byz. Elf.* II, pl. XIII, 33b; XVI, 39.

[3] Sotiriou, *Icones* I, figs. 52, 84, 85.

[4] Goldschmidt and Weitzmann, *Byz. Elf.* II, pl. XII, 32b; XIII, 33b; XVI, 39; XLI,111a.

[5] Omont, *Miniatures*, pls. xvff.

[6] *Early Christian and Byzantine Art*, Exhibition Walters Art Gallery, Baltimore 1947, pl. C no. 695. M. Chatzidakis and V. Djurić, *Les Icones dans les collections suisses*, Exhibition catalogue, Geneva 1968, nos. 1–4 with plate. *Illuminated Greek Manuscripts from American Collections. An Exhibition in Honor of Kurt Weitzmann*. The Art Museum, Princeton University, ed. Gary Vikan, Princeton, 1973 pp. 62ff. and figs. 5–7. K. Weitzmann," An Illustrated New Testament of the Tenth Century in the Walters Art Gallery," *Gatherings in Honor of Dorothy E. Miner*, Baltimore 1974, pp. 19ff.

ANNUNCIATION	NATIVITY	PRESENTATION IN TEMPLE	BAPTISM
METAMORPHOSIS or LAZARUS	ENTRY INTO JERUSALEM	CRUCIFIXION	ANASTASIS

contrast to his usual ascetic appearance—and the piercing, pinpoint irises of the eyes, which are typical of the miniatures around the Chloudov and the Pantocratoros Psalters.[7] In the icon the Constantinopolitan style has firmly taken root and we propose a date for it in the first half of the tenth century.

Since the Baptism and the Anastasis are both great feasts, it may justifiably be assumed that scenes from the cycle of the liturgical feasts were represented on the lost left wing and central panel also. But unlike the later triptychs of the eleventh and twelfth centuries, which always have the full standard cycle of twelve feasts,[8] this triptych could not possibly have accommodated so many scenes. This is typical,

however, of tenth-century ivory triptychs, for none of them, either complete or fragmentary could have had all twelve. Furthermore, it is noteworthy that all the ivory triptychs with partial feast cycles belong to the so-called painterly group, because they were copied from painted models, and our triptych wing is the first example of this to have come to light. It also seems characteristic of the tenth century that uniformity is still lacking in the selection as well as in the arrangement of the scenes. There is a complete ivory triptych in the Louvre whose central plaque is filled with an elaborate rendering of the Nativity;[9] the left wing, like our painted panel, has two scenes, the Entry into Jerusalem and

[7] Weitzmann, *Byz. Buchmalerei*, pp. 53ff. and pls. LX–LXII; S. Dufrenne, *L'Illustration des psautiers grecs du Moyen Age*, 1: *Pantocrator* 61, Paris 1966 (here more complete bibliography).

[8] K. Weitzmann, "Byzantine Miniature and Icon Painting in the

Eleventh Century," *Proceedings of the XIII International Congress of Byzantine Studies*, Oxford 1967, p. 217.

[9] Goldschmidt and Weitzmann, *Byz. Elf.* II, pl. II,4.

the Anastasis, one above the other; the right wing is entirely filled with an Ascension of Christ arranged in two zones. Another solution is offered by a triptych in Munich which has been taken apart to decorate the two covers of an eleventh-century Latin Gospel book.[10] Here the central plaque is divided into two zones, with a multi-figured Crucifixion in the upper one, and a Deposition and Entombment, side by side, in the lower. The artist has crowded three scenes on each wing, thus accommodating twice as many feasts as the artist of the Louvre triptych, i.e. eight instead of four. It will be noted that the scenes of the wings are arranged in a horizontal sequence left to right: the Annunciation and Visitation fill the top row, the Nativity and Presentation in the Temple the middle row; only the bottom row is an exception, for the Baptism at the left is followed in time by the events on the central panel, and then the sequence ends with the Anastasis at the right. The Anastasis occupies the same place—i.e. the lower right—as it does in our triptych, which could thus be reconstructed according to this arrangement, omitting, like the Munich triptych, the last three scenes of the full cycle, the Ascension, Pentecost, and Koimesis. A third possibility is that the central plaque was divided into four scenes of the same size as those of the wings. Such an arrangement offers the advantage that the cycle can be read in two rows from left to

right in the order of the feasts. The central panel of a triptych with such an arrangement is preserved in Quedlinburg;[11] the wings are unfortunately lost but the subjects represented on them can be established with a high degree of certainty. The upper zone with the Nativity and Baptism certainly had the Annunciation to the left, while to the right the Metamorphosis or the Raising of Lazarus are possibilities. The Crucifixion and Deposition of the lower register were quite certainly flanked by the Entry into Jerusalem at the left, and the Anastasis once again ending the cycle at the right.

We should like to reconstruct our painted triptych in accordance with the Quedlinburg ivory. The Baptism at the end of the top row was quite certainly preceded by the Annunciation, the Nativity, and the Presentation in the Temple, the three feasts which preceded it in the established cycle. In the bottom row the three feasts preceding the Anastasis were in all probability the Metamorphosis or the Raising of Lazarus, the Entry into Jerusalem, and the Crucifixion.

Bibl.

K. Weitzmann, "Fragments of an Early St. Nicholas Triptych on Mount Sinai," Τιμητικὸς Γ. Σωτηρίου, Δελτ. Χριστ. Ἀρχ. Ἑταιρ. Περ. Δ, Τομ. Δ, Athens 1964, p. 19 and fig. 14a-b.

[10] Ibid., pl. VI, 22.

[11] Ibid., pl. VIII, 25.

B.56. PANEL FROM AN ICONOSTASIS BEAM.
PLATES XXXV AND CXI
WASHING OF THE FEET
FIRST HALF OF TENTH CENTURY
OLD LIBRARY (FORMERLY IN CHAPEL OF CONSTANTINE AND HELEN)

H. 25.6 cm; W. 25.9 cm; thickness 2 cm. Because of a format slightly wider than it is high the painter used this wooden board with the grain running horizontally. Consequently, when the panel warped, resulting in a curvature of 2 cm, it split horizontally. At the left end of the crack a piece has broken out of the raised frame which forms one piece with the panel proper. There is some damage along the crack and flaking has occurred in large patches around the red frame and in smaller areas of the adjacent picture itself. Some abrasions occur all over the painted surface and

craquelure in the gold ground, but the colors are still fresh and intense.

In this Washing of the Feet Christ is clad in a deep purple tunic and a deep blue apron. These saturated colors are in marked contrast to the lighter colors worn by the Apostles, all of whom are clad in light blue tunics with broad crimson clavi; their mantles are light grey olive, except for that of Peter, which to distinguish him from the others is yellow brown. All the faces are painted in pink with an intense carmine for nose tips, mouths, and cheeks, and with sharp white highlights. Peter sits on a golden stool, his feet in a golden basin filled with water that gives the illusion of transparency. Christ's nimbus is painted in the same gold as the stool and basin, which is quite different from the highly burnished gold of the background. The use of different shades of gold and of different techniques in its application is also found in tenth-century miniatures and is evidence of

the refinement characteristic of that century. Christ stands before a green building with a crimson roof, and the group of Apostles is encompassed by a simple, sloping blocklike building painted in the same green, but partly showing the bare bolus underneath. An olive-colored groundstrip reaches up to Peter's knees. The inscription Ὁ ΝΙΠΤΉΡ is written in large capital letters on the golden ground.

A peculiar feature, and quite unique for this scene, is the masonry wall in the foreground, its olive-colored blocks outlined in black, which is interrupted in the center by the lintel of a door, painted in the same color but of darker hue. This kind of wall with central door is similar to the type one finds not infrequently in representations of the Incredulity of Thomas, where it is motivated by the textual reference to the "closed doors." Usually wall and door appear behind the figure composition but in a few cases, as e.g. on one of the ivory plaques of the so-called "Salerno Antependium,"[1] they fill the foreground as in this panel, and it thus seems likely that the motif here is derived from such a Thomas scene.

Before the time of our icon artists chose for representation one of two different moments of the foot-washing episode:[2] the first showed the actual washing, with Christ either performing the task realistically, or, as in the Rossano Gospels,[3] merely touching the feet of Peter. The second moment is depicted in a miniature in the ninth-century Psalter in the Pantocratoros monastery, cod. 61; here Christ, instead of washing the feet, talks with Peter, who points with one hand at his head and stretches out the other hand asking for the washing of not only the feet but also the head.[4] However, these two actions were frequently conflated and in a tenth-century lectionary on Patmos, cod. 70, the actual washing and Peter's statement while pointing at his head are fused.[5] Our icon shows a similar conflation though with one difference: Christ is not reaching down to Peter's feet, but stands in a more upright position, his outstretched hands touching only the Apostle's knees. While the action of the washing is implied, the artist has softened the realism and maintained for Christ a more dignified pose in accordance with the preference for more portly and solemn behavior prevalent in many creations of the Middle

Byzantine period. The most striking parallel to Christ's pose is found in a miniature in a lectionary fragment in Leningrad, cod. 21, which can be ascribed to about the middle of the tenth century (fig. 32).[6] Although Christ is slightly more active in the miniature, his gesture expresses a similar dignity, while Peter—unlike the Peter of the icon—holds his hands open in a gesture of astonishment. In the icon Peter leans forward, touching his right hand to the top of his head and resting his left on his knees.

Of the Apostles standing behind Peter, only the first three have white hair and can thereby be identified. The first is rather bald-headed and obviously represents Paul, an identification supported by his position as the leader of the group. The second, because of his dishevelled hair, is no doubt Andrew; and the third, distinguished by his age, must be James, the brother of the Lord, the oldest of the Apostles and the first bishop of Jerusalem. All the others have dark brown hair and either wear beards of various shapes or are clean-shaven as the one at the extreme right, who represents either Philip or Thomas. The others must remain unidentified. They are all standing and form a solid block as they do already in the miniature of the Rossano Gospels. But while in this miniature they frame the Christ-Peter group, in the icon they are placed behind the back of Peter; in this respect also the composition is most closely related to the Leningrad miniature. Here, too, the Apostles closest to Peter can be distinguished as Paul and Andrew, although in reversed order, while James is not individualized. It will be observed that in the icon only ten Apostles stand behind Peter. There is, however, the preliminary drawing of an eleventh head, which became visible only after the partial flaking of the green architecture. But since the white line of a window design is painted over the preliminary drawing, one must conclude that this Apostle figure was intentionally obliterated. Could it be that, proleptically, Judas was excluded? This remains, of course, hypothetical.

Around the middle of the tenth century, under the impact of the Macedonian Renaissance, the group of Apostles in the foot-washing scene became greatly enlivened, with one or two Apostles depicted loosening their sandals. This innovation appears for the first time in the

[1] A. Goldschmidt, *Die Elfenbeinskulpturen* IV, Berlin 1926, pl. XLVII,126,40.

[2] Millet, *Rech. Ev.*, pp. 310ff.

[1] A. Muñoz, *Il Codice Purpureo di Rossano*, Rome 1907, p. 14 and pl. V.

[4] S. Dufrenne, *L'Illustration des psautiers grecs du Moyen Age* I: *Pantocrator 61*, Paris 1966, pl. 8 where motif is unclear. Better reproduction in Weitzmann, *Byz. Buchmalerei*, pl. LX, 355.

[5] Millet, *Rech. Ev.*, p. 311 and fig. 298. Weitzmann, *Byz. Buch-*

malerei, pl. LXXIII,446; A. Grabar, *Les Manuscrits grecs enluminés de provenance italienne. IXe–XIe siècles*, Paris 1972, p. 27 and 53. Here the manuscript is attributed—in our opinion unconvincingly—to South Italy.

[6] Millet, *Rech. Ev.*, fig. 296; C. R. Morey, "Notes on East Christian Miniatures," *Art Bull.* XI, 1929, p. 83 and fig. 96 (here incorrectly dated in or near the eighth century); Weitzmann, *Byz. Buchmalerei*, pp. 59ff. and pl. LXVII, 396.

ivories of the painterly group, so-called because of the strong dependence on miniatures.[7] It had such a lasting impact on the iconography of the Washing of the Feet that one may justifiably call our icon, as well as the Leningrad miniature, "pre-Renaissance" creations.

Stylistically the icon painter stresses comparatively slender body proportions and he works with a strong emphasis on the highlights, revealing the impact of the revival of classical painterly forms after the iconoclastic period. Yet while he achieves a general illusionistic effect, he uses highlights scarcely at all to model the bodies; he prefers to render them as straight parallel lines instead of breaking them into a more varied pattern that would give a greater sense of corporeality. This tendency he shares with the painter of icons nos. B.52–54, whereas the illustrator of Leningrad 21 draws folds and highlights in curves rather than straight lines, making the garments seem to billow and producing a relatively greater sense of plasticity. This reflects a more advanced stage in the development that leads to the Macedonian Renaissance. The faces, on the other hand, show extensive modelling by a painterly technique of free brushstrokes accenting the red of the tips of the noses as well as the white of the eyeballs, producing a piercing glance. The full faces with their short noses are rather ordinary in appearance, not unlike those in the Baptism and Anastasis of icon no. B.55. For all these reasons we propose a date for this icon in the first half of the tenth century, i.e. still before the middle of the century, to which the Leningrad miniature can be assigned. As in icon no. B.55, the style is hardly that of Constantinople, but it does reflect some of the innovations characteristic of the capital without making full use of them. Due to the scarcity of icons from this period and the lack of close comparative material even in other media, we refrain from proposing any definite place of origin.

The format of this icon, slightly wider than it is high, is very unusual and raises the question of the original purpose of the icon. It could hardly have been an ordinary portable icon to be displayed on the proskynetarion; its metope-like format and the horizontal cut of the wood suggest that it was part of a frieze, which in our opinion could only have been an iconostasis beam. True, on all the later iconostasis beams of the twelfth and thirteenth centuries, of which a number have been found at Sinai,[8] the cycle of feasts is represented under an arcade; but two rectangular icons, each wider than high, one with the Raising of Lazarus in a private collection in Athens, and the other with the Metamorphosis in the Hermitage in Leningrad, attributed to the twelfth century, have convincingly been proved by Chatzidakis[9] to have belonged to a feast cycle that formed an epistyle on a marble architrave of an iconostasis. They are almost the same size as the Sinai icon, just slightly smaller, and this suggests that there must have existed a tradition according to which the individual scene on the beam resembled in format a stately miniature in a Lectionary, where the principal decoration consisted of the cycle of the great liturgical feasts. It thus seems quite likely that the inspiration for the scenic representations on iconostasis beams came from a manuscript cycle.

It must be observed, however, that the Washing of the Feet does not belong among the twelve great feasts represented on the typical iconostasis. Yet representations of the Last Supper and the Washing of the Feet, illustrating the lections τοῦ νιπτῆρος, read on Maunday Thursday, are sometimes added to the dodecaorton, as e.g. in the mosaic cycle of Daphni,[10] and at least the Last Supper does occur additionally in an only partially published thirteenth-century iconostasis beam on Sinai.[11] We believe that our icon of the Washing of the Feet is part of an iconostasis beam which would be the earliest known with depictions of the liturgical feasts.

Bibl.
Sotiriou, *Icones* I, fig. 33; II, pp. 48–49.
K. Weitzmann, "An Ivory Diptych of the Romanos Group in the Hermitage," *Vizantiysky Vremennik* XXXII, 1971, p. 150 and fig. 6.

[7] Cf. the plaque in the Berlin Museum; K. Weitzmann, "Ivory Sculpture of the Macedonian Renaissance," *Kolloquium über Frühmittelalterliche Skulptur. Vortragstexte* 1970, Mainz 1971, p. 2 and pl. 2, nos. 1–2. Idem, "A 10th Century Lectionary. A Lost Masterpiece of the Macedonian Renaissance," *Rev. Et. Sud-Est Europ.* IX, 1971, p. 626 and fig. 7.

[8] Sotiriou, *Icones* I, figs. 87–125; II, pp. 100ff.

[9] M. Charzidakis, "Εἰκόνες ἐπιστυλίου ἀπὸ τὸ Ἅγιον Ὄρος,"

Δελτ. Χριστ. Ἀρχ. Ἑταιρ., Περ. Δ, Τόμ. Δ, 1964–1965, Athens 1966, p. 399 and pl. 87a–b.

[10] E. Diez and O. Demus, *Byzantine Mosaics in Greece. Hosios Lucas and Daphni*, Cambridge, Mass. 1931, figs. 93 and 94.

[11] For other scenes of this beam cf. K. Weitzmann, "Thirteenth Century Crusader Icons on Mount Sinai," *Art Bull.* XLV, 1963, pp. 181ff. and fig. 3; Idem, "Icon Painting in the Crusader Kingdom," *D.O.P.* XX, 1966, pp. 62ff. and figs. 22–24.

B.57. ICON. PLATE CXII
ST. PETER
FIRST HALF OF TENTH CENTURY
OLD LIBRARY

H. 27.2 cm; W. 16.1 cm; thickness 2.5 cm. The surface is very badly damaged. Around St. Peter's head large areas of the ground have flaked away together with the underlying gesso, partly baring the wood, which shows traces of burning. The surface of the Apostle's mantle is almost completely rubbed off and corroded. Major parts of the elevated frame have lost their gold.

Peter is depicted standing in frontal view, his weight almost equally distributed over both legs; as there is no groundstrip, his feet, turned down and set against the gold background, contribute to the ambiguity of the stance and the general impression of weightlessness. He is dressed in a light, steel blue tunic and an olive-colored mantle which, like many areas of the icon, is discolored by a heavy varnish. He blesses with his right hand and holds a scroll in his left, as in the earlier icon no. B.33. On both sides of his head appears the inscription O ΑΓΙΟC ΠΕΤΡΟC in red capital letters.

Iconographically this Peter belongs to a period when the facial features of the saint were beginning to be cast into what might be called a canonical form. The short white beard has an undulating outline and, most important, the white hair over the forehead forms a row of curly locks. In the early Peter icon no. B.5 there is only one whirling tuft of hair over the forehead and the beard is rounded. In icon no. B.33 the hair has a simple curved outline, while the beard already has a scalloped form. The evolution of the treatment of the hair can be observed within the ivories of the tenth century. In those of the Romanos group[1] it is combed down over the forehead, unlike the two earlier icons mentioned above. In the ivories of the Nikephoros and the triptych groups, where Peter appears in a considerable number of representations of the Ascension and the Koimesis and as a bust on triptych wings,[2] the hair is arranged in the characteristic row of locks that we see in the Sinai icon.

Characteristic of the style are the straight parallel highlights on the garments tending to flatten rather than to model the figure. This trait the icon shares with the standing saints in icons nos. B.52–54 and with the Apostles in the Washing of the Feet icon, no. B.56. Yet in this icon the highlights have accumulated, and over the left arm, especially, the folds and highlights of the mantle begin to break. In these respects the figure represents a slightly more advanced stage of the development within the tenth century but may date still within its first half.

[1] Goldschmidt and Weitzmann, Byz. Elf. II, pl. XIX,44 (plaque in Vienna with Andrew and Peter); pl. XXVI,66b (diptych with Peter and Paul in Bamberg).

[2] Ibid., pl. XLI,110; XLII,113 and 115; XLVIII,116d; LX,178–181; LXI,183b and 186b.

B.58. TWO WINGS OF A TRIPTYCH. PLATES
 XXXVI–XXXVII AND CXIII–CXV
LEFT: THADDAEUS, ST. PAUL OF THEBES AND
 ST. ANTHONY
RIGHT: KING ABGARUS, ST. BASIL AND
 ST. EPHRAEM
MIDDLE OF THE TENTH CENTURY
GALLERY. GLASS CASE

Two panels that once formed the wings of a triptych are inserted into a later, gilded frame, which measures 34.5 x 25.2 cm and is 2.1 cm thick. It is difficult to determine the width of the thin wings themselves (they are about 5 mm thick). Since one cannot see how far they reach into the grooves of the frame, their actual size can be determined only approximately as ca. 28 cm in height and ca. 9.5 cm each in width. The traces of any original mounting (dowel holes, etc.) cannot be investigated because of the tight-fitting frame. Attached to the right side of the left wing is a strip of wood painted in the same red as the oblique inner rim of the frame, and apparently of the same period. It could be explained as a reinforcement of the inner side of the wing which, as for most triptych wings, has been rendered especially fragile by the drilling of the dowel holes. Both wings show a few cracks which have caused some flaking, especially severe in the right wing where the right eye of Abgarus and larger sections of the head and the back of the messenger are lost. This same wing has suffered quite heavily also in its lower register. The face of Basil is especially damaged and a whole area around his knees has fallen away, baring the wood. This has occurred also in several spots in the figure of Ephraem. Rather recently some attempts at repair have been made by pasting squares of silver foil over damaged areas of the gold ground. The back

has a very roughly painted black cross, set against a white ground, extending over both wings. Although the simple form of the cross offers no clue as to its date, the general impression is that of a later addition, perhaps of the period when the wings were joined in the frame. In 1960 the panel was cleaned by Carroll Wales.

The upper register of the left wing is occupied by the frontally seated Apostle Thaddaeus, inscribed, like all the other figures, with red letters on the gold ground: O A(ΓΙΟC) ΘΑ | [Δ]ЄOC. There appears to have been space for only one delta. The Apostle is clad in white garments, the tunic with very light blue and the mantle with equally light violet folds. A crimson clavus crosses the tunic rather casually. The seat is a brown, benchlike throne with a red cushion and a drapery of the same color as the garments at its back; the feet rest on a footstool with a white top and undecorated blue sides which melt into the same blue of the groundstrip. In the flesh areas, lively pinks and reds predominate, giving to the face with its brown hair and downy beard an impression of striking youthfulness which is enhanced by a loose brush technique. The corresponding figure on the right wing is King Abgarus (ΑVΓΑ|ΡΟC), who wears a purple tunic and a brown mantle and is seated on a green throne-bench with a drapery of the same color decorating its square back; the huge red cushion gives a strong color contrast to the green of the bench. The crimson, pearl-studded shoes of the king rest on a footstool of the same colors as that of Thaddaeus. A pearl-studded crown with pendulia frames his face; here the flesh color is darker than that of the Apostle and the greying beard has a purplish cast. In his hands—only the left one is visible—Abgarus holds the Mandylion, a white towel with fringes which bears the imprint of the head of Christ. This head is rendered in the same lively flesh colors as the head of the living king; the nimbus is marked only by a black outlined cross. The messenger who has brought the Mandylion stands behind the footstool, hemmed in between King Abgarus and the frame. He is dressed in a dark blue tunic and mantle, and extends his right hand in a gesture of offering. His youthful face is rendered in the same tones as that of Thaddaeus.

In the lower register, across both panels, stand four saints in frontal view. On the left wing are paired the two hermit saints, Paul of Thebes and Anthony (O A [ΓΙΟC]

ΠΑVΛΟC O ΘΙΒЄOC and O A [ΓΙΟC] ΑΝΤΟΝΙΟC), raising their hands in prayer. Each is dressed in a light brown tunic and a dark brown mantle, the mandyas in the case of Paul, open over the chest, and the phelonion, shaped like a paenula, in the case of Anthony. In each instance the embroidered black megaloschema is visible under the mantle, but more fully in the figure of Paul because of the opening of the mandyas; in addition Anthony wears an embroidered cowl. On the right wing St. Basil (O A [ΓΙΟC] ΒΑCΙΛΙΟC) and St. Ephraem Syrus (O A [ΓΙΟC] ЄΦΡЄΜ) stand side by side. Basil, dressed in light blue sticharion and phelonion and a broad omophorion with three thick black crosses, holds a codex with a dark cover in his veiled left hand and blesses with his right. The same attribute and gesture are repeated for Ephraem who is dressed in the same light and dark brown phelonion as Anthony, although without the cowl and megaloschema. All three monks wear white beards of different lengths, that of Ephraem being the shortest; Basil's beard is dark brown instead of black as is the rule in later Byzantine art.

The figures in the upper zone relate to the Abgarus legend, according to which Thaddaeus, one of the seventy Apostles, had baptized the Edessenes and Abgarus their king.[1] When the king became ill he asked for a portrait of Christ and was provided with the Mandylion by a messenger, whom some sources name Ananias. The veneration of the Mandylion, an ἀχειροποίητος—not made by human hands—began with its rediscovery in 544 A.D., but became greatly intensified and popularized after the famous relic was bought in 944 by the emperor Romanos I and carried in a triumphal procession to Constantinople. For the first anniversary of this event in 945 an encomium was written telling the story of the procession, a piece of writing attributed to the emperor Constantine VII Porphyrogennetos himself and, though his authorship has been questioned, the encomium was surely written at his instigation. This text was incorporated in the menologion of Simeon Metaphrastes and has survived with illustrations in two copies, one in Paris, Bibl. Nat. cod. gr. 1528 from the eleventh century,[2] and the other in Moscow, Historical Museum cod. 382, from the year 1063.[3] With only three scenes in the Paris and four in the Moscow codex, we are dealing quite certainly with an abbreviated picture cycle, and not the more extensive one we can well assume to have existed in the

[1] For a full account of the Abgarus legend, cf. E. von Dobschütz, *Christusbilder, Untersuchungen zur Christlichen Legende*, Leipzig 1899, pp. 102ff., 158*ff., 29**ff.

[2] K. Weitzmann, *Ancient Book Illumination*, Cambridge, Mass. 1959, pp. 120ff. and pl. LXI, no. 129. Idem, "Mandylion," p. 171 and

figs. 8–9 (repr. Weitzmann, *Studies*, p. 232 and figs. 217–218).

[3] Lazarev, *Storia*, p. 189 and figs. 207–208; Weitzmann, "Mandylion," p. 171 and fig. 10 (repr. Weitzmann, *Studies*, p. 232 and figs. 219–220).

lost archetype of the encomium. In 1032 an abbreviated version of the Abgarus legend was written in the form of an exchange of letters between Abgarus and Christ, and this text, in the form of a scroll, is preserved in a very richly illustrated copy in the Morgan Library in New York, cod. 499, surely not later than the second half of the fourteenth century.[4] Its cycle comprises no fewer than fourteen miniatures which hark back to the same archetype as those of the two menologia. Both manuscripts contain the scene related to the triptych wing. In the Moscow menologion (fig. 33), the fourth and last scene of the abbreviated cycle depicts Abgarus just rising from his sickbed and looking at the Mandylion in the hands of the approaching messenger; the corresponding scene in the Morgan scroll differs only slightly in that Abgarus is still stretched out on his bed. The Sinai panel is based on this miniature tradition, but the icon painter has adjusted the composition to the vertical format; this has restricted the expansion of the narrative and at the same time has allowed the artist to render Abgarus more predominantly and in the more hieratic pose of a Byzantine emperor enthroned. The motif of the sickbed is abandoned altogether. Instead of looking at the gift in the hands of the messenger, the king himself proudly displays the relic like a personal possession. Little space remains for the messenger, whose right arm and offering hand appear crippled in comparison to the huge hand of the king. The figure of Thaddaeus also was altered to fit the needs of the icon. In the Morgan scroll he is depicted standing frontally and holding a codex in his left hand.[5] Such a figure may well have been the frontispiece of the original encomium. In the icon the tiny left hand of Thaddaeus is, indeed, very awkward and appears to be an adjustment made by the icon painter, seeking to create a new relationship between this figure of the Apostle and whatever was depicted on the lost central plaque of the triptych. The icon painter apparently also took the liberty of representing the Apostle seated on a throne in order to balance him with the figure of Abgarus.

The connection of our icon with the encomium and its

purported author, the emperor Constantine, is still more intimate. It is quite obvious that the head of King Abgarus with its portraitlike features imitates that of a Byzantine emperor. In the period to which the icon must be ascribed there were only two emperors with such an imposing beard: Leo VI the Wise and Constantine VII Porphyrogennetos.[6] Since it was only during the reign of the latter that the Mandylion arrived in Constantinople and gained new prominence, it becomes evident that the facial features of King Abgarus must be those of the emperor Constantine. It appears appropriate that he, the scholar on the throne and renowned collector of relics, should hold the Mandylion in his hands, thus claiming for himself the relic, which actually had been brought to the capital at the instigation of his coemperor Romanos I. This identification is supported by the great similarity of the head with that of the emperor in a coronation ivory in the Pushkin Museum in Moscow (fig. 34),[7] which is inscribed Constantine and is so similar to the one on the coins of Constantine Porphyrogennetos that it has been likewise identified as a portrait of this emperor.

From these historical associations two facts emerge: first, the triptych wings cannot be earlier than the year 945 when the encomium was written and illustrated; second, the iconography has its origin in Constantinople. The middle of the tenth century was the height of the Macedonian Renaissance and among its most characteristic reflections are the Evangelist portraits of the Gospel book Stauronikita, cod. 43, on Mount Athos.[8] The figure of Thaddaeus in the Sinai icon shares with them the new feeling for corporeality as expressed by the billowing folds of the garments. Yet in the rendering of the details the icon painter is less accomplished than the miniaturist, as a certain weakness in the proportions of the body indicates. Especially disturbing is the difference in size of the hands of Thaddaeus, Abgarus, and the Messenger. Furthermore, the icon painter uses a broader and less distinct brush technique, creating the impression of painterly softness. The technique resembles that in the miniatures of another mid-tenth-century manu-

[4] S. Der Nersessian, "La Légende d'Abgar d'après un rouleau illustré de la bibliothèque Pierpont Morgan à New York," *Actes du IVe Congrès international des études byzantines, Bull. de l'Inst. Arch. Bulgare X*, 1936, p. 98ff.; Here it is dated fourteenth–fifteenth century. But recently Herbert Kessler has proved that the Morgan roll is only a fragment and that the University Library at Chicago possesses another segment of the same scroll. It contains a non-scribal colophon with the date 1374 in Arabic, and this dates the whole roll, including the Abgarus story, in the second half of the fourteenth century. *Illuminated Greek Manuscripts from American Collections. An Exhibition in Honor of Kurt Weitzmann*, The Art Museum, Princeton University, ed. Gary Vikan, Princeton 1973, p. 194 and figs. 102–103.

[5] Weitzmann, "Mandylion," p. 174 and fig. 11 (repr. Weitzmann, *Studies*, p. 234 and fig. 221).

[6] W. Wroth, *Catalogue of the Imperial Byzantine Coins in the British Museum* II, London 1908, pp. 444ff. and pls. LI.8ff.; *Catalogue of the Byzantine Coins in the Dumbarton Oaks Collection*, by P. Grierson, vol. III part 2, *Basil I to Nicephorus III* (867–1081), Washington, D. C. 1973, p. 512 and pl. XXIV, la–lb.2; p. 550 and pl. XXXVI, 11–13b.2.

[7] Goldschmidt and Weitzmann, *Byz. Elf.* II, p. 35 and pl. XIV,35; Weitzmann, "Mandylion," p. 182 and figs. 17–19 (repr. Weitzmann, *Studies*, p. 243 and fig. 229).

[8] Weitzmann, *Byz. Buchmalerei*, pp. 23ff. and pls. XXX–XXXI.

script, a panegyrikon in Vatopedi on Mount Athos, cod. 456; here writing and ornament clearly indicate a Constantinopolitan provenance, but the miniatures, all later additions, could have been made somewhere else.[9] A comparison of the medallion busts of the saints in this manuscript with the heads of the monks of our icon is particularly elucidating. Noteworthy is the fact that among the twenty-seven homilies of this manuscript, only the five that are concerned with the saints from Edessa—Gurias, Samonas, and Abibos—have been singled out for illustration in an entirely unsystematic fashion. This emphasis on Syro-Palaestinian saints brings the manuscript into the same iconographic and stylistic orbit as the triptych wings. Although the Abgarus legend was, if our theory is correct, first illustrated in Constantinople, the saints in the lower register of the triptych lack any specifically Constantinopolitan connotation, for the three monastic saints point rather to Syria or Palaestine.

Even more decisively, there exists a stylistic affinity to other contemporary icons on Mount Sinai. The head of Ephraem with its hair loosely combed onto the forehead may be compared with that of Zosimas in icon no. B.52, whose pose strongly resembles that of Paul and Anthony in the left wing of the triptych. The light blue garments of Basil with their straight and simple highlights find a parallel in Nicholas of the same icon no. B.52, which in my opinion is not a product of a Constantinopolitan, but of a more eastern, atelier. Even closer similarities exist with the triptych wing no. B.55, as the face of Ephraem is, in color and brush technique, much like that of John the Baptist: in both, the highlights are impressionistically set by a few strokes on the rose-colored faces with their light, olive-colored shadows. The tendency to render the faces round and youthful is so pronounced as to give the impression of chubbiness. This is especially marked in the faces of the Christ of the Mandylion, the monastic saints of our icon, and John the Baptist in icon no. B.55, i.e., in faces where in particular one would expect a more ascetic appearance. Whether our pair of wings and the one with the Baptism and Anastasis were produced in the same workshop is impossible to ascertain, but if they are not closely connected locally, they at least appear to be regionally. For the latter pair we

proposed a possible Palaestinian provenance and should like to suggest the same, although hypothetically, for the triptych wings. This then would mean that the illustration of the Abgarus legend had spread soon after its invention to the Eastern provinces; here it was combined with figures of saints unrelated to the legend, and at the same time, more familiar in Syria and Palaestine.[10]

There remains the question of what the subject of the lost central plaque is likely to have been. A priori one might expect the center panel to have been divided into two zones like the wings, particularly since in the wings and upper and lower subjects are unrelated. The inversion of Thaddaeus and Abgarus, and in particular the awkward pointing gesture of the former, suggest that the theme of the upper center was connected with the Abgarus legend. Most appropriate and striking would be a depiction of the Mandylion itself (fig. B, p. 98)[11]. But contrary to most icons of the Mandylion which show Christ with a pointed beard, even where it is forked, and with flowing hair falling on the shoulders[12]—a type which may well be based on an older tradition of the Edessene relic as indicated by the images in the Vatican and Genoa[13]—it is more likely that our icon simply repeated the type of Mandylion held in the hands of Abgarus. This Christ has a rounded Zeus-like beard and no locks falling on the shoulders. The type corresponds well with the ideals of the Macedonian Renaissance, and it is not by chance that it occurs in an eleventh-century menologion in the Patriarchial Library of Alexandria in the title miniature to the very text of the Abgarus legend which in this copy is ascribed to the emperor Constantine.[14] Thus the archetype of this variant may well have been created as a miniature for the encomium.

In the lower zone one would assume additional standing saints in analogy to the contemporary ivory triptychs of the Romanos group where five figures occupy this area.[15] Yet the similarity with these would be restricted to compositional layout. Whereas the ivories have a group of Apostles in this place, in conformity with the prayer of intercession that is the program of these triptychs, one would assume for the lost central plaque of the Sinai triptych, in addition to Basil on the right wing, church fathers such as John Chrysostom, Gregory of Nazianzus, and perhaps Gregory of Nyssa,

[9] Ibid., p. 20 and pl. XXVI,141; idem, "Mandylion," p. 176 and figs. 13–16 (repr. Weitzmann, *Studies*, p. 239 and figs. 223–226).

[10] Contrary to my earlier attribution of the miniatures of the Codex Vatopedi 456 to Constantinople, I now think it quite possible that they, too, were made in Syria or Palaestine.

[11] Acknowledgment is made to Elizabeth Lipsmeyer, graduate student of the Rutgers University Art Department, for the execution of this and the various schematic drawings.

[12] A. Grabar, *La Sainte Face de Laon*, Prague 1931, frontispiece and pls. I–III.

[13] C. Bertelli, "Storia e vicende dell'Immagine Edessena," *Paragone* N.S. 37, 1968, pp. 3ff. and pls. 1 and 7.

[14] Weitzmann, "Mandylion," p. 168 and fig. 5 (repr. Weitzmann, *Studies*, p. 229 and fig. 214).

[15] Goldschmidt and Weitzmann, *Byz. Elf.* II, pl. X,31a; XI,32a; XIII,33a.

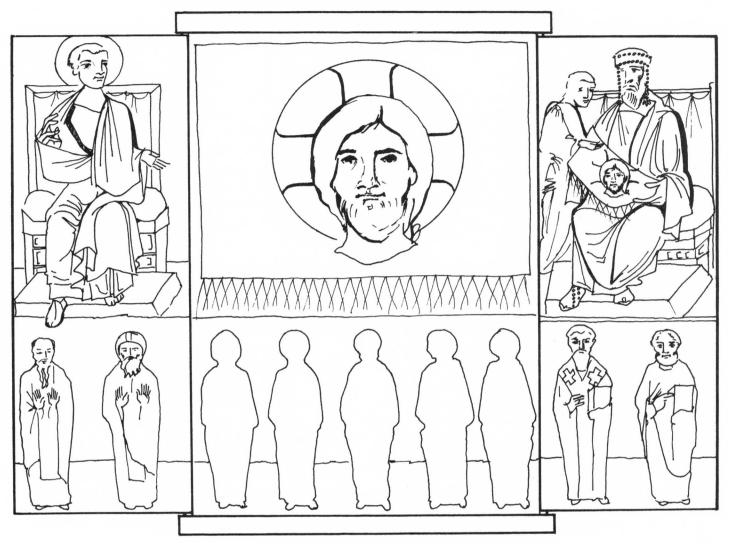

B. Reconstruction drawing for B.58

Athanasius, and still one other. Such a group of church fathers flanked by monastic saints occurs in the eleventh-century Lectionary, Dionysiu cod. 587, on Mount Athos[16] as an illustration to the Sunday before Christmas, which usually depicts the forefathers, i.e., Abraham, Isaac, and Jacob, but in this manuscript the holy fathers in general. However there is a second, very similar miniature in the same manuscript (fig. 35)[17] where the church fathers are flanked by a holy monk and soldier-saints. Here, the miniature heads the

reading for Sunday of All Saints. In our triptych the assembly of at least two categories of saints, i.e. the church fathers and monks, may have the same liturgical explanation.

Bibl.

Sotiriou, *Icones* I, figs. 34–36; II, p. 49ff.

K. Weitzmann, "The Mandylion and Constantine Porphyrogennetos," *Cah. arch.* XI, 1960, pp. 165ff. (repr. Weitzmann, *Studies*, pp. 224ff.).

Idem, *Frühe Ikonen*, pp. XI, LXXX and pl. 11.

[16] Weitzmann, "Mandylion," p. 168 and fig. 9 (repr. Weitzmann, *Studies*, p. 230 and fig. 216).

[17] S. M. Pelekanides, P. C. Christou, Ch. Tsioumis, S. N. Kadas, *The Treasures of Mount Athos. Illuminated Manuscripts* I, Athens 1974, fig. 215.

B.59. ICON. PLATE CXVI
ST. PHILIP
SECOND HALF OF TENTH CENTURY
OLD LIBRARY (FORMERLY IN CHAPEL OF
CONSTANTINE AND HELEN)

H. 32.8 cm; W. 20.2 cm; thickness 2 cm; curvature 1 cm. Except for some flaking of the gold of the ground and frame, especially at the bottom, the icon is in remarkably good condition, but at the same time so heavily covered by a darkened varnish that the impression of high artistic quality is impaired.

The Apostle Philip, standing frontally and at ease, is dressed in a light blue tunic and a mantle of the same color. Except for small patches, the largest around the neck, this color has been changed to dark olive by the varnish. The double red line of the clavi is one of the few color accents, along with the brown hair, the pink hands, and the pink face with rouge on its cheeks and bright red lips. Blessing with his right hand, held before his chest, the saint holds in his left a scroll with a golden cap. At the upper right corner a bust of Christ leans out of a segment of heaven. Dressed in a golden tunic and a dark blue mantle, he holds a scroll and blesses the Apostle who, however, indicates his awareness of the presence of Christ only by a glance from the corners of his eyes. Against the solid gold ground, which also covers the frame, the nimbi are indicated only by an incised double line and by a roughening of their surfaces, which catch the light in such a way that the nimbi seem to rotate as one turns the icon. This is one of the earliest, or, if our dating is correct, perhaps *the* earliest example of this technique, which was widely used on icons from the eleventh to the fourteenth centuries and even later. The segment of sky also is indicated by nothing more than an incised line.

The Apostle is inscribed in black letters Ο ΑΓΙΟΣ ΦΙΛΙΠΠΟ(Σ). Since this cursory inscription is written upon the varnish it must be of rather recent date, but it is impossible to say, before the icon is cleaned, whether traces of an older inscription were still visible before the varnish was applied and suggested the present inscription. Yet there is no reason to question the identity of the Apostle. Thomas is the only other Apostle depicted as youthful as Philip, and therefore the only possible alternative. In such tenth-century ivories as the triptych of Harbaville[1] and the Apostle casket in Florence,[2] these two Apostles are so

similar in appearance that only the inscriptions distinguish them and in both monuments they have the strands of hair falling loosely onto their foreheads, a motif that has become somewhat mannered in the icon.

Reference to contemporary ivories in this case is all the more justified, for direct stylistic connections with them exist. It will be observed that the mantle over the saint's upper thighs is crisscrossed by short, unconnected folds that resemble the deep grooves to be found as a characteristic feature in the ivories of the so-called painterly group. A typical example is the plaque in Venice with St. Theodore and St. George (fig. 36),[3] where the tunic of St. George shows the same deep grooves, paralleled on both sides by thinly incised lines which occur also in our icon, in painted form, as white lines along the dark folds. Since this is essentially a sculptural device, one can only conclude that our icon painter was under the influence of this group of ivories, regardless of the fact that the ivories of the "painterly group" were by definition themselves dependent on painted models. In other words, it is a question here of a retroactive influence of the ivories upon painted icons, which most likely occurred where the ivories were produced and perhaps even in the same workshop. Since the ivories were surely made in a Constantinopolitan atelier, it follows that our icon, too, was made in the capital. One would have come to this conclusion even without reference to the ivories, by making a comparison with the best miniatures produced in Constantinople. The figure of Matthew in the Sinai Lectionary, cod. 204, from the end of the tenth century[4] compares well with our icon as far as the proportions are concerned: the easy stance, the degree of corporeality, the dignified, sensitive face with its arched eyebrows, the elegant hands, the refined though slightly mannered treatment of the garments, and the setting against the brilliant, burnished gold ground before which the figure seems to move freely. For all these reasons we do not hesitate to ascribe the icon to a Constantinopolitan workshop.

Bibl.

Weitzmann, *Frühe Ikonen* pp. XII, LXXX and pls. pp. 14–15
W. F. Volbach, *Byzanz und der Christliche Osten, Propyläen Kunstgeschichte*, Berlin 1968, fig. 45a and p. 180.
K. Weitzmann, "Ivory Sculpture of the Macedonian Renaissance," *Kolloquium über Frühmittelalterliche Skulptur* 1970, Vortragstexte, Mainz 1971, p. 4 and pl. 5 no. 2.

[1] Goldschmidt and Weitzmann, *Byz. Elf.* II, p. 34 and pl. XIII,33a.
[2] Ibid. I. p. 56 and pl. LIX,99b; and in still another ivory, in the Victoria and Albert Museum, ibid. II, p. 45, and pl. XXVII,68.

[3] Ibid. II, p. 29 and pl. v.20.
[4] Weitzmann, *Byz. Buchmalerei*, p. 28 and pl. XXXVIII,211.

B.60. ICON. PLATES CXVII–CXIX
CRUCIFIXION
END OF TENTH CENTURY
OLD LIBRARY

H. 37.8 cm; W. 32.1 cm; thickness, 1 cm, with frame 2 cm. Unfortunately less than half of the surface has survived, which is all the more deplorable since this is one of the finest icons from a period for which very few have come to light. Only the figure of the Virgin is intact, except for some small damage above the feet. Of Christ on the cross there remain the right arm, a tiny piece of the hip and the loincloth, and the feet standing on a suppedaneum; of the cross there is only the right arm and the lower part, rising from the little hillock of Golgotha, too small to contain the usual skull of Adam. Of John, the major part of the body and the lower part of the face are preserved. Furthermore, at the upper left can be seen a small bust of a flying angel, which was matched by a corresponding bust, now lost, in the right corner, but there are no indications that the sun and moon were represented. In this period the elevated frame is normally cut from the same panel as the picture, and no longer worked separately as in the earlier period. In our icon, however, only the top and lateral frame are of a piece with the panel proper; at the bottom, the frame is a separate insert.

What remains shows an execution in very delicate techniques. The stately Virgin is clad in a dark blue tunic and dark purple paenula, colors which are more saturated than ever before, rivalling enamels in their polished effect. In contrast, the colors of John's garment are very light, blue for the tunic and brown for the mantle, and the same colors are used for the garments of the angel. In his left hand John holds a red codex with a golden cover. The inscription H CTAV[PωCIC] is written in black letters, apparently contemporary, and above Christ's nimbus is visible an omikron in red which I presume is from the inscription O [BACIΛEVC TωN IOVΔAIωN]. Although normally written on a tablet, on the earlier icon no. B.36 it is written directly on the background as must have been the case in this icon.

Of special refinement is the use of the gold. Not only are the nimbi, indicated merely by a double line, roughened to

give the illusion of turning as in the icon of St. Philip (no. B.59), but this motif with marked compass points is used also ornamentally for the decoration of the frame; each side has five such turning discs, as one might call them— counting those in the corners twice, those on the longer sides being spaced farther apart. Moreover, the ground on which the Virgin and John stand is indicated by the roughening of the gold in a horizontal direction, so that the ground becomes visible only when light falls on the surface from a particular angle.

Exceptional are the ornamental strips that border the frame. On the bevelled inner rim is a delicate rinceau motif which reflects the traditional fretsaw pattern, while adapting at the same time the highlighting of the flower-petal style introduced into Constantinopolitan art, chiefly in book illumination, around the middle of the tenth century.[1] A similar amalgamation of these two otherwise distinct patterns may be seen in the headpieces of a John Chrysostom manuscript in the monastery Lavra on Mt. Athos, cod. 451, which is dated 987 A.D. and was written at Lavra by a certain Johannes.[2] On the outer side of the frame, on a narrow bevelled ledge is a geometric crenellated pattern, very common also in book illumination, which indeed must have inspired it. Furthermore, the back of the icon is filled with exuberant ornament executed in black on the gesso. One large circle encloses four smaller ones, with small rosettes in their centers, and four more identical small circles fill the spandrels. The spaces in between are very densely filled with almost jumbled fretsaw ornament of the type that appears as a late mannered phase alongside the early flower-petal style in manuscripts of the second half of the tenth century.[3]

Iconographically the Crucifixion is stripped of all narrative elements, additional figures and landscape setting as well. The more common type of Virgin extends both hands towards Christ, but the motif here of arms crossed over the breast does occur, on occasion, in late tenth-century ivories like the one formerly in the Marquet de Vasselot Collection in Paris.[4] John, holding his Gospel in his left hand, must have raised his right hand towards Christ, as e.g. he does in an ivory triptych at the Cabinet des Médailles in Paris.[5] Almost nothing is left of the figure of Christ, but it seems reasonable to assume that it resembled somewhat the Christ of this same ivory triptych.

[1] For this development of the ornament, cf. Weitzmann, *Byz. Buchmalerei*, passim.

[2] Ibid., p. 35 and pl. XLII,239.

[3] Cf. e.g. the canon tables and headpieces of the Gospel book, Athens Nat. Lib. cod. 56, which can be dated at the end of the tenth

century. Ibid., p. 21 and pl. XXVII,148–149. Other examples pl. XXVIII,156–159.

[4] Goldschmidt and Weitzmann, *Byz. Elf.* II, p. 55 and pl. XXXIX,101.

[5] Ibid., p. 37 and pl. XVI,39.

Stylistically noteworthy is the almost exaggerated craning of the Virgin's neck, all the more effective as it contrasts with her stiff body. The few traces of John's head indicate the similarly marked craning of the neck. This is a feature especially notable in some figures of the menologion of Basil II, which has been dated in the earlier part of the long reign of this emperor, i.e. still in the tenth century.[6] Since such figures occur only in New Testament scenes, executed by various painters, it is clear that the craned necks are not the idiosyncrasy of an individual menologion painter, but must have existed in the model.[7] This was, in our opinion, a lectionary with representations of the feasts, from the second half of the tenth century.[8] We assume that our icon, where the ornament, too, shows a close relation-ship to book illumination, is also dependent on the Crucifixion miniature of such a lost lectionary of the Macedonian Renaissance. This would imply that it is the product of one of the leading ateliers of Constantinople, in close touch with the court, and that it dates from the end of the tenth century. The wide expanse of the gold ground, imitating the effect of a mosaic, is particularly forceful in suggesting a hieratic atmosphere. This impression is further enhanced by the unusually large nimbi, which also have parallels in miniatures from the end of the tenth century; e.g. that of St. Mark on a cut-out leaf in the Walters Art Gallery in Baltimore,[9] though in the case of our icon the Virgin's nimbus is even exaggerated, in order to set off her head most effectively against the rotating light.

[6] S. Der Nersessian, "Remarks on the Date of the Menologium and the Psalter Written for Basil II," *Byzantion* xv, 1940–1941, pp. 104ff.

[7] Weitzmann, *Illustrations in Roll and Codex*, 2nd ed., Princeton 1970, p. 202 and pl. LV,197 and 200; p. 260.

[8] Weitzmann, "A Tenth-Century Lectionary. A Lost Masterpiece of the Macedonian Renaissance," *Rev. Et. Sud-Est Europ.* IX, 1971,

pp. 630 and passim, figs. 11, 14–16.

[9] *Early Christian and Byzantine Art. Catalogue of an Exhibition at the Baltimore Museum of Art, Walters Art Gallery*, Baltimore 1947, p. 141 no. 714 and pl. XCVI; *Illuminated Manuscript from American Collections. An Exhibition in Honor of Kurt Weitzmann*, the Art Museum, Princeton University, ed. Gary Vikan, Princeton 1973, p. 70 and fig. 10.

B.61. ICON. PLATES XXXVIII AND CXX–CXXII
BUST OF ST. NICHOLAS
END OF TENTH CENTURY
OLD LIBRARY (FORMERLY IN CHAPEL OF
JAMES MINOR)

H. 43 cm; W. 33.1 cm; thickness 2.4 cm; curvature 1.3 cm. There is a crack at the top reaching into Nicholas's forehead and two more through the lower frame. The few spots of flaking are fortunately in the background areas and frame so that no figure is damaged except for some smaller cracks and scratches. Otherwise the surface is in good condition and its original freshness could be restored by the removal of the heavy varnish that now covers it.

The bust, inscribed in red on the gold ground O AΓIOC [N]I [K]OΛAOC, fills the frame quite tightly, with the bottom of the bust and the curve of the large nimbus reaching into the bevelled rim of the frame. St. Nicholas is dressed in a sticharion of which only the gold cuffs are visible, a gold epitrachelion around the neck, a brown phelonion, and an omophorion with huge golden crosses. All the gold parts are decorated with a dense fretsaw ornament. The saint holds a large codex with jewel- and pearl-studded cover in his left hand and his right hand is held inactively before his breast. His face is plastically modelled with sensitive brushstrokes in many shades of yellow, red, and brown, and framed by hair and beard of a grey olive color with white highlights; the same grey olive is used also around the eyes. The nimbus is indicated merely by an incised line but is nevertheless very effective because its surface has been roughened so that as it catches the light the nimbus seems to turn.

The gold frame is decorated with ten medallions with busts of saints; there are no nimbi, for the outlines of the medallions themselves substitute for them. The border of each medallion is roughened to produce the effect of turn-ing, like the entire nimbus of St. Nicholas. The medallions fall into three groups arranged in hierarchical order. At the top we see Christ between Peter and Paul. Christ (\overline{IC} \overline{XC}) clad in carmine tunic and blue mantle, is represented in frontal pose, makes the gesture of blessing, and holds a golden book; Peter, at the left (O AΓ [IOC] ΠЄTP [OC]) in blue and yellow brown garments, does not seem to hold any attribute, whereas Paul (O AΓ [IOC] ΠAVΛOC), bald-headed and with a dark brown beard and dressed in blue and red brown garments, turns and looks towards Christ with a piercing glance; he makes the gesture of blessing and holds a red book. The sides of the frames are occupied by the

medallions of four soldier-saints. The matching upper pair are, at the left, St. Demetrius (O AΓ[IOC] ΔHMHTPIOC) and, at the right, St. George (O AΓ[IOC] ΓEωPΓIOC). Both are dressed in gold armor and hold lances. They are distinguished only by the color of their tunics, one blue and the other fiery red; furthermore, George is very pale as he is also in the early icon no. B.3. The lower pair are St. Theodore (O AΓ[IOC] ΘEOΔωPOC) and St. Procopius (O AΓ[IOC] ΠPO[KOΠIOC]), likewise in golden armor but differentiated to the extent that St. Theodore is bearded and holds a golden shield, while St. Procopius holds a drawn sword; both wear blue mantles. At the bottom we see a triad of physician-saints. The outer ones are SS. Cosmas and Damian (O AΓ[IOC] KOCMAC and O AΓ[IOC] ΔAMIANOC), both with ascetic faces and downy beards; they wear light violet tunics with gold shoulder patches and dark blue mantles, and hold in their hands red instrument cases. In the center is St. Panteleimon (O AΓ[IOC] ΠANTEΛEHMωN) in light blue and dark purplish garments, holding a golden pyxis. All three show the hair in characteristic fashion: SS. Cosmas and Damian have receding foreheads, and St. Panteleimon thick locks.

The face of St. Nicholas is, iconographically, in the tradition of the two Nicholas figures of icons nos. B.52 and 53, with which it shares its fleshiness and vigorous expression in contrast to later faces in which a more ascetic appearance is stressed and tends to make the saint look somewhat older. Yet certain characteristics begin to appear that are still absent in the earlier icons: the lock in the middle of the forehead, the beard with its oval swirl over the chin, and its undulating outline. In icon B.61 the forehead is fairly high but has not yet the exaggerated height of later Nicholas icons.[1] As in the earlier icons there are wrinkles in the forehead, but they have not yet multiplied and become an ornamental pattern. As in the early icons (no. B.33) St. Nicholas wears the earlier form of omophorion thrown over his left shoulder. Other indications of a rather early type of St. Nicholas are the almost casual pose of the right hand and the free movement of the head, which is not axial but

slightly turned to the saint's right, while the eyes turn to the left. The vivid expression of the eyes results from their being differently shaped, the left eye having a slightly drooping lid. This asymmetry is repeated in the beard. This is surely the work of a great master who used devices somewhat similar to those of the painter of the early Christ (no. B.1) to combine successfully in one work both spontaneity and hieratic dignity.

As far as our knowledge goes, this is the earliest icon with a large bust of St. Nicholas, a type that was to become extremely popular and widespread in icon painting, quite often as the fourth icon in an iconostasis in addition to the Deesis. Whether this icon could already have been part of an iconostasis is impossible to determine with certainty, but it seems possible, for the icon belongs approximately to the period when large scale icons began to replace curtains in iconostases.[2] Among the Sinai icons this is the only one of the tenth century of such imposing size that it cannot be classified as a portable icon.

It seems also to be the earliest icon with medallions decorating the frame. Their strikingly brilliant colors, in contrast to the subdued color of the phelonion of St. Nicholas, suggest the influence of cloisonné enamels. We know that the famous enamel medallions of the Svenigorodskoi collection, now in the Metropolitan Museum in New York, actually once decorated the frame of a huge icon of St. Gabriel,[3] and there is every reason to believe that the medallions of this icon were actually inspired not only in form but also in color by enamelled frames.

The mastery of the style and the imitation of the effect of cloisonné enamels indicate a Constantinopolitan atelier, and we propose a date at the end of the tenth century, although not excluding as a possibility the beginning of the eleventh.

Bibl.

K. Weitzmann, "Fragments of an early St. Nicholas Triptych on Mount Sinai," Τιμητικὸς Γ. Σωτηρίου, Δελτ. Χριστ. Ἀρχ. Ἑταιρ., Περ. Δ, Τόμ. Δ, 1964–1965, Athens 1966, p. 12 and fig. 9.
Idem, *Frühe Ikonen*, pp. XII, LXXX and pl. 16.

[1] Sotiriou, *Icones* I, fig. 165 and color plate.

[2] According to Lazrev ("Trois fragments d'epistyles peintes et le templon Byzantin," Τιμητικὸς Γ. Σωτηρίου, Δελτ. Χριστ. Ἀρχ. Ἑταιρ., Περ. Δ, Τόμ. Δ, 1964–1965, Athens 1966, pp. 131ff.) the earliest literary witness is from the eleventh century, but at the time of its first mention,

the insertion of icons in the iconostatis could, of course, have been common usage.

[3] N. Kondakov, *Histoire et monuments des émaux byzantins*, Frankfurt 1892, p. 255 fig. 91 and pls. 1–12; M. Frazer, "The Djumati Enamels," *Metropolitan Museum Bulletin*, Feb. 1970, pp. 240ff.

Index

PLATES

PLATE I

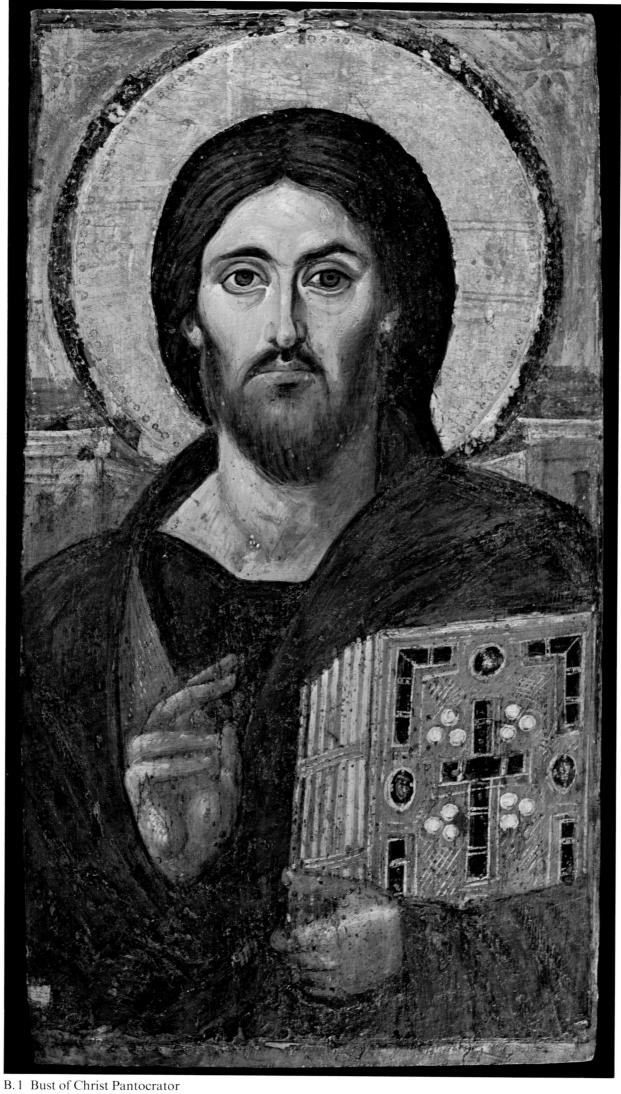

B.1 Bust of Christ Pantocrator

PLATE II

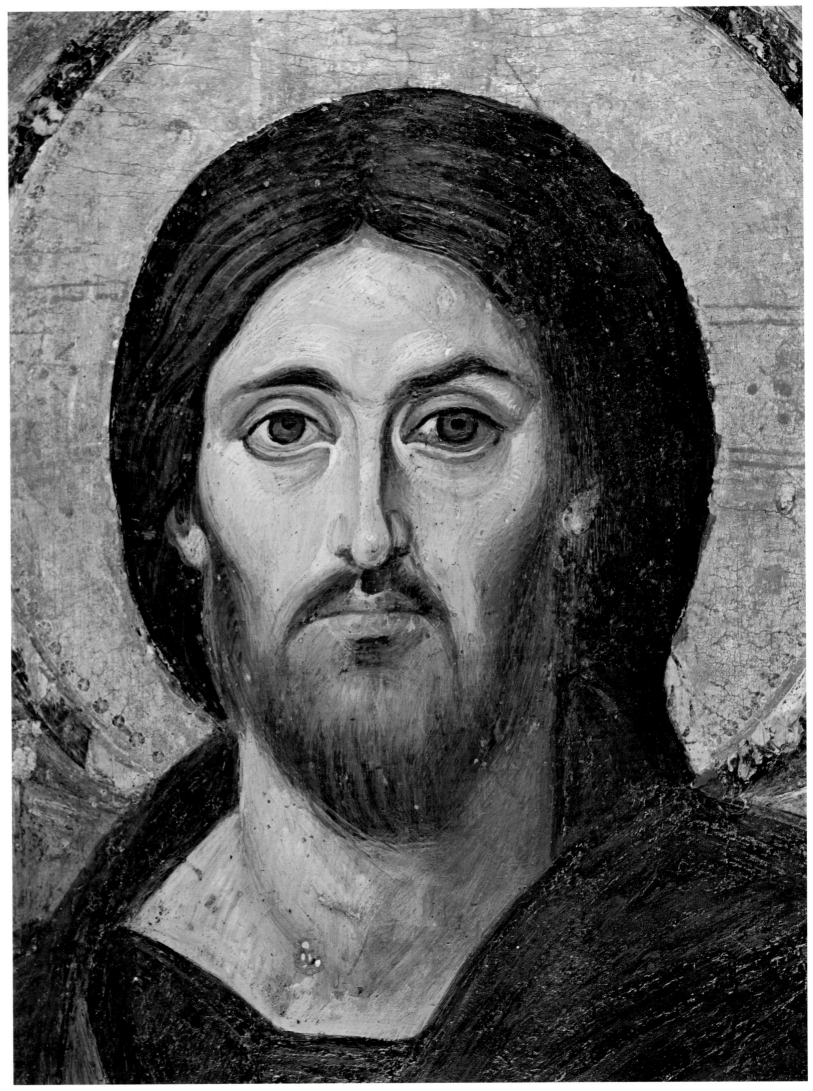

B. 1 (detail) Head of Christ

PLATE III

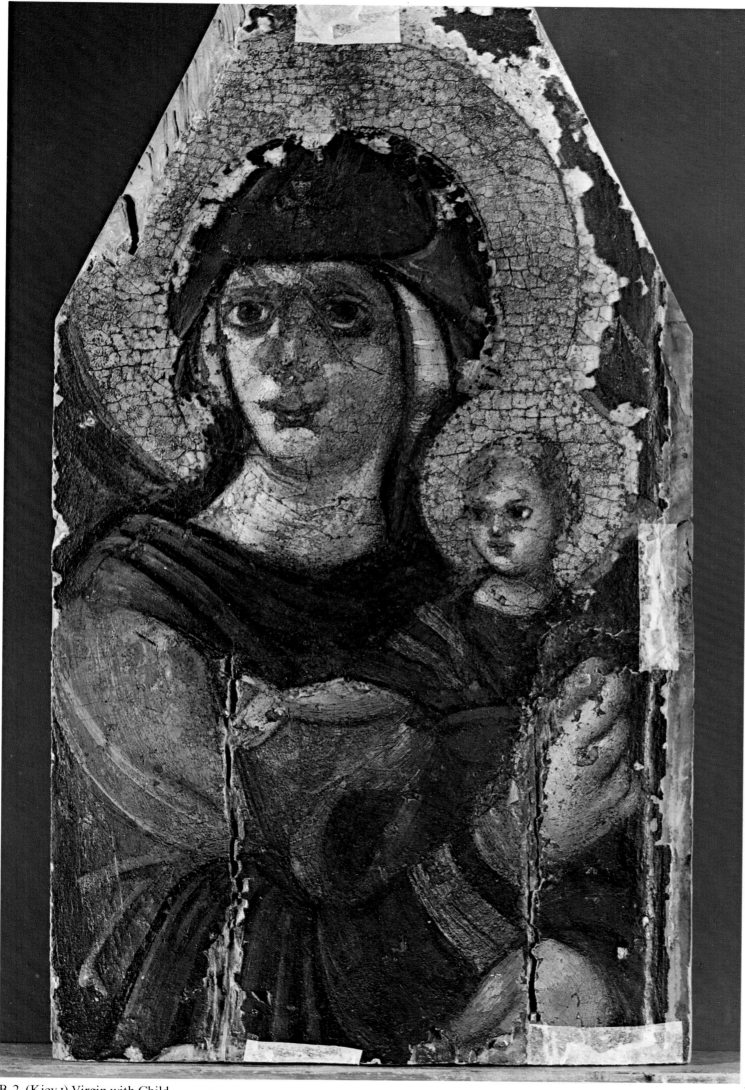

B.2 (Kiev I) Virgin with Child

PLATE IV

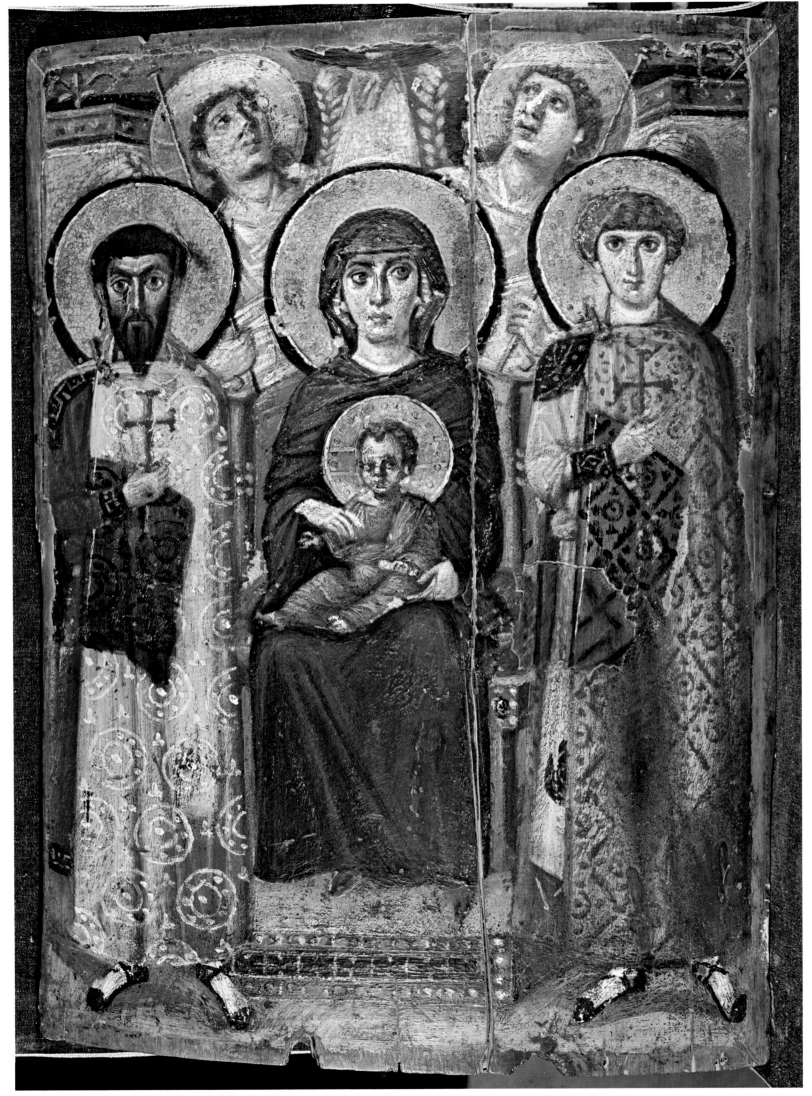

B. 3 Virgin between St. Theodore and St. George

PLATE V

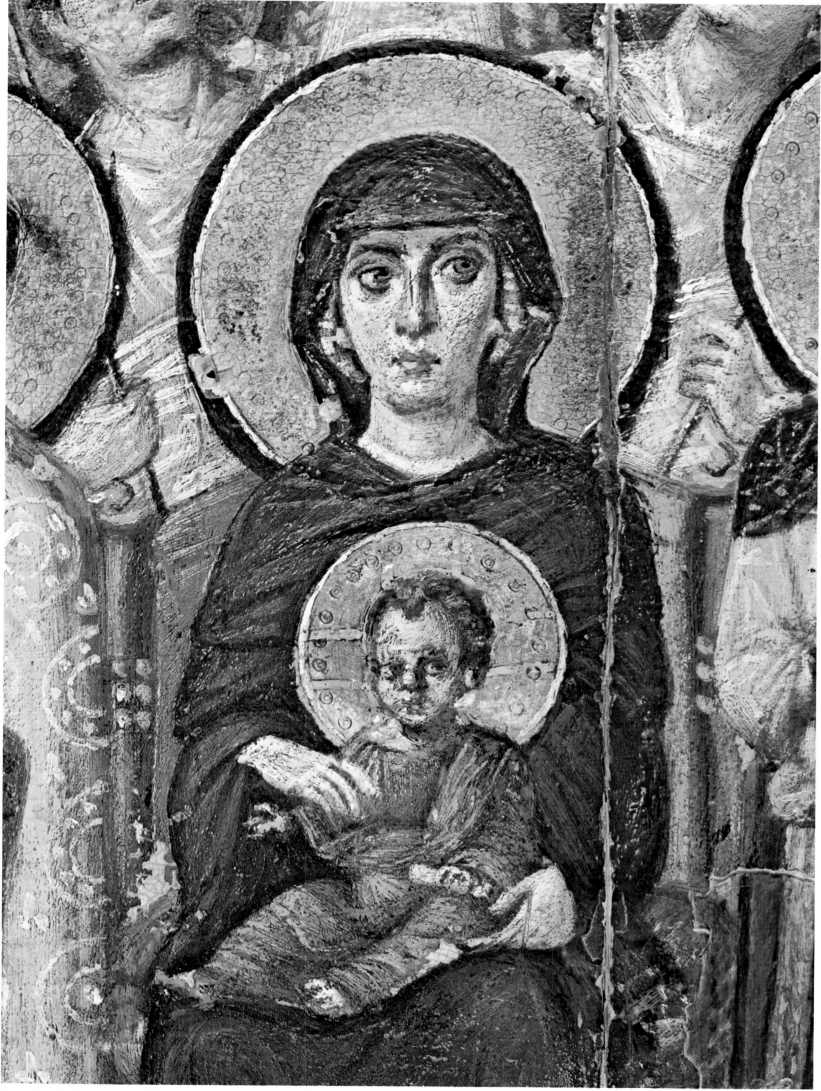

B. 3 (detail) Virgin with Child

PLATE VI

a. Left angel

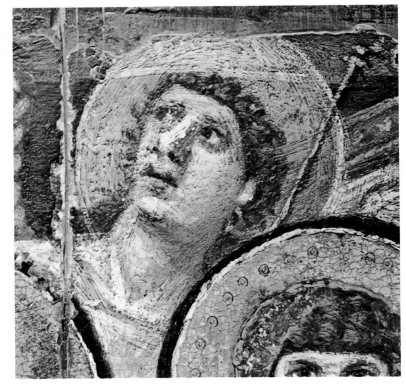

b. Right angel

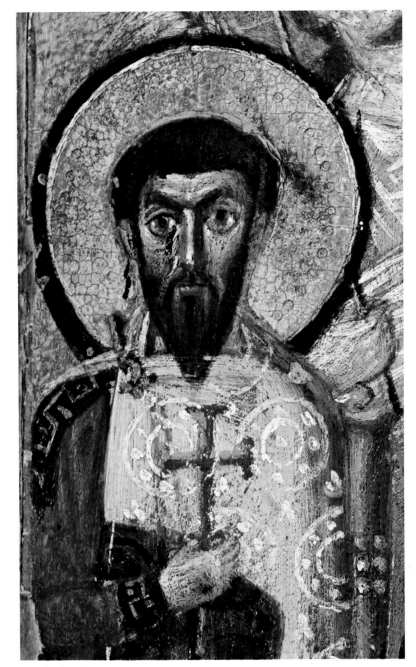

c. St. Theodore

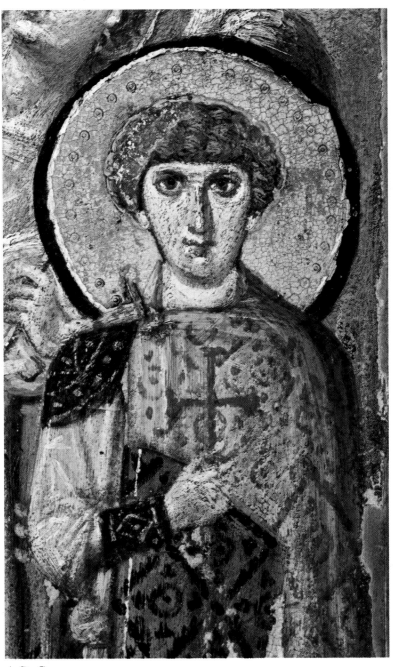

d. St. George

B. 3 (details)

PLATE VII

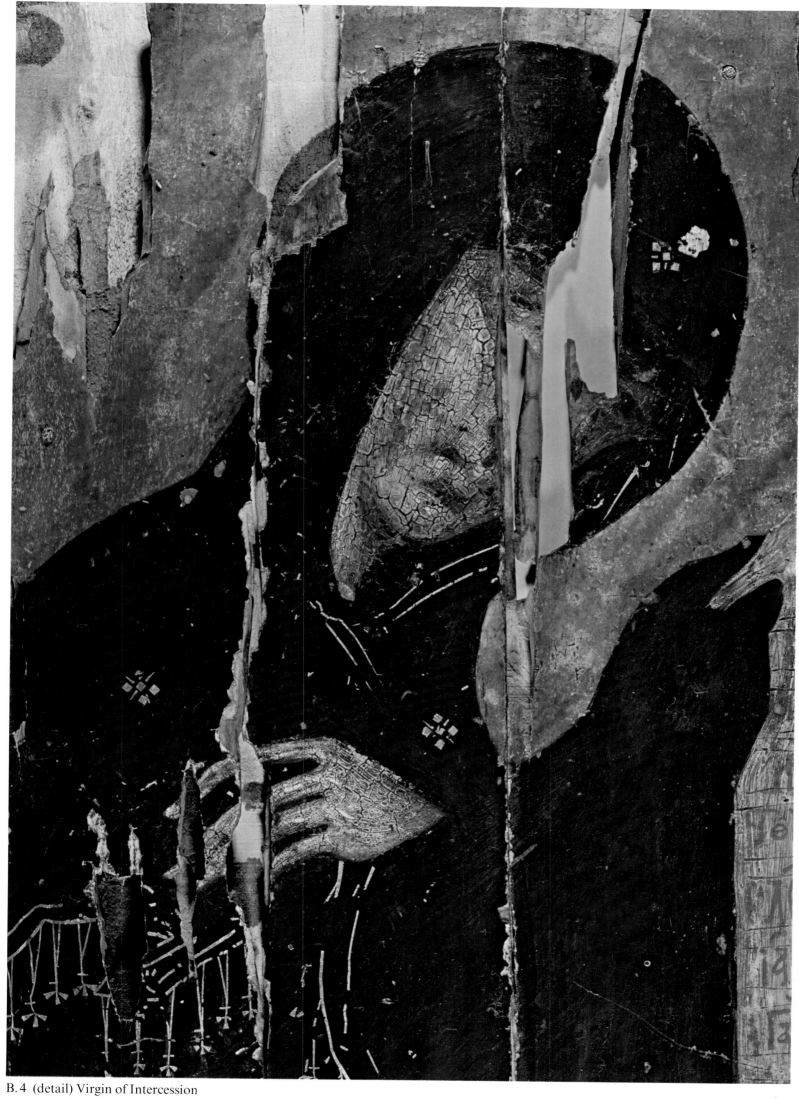

B. 4 (detail) Virgin of Intercession

PLATE VIII

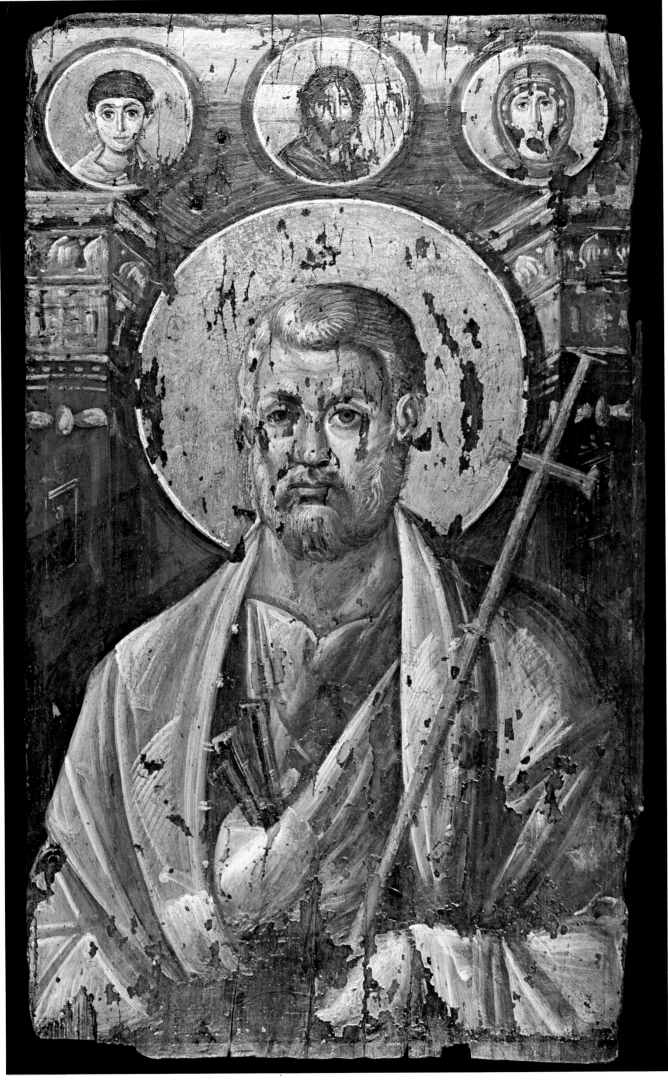

B. 5 St. Peter

PLATE IX

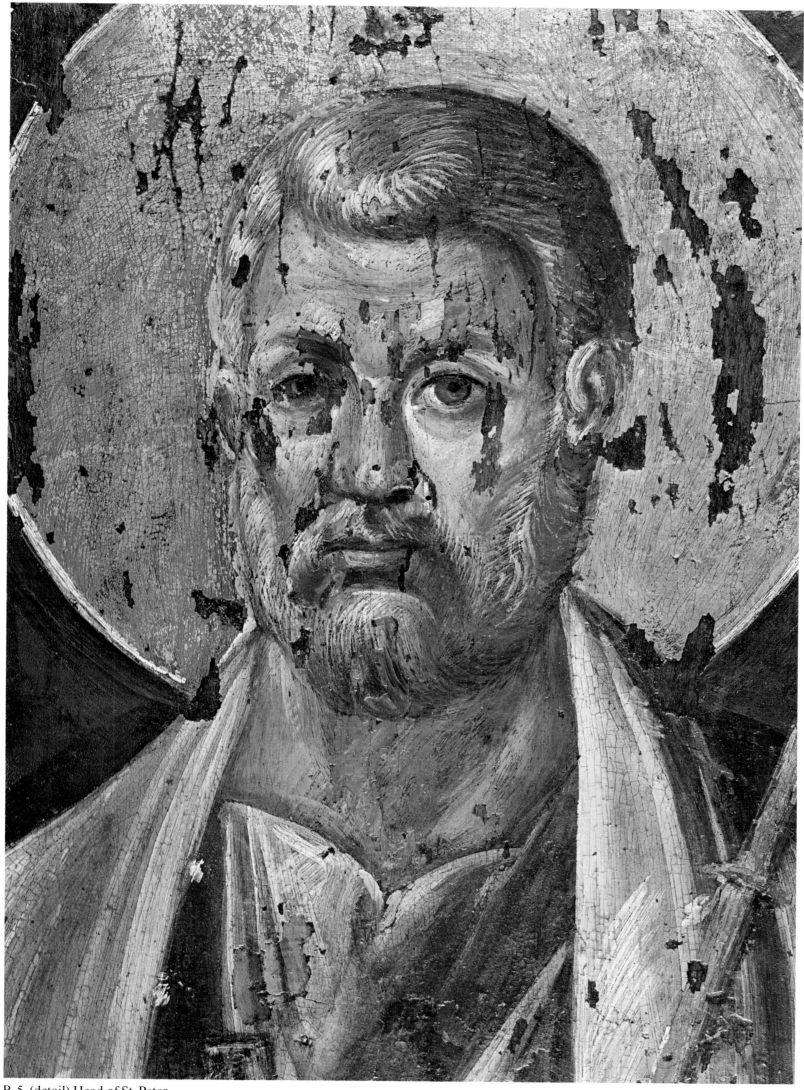

B. 5 (detail) Head of St. Peter

PLATE X

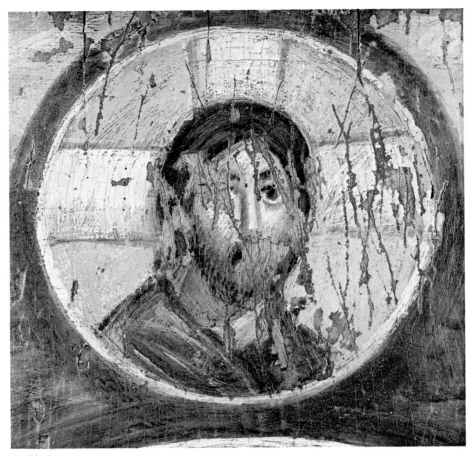

a. Christ

b. St. John the Evangelist (?)

B. 5 (details)

c. Virgin

PLATE XI

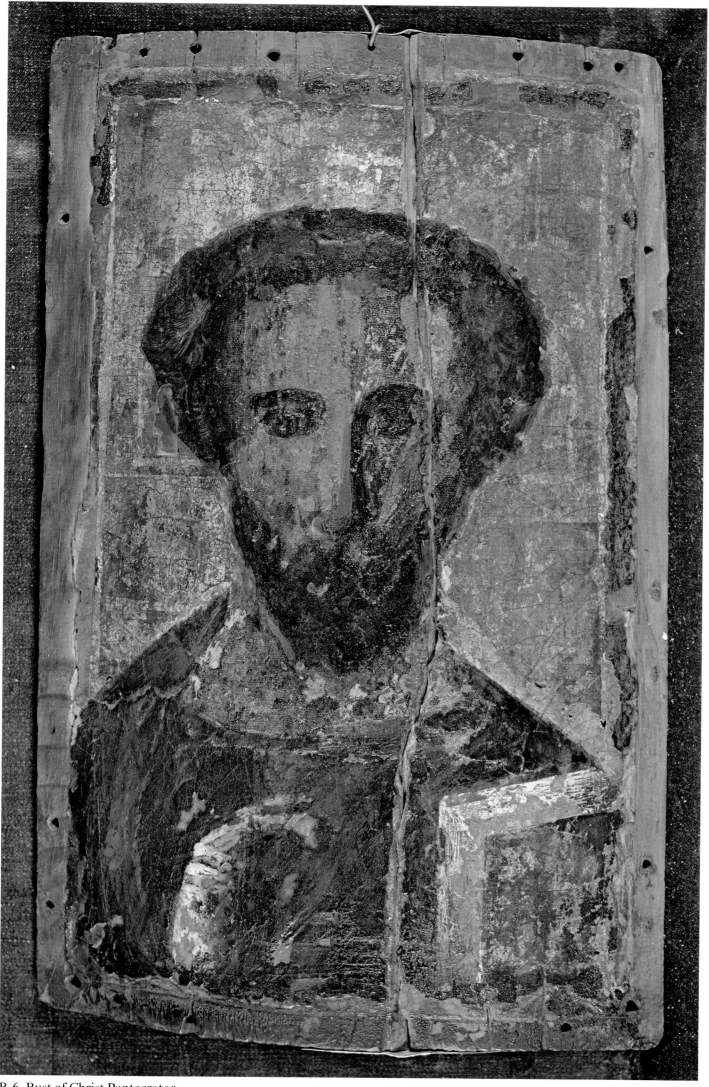

B.6 Bust of Christ Pantocrator

PLATE XII

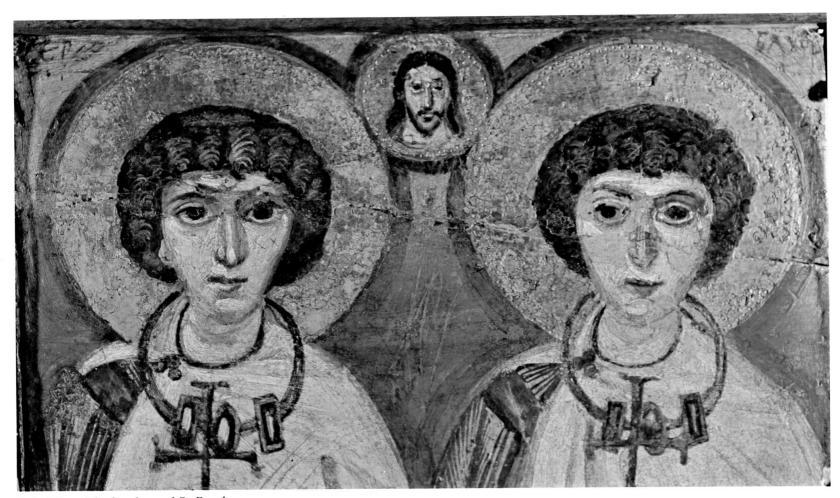

B.9 (Kiev II) St. Sergius and St. Bacchus

PLATE XIII

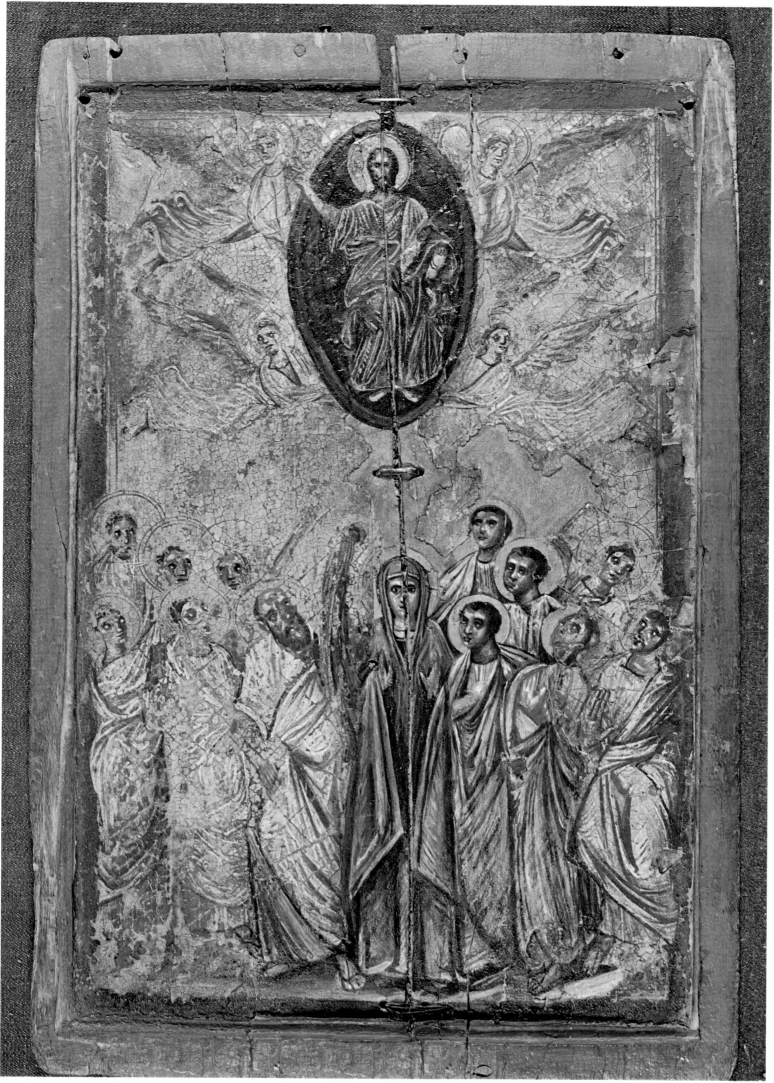

B.10 Ascension of Christ

PLATE XIV

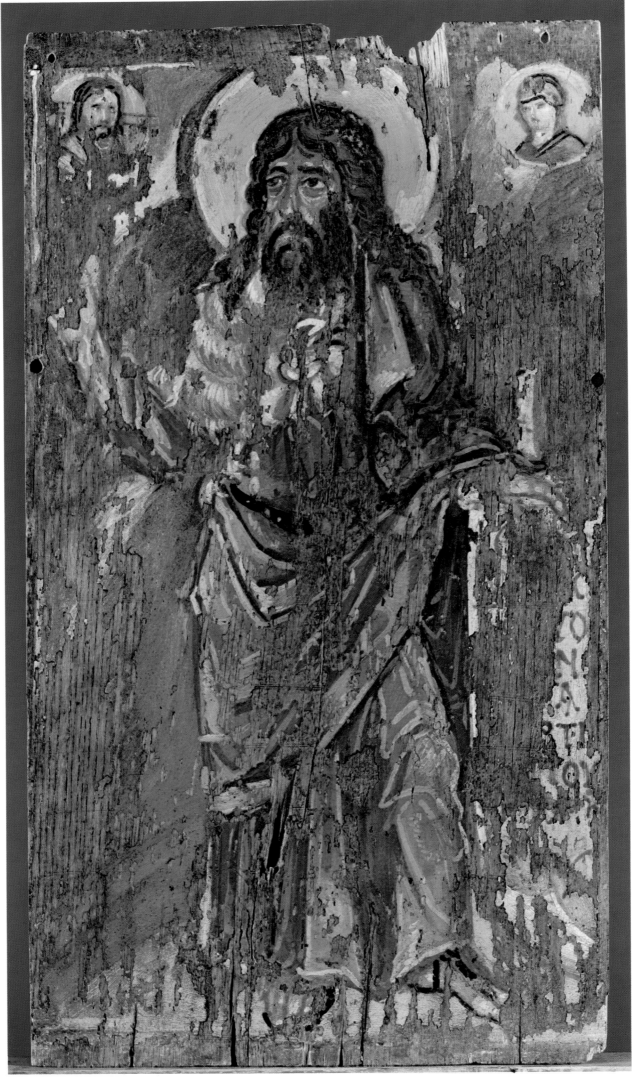

B. 11 (Kiev III) St. John the Baptist

PLATE XV

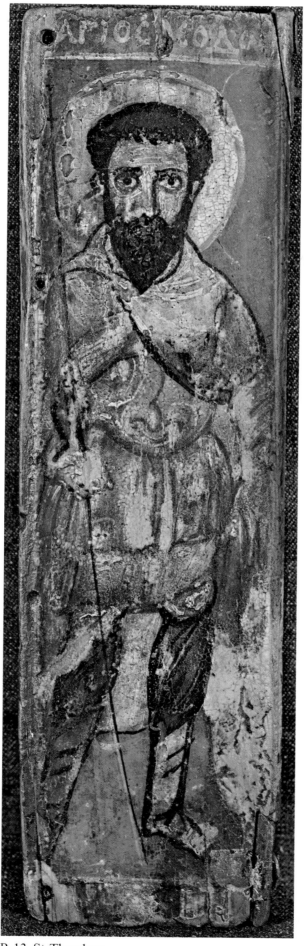

B.13 St. Theodore

PLATE XVI

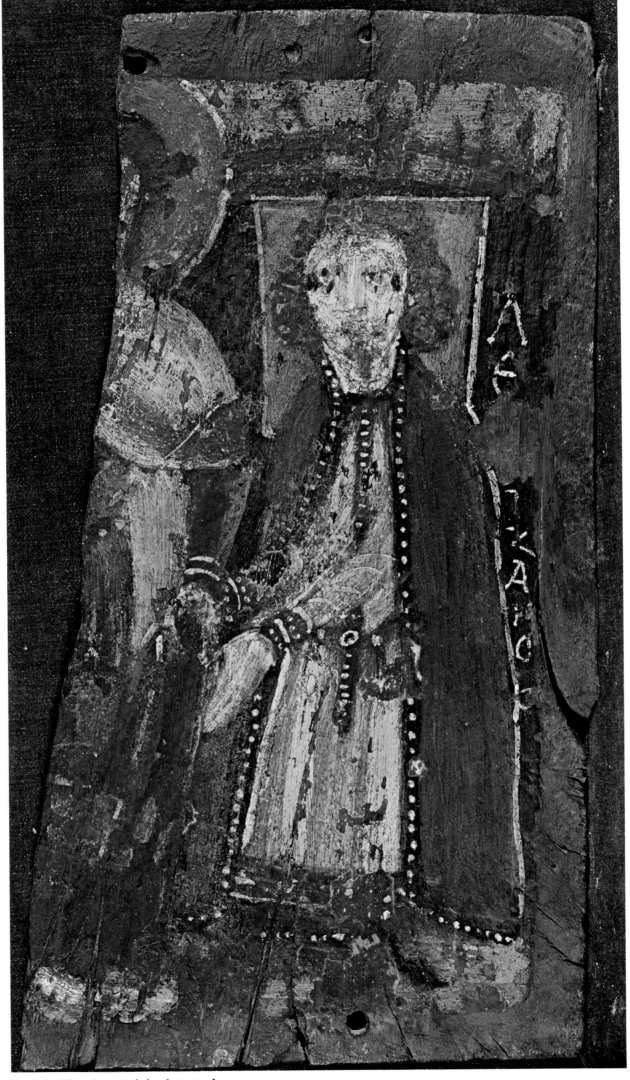

B. 14 St. Theodore and the decanos Leo

PLATE XVII

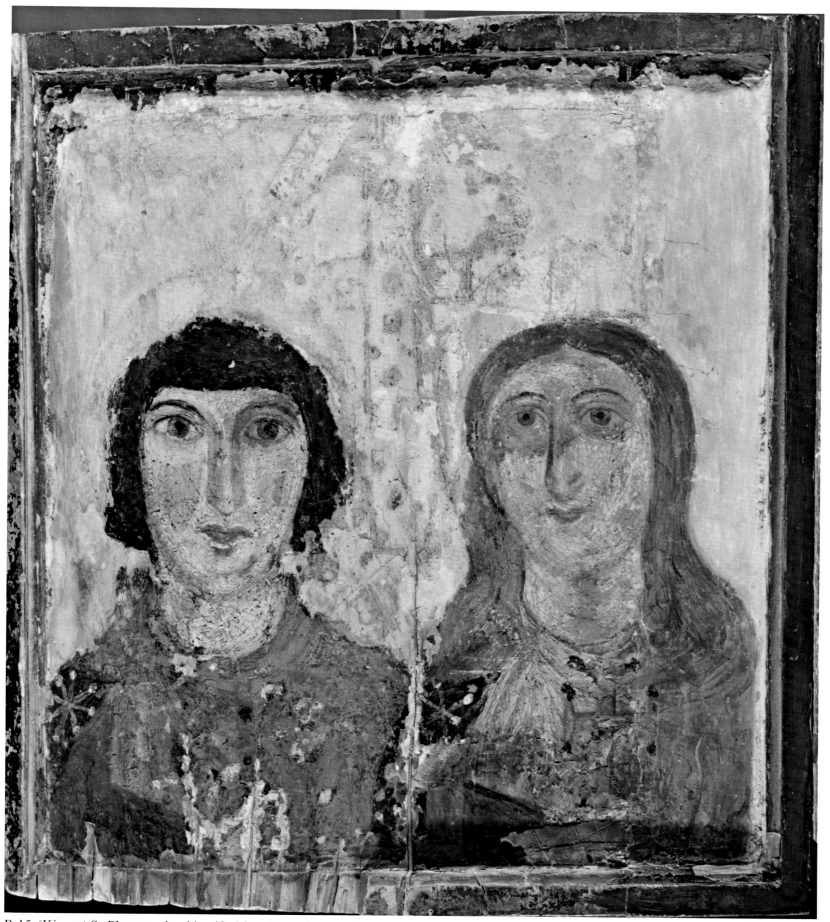

B. 15 (Kiev IV) St. Platon and unidentified female martyr

PLATE XVIII

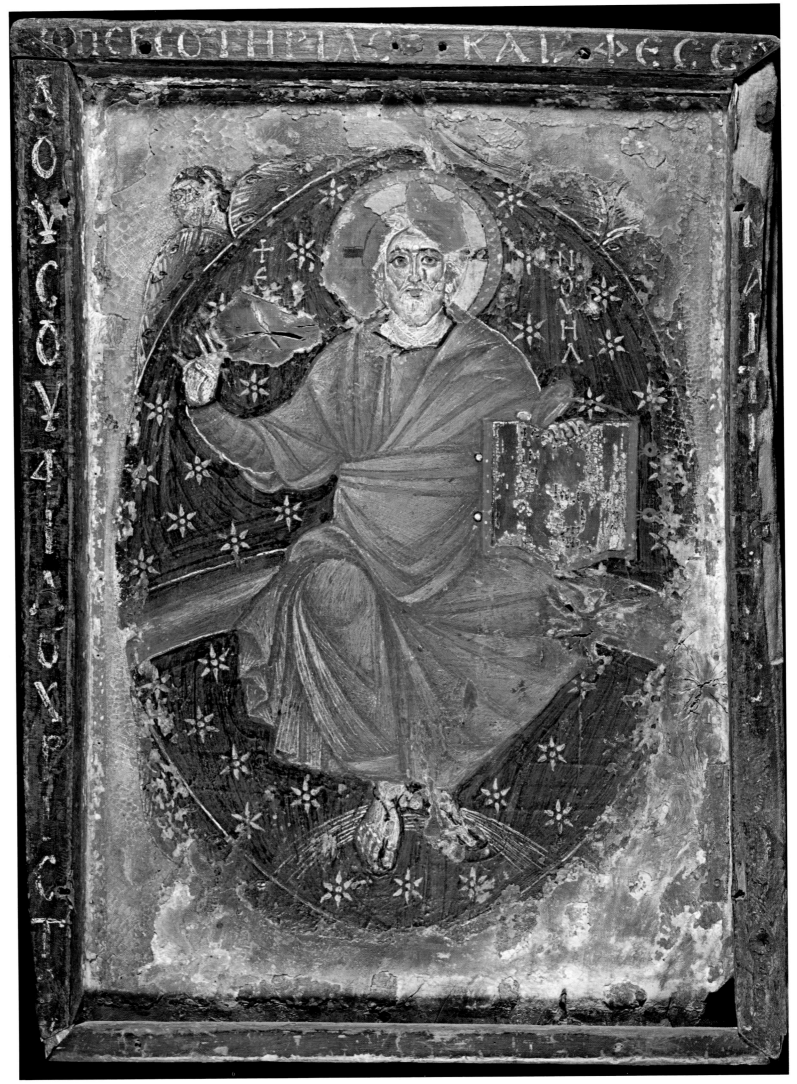

B.16 Christ enthroned

PLATE XIX

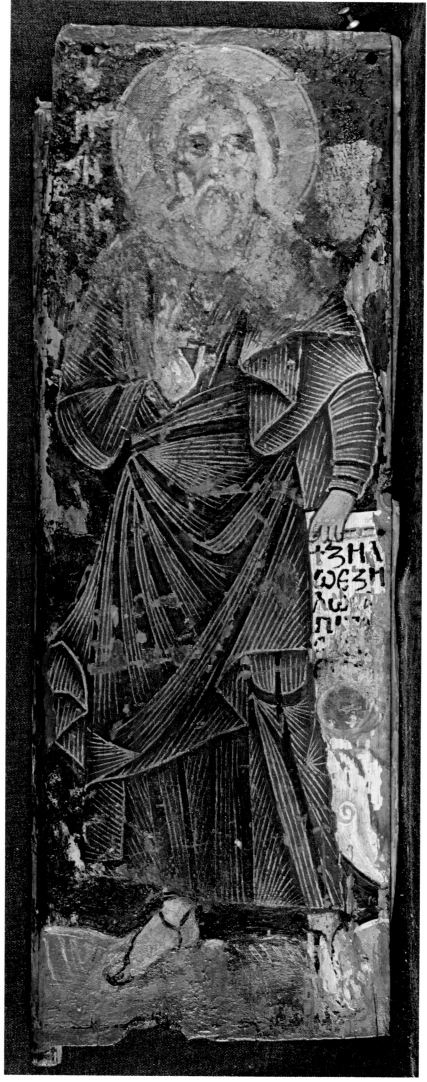

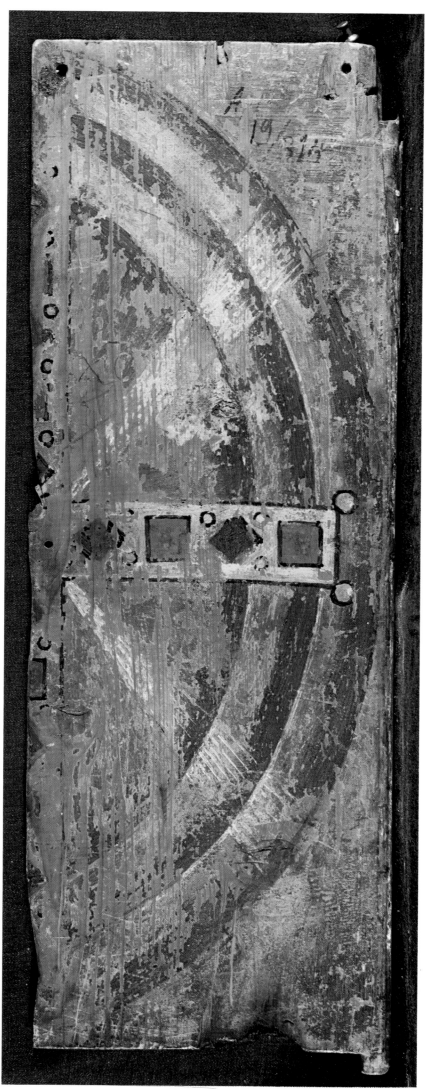

a. (front) Prophet Elijah

b. (back) Cross in mandorla

B. 17

PLATE XX

PLATE XXII

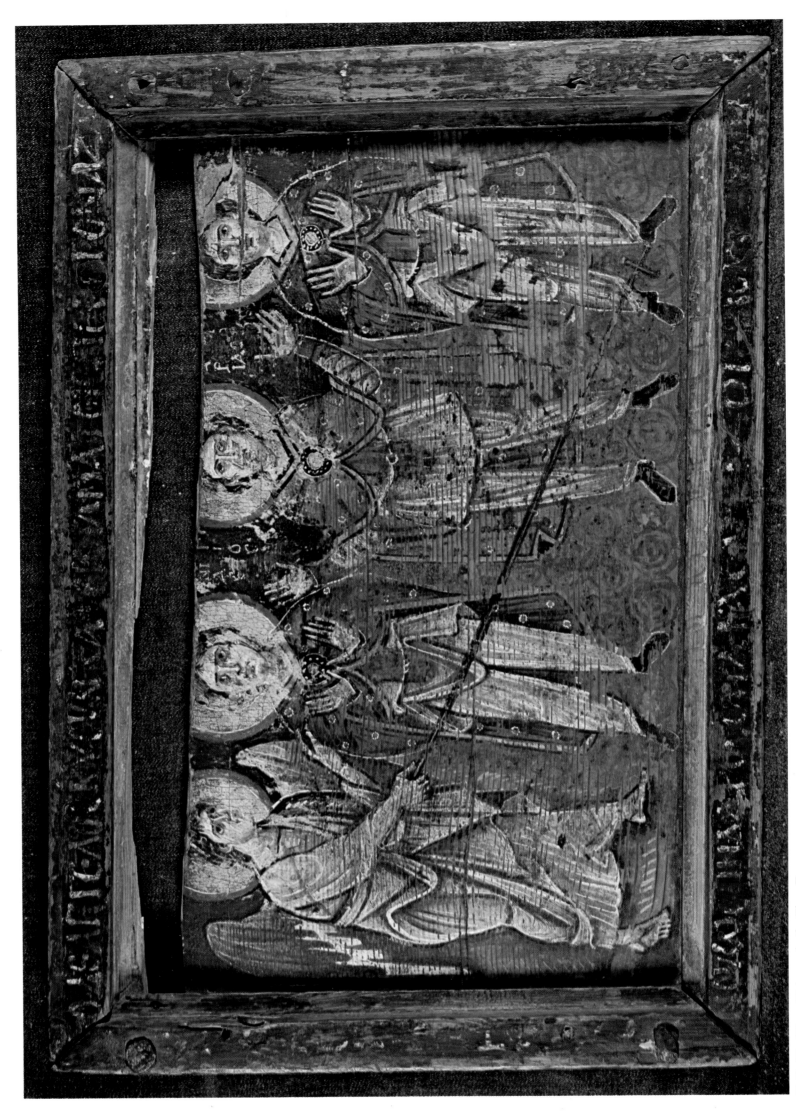

B.31 The Three Hebrews in the Fiery Furnace

PLATE XXIII

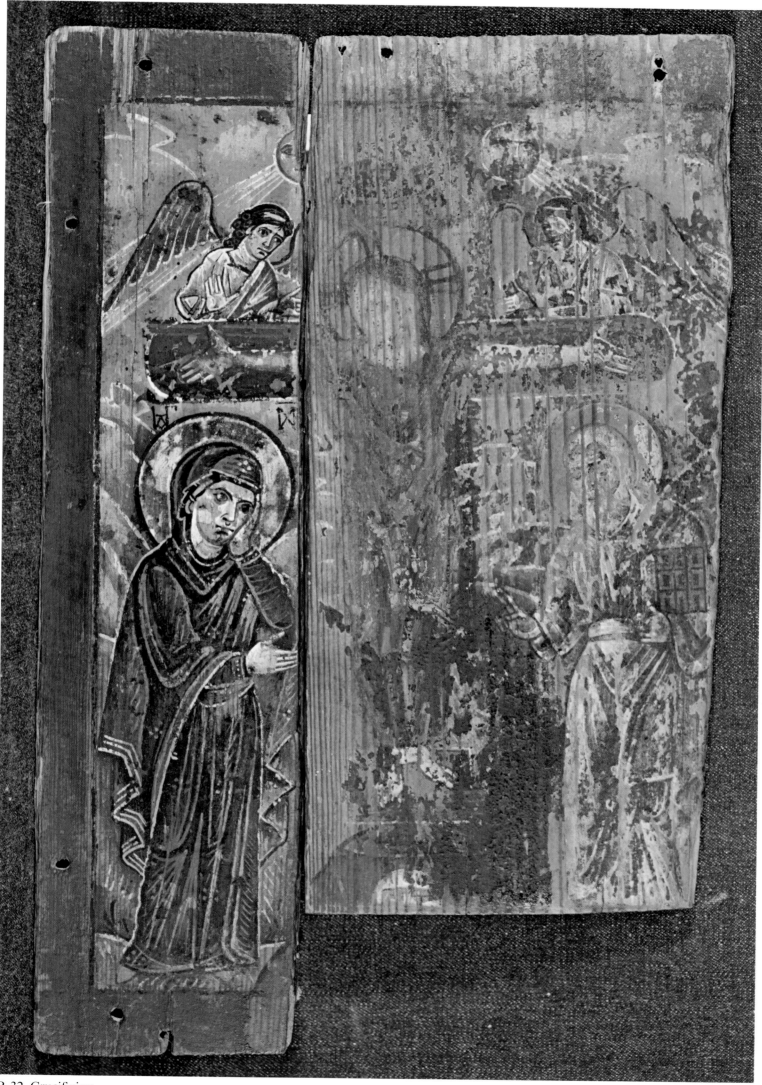

B.32 Crucifixion

PLATE XXIV

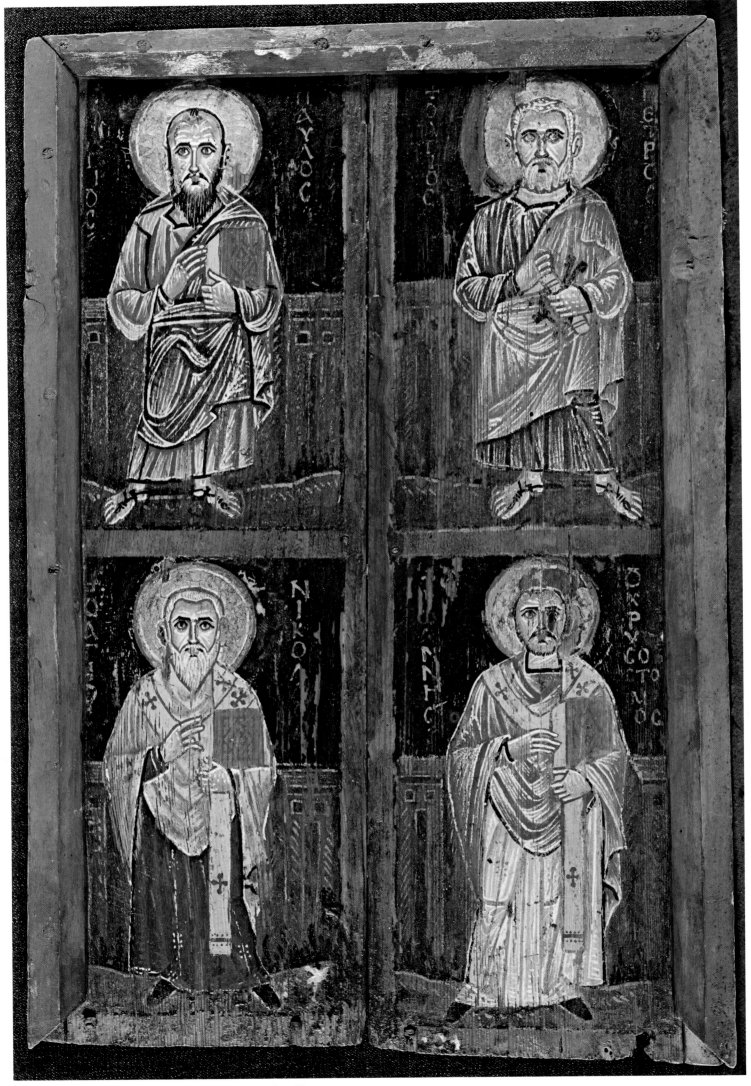

B.33 St. Paul, St. Peter, St. Nicholas and St. John Chrysostom

PLATE XXV

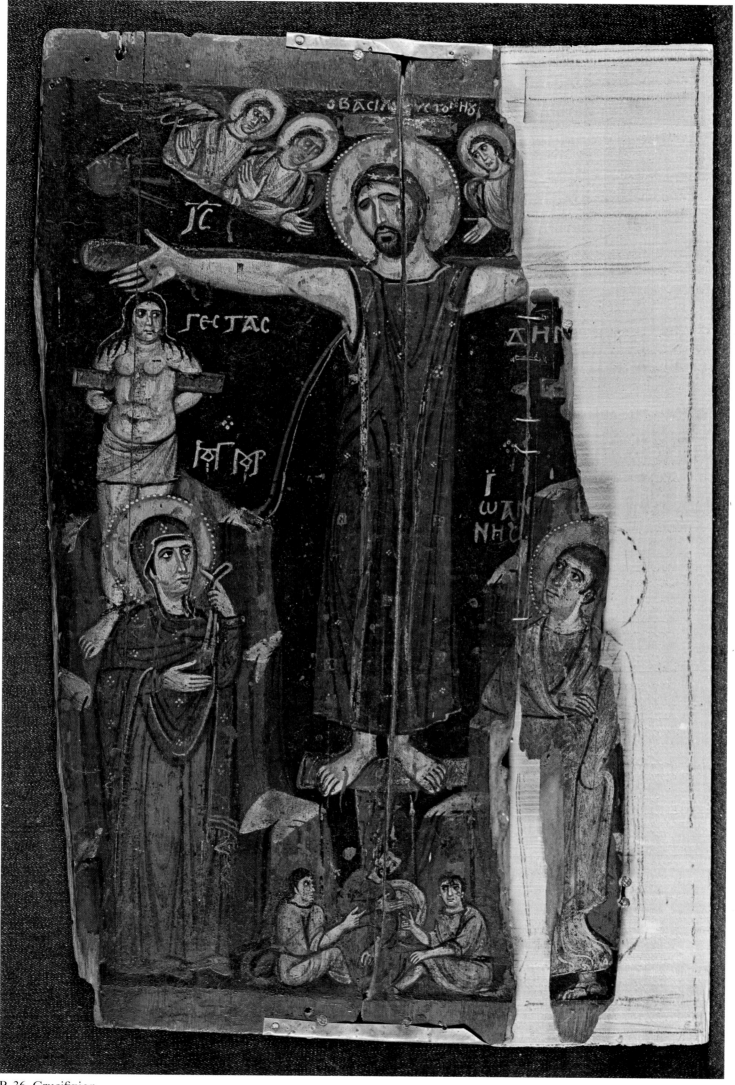

B.36 Crucifixion

PLATE XXVI

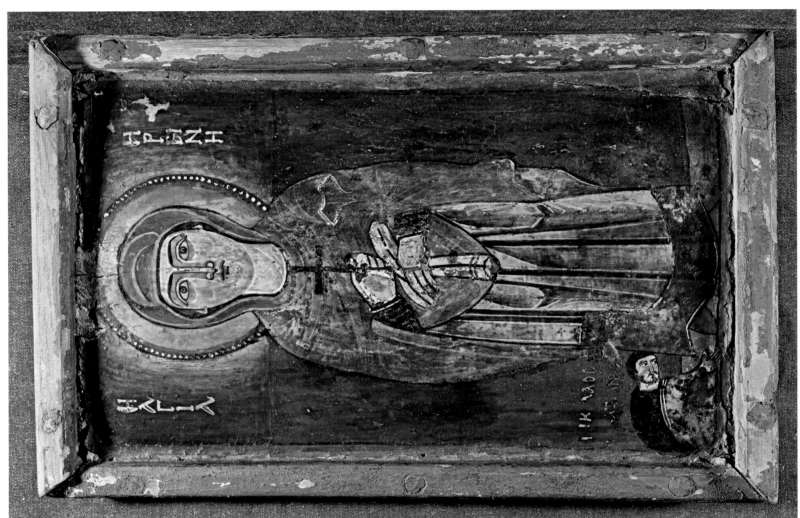

B. 39 St. Irene

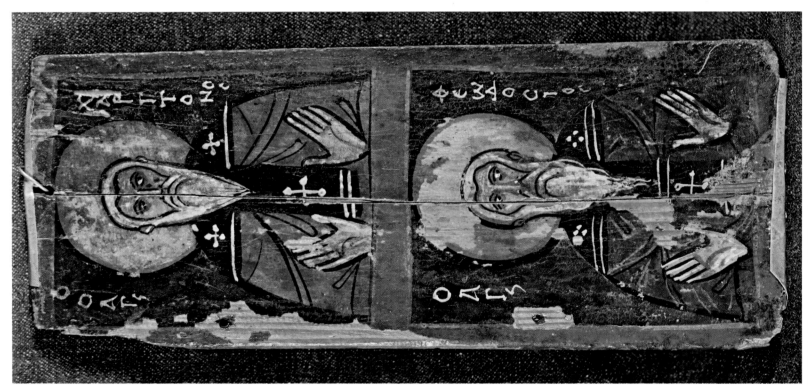

B. 37 St. Chariton and St. Theodosius

PLATE XXVII

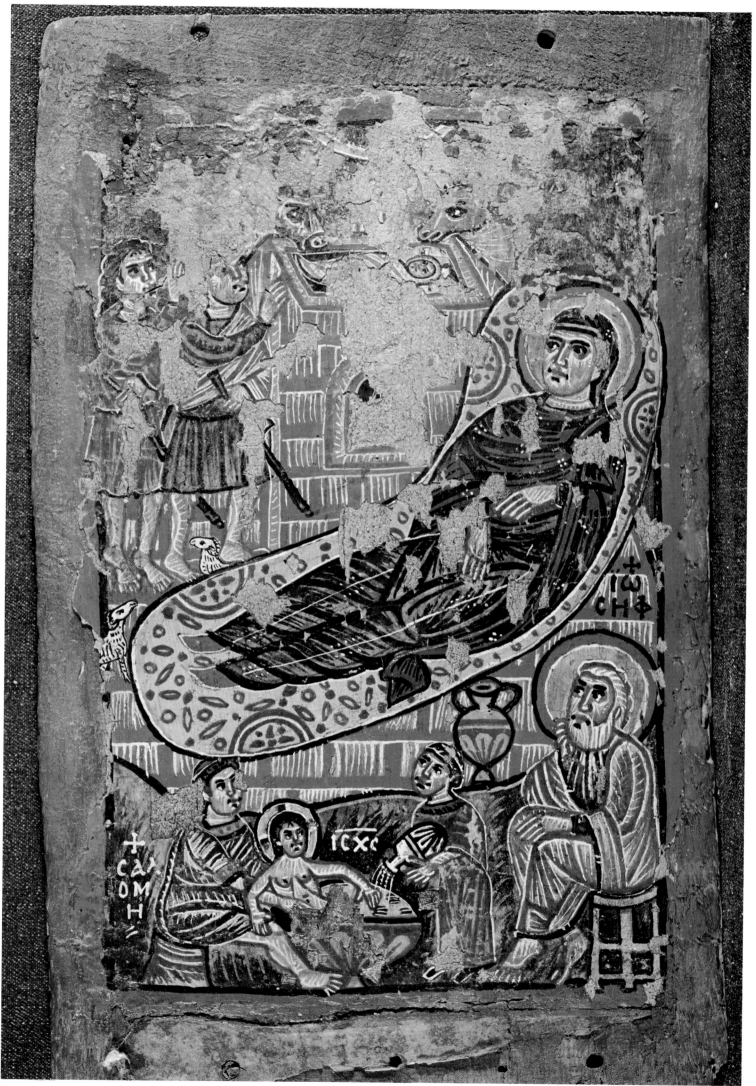

B. 41 Nativity of Christ

PLATE XXVIII

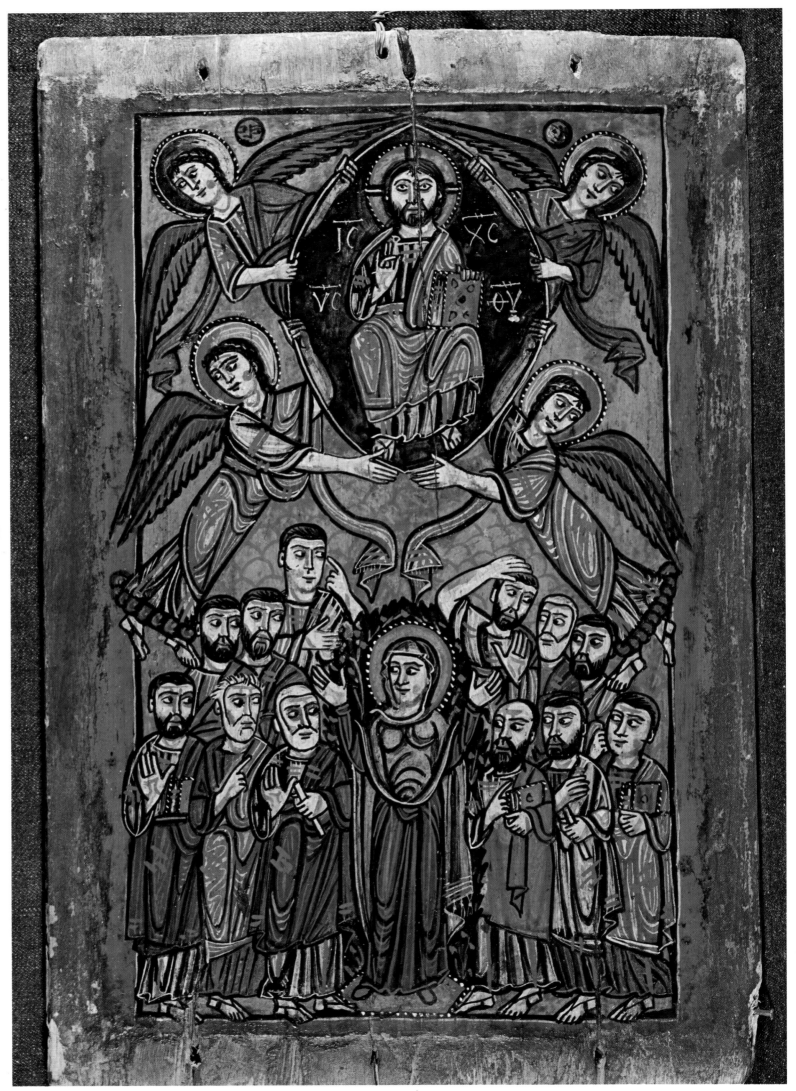

B. 42 Ascension of Christ

PLATE XXIX

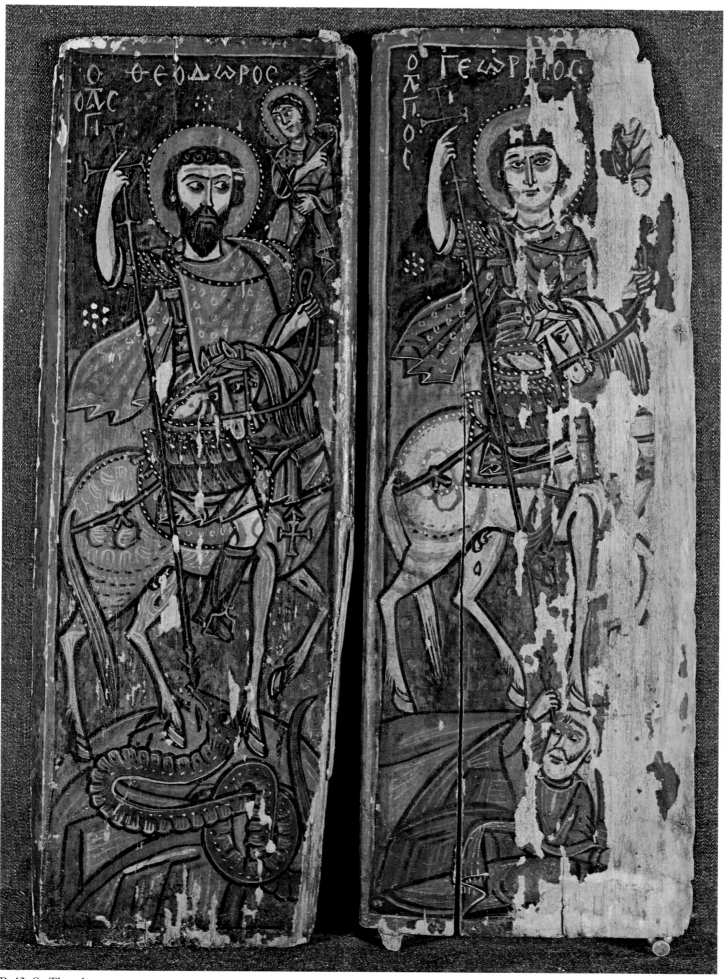

B.43 St.Theodore

B.44 St.George

PLATE XXX

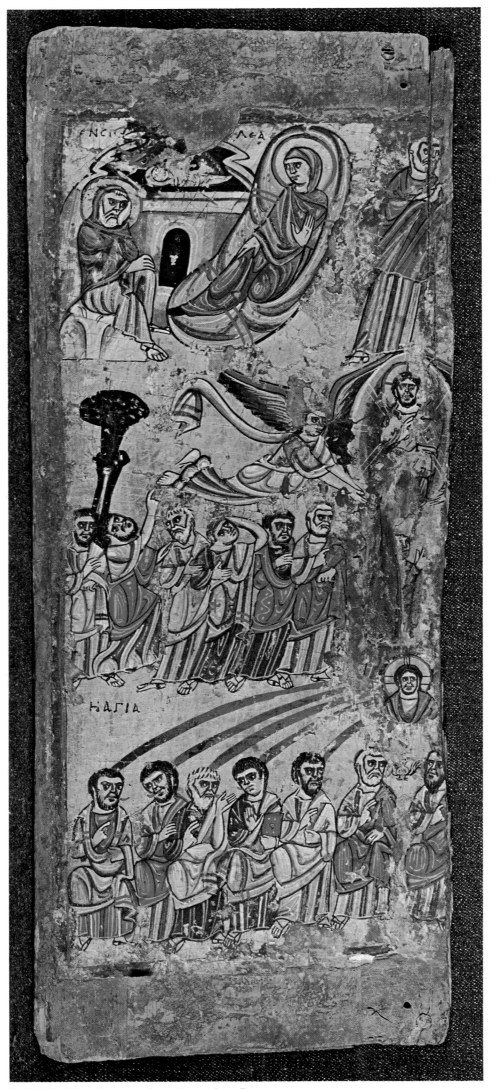

B.45 Nativity, Presentation, Ascension, Pentecost

PLATE XXXI

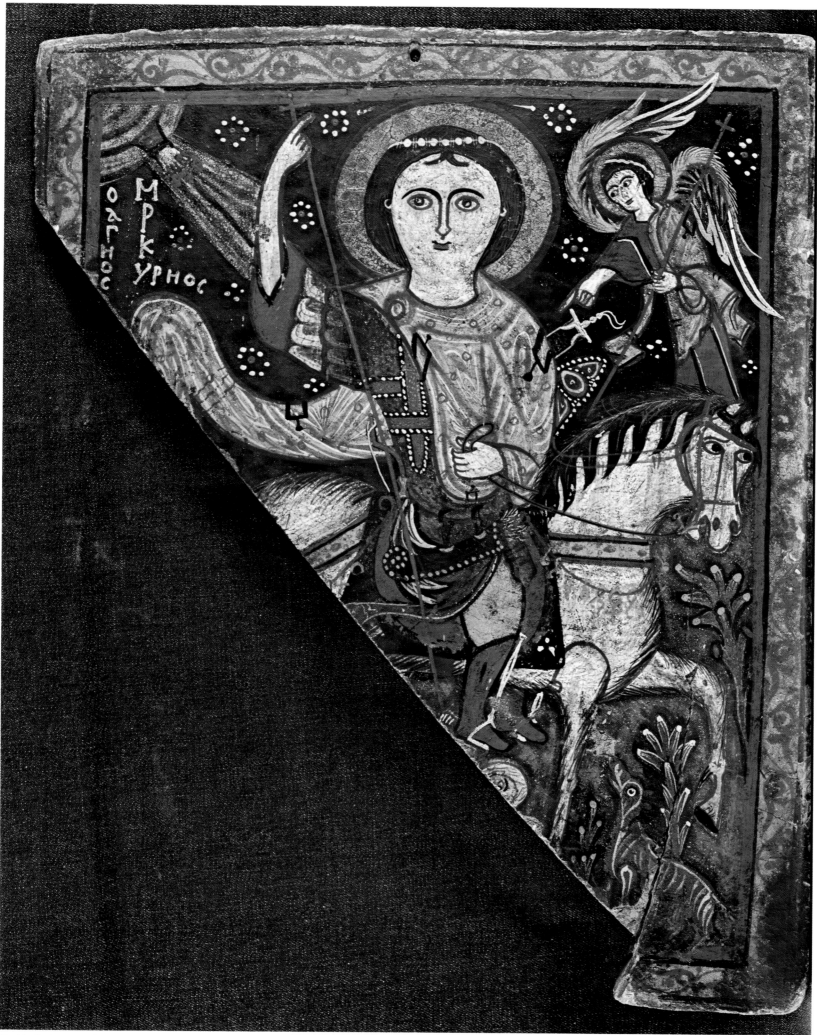

B. 49 St. Mercurius

PLATE XXXII

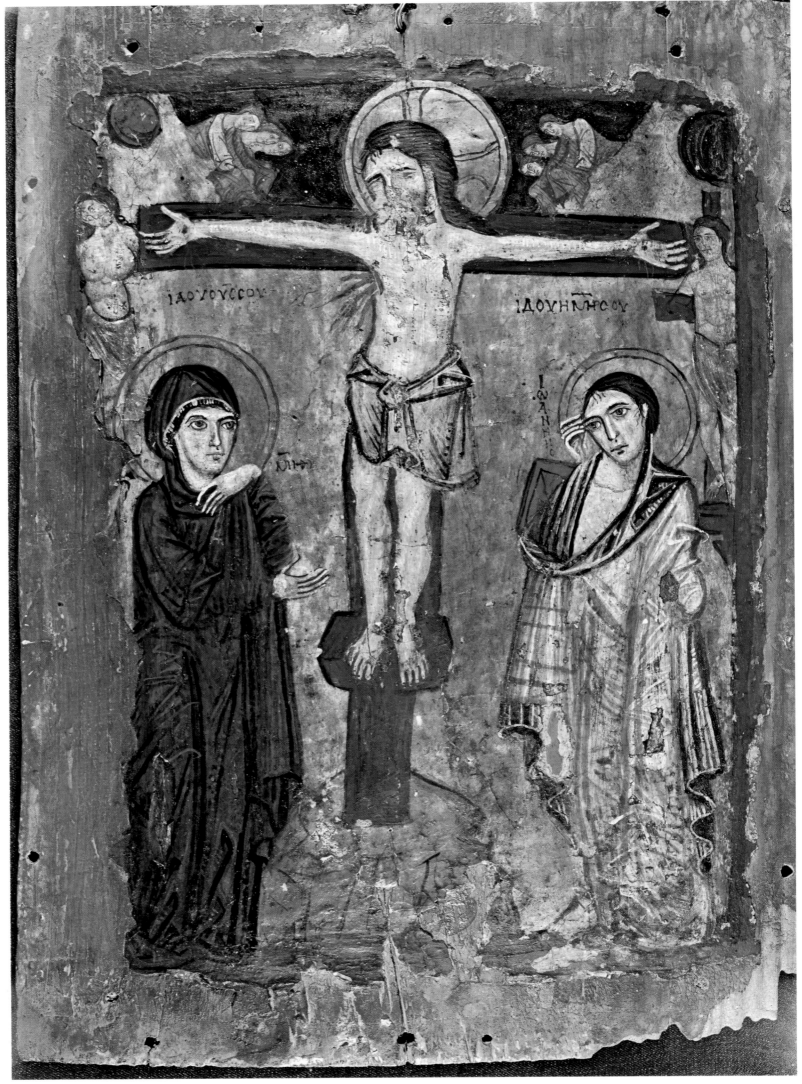

B.50 Crucifixion

PLATE XXXIII

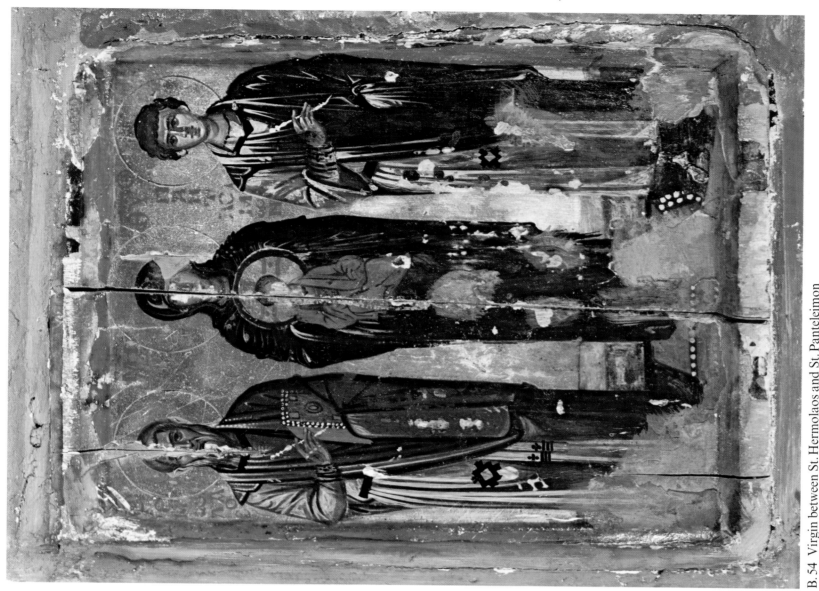

B. 54 Virgin between St. Hermolaos and St. Panteleimon

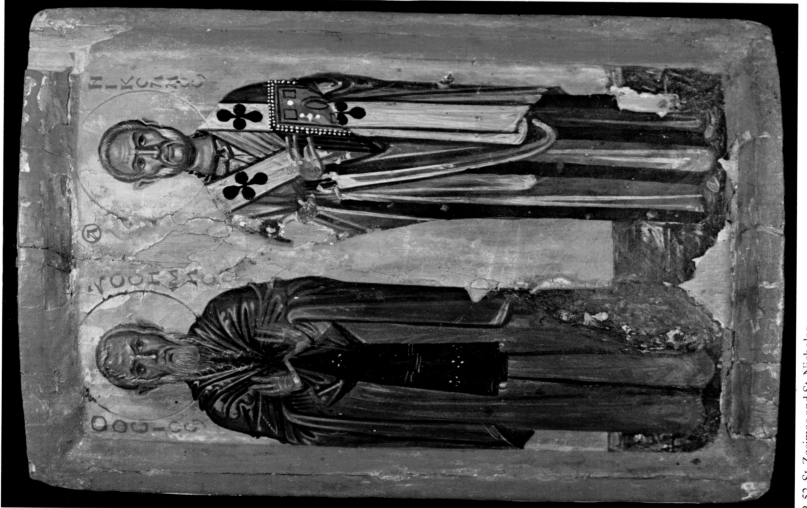

B. 52 St. Zosimas and St. Nicholas

PLATE XXXIV

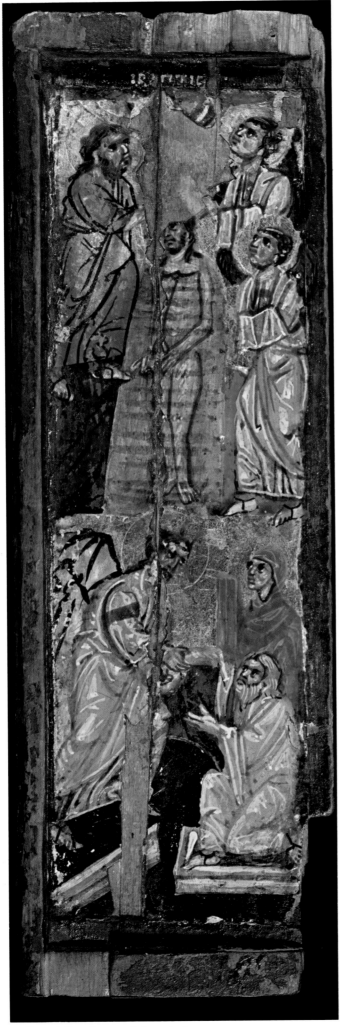

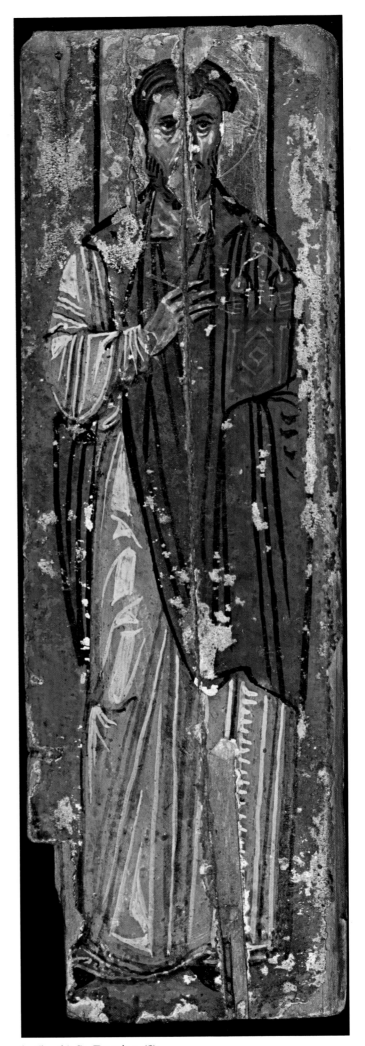

a. (front) Baptism and Anastasis

b. (back) St. Damian (?)

B. 55

PLATE XXXV

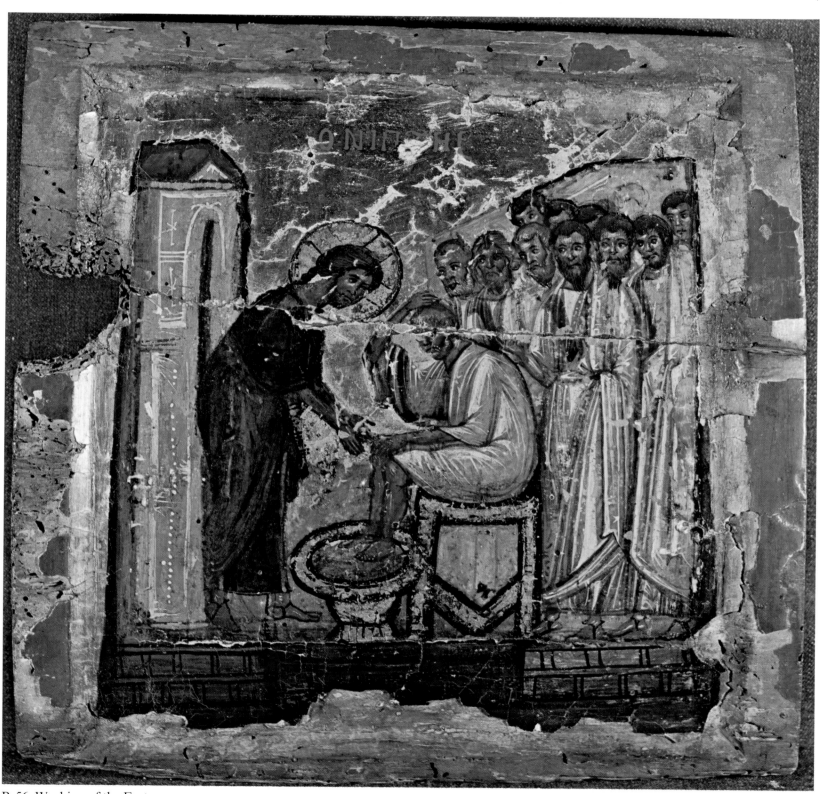

B. 56 Washing of the Feet

PLATE XXXVI

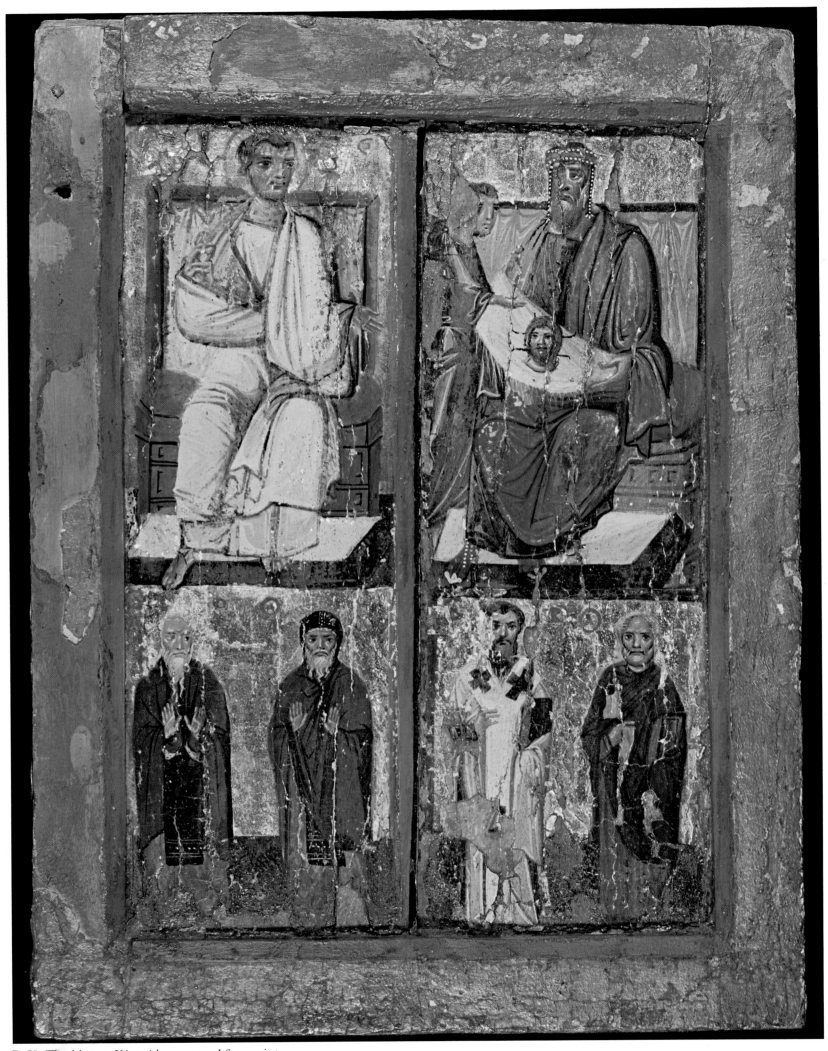

B.58 Thaddaeus, King Abgarus, and four saints

PLATE XXXVII

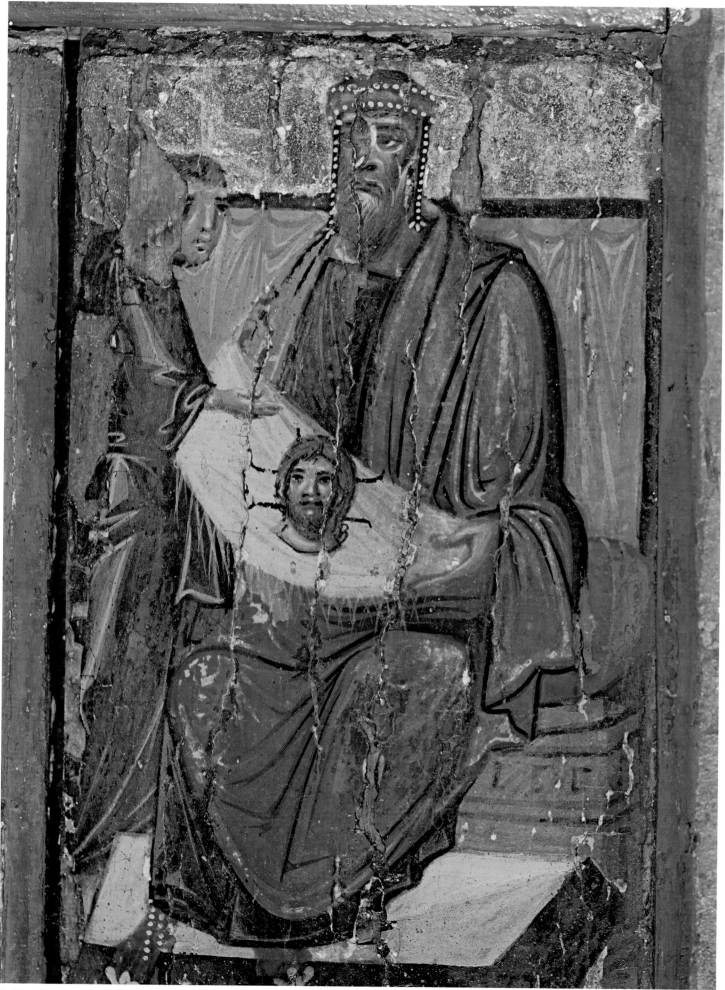

B.58 (detail) King Abgarus

PLATE XXXVIII

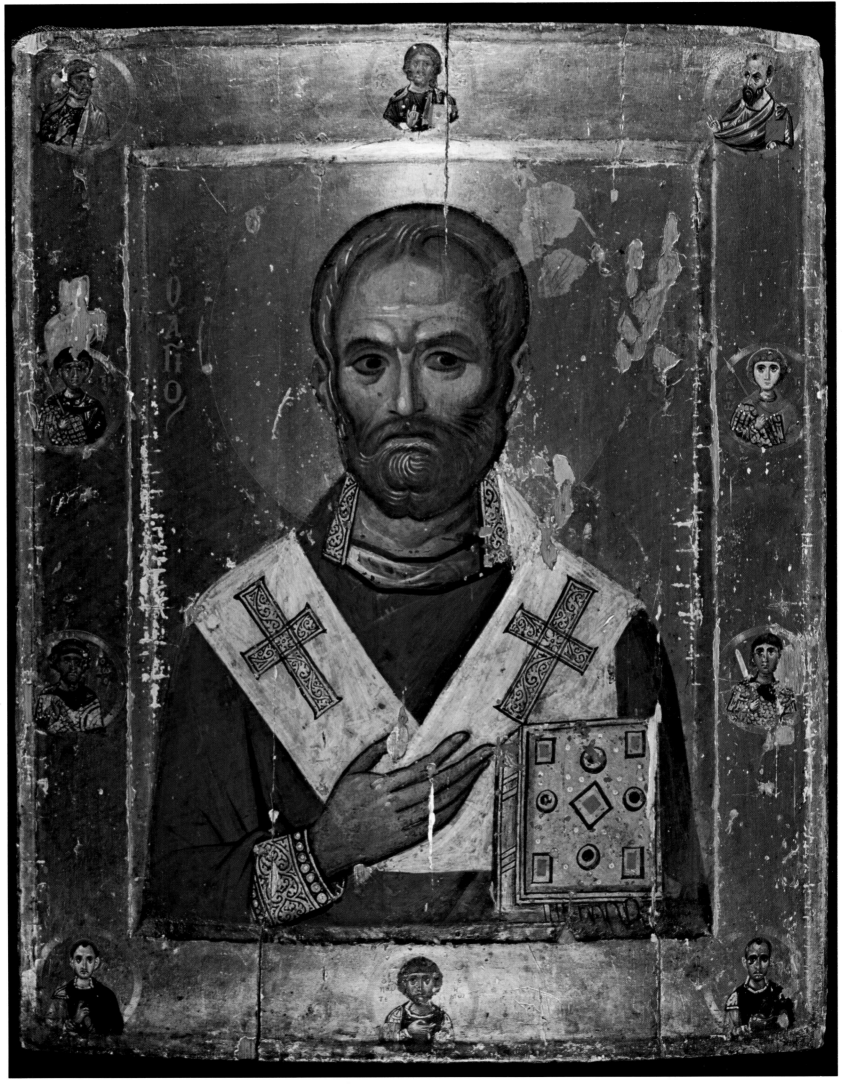

B.61 St. Nicholas

PLATE XXXIX

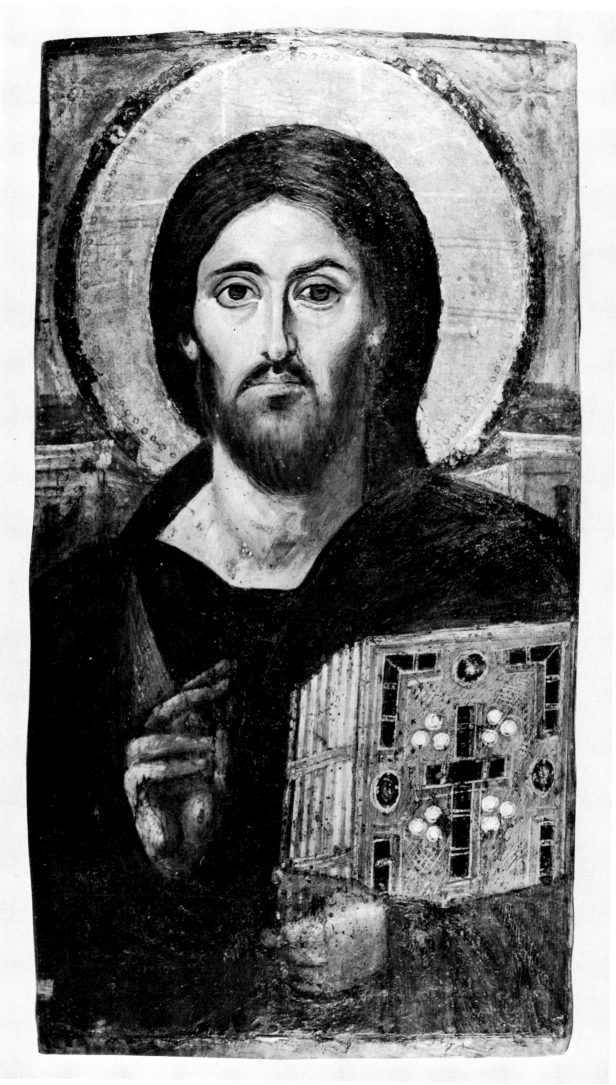

B. 1 Bust of Christ Pantocrator

PLATE XL

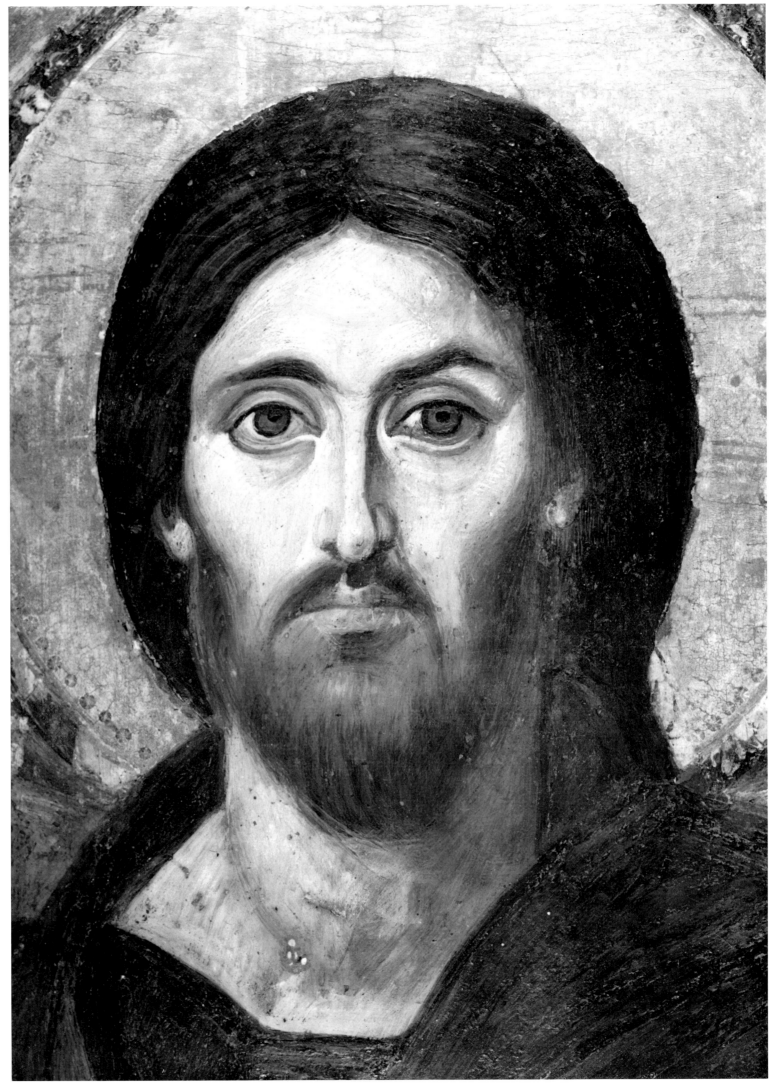

B.1 (detail) Head of Christ

PLATE XLI

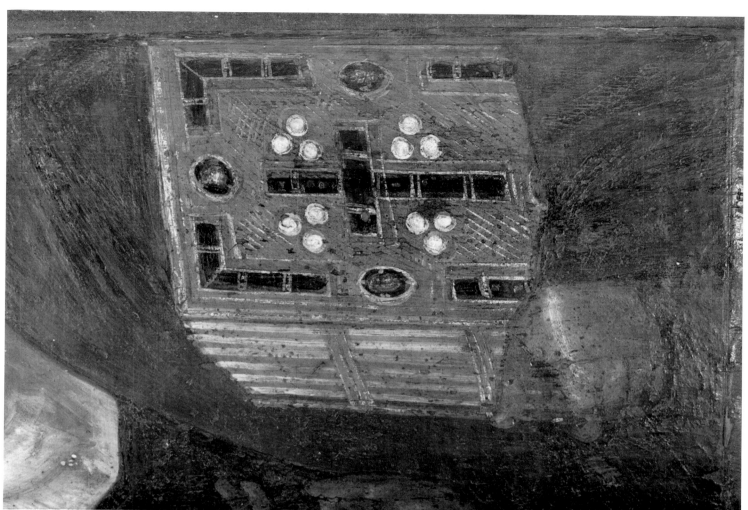

b. Left hand

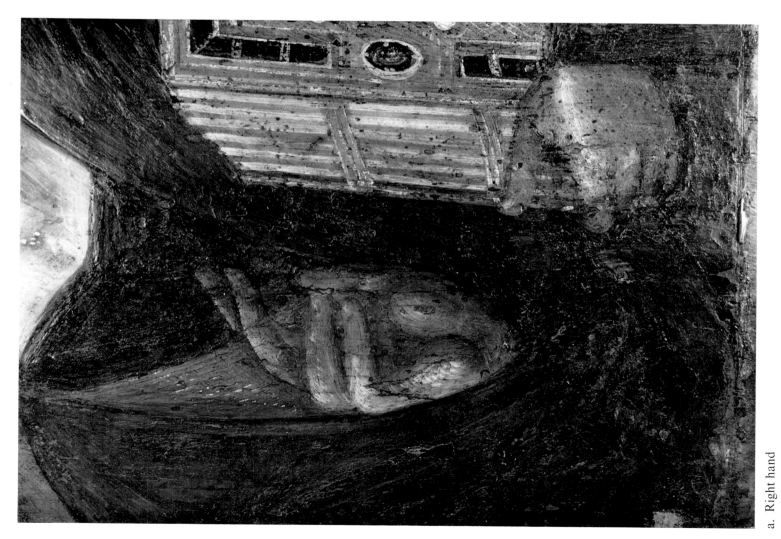

a. Right hand

B.1 (details)

PLATE XLII

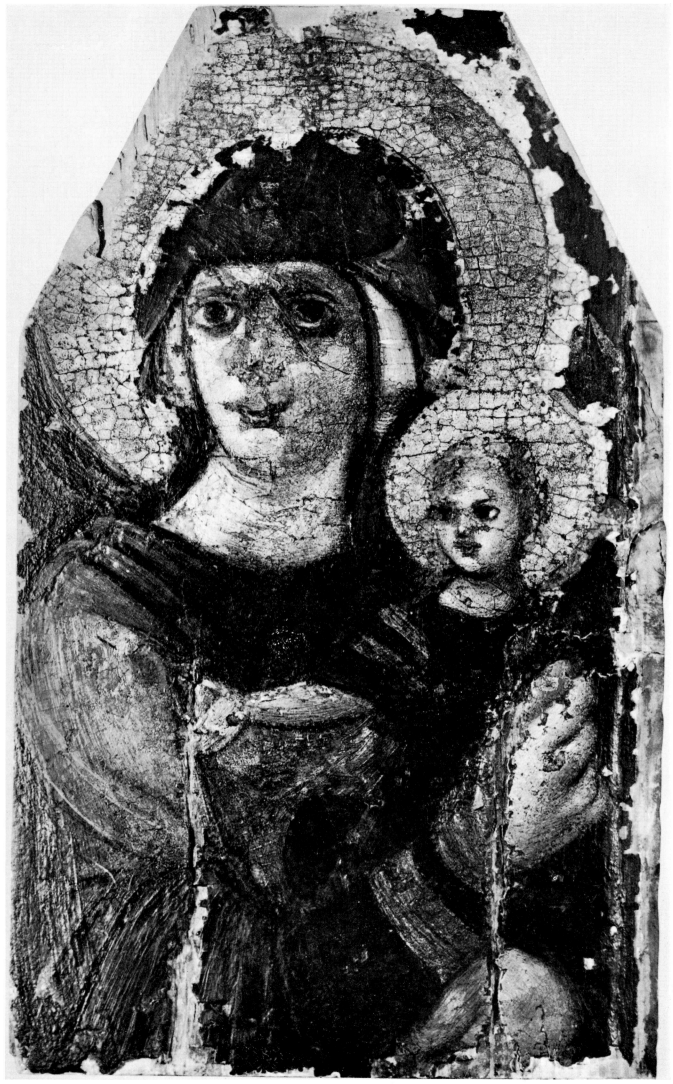

B.2 (Kiev 1) Virgin with Child

PLATE XLIII

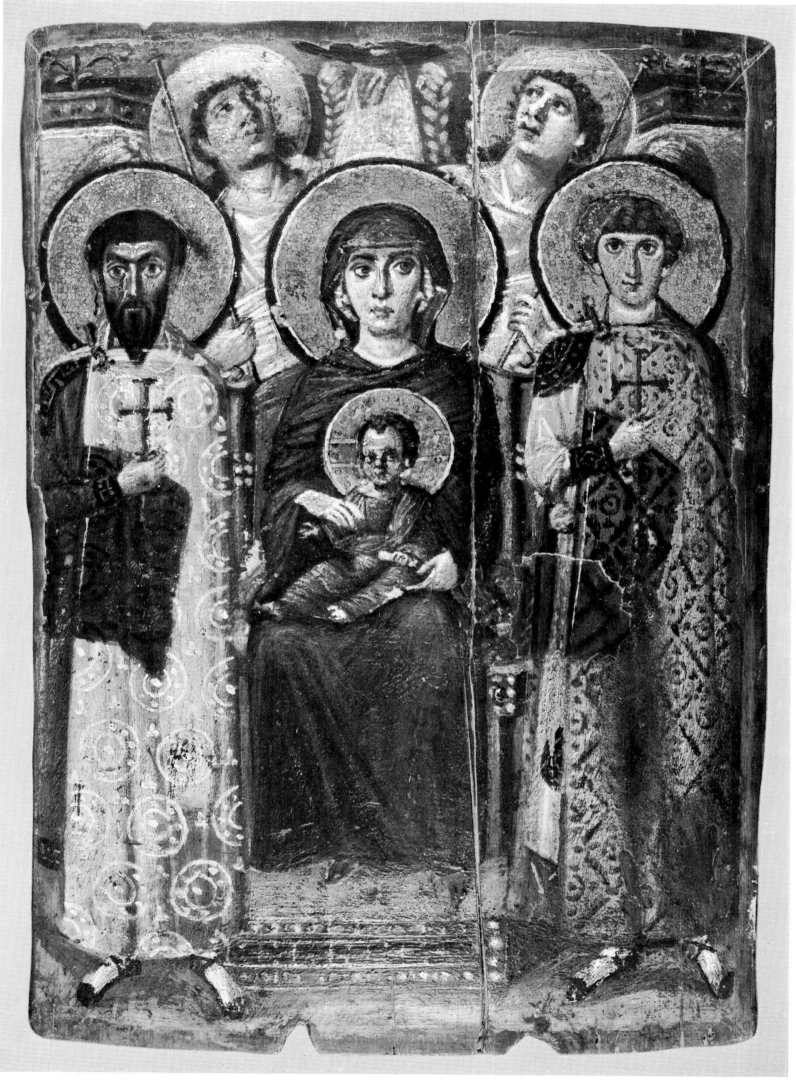

B.3 Virgin between St. Theodore and St. George

PLATE XLIV

b. Christ Child

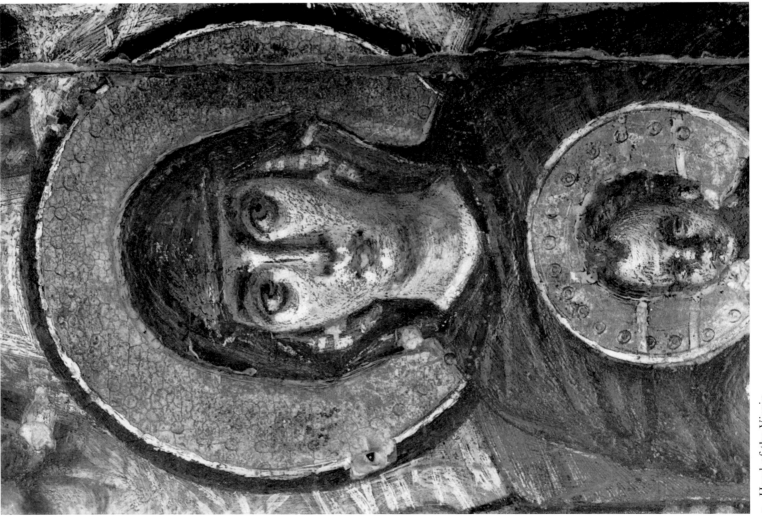

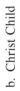

a. Head of the Virgin

PLATE XLV

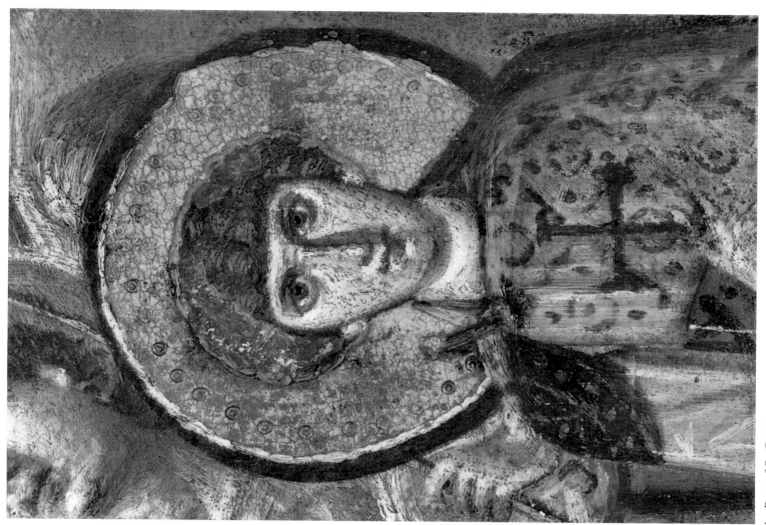

b. Bust of St. George

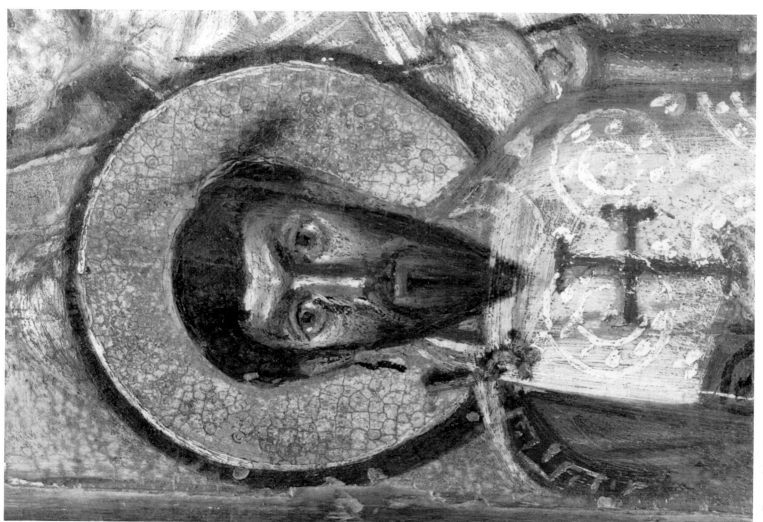

a. Bust of St. Theodore

B.3 (details)

PLATE XLVI

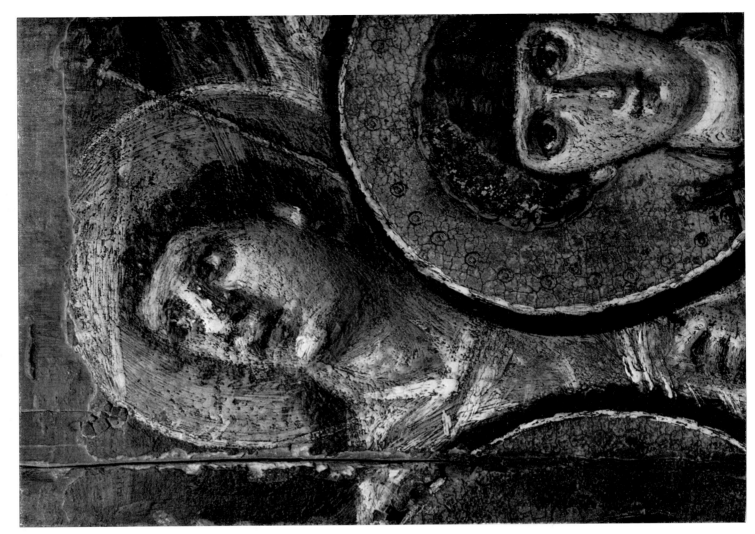

b. Right angel

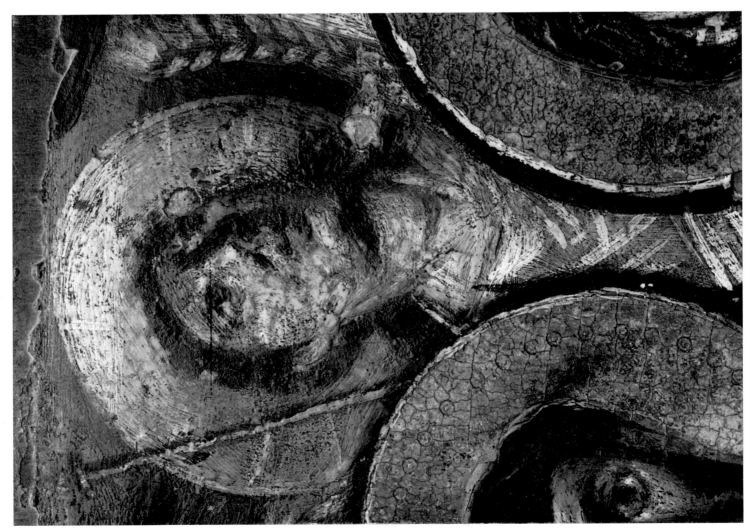

a. Left angel

B.3 (details)

PLATE XLVII

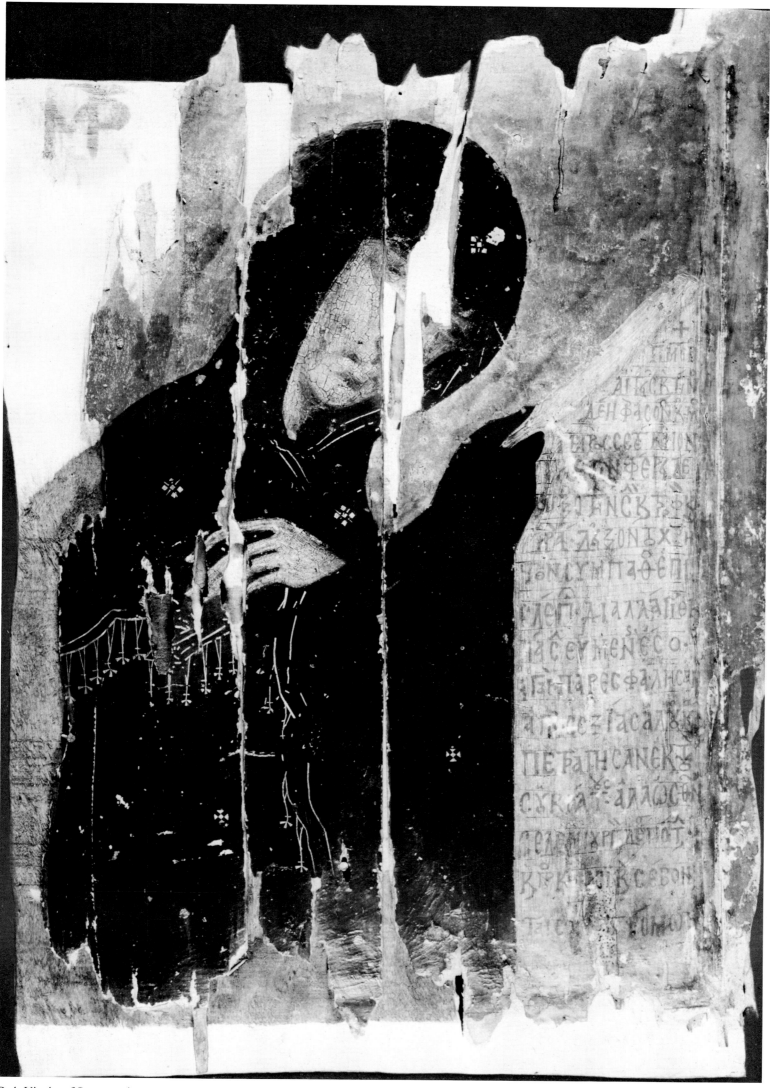

B.4 Virgin of Intercession

PLATE XLVIII

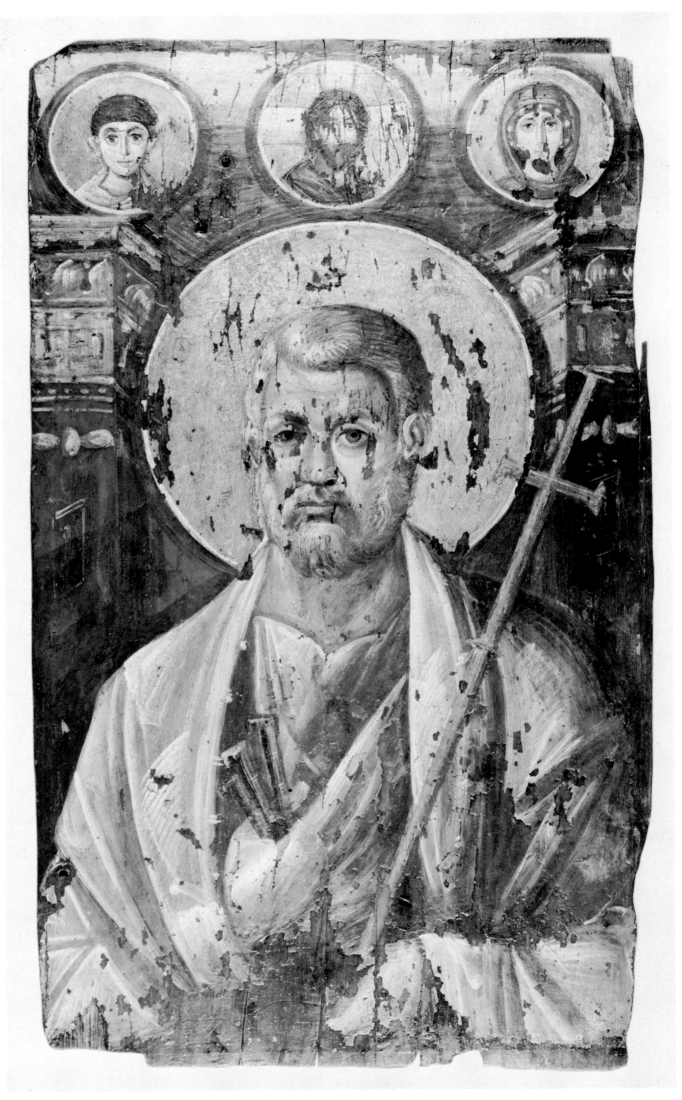

B. 5 St. Peter

PLATE XLIX

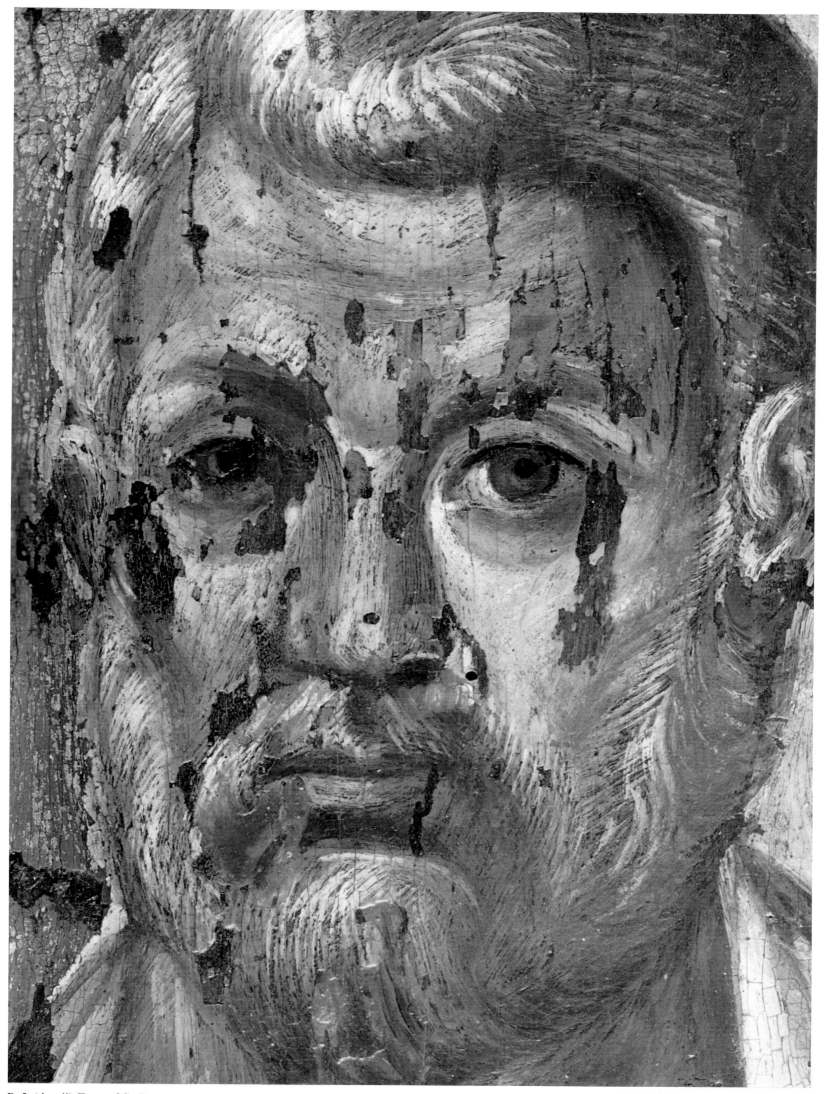

B. 5 (detail) Face of St. Peter

PLATE L

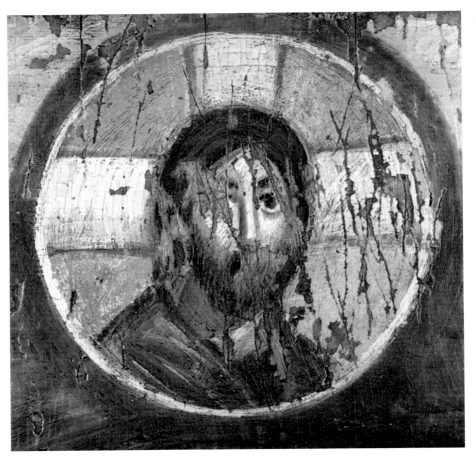

a. Christ

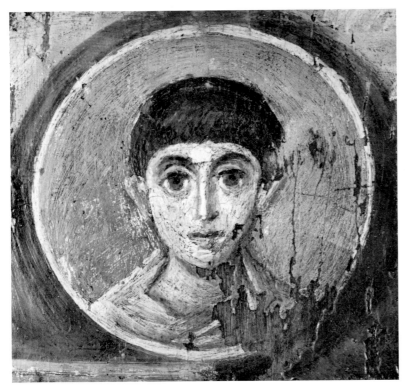

b. St. John the Evangelist (?)

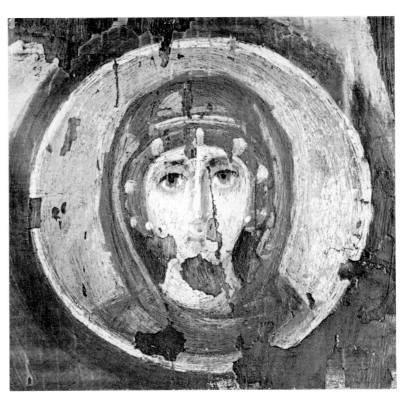

c. Virgin

B.5 (details)

PLATE LI

b. Left hand with cross-staff

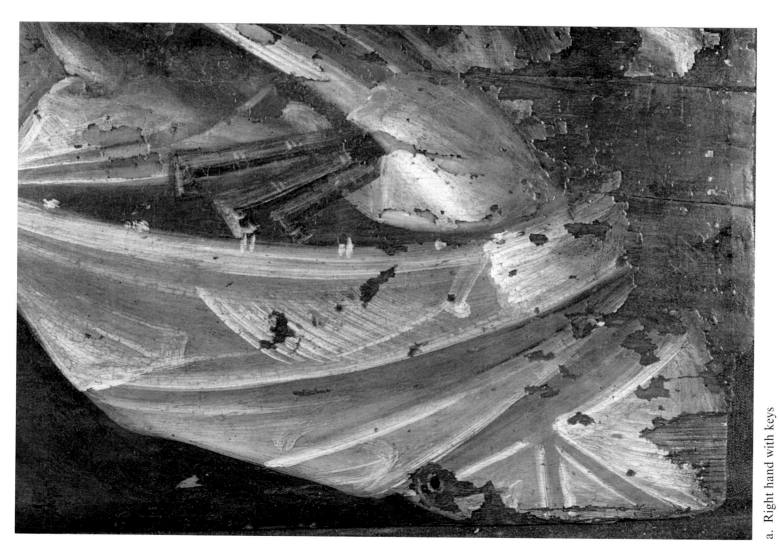

a. Right hand with keys

B. 5 (details)

PLATE LII

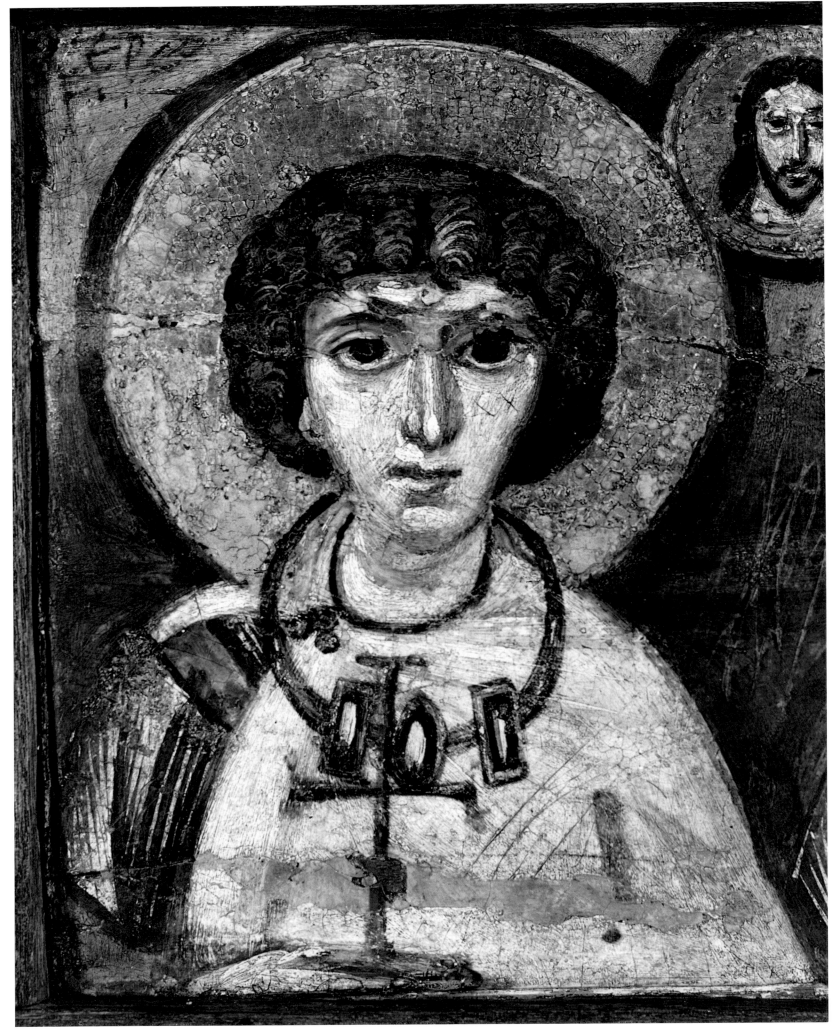

B.9 (Kiev II) (detail) St. Sergius

PLATE LIII

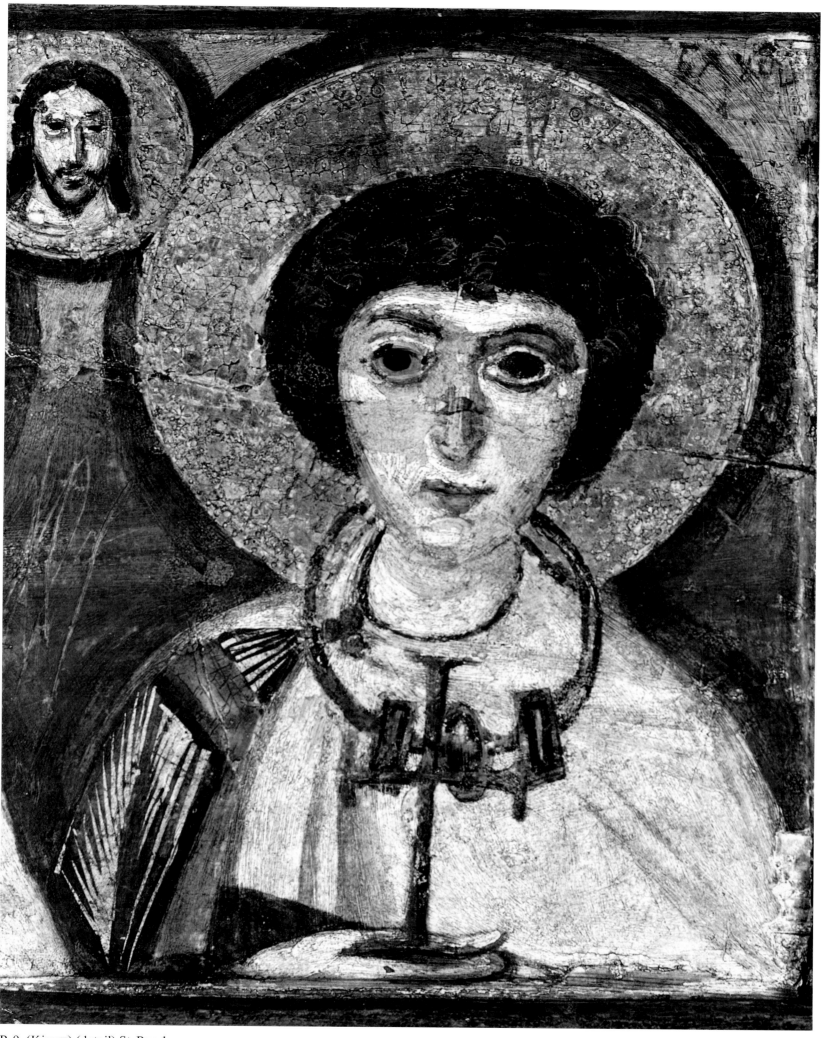

B.9 (Kiev II) (detail) St. Bacchus

PLATE LVI

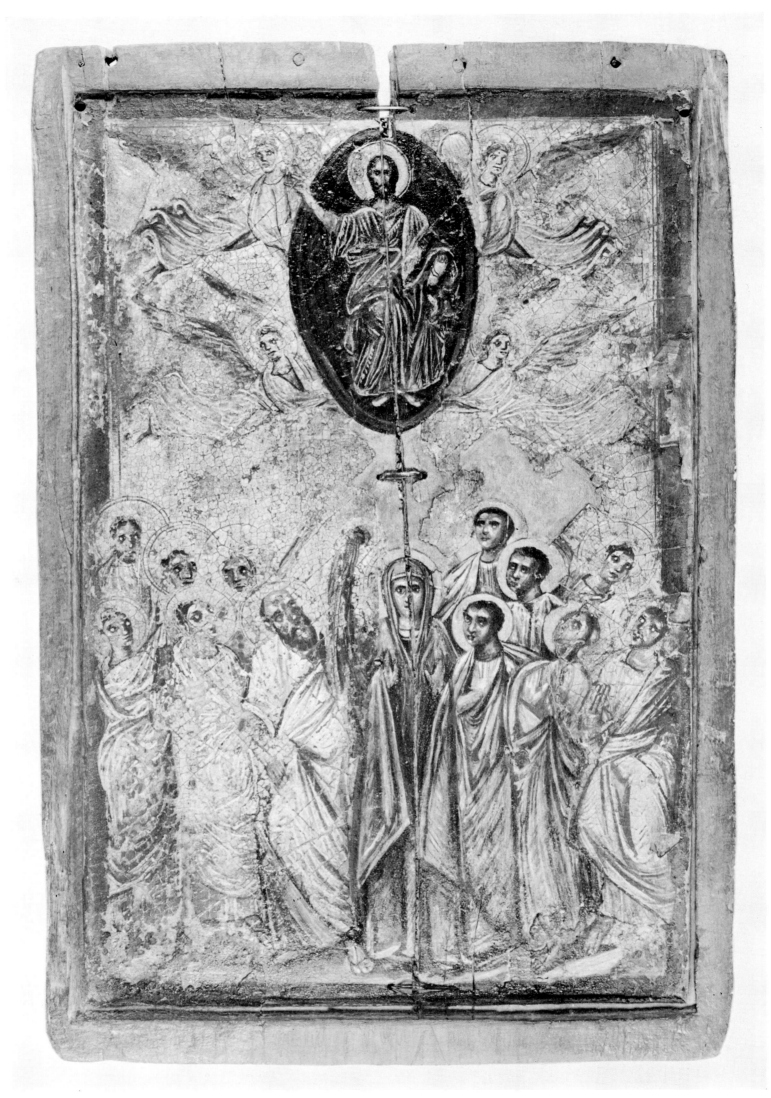

B.10 Ascension of Christ

PLATE LVII

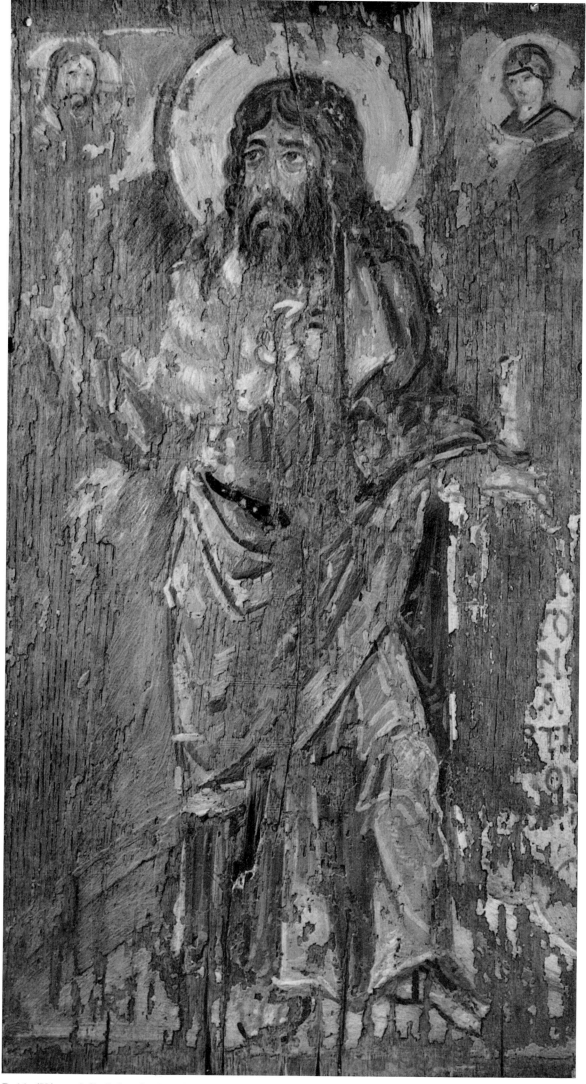

B.11 (Kiev III) St. John the Baptist

PLATE LX

PLATE LXIV

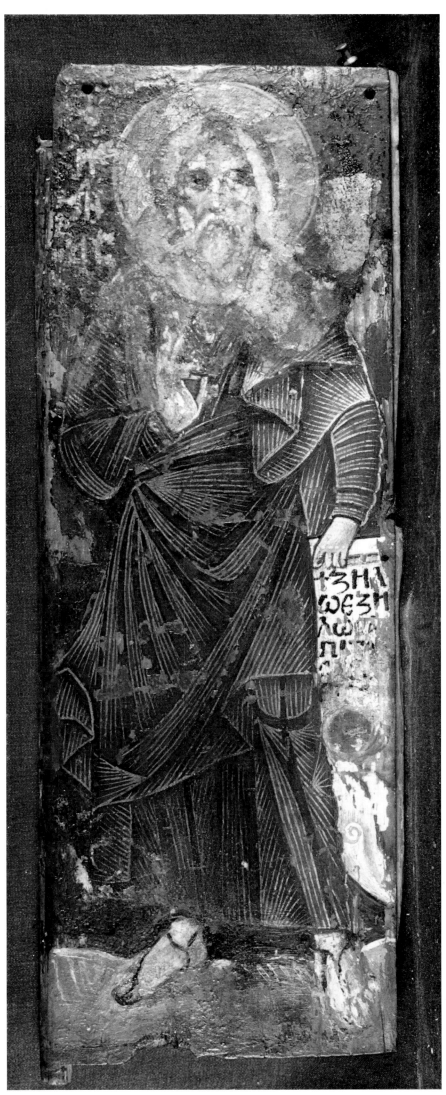

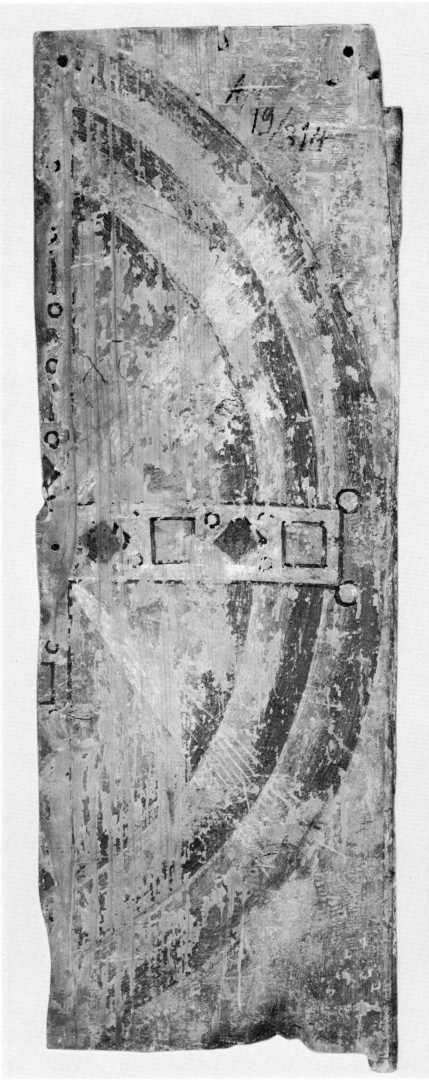

a. (front) Prophet Elijah

b. (back) Cross in mandorla

B.17

PLATE LXV

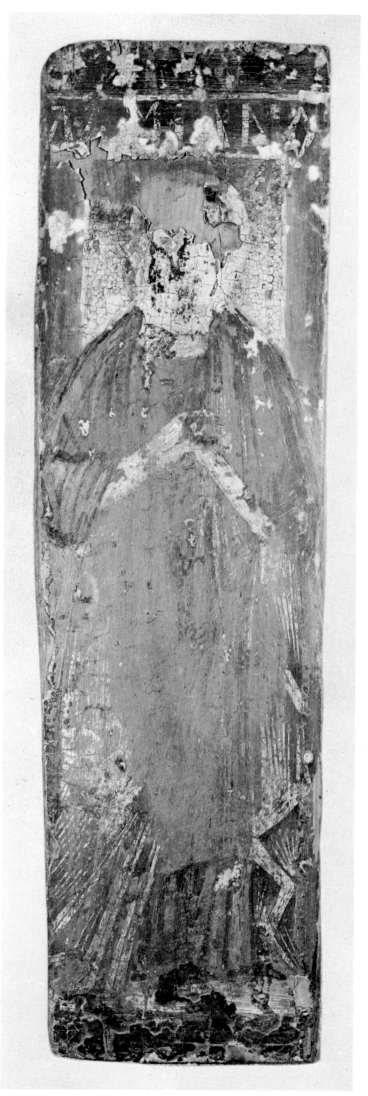

B. 18 St. Damian

PLATE LXVI

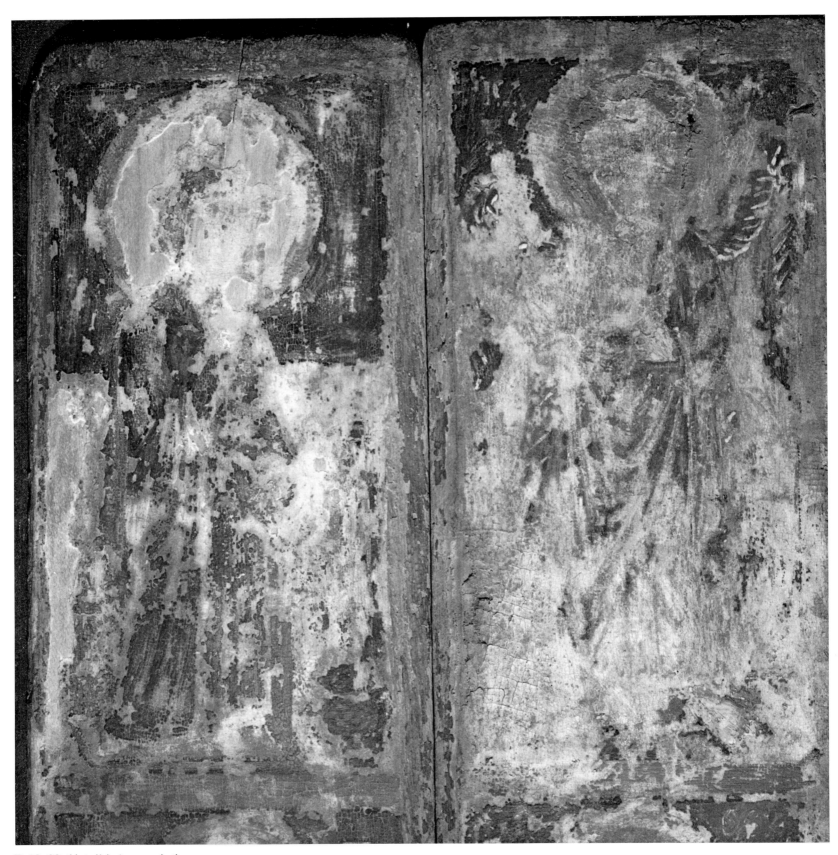

B. 19–20 (details) Annunciation

PLATE LXVII

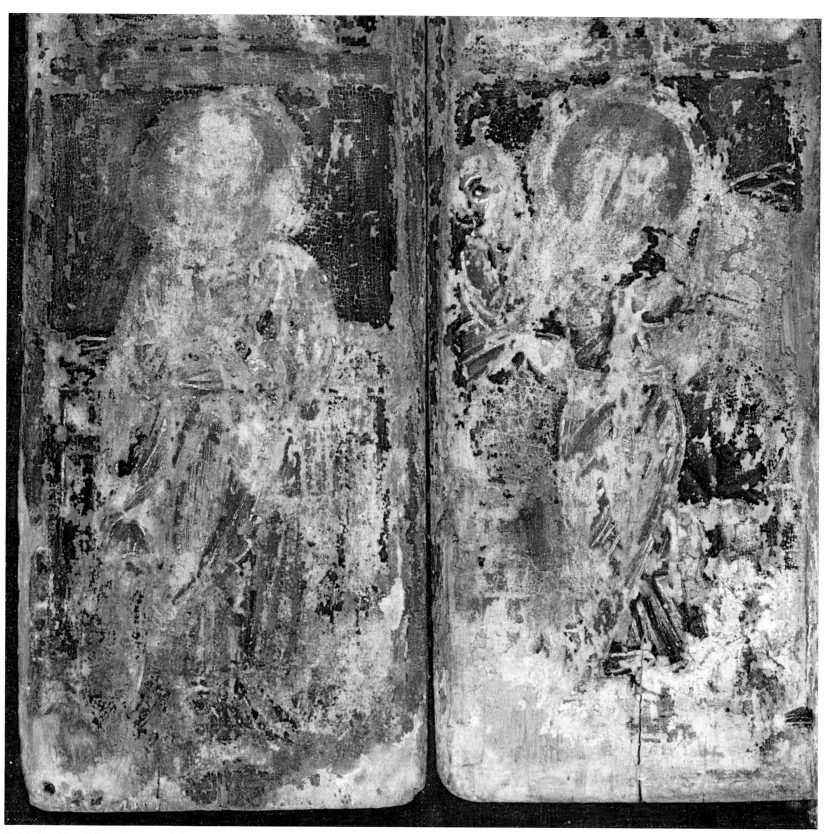

B. 19–20 (details) St. Peter and St. Paul with St. Thecla

PLATE LXVIII

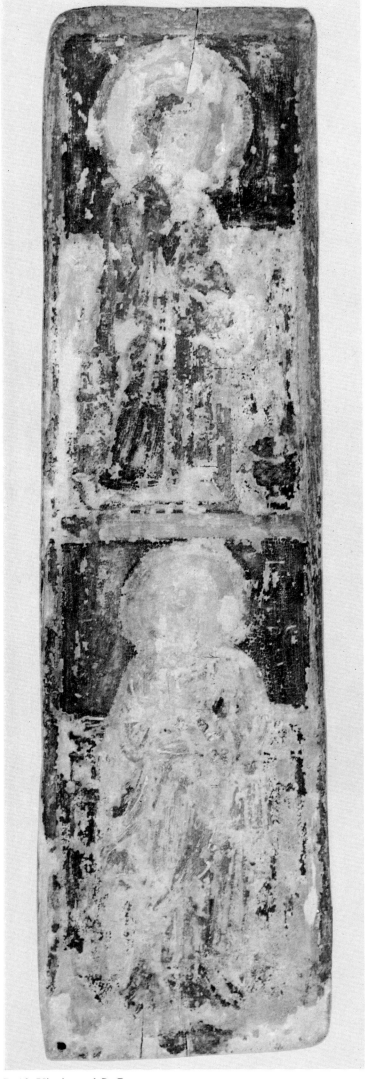

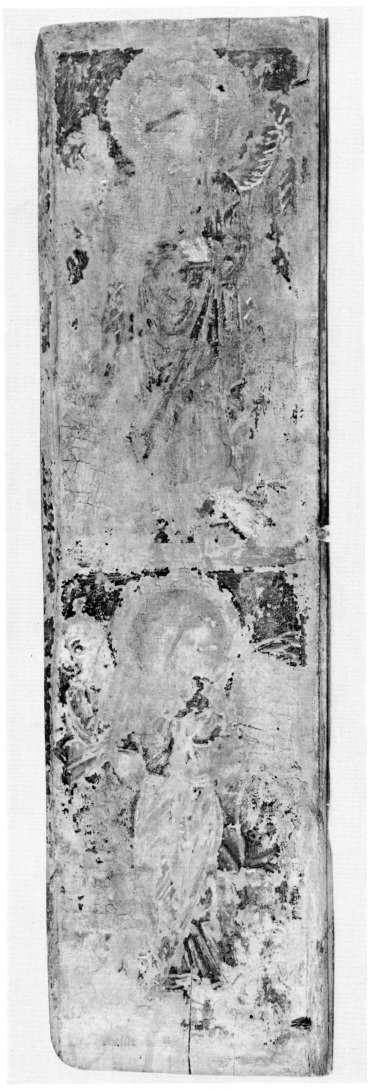

B.19 Virgin and St. Peter

B.20 Gabriel and St. Paul with St. Thecla

PLATE LXIX

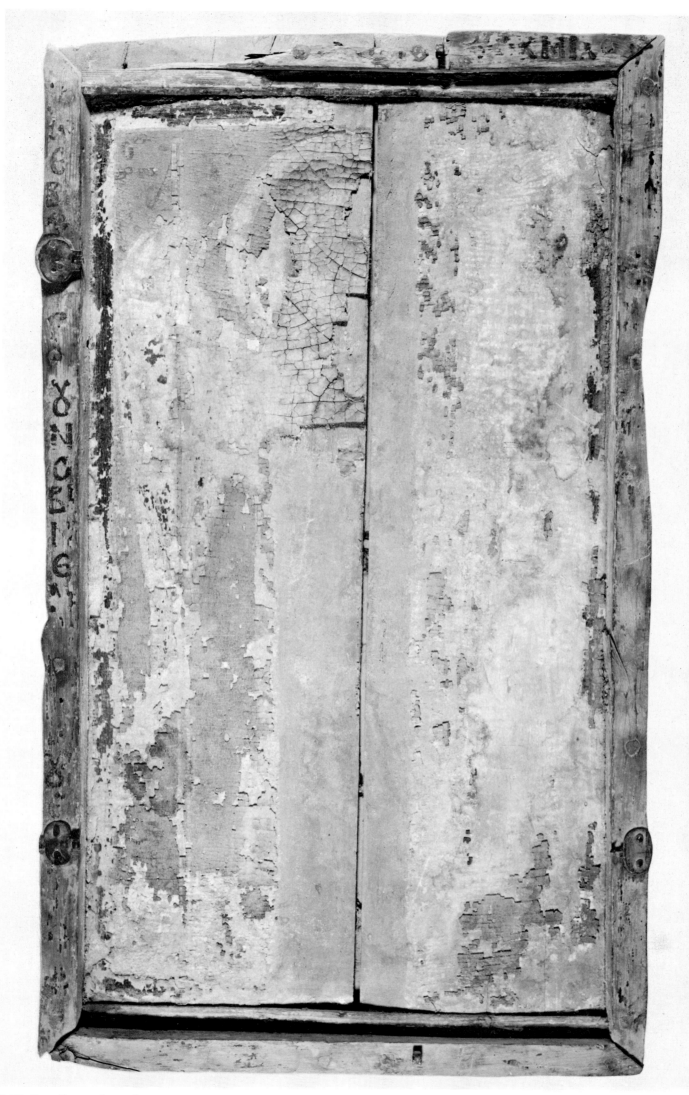

B.21 Standing archangel

PLATE LXX

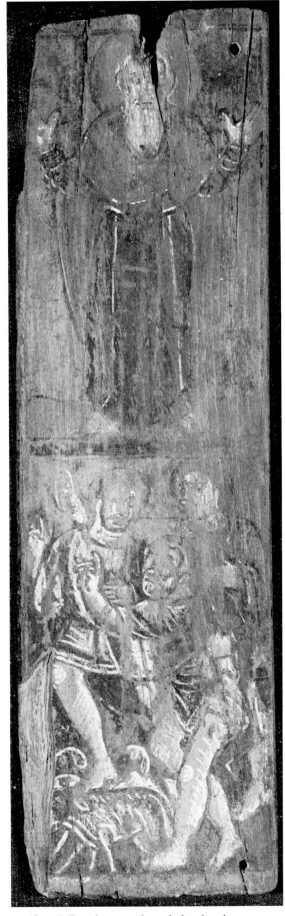

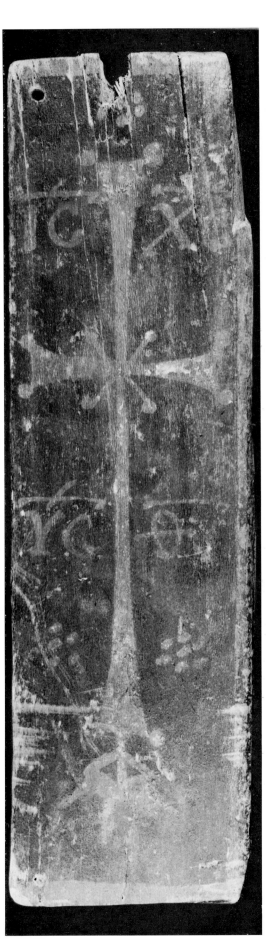

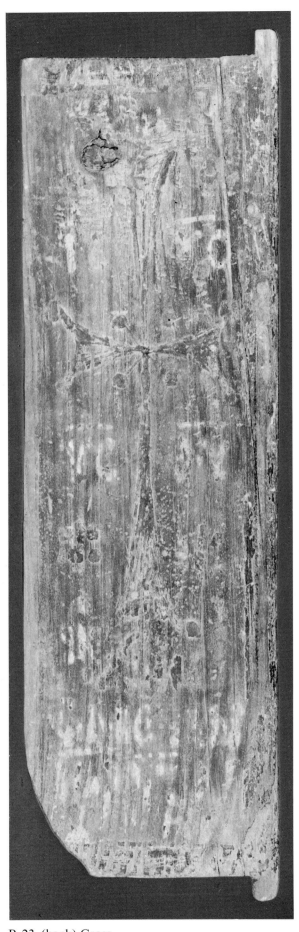

a. (front) Praying monk and shepherds from a Nativity

b. (back) Cross

B. 23 (back) Cross

B. 22

PLATE LXXI

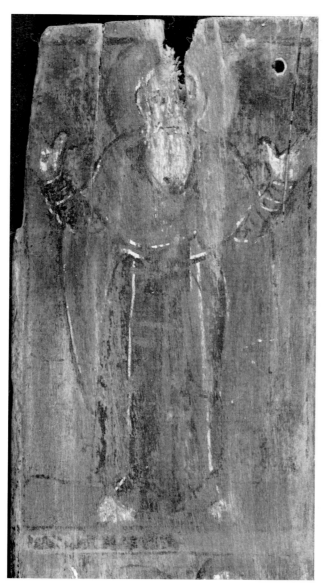

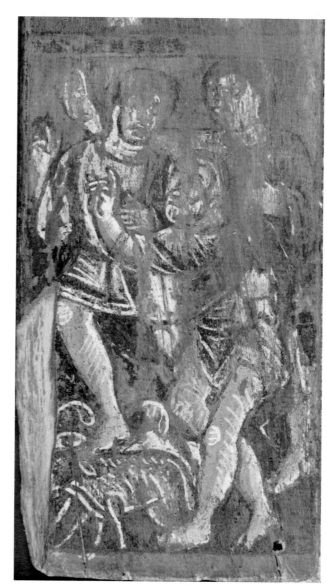

a. Praying monk

b. Shepherds from a Nativity

B. 22 (details)

PLATE LXXII

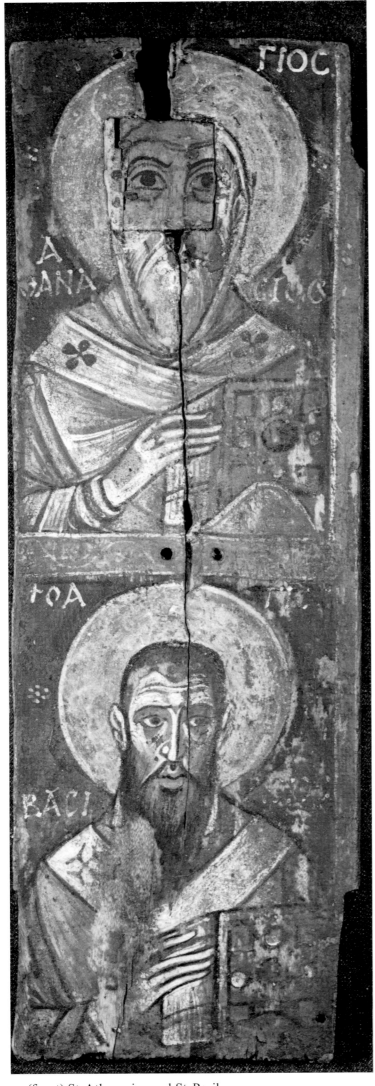

a. (front) St. Athanasius and St. Basil

b. (back) Liturgical prayer

B. 24

PLATE LXXIII

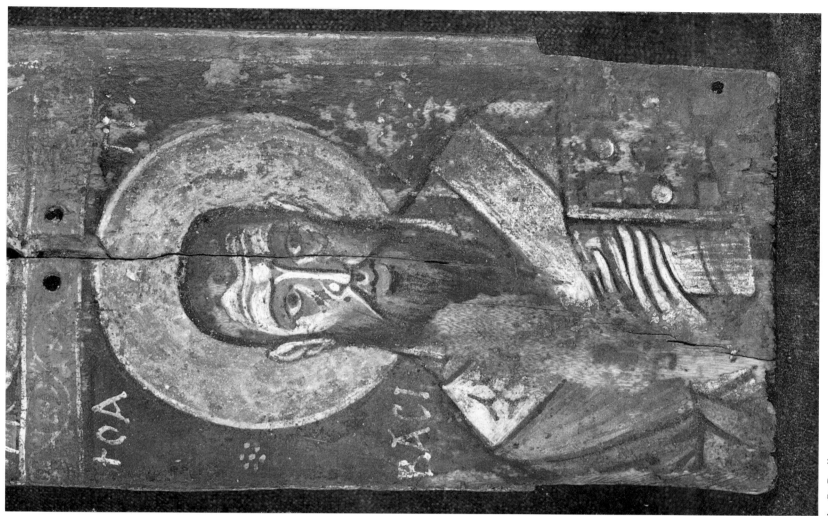

b. St. Basil

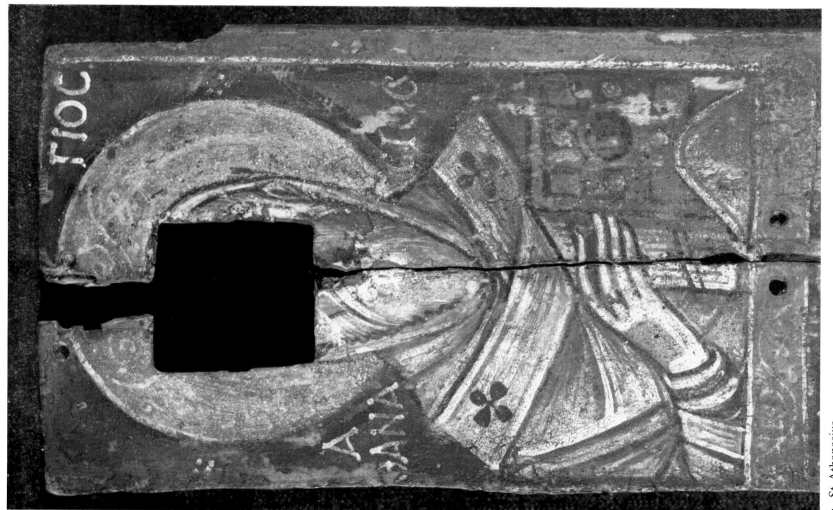

a. St. Athanasius

B. 24 (details)

PLATE LXXIV

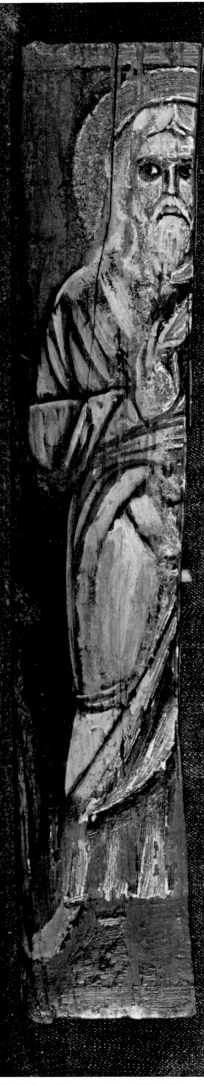

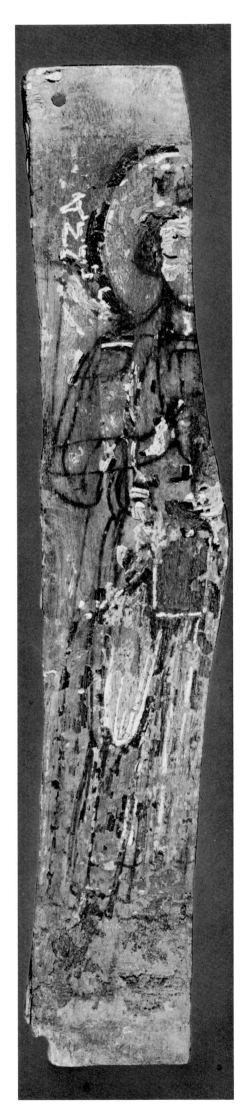

B.25 Standing prophet (Elijah?) B.26 St. John (of uncertain identity)

PLATE LXXV

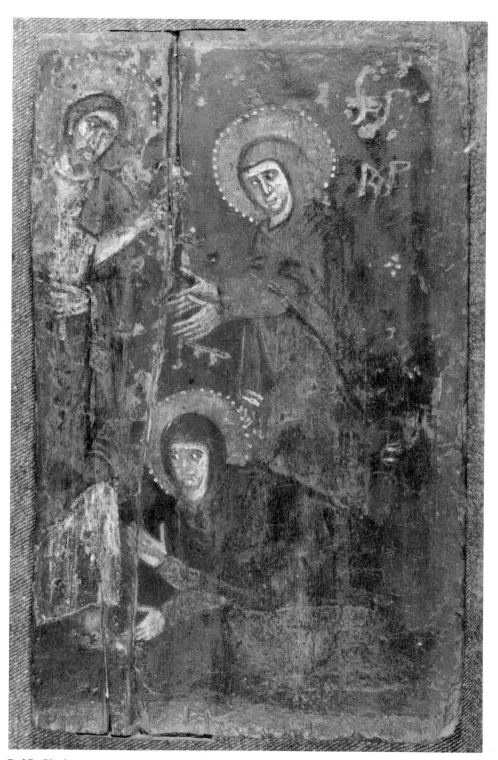

B.27 Chairete

PLATE LXXVI

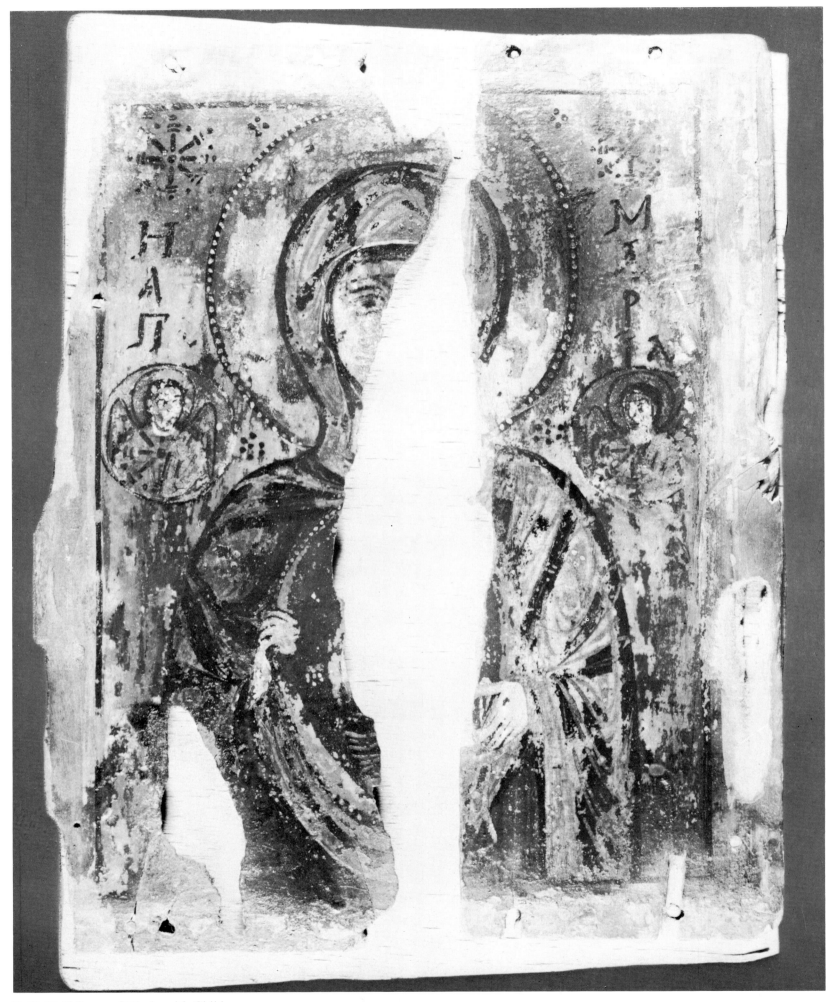

B.28 Half-figure of Virgin with Child

PLATE LXXVII

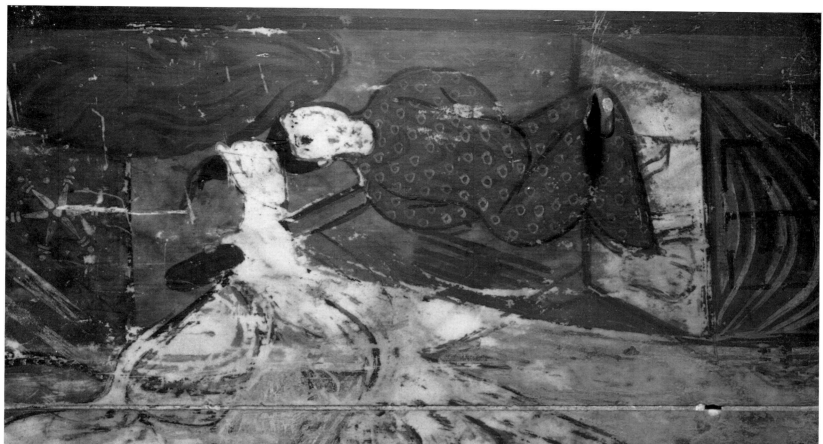

b. Isaac

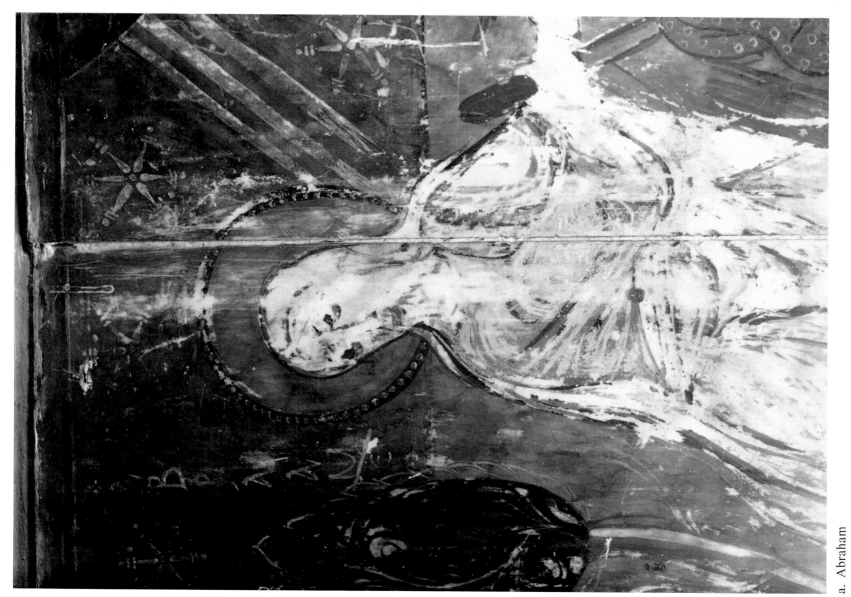

a. Abraham

B. 29 (details)

PLATE LXXVIII

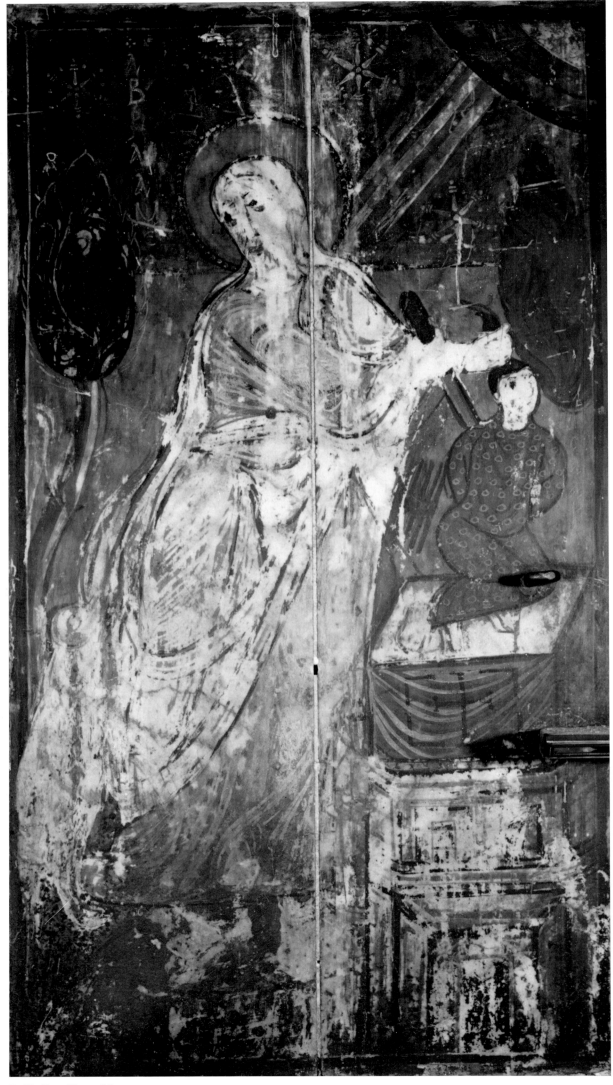

B. 29 Sacrifice of Isaac

PLATE LXXIX

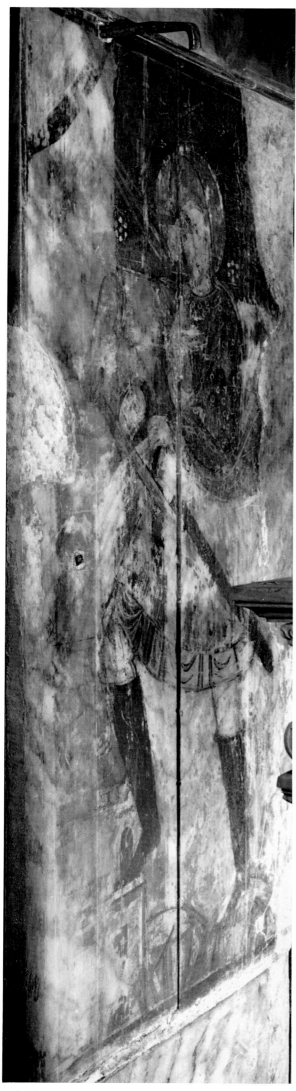

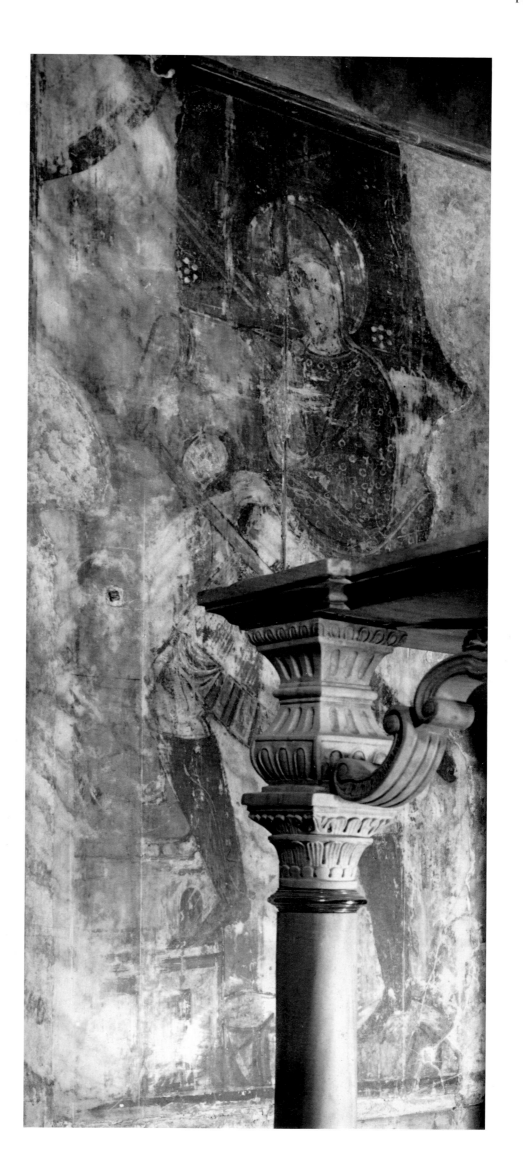

a–b. Sacrifice of Jephthah's Daughter

B. 30

PLATE LXXX

d. Jephthah

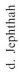

c. Jephthah

B. 30 (details)

PLATE LXXXI

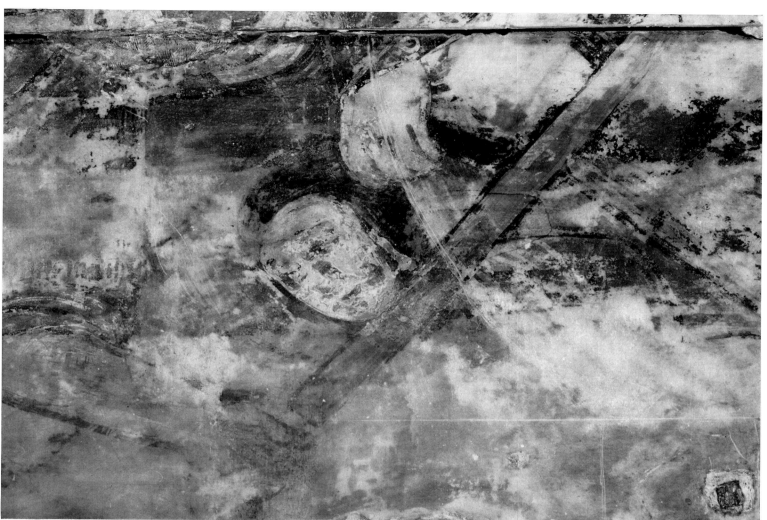

f. Jephthah's Daughter

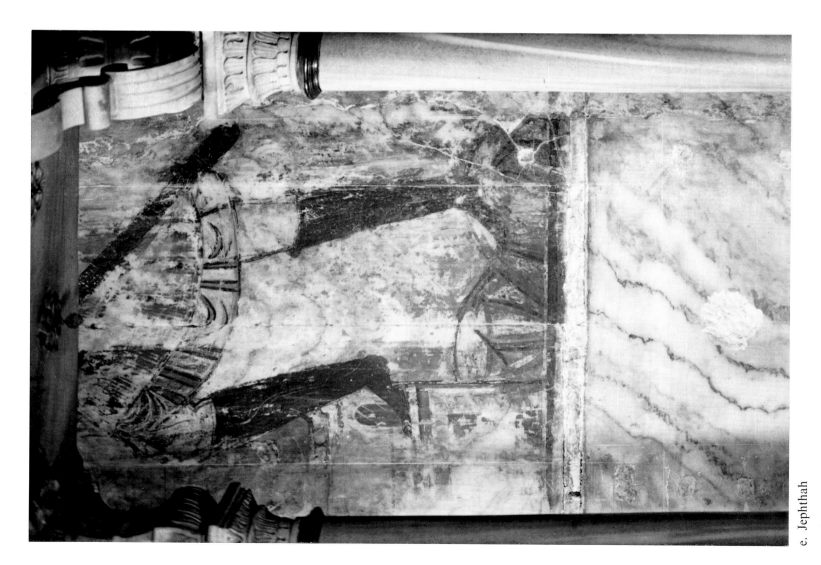

e. Jephthah

B. 30 (details)

PLATE LXXXII

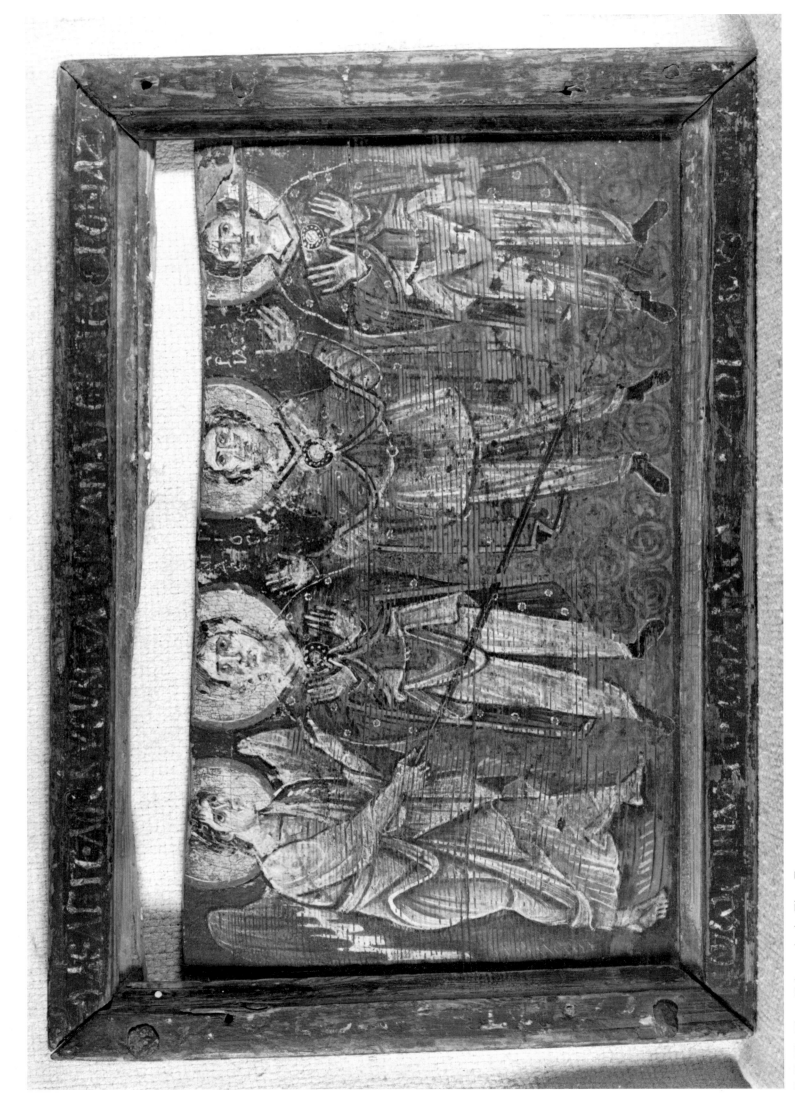

B.31 The Three Hebrews in the Fiery Furnace

PLATE LXXXIII

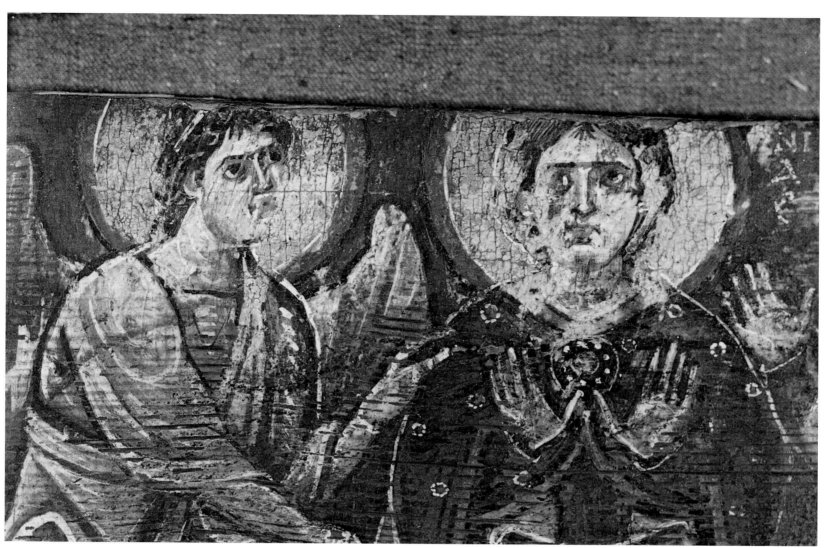

a. Angel and Ananias

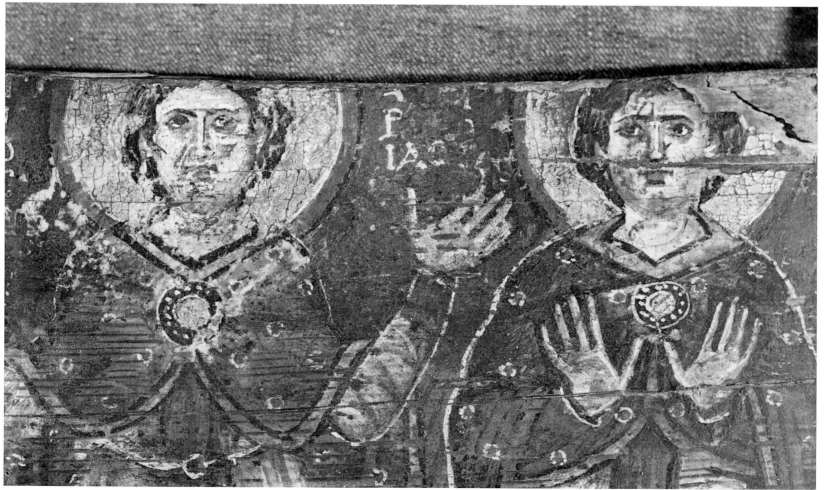

b. Azarias and Misael

B. 31 (details)

PLATE LXXXIV

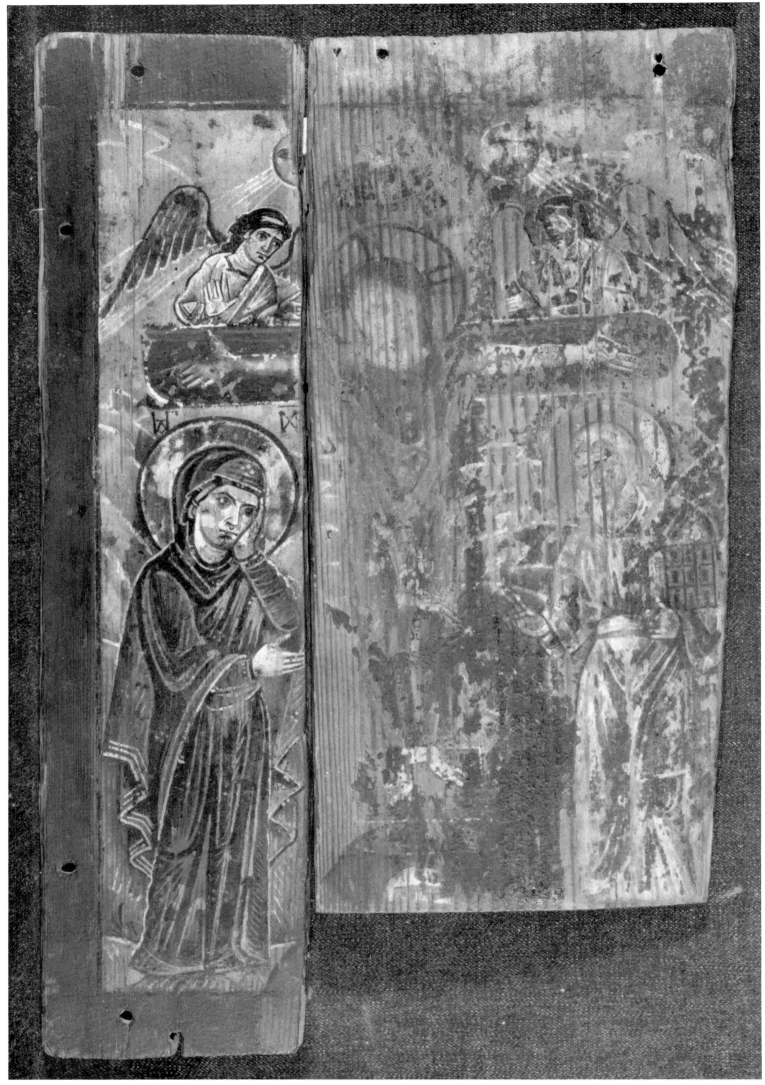

B.32 Crucifixion

PLATE LXXXV

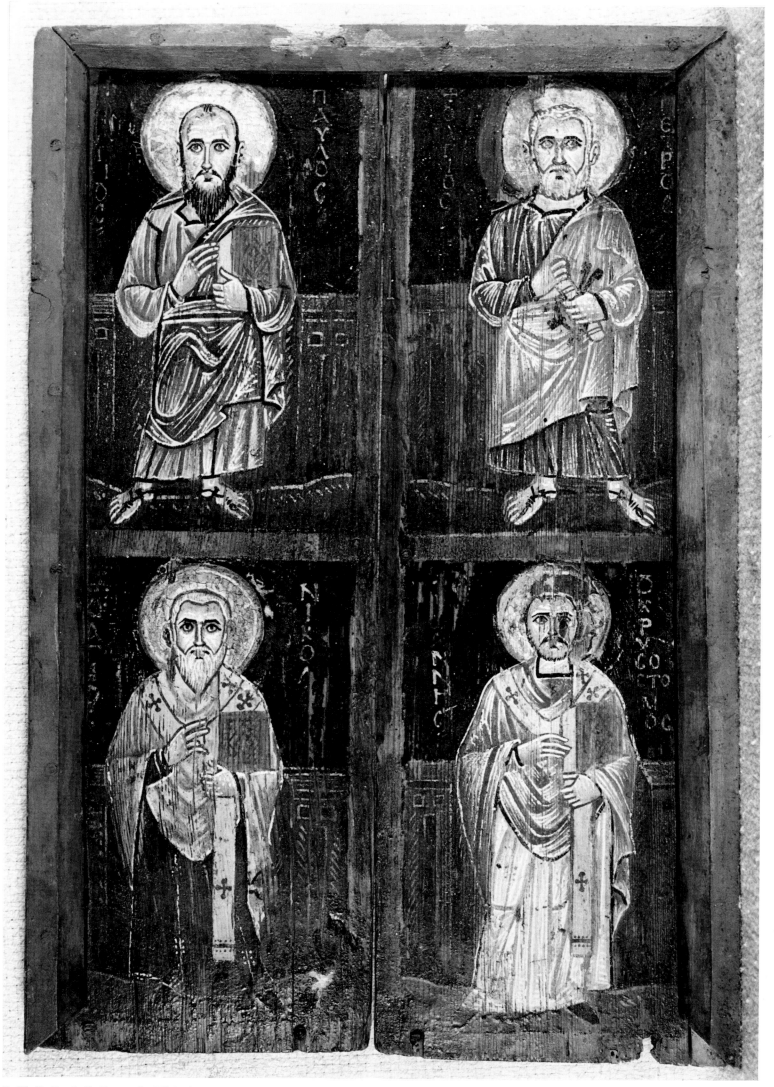

B.33 St. Paul, St. Peter, St. Nicholas and St. John Chrysostom

PLATE LXXXVIII

B. 34 St. John the Evangelist

b. (back) Cross

a. (front) Virgin

B. 35

PLATE LXXXIX

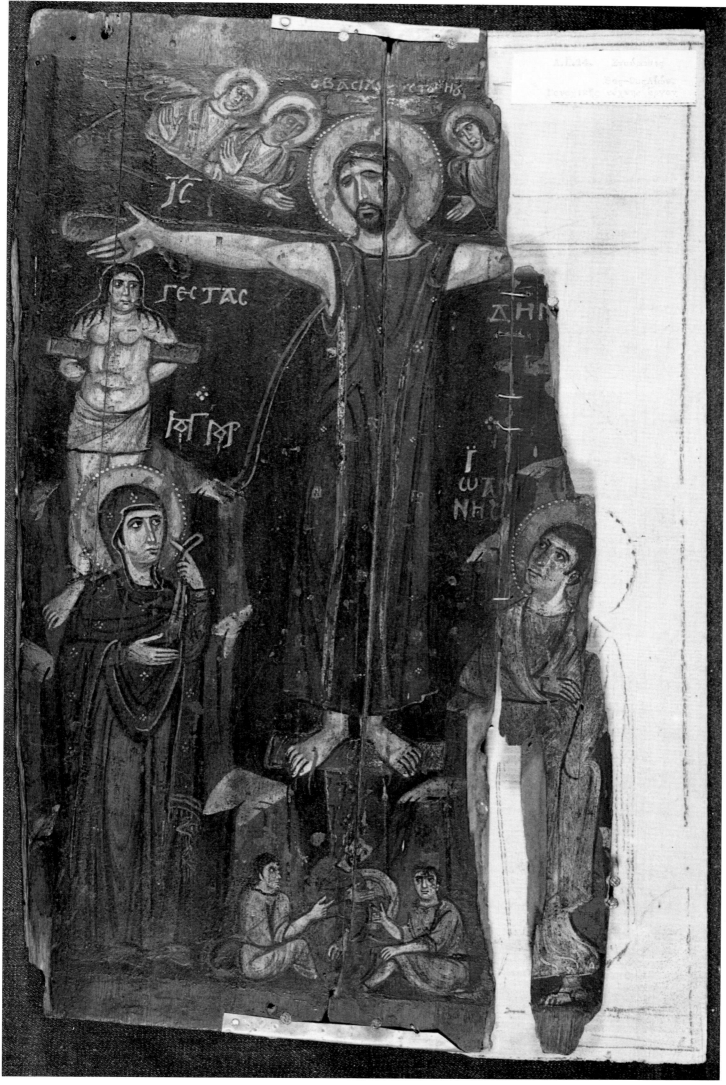

B.36 Crucifixion

PLATE XC

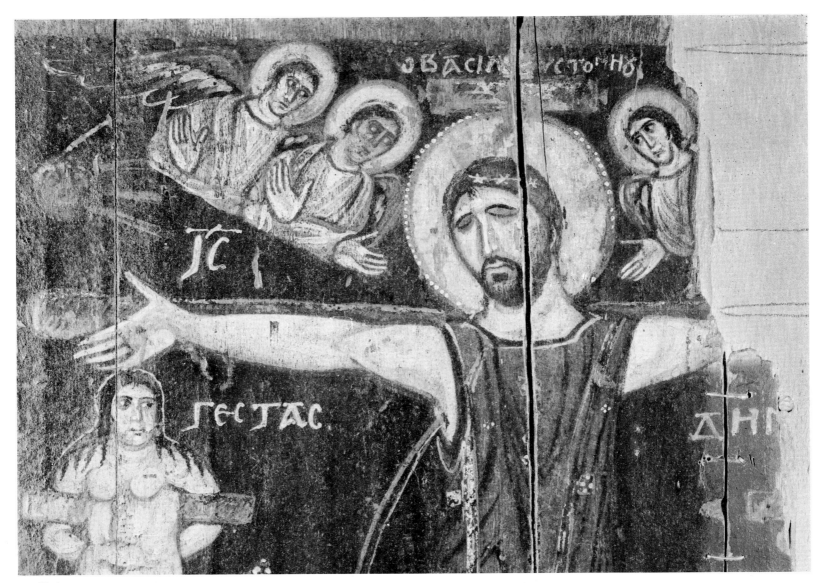

a. Christ

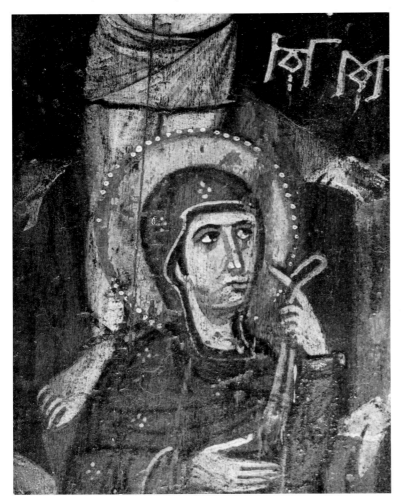

b. Virgin

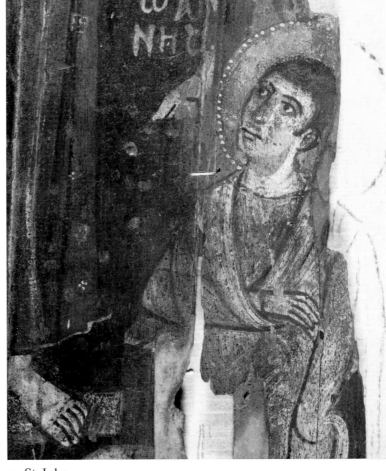

c. St. John

B. 36 (details)

PLATE XCI

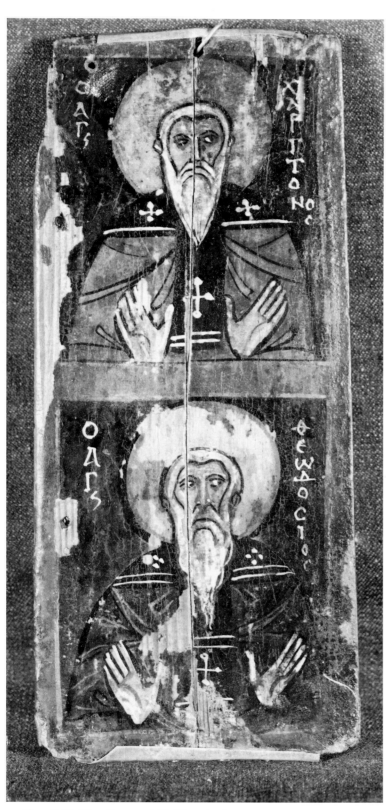

a. (front) St. Chariton and St. Theodosios

b. (back) Half of a Cross

B. 37

PLATE XCII

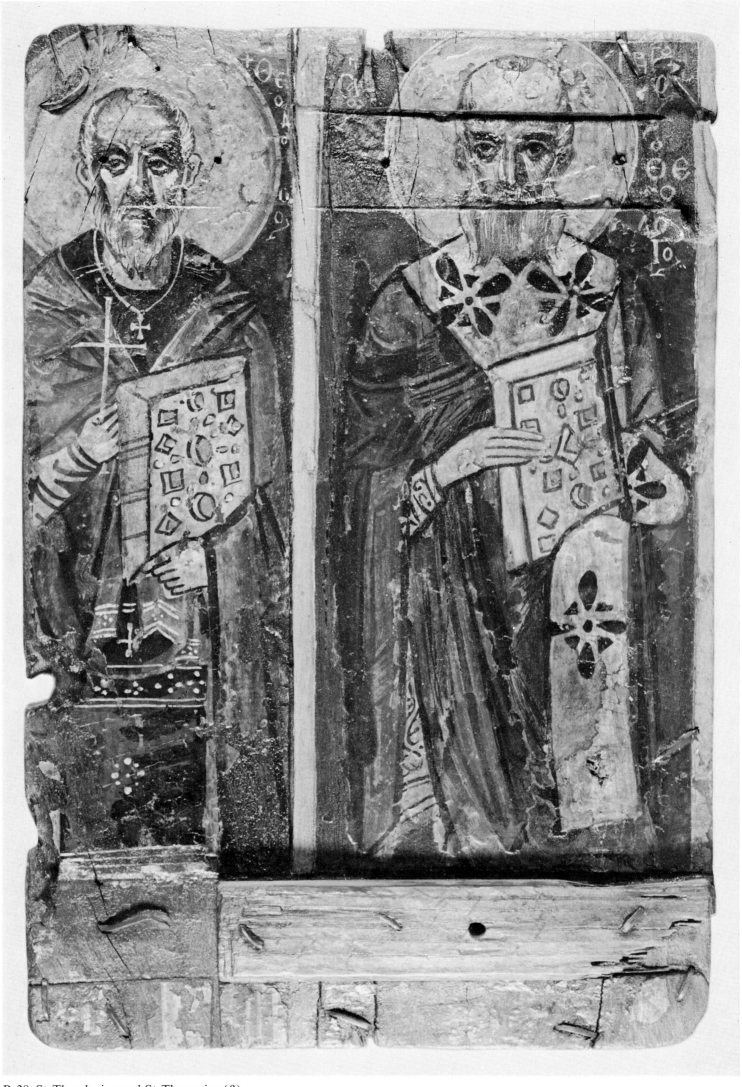

B.38 St. Theodosios and St. Theognios (?)

PLATE XCIII

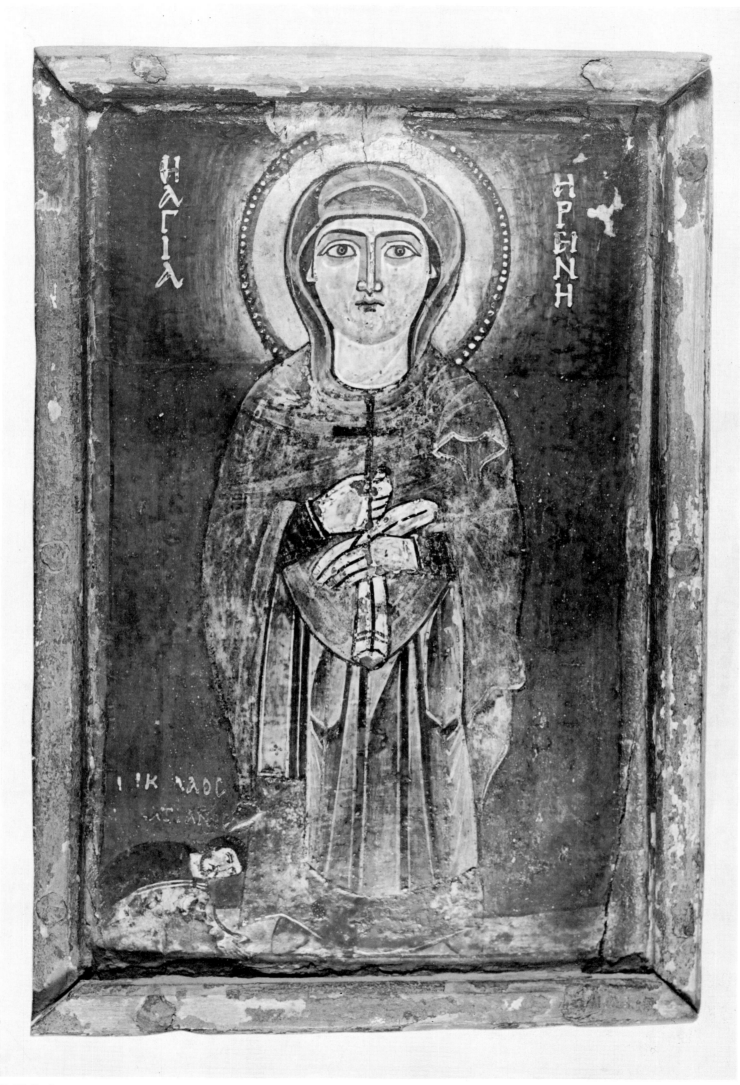

B. 39 St. Irene

PLATE XCIV

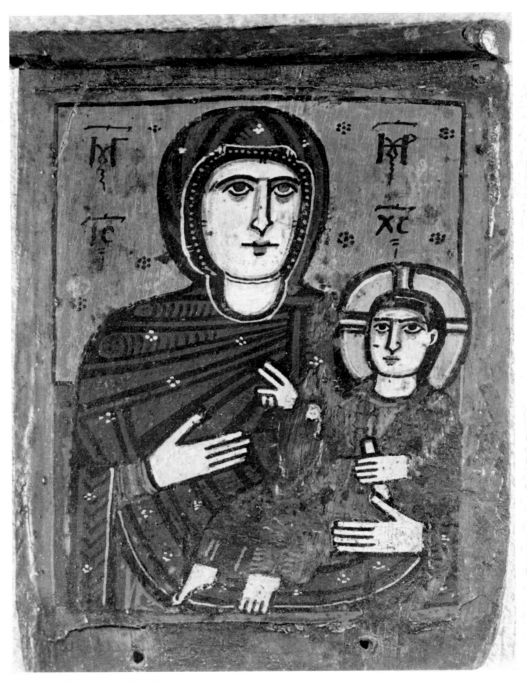

B.40 Half-figure of the Hodegetria

PLATE XCV

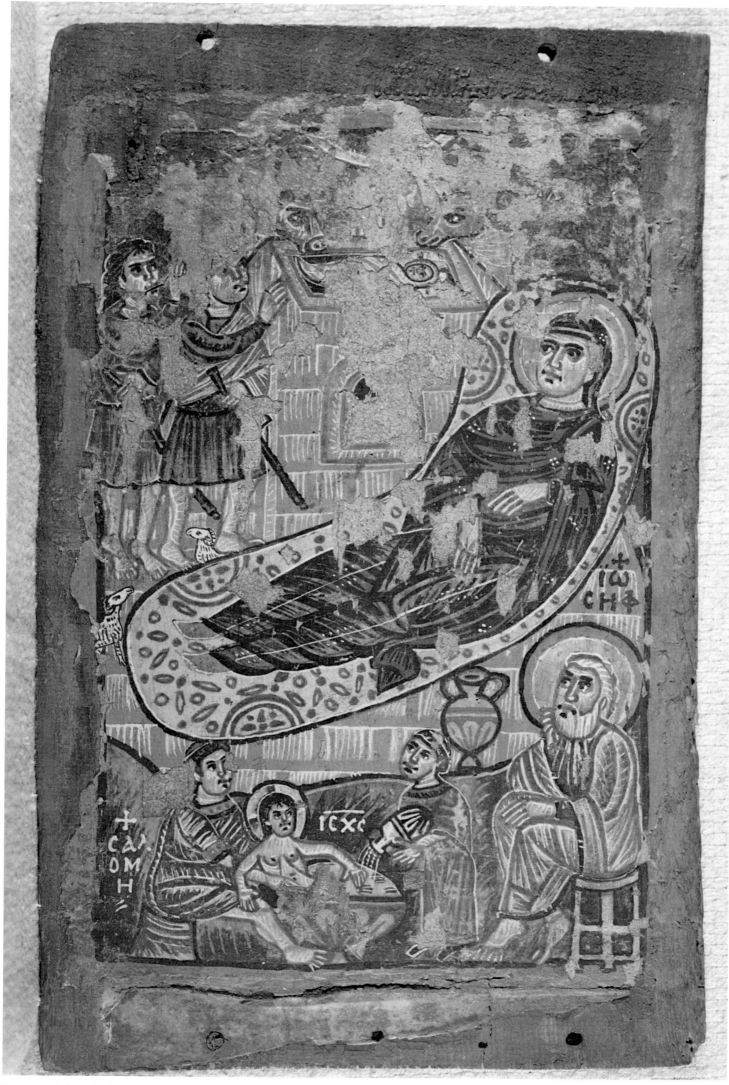

B.41 Nativity of Christ

PLATE XCVI

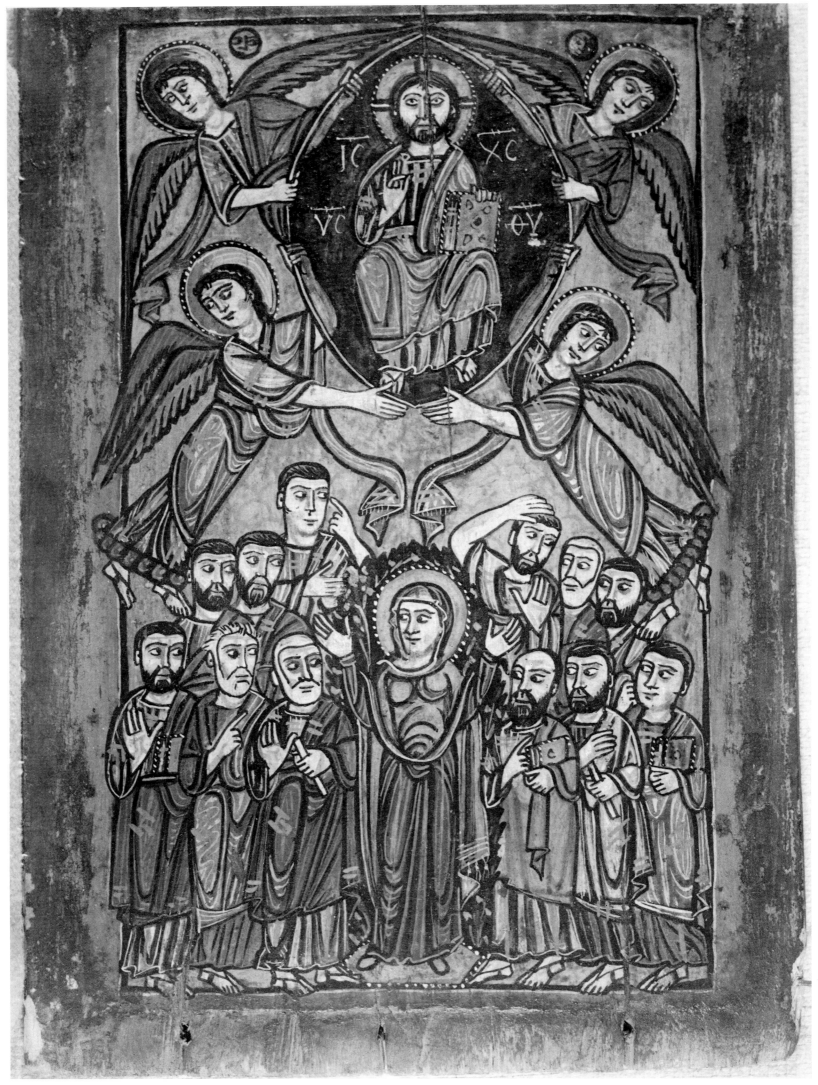

B.42 Ascension of Christ

PLATE XCVII

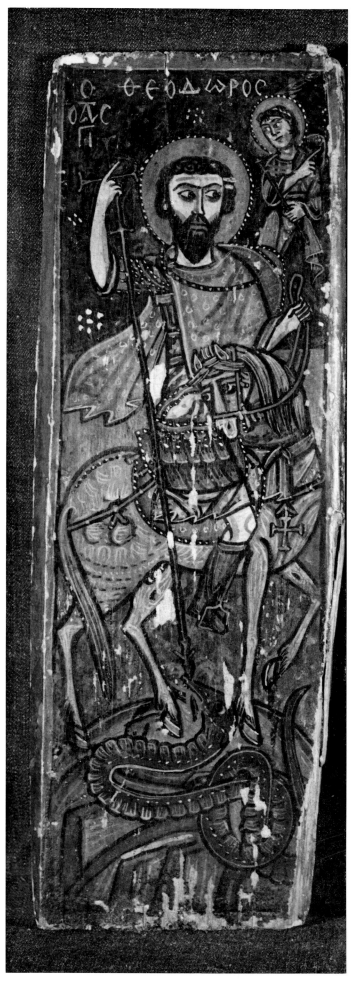

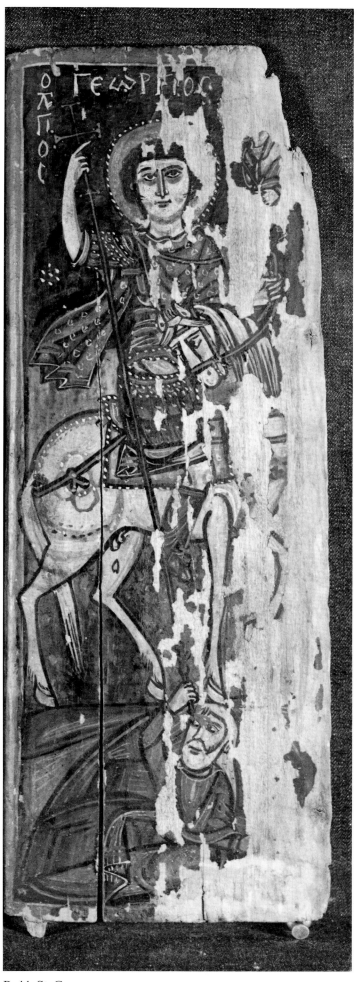

B.43 St. Theodore B.44 St. George

PLATE XCVIII

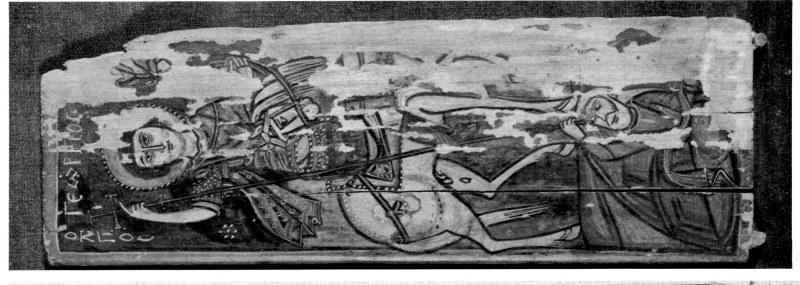

B. 44

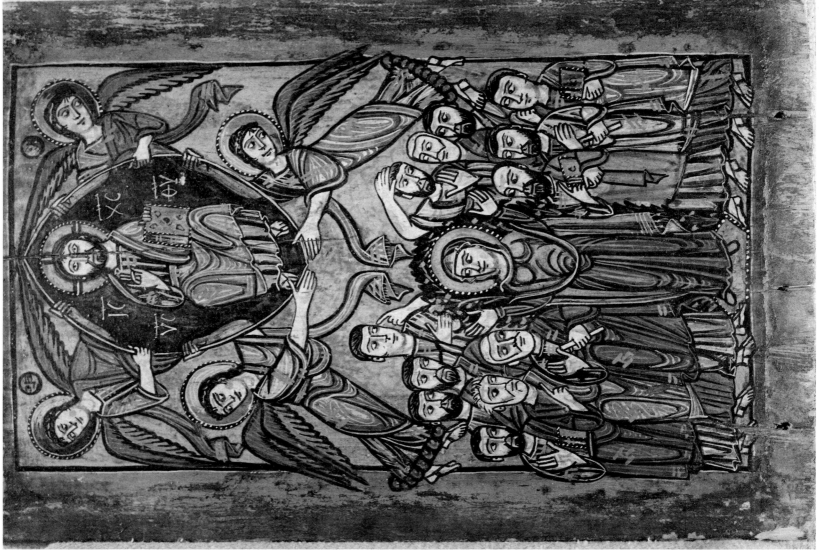

B. 42

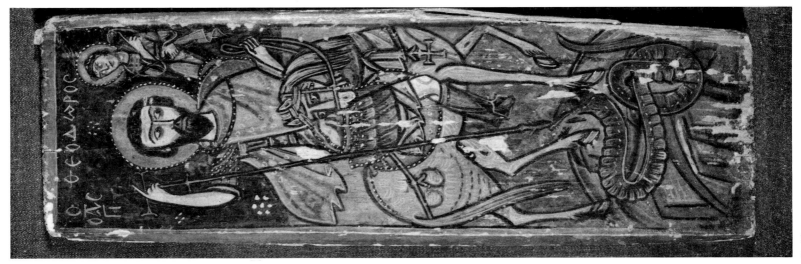

B. 43

B.42-44. Triptych with Ascension, St. Theodore and St. George

PLATE XCIX

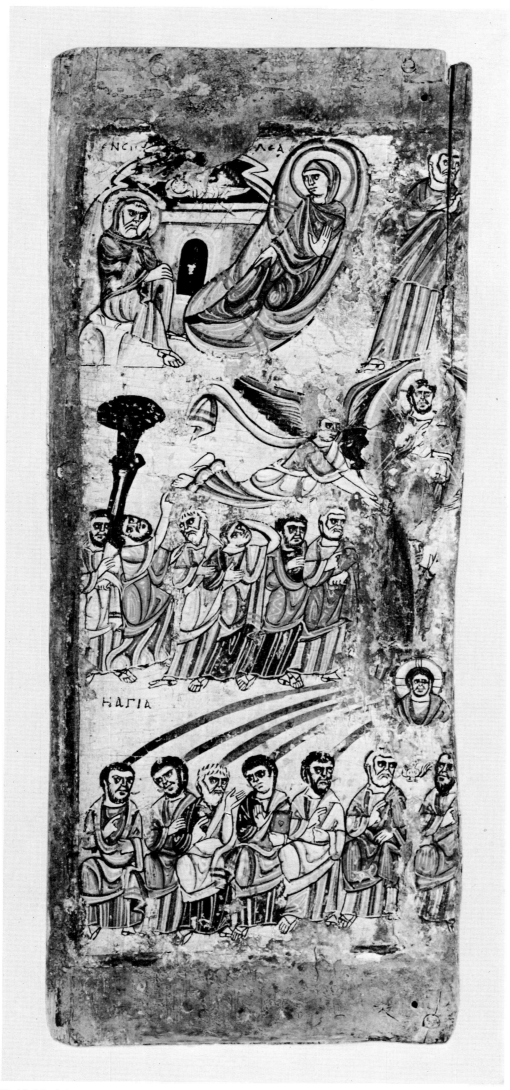

B.45 Nativity, Presentation, Ascension, Pentecost

PLATE C

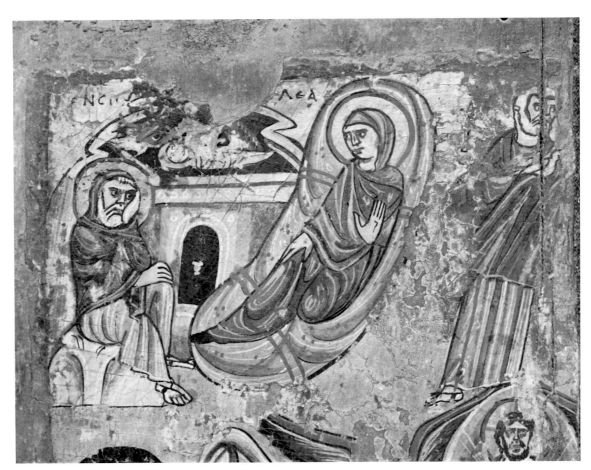

a. Nativity and Presentation

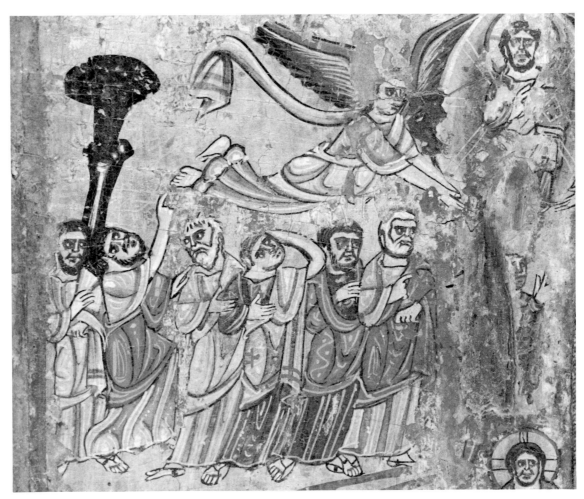

b. Ascension

B.45 (details)

PLATE CI

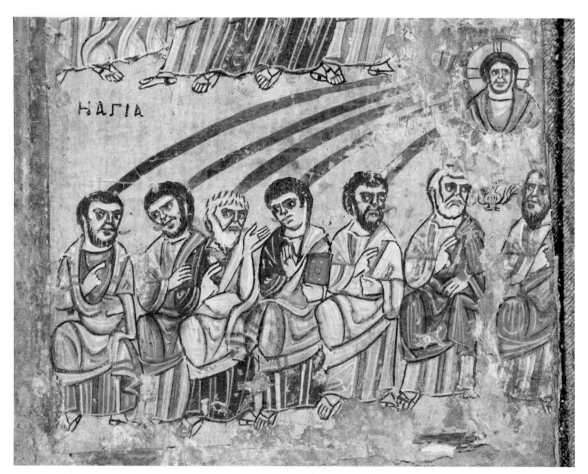

B.45 c. (detail) Pentecost

PLATE CII

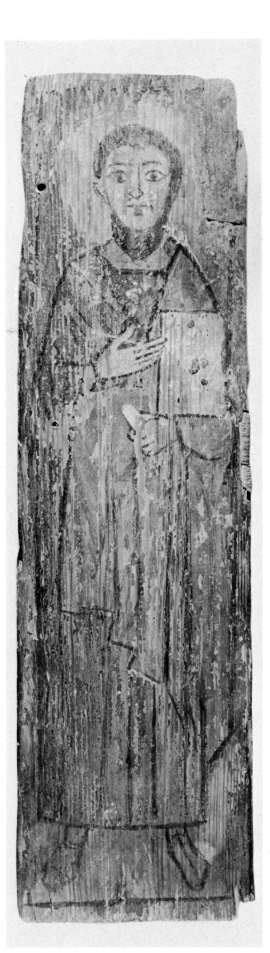

B.46 Christ enthroned
(fragment)

B.47 a. (front) St. Cosmas

B.47 b. (back) Three Crosses

PLATE CIII

b. (back) Diaper pattern

a. (front) Virgin enthroned with Child

B.48

PLATE CIV

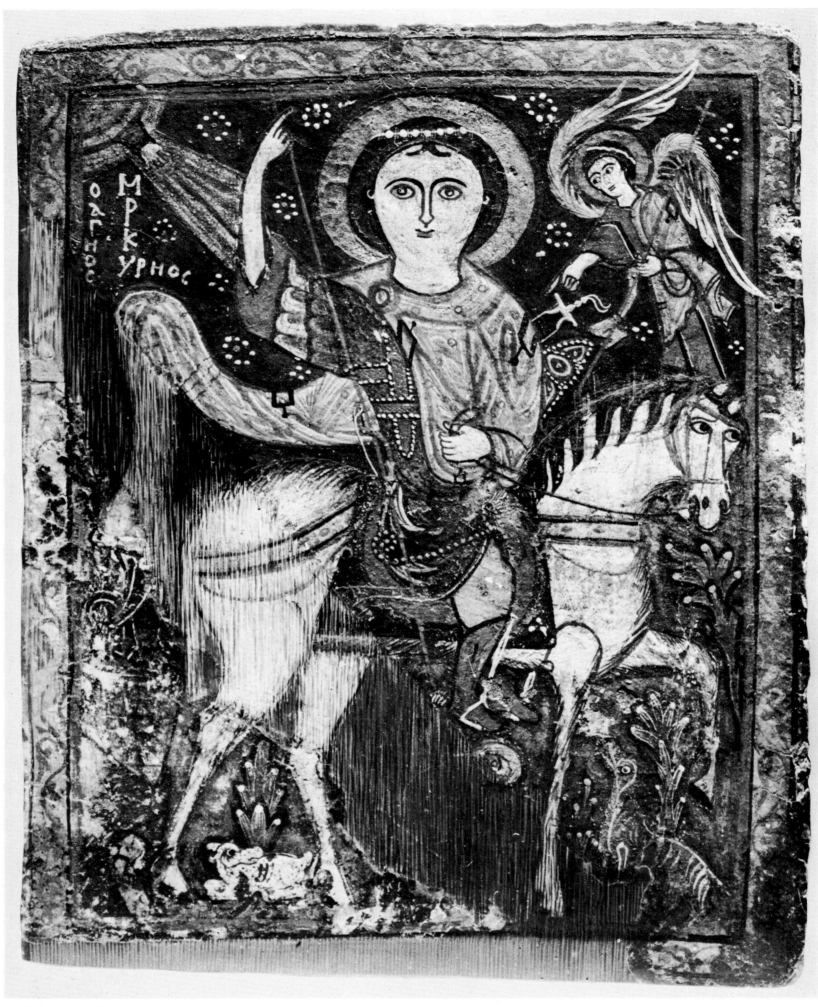

B.49 St. Mercurius

PLATE CV

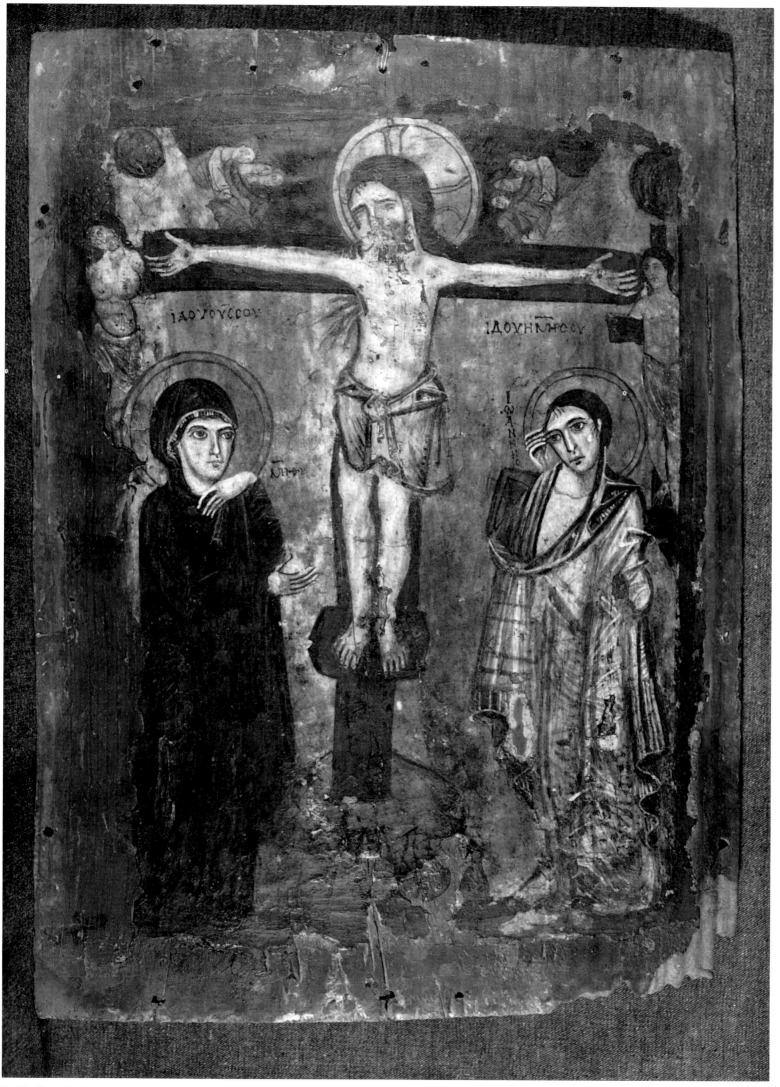

B. 50 Crucifixion

PLATE CVIII

b. (back) Cross

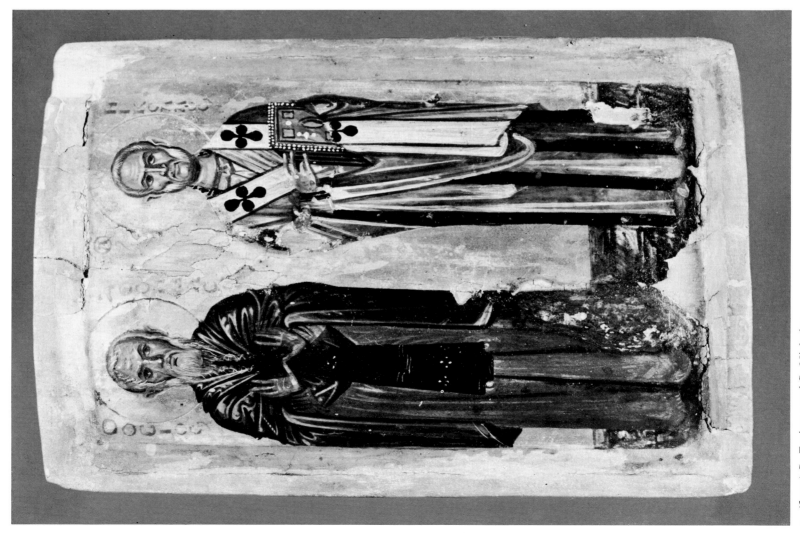

a. (front) St. Zosimas and St. Nicholas

B.52

PLATE CIX

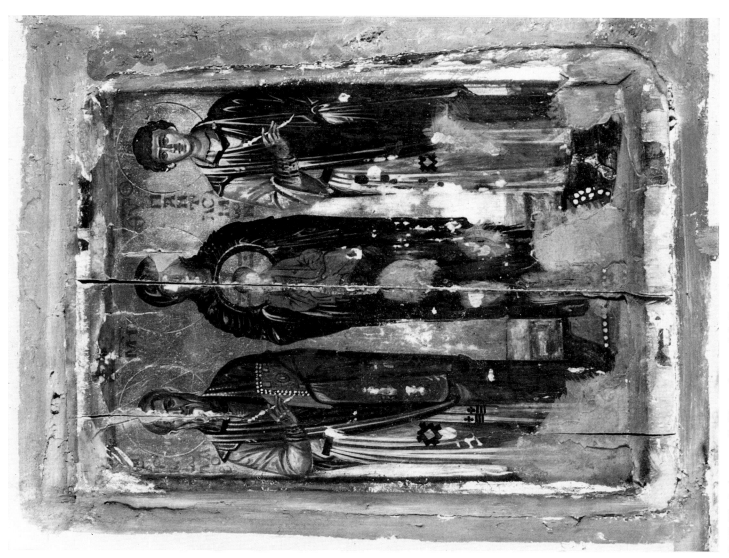

B. 54 Virgin between St. Hermolaos and St. Panteleimon

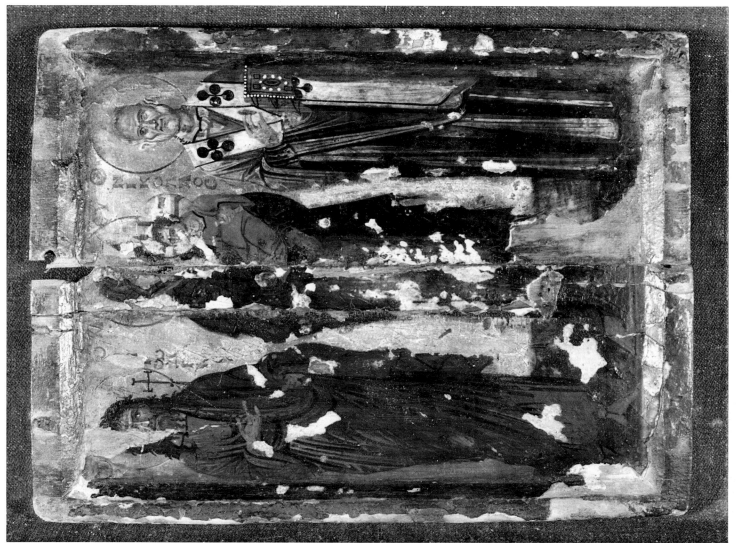

B. 53 Virgin between John the Baptist and St. Nicholas

PLATE CX

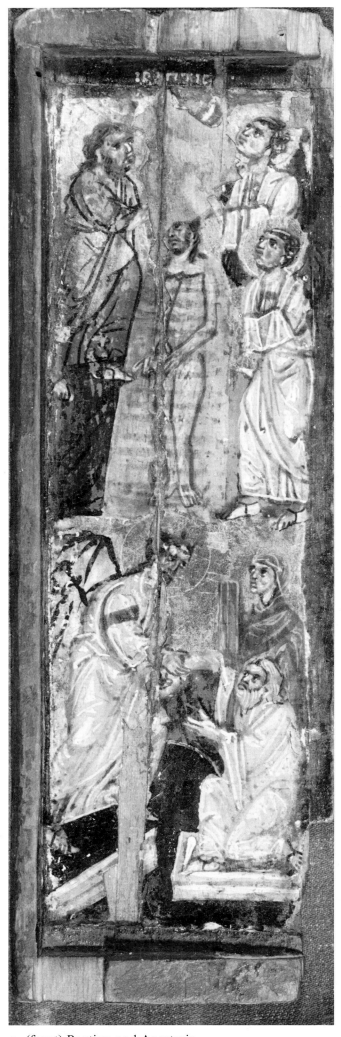

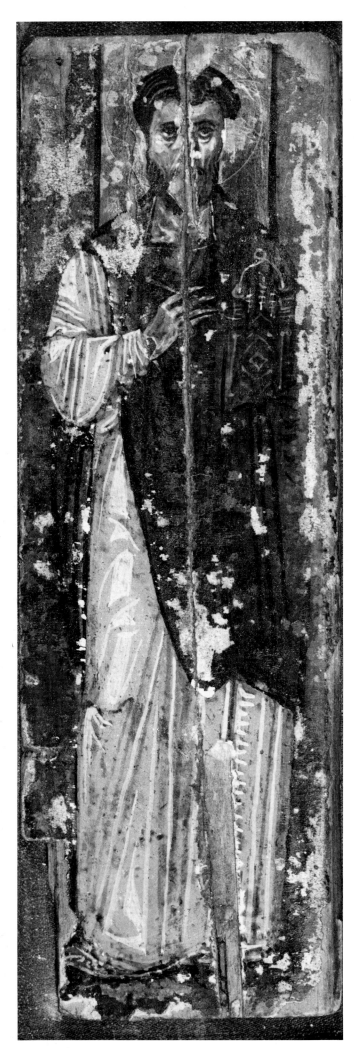

a. (front) Baptism and Anastasis

b. (back) St. Damian (?)

B.55

PLATE CXI

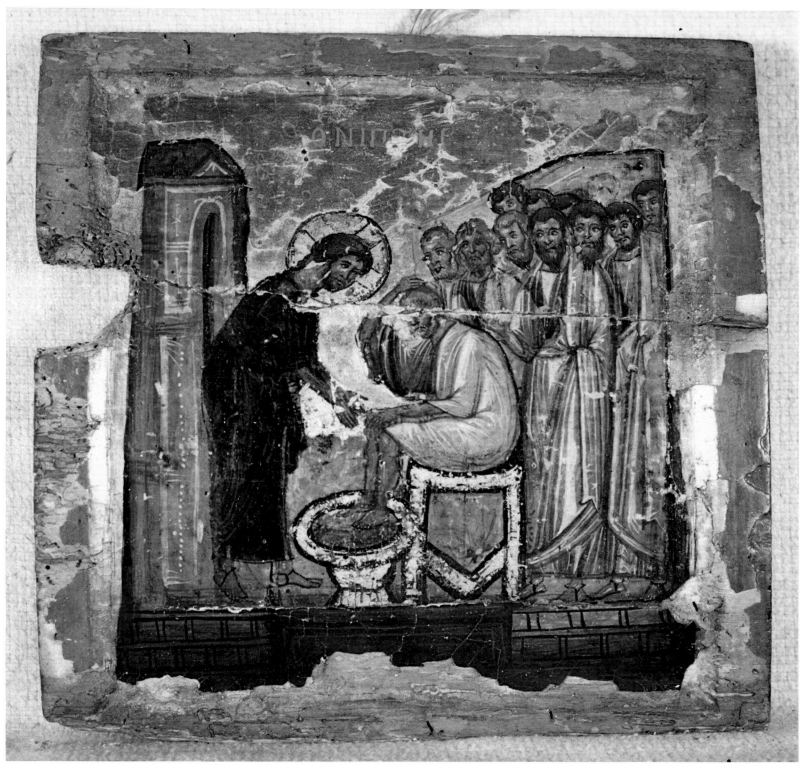

B.56 Washing of the Feet

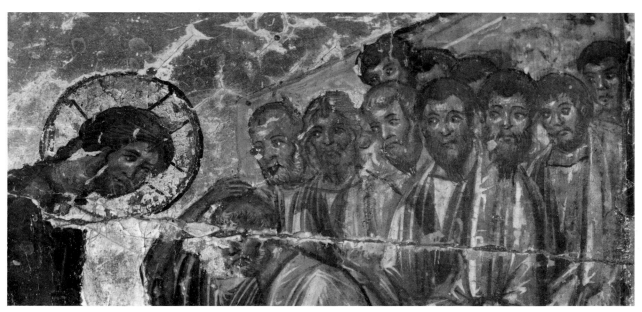

B.56 (detail)

PLATE CXII

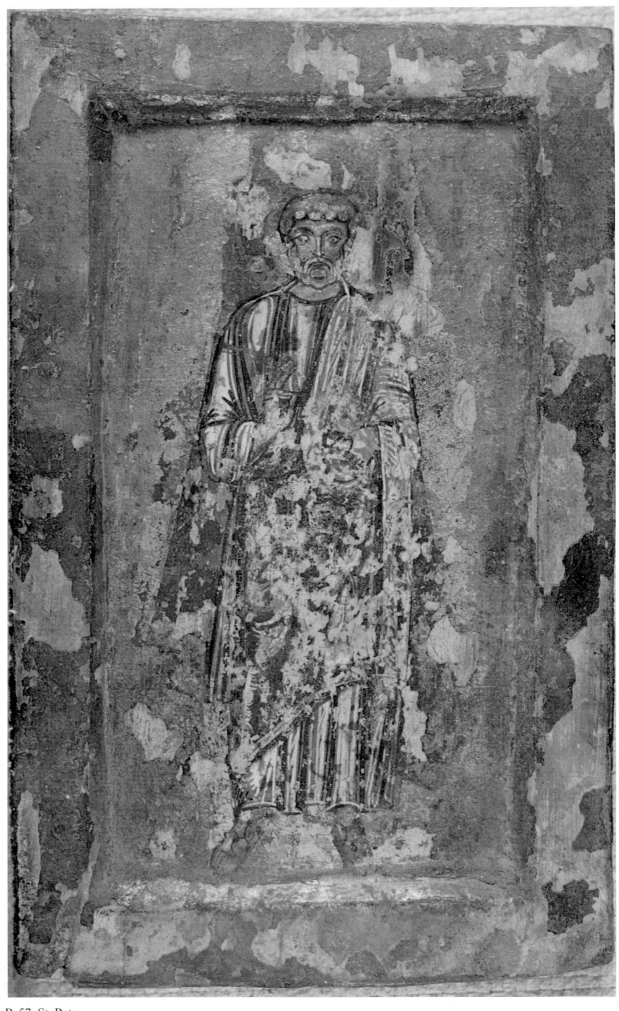

B.57 St.Peter

PLATE CXIII

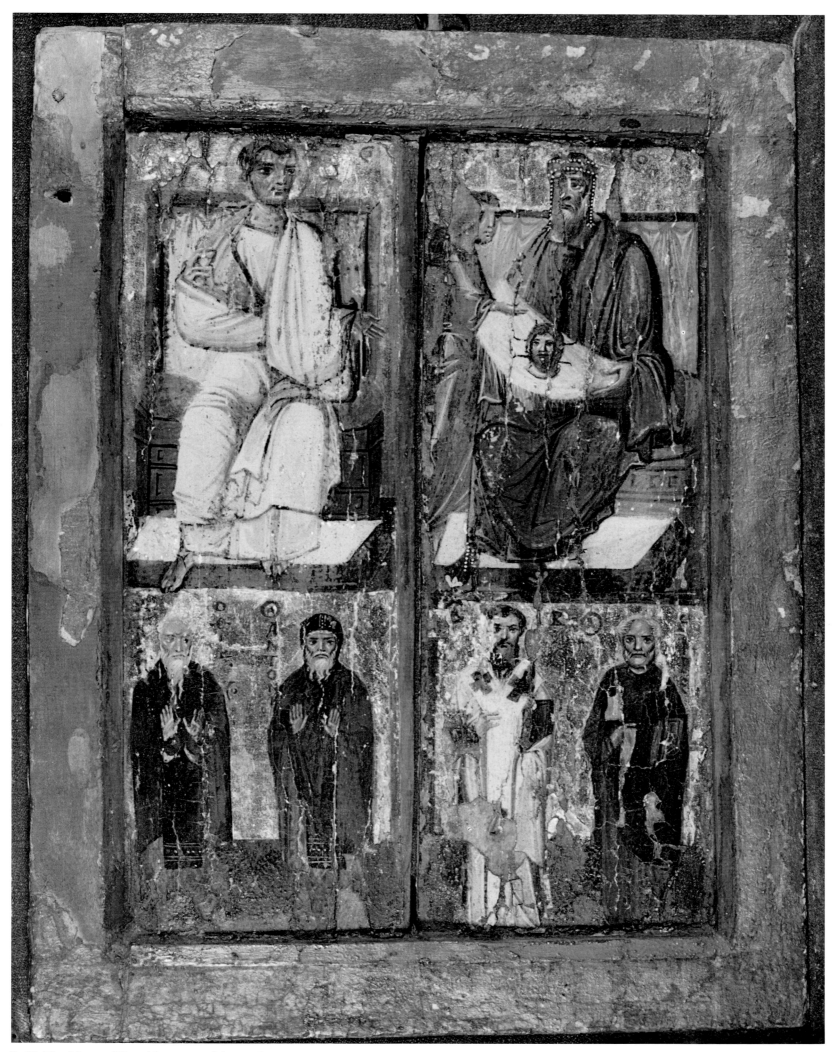

B.58 Thaddaeus, King Abgarus and four saints

PLATE CXIV

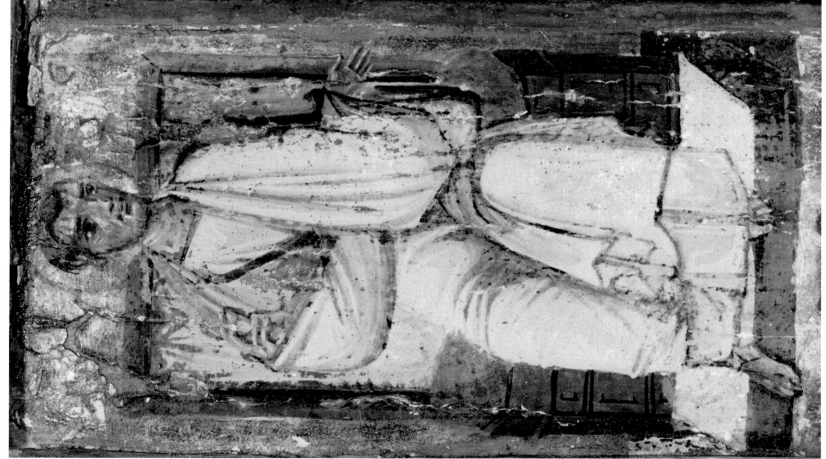

b. King Abgarus

a. Thaddaeus

B.58 (details)

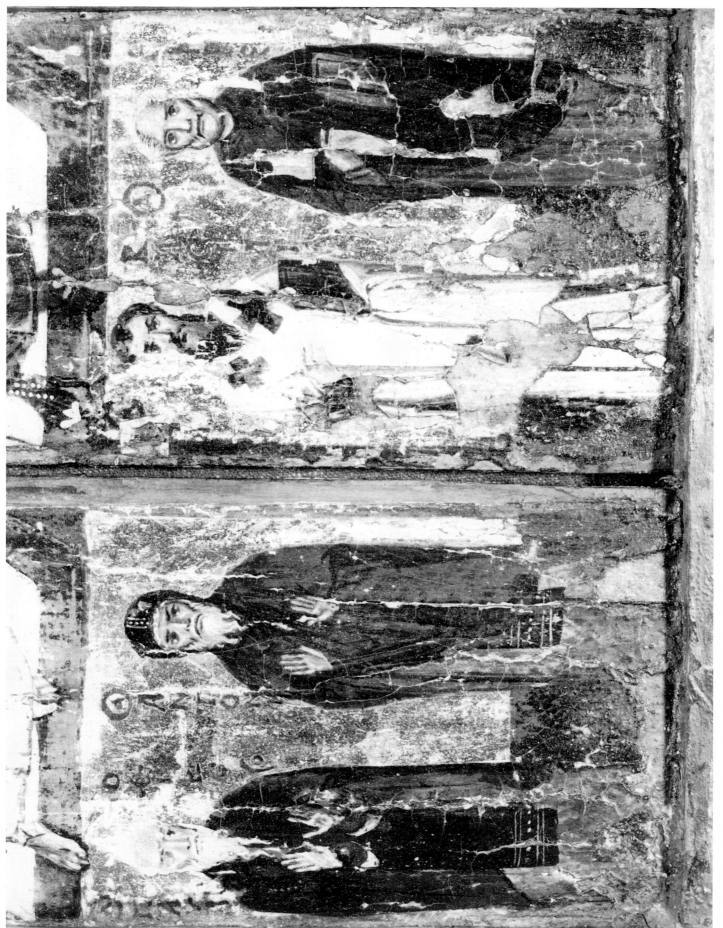

PLATE CXV

B. 58 (detail) c. St. Paul of Thebes, St. Anthony, St. Basil and St. Ephraem

PLATE CXVI

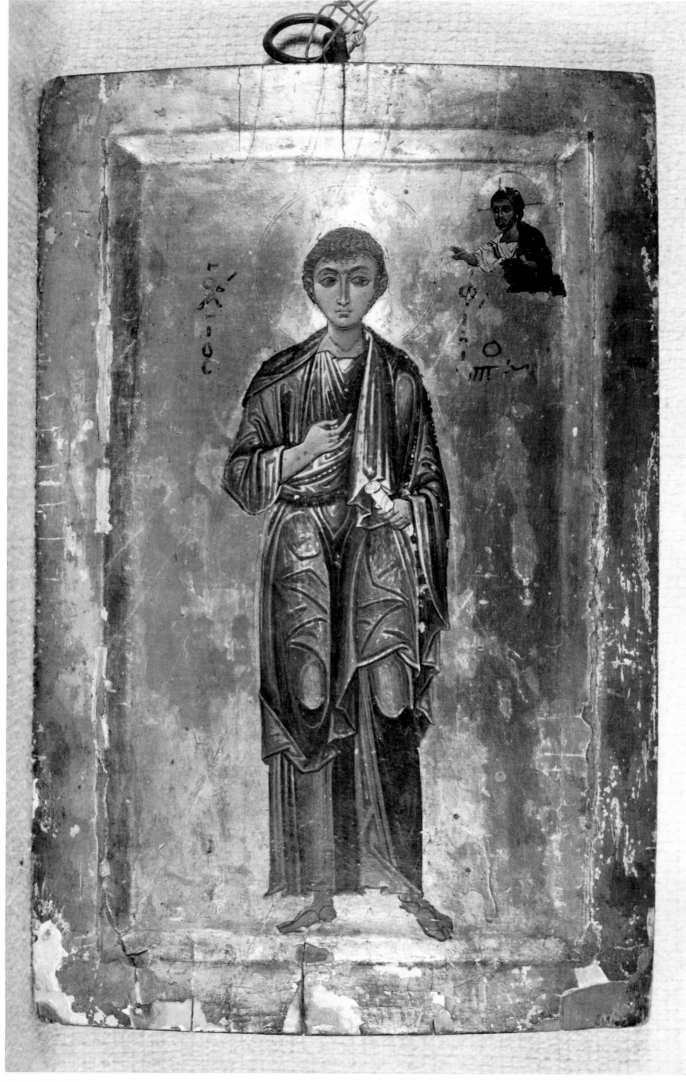

B.59 St. Philip

PLATE CXVII

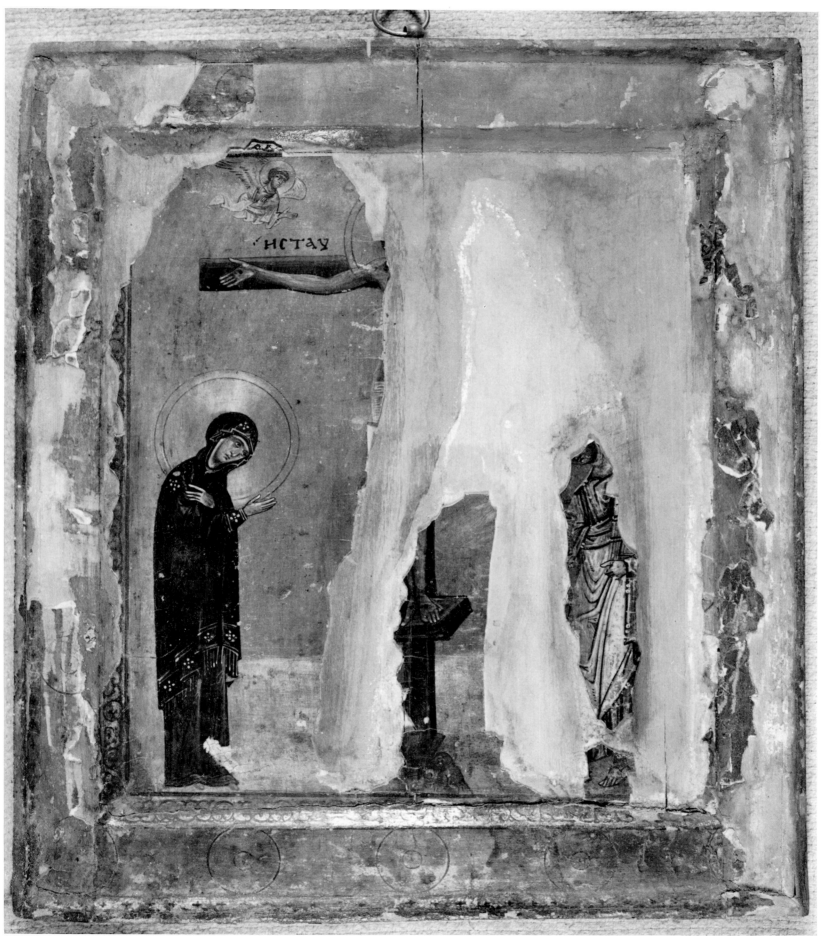

B.60 Crucifixion

PLATE CXVIII

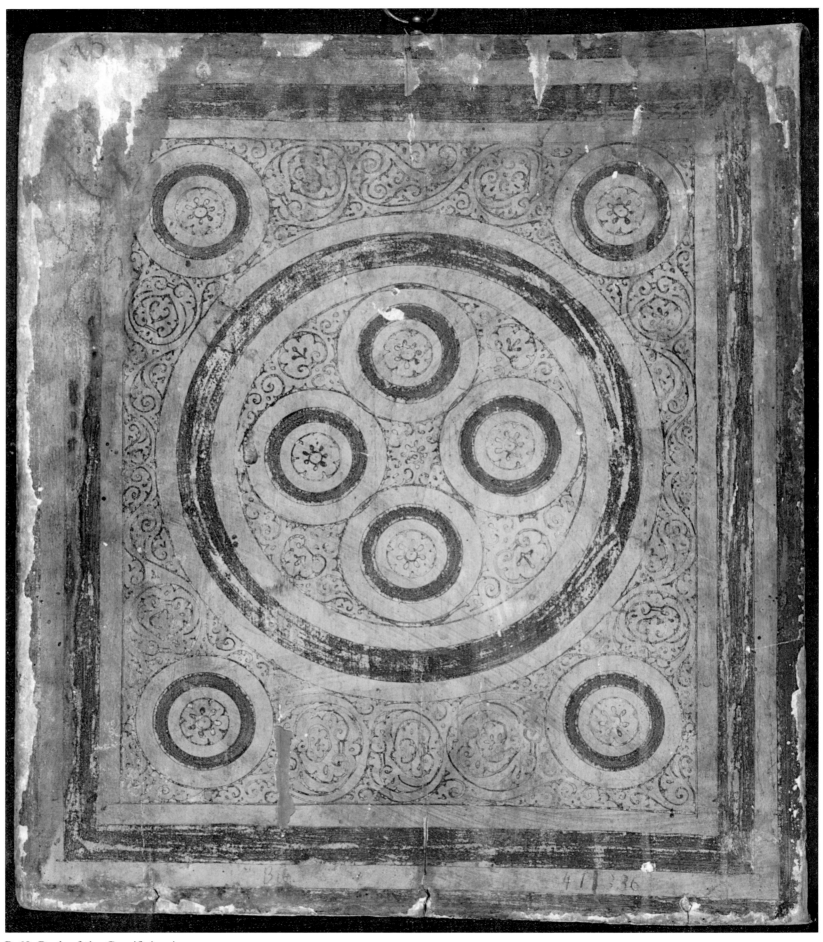

B.60 Back of the Crucifixion icon

PLATE CXIX

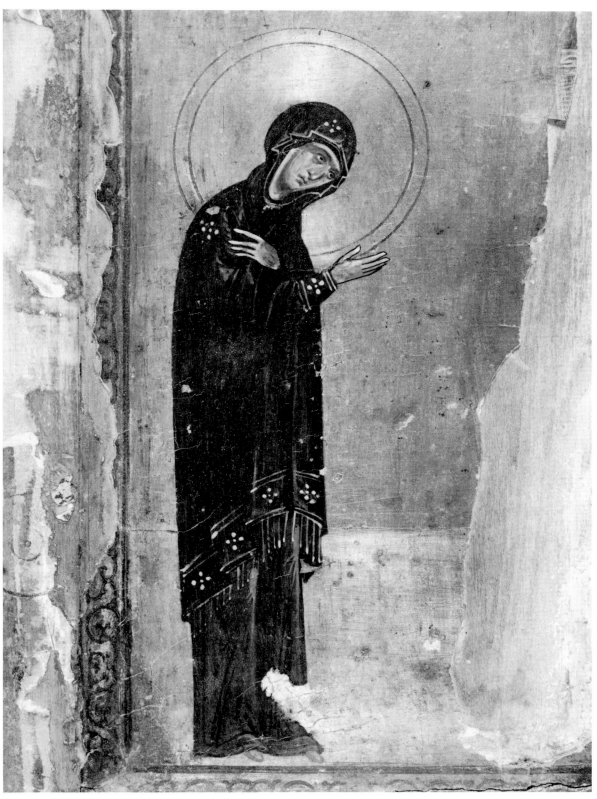

B.60 (detail) Virgin of the Crucifixion

PLATE CXX

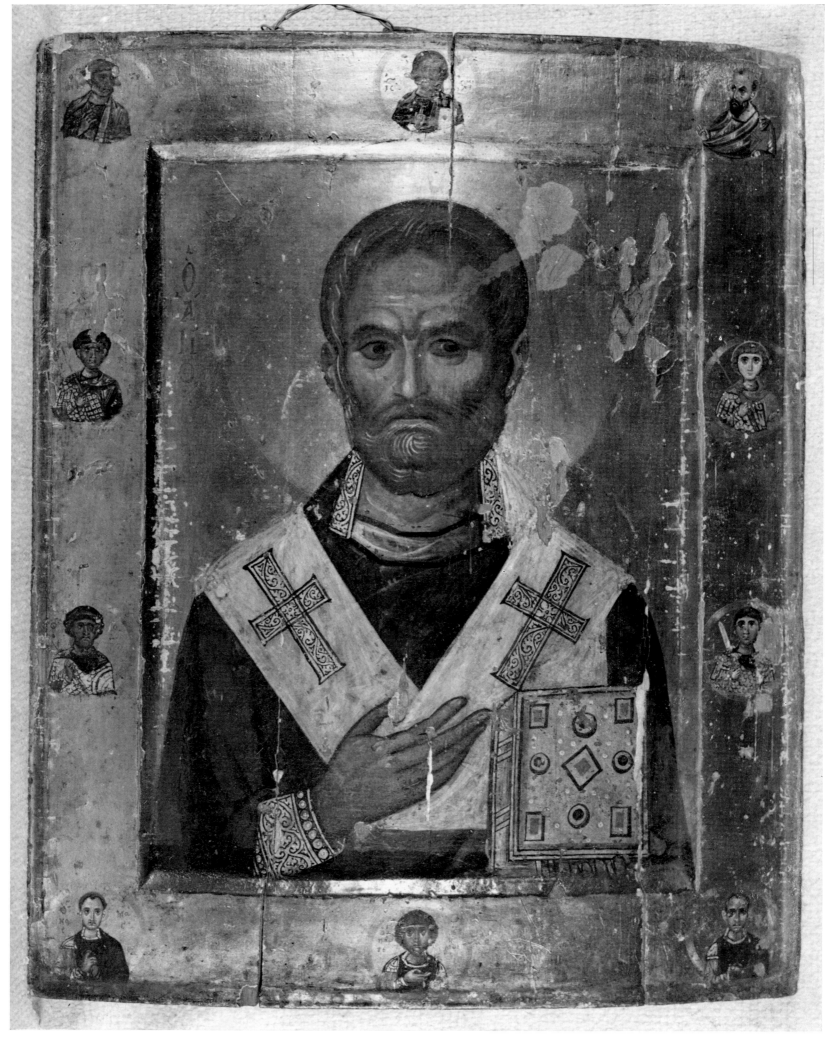

B.61 St. Nicholas

PLATE CXXI

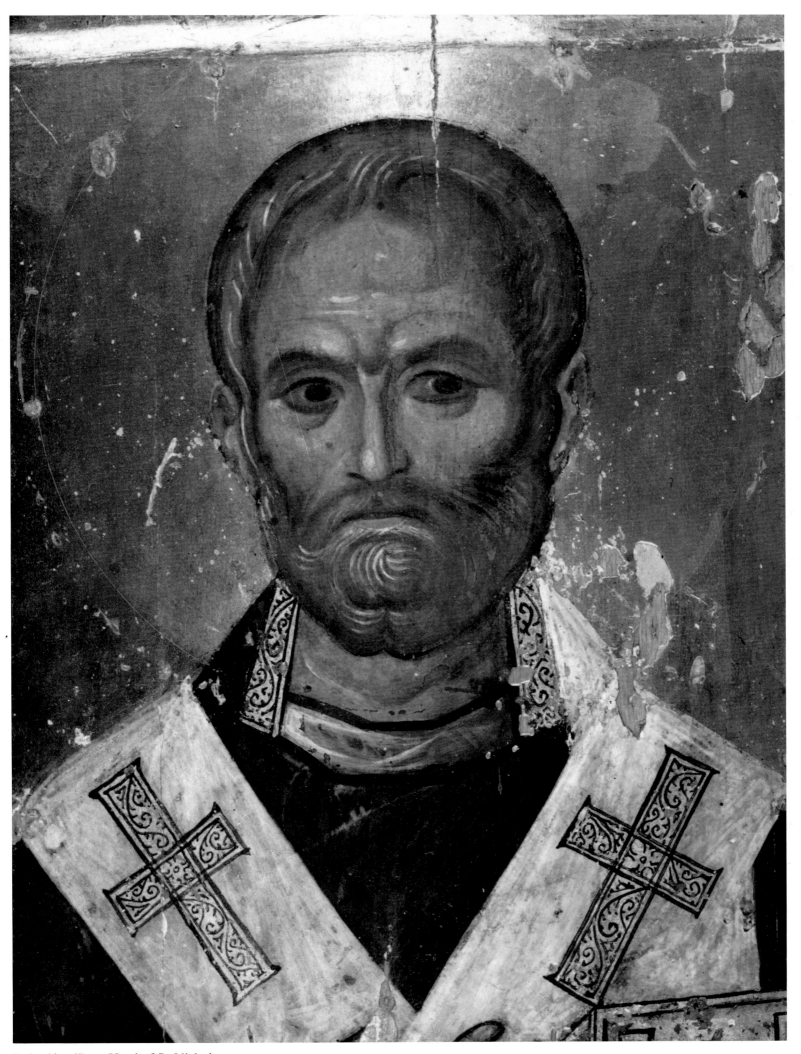

B.61 (detail) a. Head of St. Nicholas

PLATE CXXII

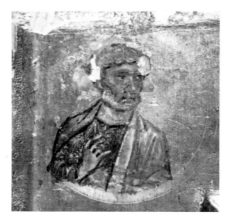

b. St. Peter

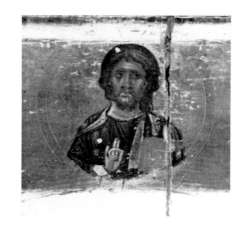

c. Christ

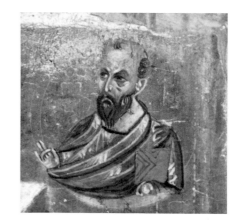

d. St. Paul

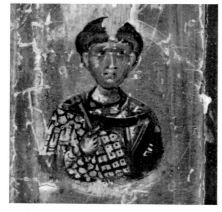

e. St. Demetrius

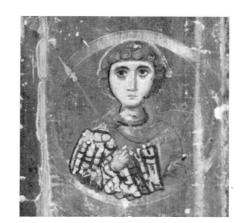

f. St. George

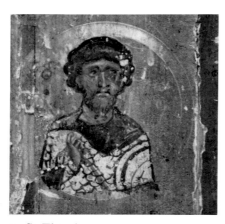

g. St. Theodore

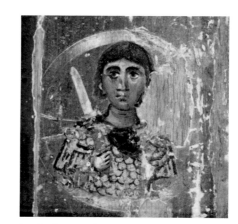

h. St. Procopius

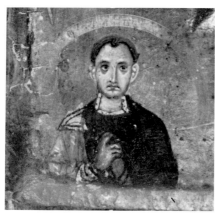

i. St. Cosmas

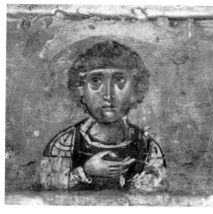

k. St. Panteleimon

l. St. Damian

B.61 (details) b–l. Frame medallions